WITHDRAWN

Inscriptions in the Private Sphere in the Greco-Roman World

Brill Studies in Greek and Roman Epigraphy

Editorial Board

John Bodel (*Brown University*)
Adele Scafuro (*Brown University*)

VOLUME 7

The titles published in this series are listed at *brill.com/bsgre*

Inscriptions in the Private Sphere in the Greco-Roman World

Edited by

Rebecca Benefiel and Peter Keegan

BRILL

LEIDEN | BOSTON

Cover illustration (foreground): Tablet of hospitality and patronage from Zama Regia (CIL VI.1686; Museo Nazionale di Napoli);
Cover illustration (background): Line-drawing of a graffito found in a house at Dura Europos. From Baur, Rostovzeff, and Bellinger 1933, *The Excavations at Dura-Europos*, no. 227.

Library of Congress Cataloging-in-Publication Data

Names: Benefiel, Rebecca (Rebecca Ruth), 1975- editor. | Keegan, Peter
 (Lecturer in Roman history) editor.
Title: Inscriptions in the private sphere in the Greco-Roman world / edited
 by Rebecca Benefiel and Peter Keegan.
Description: Leiden : Brill, [2016] | Series: Brill studies in Greek and
 Roman epigraphy, ISSN 1876-2557 ; Volume 7 | The majority of the papers in
 this work were presented at the XIV Congressus Internationalis Epigraphiae
 Graecae et Latinae, held in Berlin, 27-31 August 2012. | Includes
 bibliographical references and index.
Identifiers: LCCN 2015034561| ISBN 9789004307117 (hardback : alkaline paper)
 | ISBN 9789004307124 (e-book)
Subjects: LCSH: Inscriptions, Greek—Congresses. | Inscriptions,
 Latin—Congresses. | Graffiti—Greece—Congresses. |
 Graffiti—Rome—Congresses. | Greece—Social life and
 customs—Sources—Congresses. | Rome—Social life and
 customs—Sources—Congresses.
Classification: LCC CN350 .I56 2016 | DDC 938—dc23
LC record available at http://lccn.loc.gov/2015034561

ISSN 1876-2557
ISBN 978-90-04-30711-7 (hardback)
ISBN 978-90-04-30712-4 (e-book)

Copyright 2016 by Koninklijke Brill NV, Leiden, The Netherlands.
Koninklijke Brill NV incorporates the imprints Brill, Brill Hes & De Graaf, Brill Nijhoff, Brill Rodopi and Hotei Publishing.
All rights reserved. No part of this publication may be reproduced, translated, stored in a retrieval system, or transmitted in any form or by any means, electronic, mechanical, photocopying, recording or otherwise, without prior written permission from the publisher.
Authorization to photocopy items for internal or personal use is granted by Koninklijke Brill NV provided that the appropriate fees are paid directly to The Copyright Clearance Center, 222 Rosewood Drive, Suite 910, Danvers, MA 01923, USA. Fees are subject to change.

This book is printed on acid-free paper.

Printed by Printforce, the Netherlands

Contents

Preface VII
List of Illustrations XI
Abbreviations XV
Notes on Contributors XVI

1 Inscriptions in Private Spaces 1
Andrew Wallace-Hadrill

PART 1
Graffiti and the Domestic Sphere

2 Private Graffiti? Scratching the Walls of Houses at Dura-Europos 13
J. A. Baird

3 Graffiti in a House in Attica: Reading, Writing and the Creation of Private Space 32
Claire Taylor

4 The Spatial Environment of Inscriptions and Graffiti in Domestic Spaces: The Case of Delos 50
Mantha Zarmakoupi

5 The Culture of Writing Graffiti within Domestic Spaces at Pompeii 80
Rebecca R. Benefiel

PART 2
Discourses of Public and Private

6 Newly Discovered and Corrected Readings of *iscrizioni "privatissime"* from the Vesuvian Region 113
Antonio Varone

7 *Honos clientium instituit sic colere patronos*—A Public/Private Epigraphic Type: *Tabulae* of Hospitality and Patronage 131
Francisco Beltrán Lloris

8 The Significance of Sculptures with Associated Inscriptions in Private
 Houses in Ephesos, Pergamon and Beyond 146
 Elisabeth Rathmayr

PART 3
Place and Space

9 Painted and Charcoal Inscriptions from the Territory of Cyrene:
 Evidence from the Underworld 181
 Angela Cinalli

10 Harnessing the Sacred: Hidden Writing and "Private" Spaces in
 Levantine Synagogues 213
 Karen B. Stern

11 Graffiti as *Monumenta* and *Verba*: Marking Territories, Creating
 Discourses in Roman Pompeii 248
 Peter Keegan

12 Writing in the Private Sphere: Epilogue 265
 Mireille Corbier

 Index Locorum 279
 Index Nominum 284
 Subject Index 287

Preface

When one thinks of inscriptions produced under the Roman Empire, public inscribed monuments are likely to come to mind. Prominent dedicatory inscriptions on building architraves, statue bases listing the achievements and *cursus honorum* of an honorand, funerary monuments recording years lived and relationships left behind—these are the concrete results of an explosive interest in monumentalizing text that is commonly referred to as the epigraphic habit.[1] Hundreds of thousands of such inscriptions are known from across the breadth of the Roman Empire, preserved because they were created of durable material or were reused in subsequent building. Indeed, the theme of the most recent *Congressus Internationalis Epigraphiae Graecae et Latinae* was: **Publicum—Monumentum—Textus**. That first term, *Publicum*, underscores the public nature of most epigraphy. The public sphere has yielded such numerous instances both because public spaces in antiquity were so rich with inscriptions, especially relevant to self-representation and euergetism, and because public spaces, such as the agora or forum, or monumental public buildings, are often the best preserved or most fully excavated spaces of an ancient town.

This volume sets out to look beyond those central, public spaces and consider how inscriptions might be present within the private sphere as well. The types of inscriptions that occurred in private spaces tend to be far more portable, fragile, or ephemeral, and as such they are preserved in smaller quantity; in most instances, it is remarkable that they have survived at all. Yet from handwritten messages traced on wall-plaster to letters and symbols scratched on pottery, from domestic sculptures labeled with texts to displays of official patronage posted in homes, a range of inscriptions appeared within the private sphere in the Greco-Roman world.[2] Chance finds, such as a series of names and letters etched into the floor in a house in classical Attica, offer glimpses into the type of inscriptions that might be found in the private sphere in the classical Greek world. Archaeological sites of the Roman Empire present abundantly more and a wider variety of material, with inscribed domestic sculpture, bronze tablets, and graffiti written on the walls of homes; all together these

1 MacMullen 1982, Meyer 1990, Woolf 1996, Beltrán Lloris 2014.
2 We have not included treatment of inscribed *instrumentum domesticum* in this volume, since a recent issue of *Sylloge Epigraphica Barcinonensis* (*SEBarc*) X, 2012, containing more than twenty contributions, was dedicated to the topic: *Instrumenta Inscripta IV. Nulla dies sine littera. La escritura cotidiana en la casa romana*.

offer a look into the types of text that might surround an individual at home. The chapters within this volume represent a spectrum of private spaces—from the household latrines that feature graffiti *privatissimi* to the patronage tablets that straddle the private/public divide, produced in duplicate copies so that one could be displayed in the home of the *patronus* while the other went on public display in the issuing city. The geographical areas included here as well, from Spain to Italy to Dura-Europos (see Fig. 0.1), further reveal that writing in private spaces was very much a part of the epigraphic culture of the Roman Empire.

The volume is arranged into three sections. It begins with a section on graffiti and writing on walls in the ancient house. The first two chapters by J. A. Baird and Claire Taylor, which examine the graffiti of third century CE Dura-Europos and floor inscriptions from a house of classical Athens, though far separated in terms of chronology, both confront the issue of how we characterize domestic space as private and discuss how graffiti can contribute to our understanding of how space was used. These studies are followed by chapters on graffiti of the Hellenistic and Roman-eras—Mantha Zarmakoupi writes about Delos and Rebecca Benefiel about early imperial Pompeii—which further illustrate how the custom of creating handwritten messages in the interiors of houses spread across the Empire.

The second section of the volume underscores how even private spaces incorporated elements of public communication. Antonio Varone focuses his attention on what might have been the most private of inscriptions, those found in latrines, and in addition to providing new readings, brings to light how these texts take private functions and publicize them through the medium of writing. Francisco Beltrán Lloris' chapter anchors the other end of the spectrum,

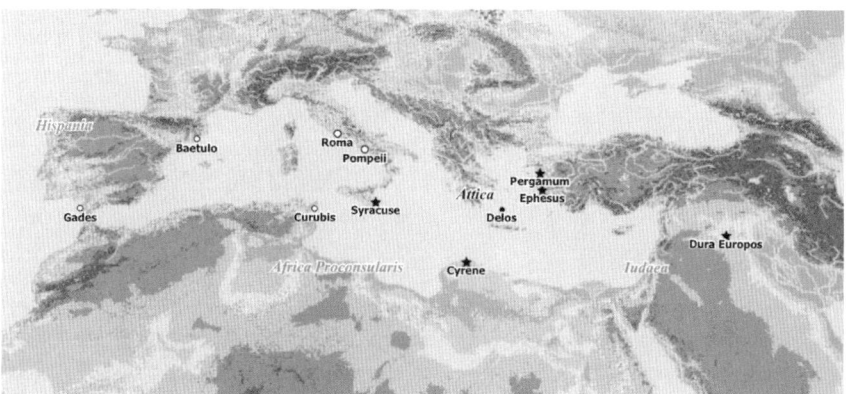

FIGURE 0.1 *Geographical location of inscriptions in the private sphere examined in this volume. Map Tiles © 2015 Ancient World Mapping Center*

with inscriptions taken directly from the public sphere and incorporated into private environments. He explores the bronze inscribed tablets of the *tabulae patronatus* and the *tabulae hospitales* as artefacts that straddled the public/private divide since they were produced in duplicate and were intended for prominent display in both types of locations. Elisabeth Rathmeyer's chapter then introduces the subject of domestic sculpture and how associated inscriptions could affect a decorative program and its mode of communication.

The final three chapters engage with different types of spaces, focusing on space and place, the subject of the third section of this volume. Angela Cinalli writes about the epigraphy within tombs of the region of Cyrene and illustrates how it was added to over time. She also presents a medium that is even more temporary than those already discussed: inscriptions in charcoal. Charcoal is easily erased and quickly vanishes if exposed to rain and wind. The tombs she discusses provide some of the very few examples of charcoal inscriptions we have from antiquity, yet their survival should remind us to consider how much we have lost and hints at what must have been a much broader use of this informal medium for writing. Karen Stern then turns to synagogues in the Levant and explores how the use of writing and particularly the use of writing hidden from view could create private space in the religious sphere. Peter Keegan's essay brings together many of the threads in previous chapters with a discussion of how writing in the ancient city offers a mode of communication that uncovers activity and discourses involving a broad spectrum of society, including non-elites not usually visible in other media.

The genesis of this volume was a panel held during the 2012 Epigraphic Congress in Berlin and devoted to "Inschriften in privaten Räumen." In discussions among the authors and respondents following the panel, we realized that, just as inscriptions from the private sphere are often more scattered and fragmented than those from the public realm, so too are published discussions of such material. We therefore proposed to approach epigraphy of the private sphere as a topic that could be effectively discussed as a cross-cultural phenomenon of classical antiquity. Two papers originally delivered in that panel have appeared in other venues.[3] Four other scholars who were not present in Berlin but who have been working on material germane to this topic agreed to contribute chapters, making this a more robust study, both geographically and chronologically, of where and how inscriptions might appear in the private realm. We are pleased that Andrew Wallace-Hadrill and Mireille Corbier, who chaired and offered the response for the CIEGL panel in Berlin, agreed

3 Hans Taeuber discussed the graffiti of Ephesus (Taeuber 2014a and 2014b), and William West presented inscribed potsherds from a workshop in sixth century Crete (West 2014 and 2015).

to contribute introductory and concluding essays to this volume: the former contextualizes the blend of public and private characterizing Rome's sociocultural (and, by association, epigraphic) landscape; the latter casts a critical eye across the spectrum of studies constituting the volume, providing in sum a variety of important observations on the role of writing in the Roman house.[4]

Bibliography

Beltrán Lloris, Francisco. 2014. "The 'Epigraphic Habit' in the Roman Empire." In *The Oxford Handbook of Roman Epigraphy*, edited by Christer Bruun, and Jonathan Edmondson, 131–152. Oxford: Oxford University Press.

MacMullen, Ramsay. 1982. "The Epigraphic Habit in the Roman Empire." *American Journal of Philology* 103: 233–246.

Meyer, Elizabeth A. 1990. "Explaining the epigraphic habit in the Roman Empire: the evidence of epitaphs." *Journal of Roman Studies* 80: 74–96.

Taeuber, Hans. 2014a. "Einblicke in die Privatsphäre. Die Evidenz der Graffiti aus dem Hanghaus 2 in Ephesos." In *ÖFFENTLICHKEIT—MONUMENT—TEXT. XIV Congressus Internationalis Epigraphiae Graecae et Latinae (2012). Akten*, edited by Werner and Peter Funke Eck, 487–489. Berlin: De Gruyter.

———. 2014b. "Graffiti und Steininschriften." In *Hanghaus 2 in Ephesos: Die Wohneinheit 6*, edited by H. and Elisabeth Rathmayr Thür, 331–344. Verlag der Österreichischen Akademie der Wissenschaften.

West, William C. 2014. "Informal and Practical Uses of Writing in Graffiti from Azoria, Crete." In *ÖFFENTLICHKEIT—MONUMENT—TEXT. XIV Congressus Internationalis Epigraphiae Graecae et Latinae (2012). Akten*, edited by Werner and Peter Funke Eck, 483–484. Berlin: De Gruyter.

West, William C. 2015. "Informal and Practical Uses of Writing on Potsherds from Azoria, Crete." *ZPE* 193: 151–163.

Woolf, Greg. 1996. "Monumental writing and the expansion of Roman society in the early Empire." *Journal of Roman Studies* 86: 22–39.

4 We would like to thank Pasquale Toscano for providing editorial assistance with this volume.

List of Illustrations

0.1 Geographical location of inscriptions in the private sphere examined in this volume viii
2.1 Plan of the 'House of Lysias', state plan, by N. C. Andrews. Used by kind permission of the Yale University Art Gallery, Dura-Europos Archive 19
2.2 Photograph of Room D1–13, the north entrance to the 'House of Lysias,' from north. YUAG Glass negative i89a, 1935–1936 Season. Used by kind permission of the Yale University Art Gallery, Dura-Europos Archive 20
2.3 Plan of B8-H (the 'House of Nebuchelus'), and adjacent shops, by Henry Pearson. North at top of plan. Used by kind permission of the Yale University Art Gallery, Dura-Europos Archive 23
2.4 Line-drawing of horoscope graffito from house B8-H. From Baur, Rostovtzeff and Bellinger 1933, no. 232 24
2.5 Line-drawing recording a shipment, also found in house B8-H. From Baur, Rostovtzeff and Bellinger 1933, no. 227 25
3.1 Map of southeast Attica showing Thorikos, with inset showing location of the *ergasterion*. Drawn by Thanasi Papapostolou 35
3.2 Plan of Euthydike's *ergasterion*. Adapted from Jones 2007, fig. 29.2 36
3.3 Line-drawing of inscription (i) in the courtyard. Drawn by Thanasi Papapostolou 37
3.4 Neighbouring *ergasterion* at Kavodokano. From Jones 2007, fig. 29.2 38
4.1 Plan of House III.1 or House of Kleopatra and Dioskourides, Theater District 54
4.2 Statue group and inscribed base, House III.1, Theater District 55
4.3 Plan of House IC or House of Quintus Tullius, Stadion District 56
4.4 Plan of House of Dionysos, Theater District 61
4.5 Graffito of ship in exedra (l), House of Dionysos 62
4.6 Plan of House II, Insula of the Jewelry 63
4.7 S. courtyard, House of Dionysos, Theater District 64
4.8 W. portico, House II, Insula of the Jewelry 65
4.9 Entrance, House ID, Stadion District 66
4.10 Plan of House of the Lake 67
5.1 *Dipinti* along the Via dell'Abbondanza 82
5.2 Plan of Pompeii highlighting two city-blocks under discussion, I.9 and VI.15 84
5.3 Detail of city-blocks to the south of the Via dell'Abbondanza 85

LIST OF ILLUSTRATIONS

5.4 Distribution of graffiti in *Insula* I.9 88
5.5 Distribution of graffiti in *Insula* VI.15 90
5.6 Plan of Pompeii showing the locations of highly inscribed residences 95
5.7 Mosaic decoration, atrium, I.7.1 97
5.8 Distribution of graffiti through the main floor of VI.16.17 (Casa di Maius Castricius) 99
5.9 Peristyle columns in V.2.i (Casa delle Nozze d'Argento), with detail of graffito on column 100
5.10 Graffiti found on wall plaster in stairway, VII.16.17 (Casa di Maius Castricius) 101
5.11 Line drawings of graffiti found in *tabernae* 102
5.12 Line-drawing and photograph of graffito naming Cucuta, in the vestibule of I.7.1 (Casa di Paquius Proculus) 104
6.1 Stabiae. Villa San Marco. Inscription in the latrine (73): *Cacavi et culu non extersi* 116
6.2 Stabiae. Villa San Marco. Detail of the previous inscription showing the profile of a man turned to the left 116
6.3 Herculaneum. Latrine in the house at Insula V.30. The line-drawing of the inscription, *CIL* IV.10580, by Della Corte, gives the reading: *ex sept(em)*, which is here corrected to *exsetri*, an anagram of *extersi* 118
6.4 Boscoreale, Museo dell'Uomo e dell'Ambiente. The inscription *CIL* IV.10070, found on the façade of the house at I.13.9 in Pompeii, and the new line-drawing proposed by the author 121
6.5 Boscoreale, Museo dell'Uomo e dell'Ambiente. Detail of the final part of inscription *CIL* IV.10070. It reads: <scri>bit qui valuit 121
6.6 Painted inscription from Pompeii, issuing a warning to *defecatores*, *CIL* IV.7038 123
6.7 Pompeii. Latrine of the Casa del Centenario. Detail of *CIL* IV.5242 125
6.8 Pompeii. Latrine of the Casa del Centenario. Detail of *CIL* IV.5244 127
7.1 Tablet of hospitality and patronage from *Baetulo* on behalf of Q. Licinius Silvanus Granianus, 98 CE (*AE* 1936, 66; Museo Municipal de Badalona; photo by the author) 133
7.2 Tablet of patronage from *Ferentinum* on behalf of T. Pomponius Bassus, 101–102 CE (*CIL* VI.1492; Museo Archeologico di Firenze; photo: E. Cimarosti) 137
7.3 Tablet of hospitality and patronage from *Thenas* on behalf of Q. Aradius Rufinus Valerius Proculus, 321 CE (*CIL* VI.1685; Museo Nazionale di Napoli; photo: E. Cimarosti) 139

LIST OF ILLUSTRATIONS XIII

7.4 Tablet of hospitality and patronage from *Zama Regia* on behalf of
Q. Aradius Rufinus Valerius Proculus, 322 CE (*CIL* VI.1686; Museo
Nazionale di Napoli; photo: E. Cimarosti) 139

7.5 Pedestal of the *corpus suarorium et confectuariorum* (sic) for L. Aradius
Valerius Proculus, after 340 CE. (*CIL* VI.1693; photo: *Corpus
Inscriptionum Latinarum*—BBAW) 140

8.1 Town plan of Ephesos: ÖAI 2005, based on: Generalisierter Stadtplan
(Klotz, 2001); numbering of the objects after P. Scherrer, Ephesos. Der
Neue Führer (Wien 1995). Adaptations by Chr. Kurtze/ÖAI, markings by
I. Adenstedt/ÖAW 147

8.2 Layout plan of Terrace House 2: K. Koller, ÖAW 02/01, nach ÖAI
PlanNr. 1963–1 4/97 148

8.3 Layout plan of Dwelling Unit 6 in Terrace House 2 (I. Adenstedt, after
H. Thür and E. Rathmayr, ÖAW) 149

8.4 Peristyle 31a, view onto the rear wall of the fountain with inscription 1
(photo Elisabeth Rathmayr/ÖAW) 151

8.5 Statue bases with inscriptions 2 and 3 in room 36
(photo Niki Gail, ÖAI) 154

8.6 Layout plan of the Attalos house in Pergamon (after W. Dörpfeld, Die
Arbeiten zu Pergamon 1904–1905. Die Bauwerke, Mitteilungen des
Deutschen Archäologischen Instituts. Athenische Abteilung 32 (1907)
167–189 pl. 14) 157

8.7 Alkamenes-Herme (after W. Radt, Peramon. Geschichte und Bauten,
Funde und Erforschung einer antiken Metropole (Köln 1988)
fig. 30) 161

8.8 Sculpture-text-ensemble in the house of Kleopatra and Dioskurides
in Delos, view from the house entrance (photo by Elisabeth Rathmayr,
2012) 163

9.1 Cyrene, view of the Necropolis 182
9.2 Dimitria's Tomb, inscription 186
9.3 The Veteran's Tomb, Leda inscription top right 189
9.4 The Veteran's Tomb, inscriptions accompanying figures 190
9.5 Ludi Tomb, inscriptions on the panel of musical and dramatic
agones 192
9.6A Plan of The Garden Tomb. Position of Inscriptions 195
9.6B Inscription B in The Garden Tomb 198
9.7 Plan of the Carboncini Tomb (L. Cherstich) 200
9.8 The Carboncini Tomb, Gallery A 202
9.9 The Carboncini Tomb. Room D, the barrel-vaulted soffit 204
9.10 The Carboncini Tomb. Room L, painted inscription of Κρίσπος 205

9.11	The Carboncini Tomb. Room L, painted inscription of Εὐίππιον	206
10.1	Ceramic sherds from Aramaic erotic amulet from the synagogue of Ḥorvat Rimmon. Reproduced with permission of the Israel Antiquities Authority	214
10.2	Map of synagogues and locations mentioned in this chapter. Map Tiles © 2015 Ancient World Mapping Center	215
10.3	Bronze *defixio* found under the eastern threshold of the synagogue in Meroth. Photo reproduced with permission of the Israel Antiquities Authority	226
10.4	Aerial photograph of remains of the Meroth synagogue, facing East. Courtesy of the Israel Exploration Society	228
10.5	Bronze inscribed tablets discovered in the synagogue of Ma'on/Nirim. Photo reproduced with permission of the Israel Antiquities Authority	231
11.1	Graffito of Pyrrhus (*CIL* IV.1852), inscribed on a wall panel from the Basilica at Pompeii	250
11.2	Hiphop graffito. Melbourne, Australia (P. Keegan)	251
11.3	Graffito to Chios (*CIL* IV.1820), inscribed on a wall panel from the Basilica at Pompeii	253

Abbreviations

ADelt	Archaeologikon Deltion
AE	L'Année épigraphique
AEphem	Archaeologikon Ephemeris
AJA	American Journal of Archaeology
BMI	Ancient Greek Inscriptions in the British Museum
CIG	Corpus Inscriptionum Graecorum
CIL	Corpus Inscriptionum Latinarum
CLE	Carmina Latina Epigraphica
DAI	Deutsche Archäologische Institut
GMA	Kotansky, R. *Greek Magical Amulets: The Inscribed Gold, Silver, Copper, and Bronze Lamellae. Part I: Published Texts of Known Provenance*. Opladen: Westdeutscher Verlag, 2004.
GVI	Peek, W. *Grieschische Vers-Inschriften*, vol. I. Berlin, 1955.
HEp	Hispania Epigraphica
IAM	Inscriptions Antique du Maroc
ID	Inscriptions de Délos
IEph	Engelmann, H., H. Wankel, R. Merkelbach, *Die Inschriften von Ephesos*. IGSK 11–17. Bonn: Rudolf Habelt, 1972
IG	Inscriptiones Graecae
IGUR	Inscriptiones Graecae Urbis Romae
ILCV	Inscriptiones Latinae Christianae Veteres
ILLRP	Inscriptiones Latinae Liberae Rei Publicae
LGPN	Lexicon of Greek Personal Names
LSJ	Liddel, H. G., R. Scott, H. S. Jones, *A Greek-English Lexicon*. Oxford: Clarendon, 1819–1996
JRA	Journal of Roman Archaeology
JRS	Journal of Roman Studies
MDAI(A)	Mitteilungen des deutschen archäologischen Instituts. Athenische Abteilung (Berlin)
PIR	Prosopographia Imperii Romani
PLRE	Prosopography of the Later Roman Empire
PPM	Pugliese Carratelli, G., I. Baldassarre, eds. *Pompei: Pitture e Mosaici*. Istituto della Enciclopedia Italiana, 11 vols. Rome 1990–2003.
SEBarc	Sylloge Epigraphica Barcinonensis
SECir	Pugliese Carratelli, G., D. Morelli, "Supplemento epigrafico cirenaico", *Annuario* 39–40 (= N.S. 23–24), 1961–62, pp. 217–375
SEG	Supplementum Epigraphicum Graecum
ThLL	Thesaurus Linguae Latinae

Notes on Contributors

J. A. Baird
is Senior Lecturer in Archaeology at Birkbeck, University of London. Her main interest is in the archaeology of Rome's Eastern provinces and the archaeology of everyday life, but she has also published on ancient graffiti, ancient urbanism, archaeological photography, and the history of Classical archaeology.

Francisco Beltrán Lloris
is a Professor of Ancient History at the University of Zaragoza. He is chair of the European network "Ancient Languages and Writings," director of the journal *Palaeohispanica*, and has published widely on ancient Hispania, with special attention to the problems of cultural contact, as well as on the epigraphic habit and on irrigation in the Roman west.

Rebecca Benefiel
is Associate Professor of Classics at Washington and Lee University. Her research centers on Roman social and cultural history, with a focus on Latin epigraphy. She is director of the Herculaneum Graffiti Project and a supervisor for the Epigraphic Database Roma.

Angela Cinalli
is a postdoctoral fellow with the Center for Hellenic Studies at Harvard University. Her current research relates to the itinerant *poeti vaganti* in the Hellenistic world and the epigraphic formulas for hospitality.

Mireille Corbier
is Directeur de recherche emerita at the Centre National de la Recherche Scientifique and Director of *L'Année épigraphique* since 1992. She has published extensively on various aspects of Roman history.

Peter Keegan
is Senior Lecturer in Roman History at Macquarie University and Latin editor of the Female Biography Project. His recent publications include Graffiti *in Antiquity* (Routledge 2014) and *Roles for Men and Women in Roman Epigraphic Culture and Beyond* (Archaeopress 2014), and his current research revolves around the epigraphic landscape in the ancient world.

Elisabeth Rathmayr

is a postdoctoral fellow with the Institute for the Study of Ancient Culture in the Austrian Academy of Sciences. She has published numerous studies on the archaeological heritage of Ephesos, including a co-authored report on Hanghaus 2 (Wien 2014), and continues to explore her interest in Greco-Roman art and architecture.

Karen Stern

is Assistant Professor of History at Brooklyn College of the City University of New York. She conducts research across disciplines of archaeology, history, and religion and considers the relationships between hegemonic and minority populations throughout the Mediterranean. Her first book addressed Jewish populations in Roman North Africa and her current book project investigates graffiti and the daily lives of Jews in late antiquity.

Claire Taylor

is Assistant Professor of Greek History at the University of Wisconsin-Madison. She specializes in the social, political and economic history of fifth- and fourth-century BCE Athens. Her current research examines poverty in fourth-century Athens, and she has also published work on ancient graffiti, political participation and female friendship.

Antonio Varone

is an archaeologist within the Italian Ministry of Cultural Heritage and former director of the Archaeological Superintendency of Pompeii. He is the author of more than 150 articles on Pompeii and its graffiti, as well as *Erotica Pompeiana: Love Inscriptions on the Walls of Pompeii* and a three-volume reference set illustrating the wall-inscriptions of Pompeii (2009–2012). He is currently editing recent discoveries for the next edition of *CIL* vol. IV.

Andrew Wallace-Hadrill

is Director of Research and Honorary Professor of Roman Studies in the Faculty of Classics, University of Cambridge. He currently directs the Herculaneum Conservation Project and has published extensively on Pompeii and Herculaneum, Roman urbanism, public and private space, and Roman cultural identity.

Mantha Zarmakoupi
is Birmingham Fellow in Visual and Material Culture of Classical Antiquity at the University of Birmingham. Her research focuses on the art and architecture of the Hellenistic and Roman periods, including a current project on urbanization in late Hellenistic Delos. She has published most recently on the cultural factors affecting the architecture of Roman luxury villas around the Bay of Naples (OUP 2014).

CHAPTER 1

Inscriptions in Private Spaces

Andrew Wallace-Hadrill

The idea that, in the context of a Congress discussing Greek and Roman epigraphy in general, a session should be set aside for the private sphere, seems at first so self-explanatory as scarcely to require justification, let alone definition. And yet the authors of the papers that follow, the majority of them brought together by the Berlin Congress in 2012, together with some additional recruits, find themselves again and again coming up against problems of definition, above all of what constitutes the private in contrast to the public. Nor should a category problem of this sort be seen as negative, a deterrent from undertaking the enquiry in the first place. Nothing illuminates the ancient world so brightly as those points at which we find that our modern categories, seemingly self-explanatory and unproblematic, fit awkwardly with the categories of Greek and Roman society. It is in unpacking the misfit that we begin to grasp what is distinctive about an alien world.

The contrast of public and private is so fundamental, and so pervasive, that it seems hard to believe it is not a cultural universal, and the more so when our vocabulary, not merely in English, but in most European languages (privé/publique, privato/pubblico, though only half so with privat/öffentlich) is directly derived from the Latin *privatus/publicus*.[1] The Latin opposition is in turn closely related to the Greek *idios/demosios*. The crucial contrast is between what belongs to the people (*demos/populus*), that is to say the formally constituted citizen body, as opposed to the individual citizen. In so far as every built space must belong either to the people, or to an individual (though one could make a separate category of the sacred, being set aside for the gods), it might seem that the *publicus/privatus* contrast was crystal clear in antiquity, and that the inscriptions of the private sphere are readily distinguishable. Not so.

Take the space of the street, which in the context of inscriptions is particularly significant, and simultaneously ambivalent. Naturally the street is public space, and as Latin municipal charters make clear, the city authorities are anxious to assert and defend its public character. As the portion of metropolitan Roman legislation copied into the local regulations in the bronze tables of Heracleia spells out, the aediles have the duty of keeping the *viae publicae*

1 Riggsby 1997.

clear of obstruction.[2] They are given the powers to enforce on the house-owners of the properties facing the street the maintenance of its fabric; it is the responsibility of the householder, at the discretion of the aediles, to keep the road unencumbered by obstructions or pooling water. That is to say, the street belongs to the public sphere, and at the same time can be the responsibility of the private owner, constrained by the jurisdiction of the public elected official, the aedile. And while the continuity of the basalt paving of the road itself suggests that road repairs, albeit undertaken at the expense of neighbouring properties, must have been undertaken under the direct supervision of the public authorities, the sidewalks show a more nuanced approach. As Catherine Saliou has demonstrated, the tendency for the construction and materials of the sidewalk to change in correspondence with property boundaries suggests that householders commissioned repairs directly, and even took pride in embellishing distinctively the approaches to their own boundaries.[3]

Already, then, we encounter shades of grey. The carriageway itself is clearly public, but maintained at private expense on public initiative; the sidewalk is also public, but maintained at private expense and seemingly at private initiative. But this ambivalence of the sidewalk goes further. It may be actually encumbered with private construction, as we see in the porticoes which frequently support upper balconies in Herculaneum and other Roman cities. Such porticoes may be read as acts of public-spirited generosity on the part of the householders, offering the passer-by shelter from sun and rain. But they also allow the extension of private property at upper levels. Given the firm legal principle that ownership at all levels is defined by the ground level, we may ask who in law was the owner of the private balconies so suspended over the public street? Was it necessary to seek building permission (from the aedile? from the city council?) for the construction of such porticoes with upper floors? Did house-owners pay the public purse a forfeit for such permission? Or was it rather the case that the sidewalk was in fact private property, over which the public had an absolute right to access and passage?[4] The legalities remain unclear. The problem is nicely illustrated in Martial's vivid epigram (12.57) celebrating Domitian's disencumbering of the streets of Rome from invasion by private businesses—barbers brandishing razors, shopkeepers hanging jars on chains—that forced the passing magistrate to step down into the mud of the carriageway; yet it leaves us still in the dark as to whether we are looking at a private or a public sphere.

2 Zaccaria Ruggiù 1995, 246–285.
3 Saliou 1999.
4 Saliou 1994, 255–262.

The same problem is raised by the benches that not infrequently are found on sidewalks against the housewall.[5] If, as is traditionally assumed, these are provided for the convenience of *clientes*, waiting to pay their respects, or for that matter waiting around shops and taverns, one may ask whether the householder has any right to create these obstructions. An interesting passage of Aulus Gellius (16.5) suggests that by the second century CE, the word *vestibulum* had migrated inside the house into the *atrium*, at least in the usage of the uneducated. He can cite the lawyer Aelius Gallus to show that properly the *vestibulum* was the area outside the house doors, neither inside the house nor a part of it, but the approach to it from the road. From this perspective, the sidewalk outside the house is its *vestibulum*, whether or not provided with seating. The private literally spills out onto the sidewalk and turns it into a waiting room. And yet, it is precisely this overlap of private and public spaces that arguably make the traditional street effective as a zone of sociability: the modernists who denied Brazilia such streets were attacking sociability itself.[6]

These reflections become more pressingly relevant when we consider the numerous inscriptions in the street on the walls of houses and shops. The public sphere is of course the expected location of public and official writing: the greatest concentration of public inscriptions is to be expected in the spaces explicitly marked as public, the forum, the theater, the gymnasium. Here, especially in the city's heart, *in loco celeberrimo*, we expect inscriptions to be put up on public initiative, at public expense, and to address themselves to the broadest public, aiming at durability and accessibility by engraving on solid supports (bronze or stone) in letters of significant size and carved with a formal clarity. The streets too evidently belong to the public sphere, and may be densely populated (the more densely, as Ray Laurence has shown, the more trafficked the street) with advertisements addressed to the public.[7] Such are the declarations of electoral support (*programmata*) and the advertisements for gladiatorial games, generally painted on plaster, and in large and legible (non-cursive) script, which are so characteristic of Pompeii.

But though clearly addressed to the public, these cannot count as public initiatives. They are undertaken on private initiative, as is confirmed by the frequent addition of names of *rogatores*, those who invite your suffrage for a candidate. It is not even particularly likely that the candidates themselves directly commissioned and financed them, though it is possible that behind the scenes candidates made efforts to coordinate declarations of support.

5 Hartnett 2008.
6 Holston 1999.
7 Laurence 2007, 109–113.

But short of a world of political parties and party funding, such expressions of suffrage must be taken to be purely private, albeit with an impact on the public sphere should the candidate be elected.[8]

The plastered walls, however, on which these advertisements are painted and overpainted are generally the private walls of domestic and commercial structures. By definition, such walls were private property: but does this mean that they could only be painted over with the permission of the householder? So much is sometimes taken for granted: repeated advertisements for a particular candidate on the walls of a grand house have been taken as evidence that this must be the abode of the candidate himself, who must have given permission and encouragement, though the frequency with which advertisements for one candidate are scattered at numerous locations across the city must bring that hypothesis into question. On occasion, however, the identification works, as with the house attributed to M. Lucretius Fronto (V.4.a). The cluster of *programmata* in the lane outside his front door coincides with the naming of the same individual inside the house. But does this mean that the house-owner's permission was necessary in order to paint a *programma*? Surely not. Lucretius Fronto is promoted not only on his own house walls, but those of his neighbours, though this may be taken as a sign of neighbourhood solidarity. But in general, it is difficult to see how the painters of *programmata* can have operated, overpainting the names of candidates at numerous locations up and down a variety of streets, if it was necessary to knock repeatedly on doors asking permission, least of all if they were operating as one notable advertisement proclaims, by the light of the moon. Nor would it be easy to explain the permission given to the not infrequent parodic advertisements, as by prostitutes or drunkards.

The problem is surely our modern conception of the watertight boundaries between public and private. We find it hard to envisage modern house-owners allowing their frontages to be used for publicity, unless with consent (fliers for candidates for local elections plastered in front windows), and particularly in the case of commercial advertisements, in exchange for payment. The very promiscuity of the writing on walls facing streets in Pompeii suggests that, just as the public had right of access to pavements laid and maintained at private cost, and sheltered by the overhang of private balconies, so it was taken for granted that a private facade was a suitable location for messages addressed to the passing public. The sidewalk is thus the sphere in which public and private invade each other reciprocally.

8 Mouritsen 1988, 61–64.

Exactly the same set of issues is encountered as we enter the private sphere of the house. Vitruvius, in a much cited and endlessly discussed passage (6.5.1), asserts that there were areas of the house which could be regarded as *communia* on the grounds that the people could come in as of right even uninvited (*etiam invocati suo iure de populo possunt venire*).[9] That is not the same as asserting that part of the private house is public property: it evidently is not. But he uses the language that is at the heart of the separation of public and private: the access of the *populus*, even if this is *solum privatum*, is treated as a quasi-legal right (*de iure*). One may doubt whether this point of view could have been sustained in court. Indeed, Fronto, in contrasting public and private, says that while the gates of the city and the doors of public buildings are open to the public, those of private properties are not, and the doorkeeper's function is to bar the way to uninvited visitors (*Epist. Graec.* 5.1). This public/private contrast appears to contradict Vitruvius.[10] Vitruvius' language here is surely metaphorical: it is as if, by paradox, the private can be treated as public. But he goes on to articulate the logic behind it: since the nobles in holding office are under obligation to their fellow citizens (*praestare debent officia civibus*), it is suitable to entertain them in spaces that aspire to the magnificence of public spaces (*non dissimili modo quam publicorum operum magnificantia comparatas*). Thus while the public, the *populus*, surely enjoyed an actual legal right of access (*de iure*) to the pavement outside a house, and could exploit that access by turning private house-walls into a location for advertisements affecting public affairs, so metaphorically the tenure of public office led to treating private space as if it were public, with a corresponding bundle of expectations of a scale that exceeded the private.

The focus of the conference session was the *private* sphere, not *domestic* space, which is only one variety, albeit a dominant one, of the private. Yet what emerged repeatedly is that, thanks to the ambivalence of the boundaries between public and private, and thanks to the enthusiasm with which, at least in the Roman world, the metaphor of quasi-public space was embraced within the domestic, it became harder to draw fast lines between writing in public and writing in private. The most explicit examples of this crossover are the *tabulae patronatus*, typically in the west inscribed on bronze, by which a community might formally honour a patron. Such a bronze *tabula* in a private *atrium* performs an exactly analogous function to an inscription erected in the patron's honour in a public space, and sometimes the two forms of honour go hand in hand. Beltran Lloris (Chapter Seven) well cites the phrase of the elder

9 Wallace-Hadrill 1994, Riggsby 1997, Hales 2003.
10 Hales 2003, 36.

Pliny that by introducing statues into homes, '*forum et in domibus privatis factum et in atriis*': the practices of *clientela* that sought to honour patrons in their own homes in parallel to the honours celebrated in public spaces turned the domestic *atrium* into a *forum*, and with the statues came formal writing, inscriptions carved onto lasting materials in clear letters. Equally, Elisabeth Rathmayr shows (Chapter Eight) how the statues of gods in the grand houses of Ephesos or Pergamum by which the owners displayed their personal piety served to advertise in writing the owner's identity and personality in a way closely analogous to the dedication of statues in the public sphere. Public and private are separate, but nevertheless in constant dialogue with each other.

But while metaphorically the private space of the grand house could be treated as public, so allowing the private to draw on the prestige of the language of the public, it also has its own distinctive language which sets it apart from the public. In terms of graphics, clear letters elegantly inscribed on solid supports, like bronze or marble, stand at the opposite end of the spectrum from what students of antiquity describe as 'graffiti', small, cursive, often illegible, in whole or in part, informal and ephemeral in their production. Despite the ultimate derivation of this word from the Greek for writing in general, *graphein*, its immediate context is Italian (*graffiare*), and the term retains its precise connotation of 'scratching'. Italian scholarship maintains a clear distinction between scratched graffiti and painted *dipinti*. As we have seen, *dipinti*, such as electoral publicity, belong to the world of the public street, even if painted on private plasterwork.

Graffiti, by contrast, belong to the technology of private communication: they are an extension of the normal use of the stylus for writing on waxed wooden tablets, typically used for private communications and private business documents, like the archive of Caecilius Jucundus at Pompeii, of the Sulpicii at Murecine, and of at least 8 individuals in Herculaneum.[11] The stylus was surely the first writing implement the Roman schoolchild learned to master: the inked reed, *calamus*, was more difficult, and also more prestigious, the necessary tool for writing literary texts. The level of scribal skill involved in the stylus is lower, and the fact that any pointed object could be used to the same effect made the matter even easier; the diffusion of the graffito across the plastered walls of Pompeii, and any other site where plaster survives, like Ephesos or Dura Europos, is remarkable.

Here, as a number of our contributors have remarked, the ancient graffiti belong to a fundamentally different world from their modern homonyms. The modern instrument of choice is the spray-can, making the products in Italian terms *dipinti* not graffiti. Moreover, they belong to a world of the subversive:

11 Camodeca 2011.

the wilful invasion and spoiling of public space by the rebellious individual, leaving his highly personalised assertion of identity, the 'tag.' Roman graffiti may indeed invade public space, the Basilica of Pompeii being a fine example, but their most frequent occurrence is in private space. Perhaps the common factor is that the space is internal: not a loud announcement in large letters to the public outside, but a quietly internalised discussion. And discussions they can literally be, as one graffito respects the space of others, and offers variations on the theme of surrounding comments (Keegan, Chapter Eleven).

What ancient and modern graffiti have in common is their unofficial status. They are not formally commissioned from professional sign-writers by the proper authorities, whether public (the town council) or private (the house or shop-owner). This is not to say that ancient graffiti are made against the will of the house-owner. It is very hard to say whether permission is involved, positively or negatively. The activity was so widespread as to be unstoppable: plastered walls simply asked for stylus marks. In this sense it becomes significant to ask which precise locations were favoured for graffiti. As Benefiel shows for Pompeii (Chapter Five), or Baird to a lesser extent for Dura-Europos (Chapter Two), or indeed Zarmakoupi for Delos (Chapter Four), the favoured locations within the house were in a sense the most public, circulation areas like the entrance passage, the *atrium*, and in particular the columns of the peristyle. If we applied the sort of 'viewshed' analysis advocated by the Space Syntax approach of Hillier and Hanson, these are precisely the areas which would show up as the most visible from within the house.[12] Here too we detect the mimicking of the public by the private sphere. Just as the columns of the forum were used to display public notices, the columns of the peristyle invited private postings. The letters are small, and only legible from close-up: nevertheless, a column was a good place to leave a message. Just as with the official inscriptions of the forum, the best place for domestic writing was *in loco celeberrimo*.

Not all private spaces were domestic. Shops too, privately owned, attracted writing. The most spectacular example in Pompeii is the Great Brothel, where graffiti, especially of an overtly erotic nature, cluster densely, with nearly a hundred specimens on a single wall. As Mireille Corbier rightly observes, graffiti may be the time-killing activity of bored young men. The ephemeral documentation of a banal act could add a low-level thrill to your two-asses' worth. And here too we have a meeting of public and private. The brothel is privately owned space, but open by definition to the public. The act is intimately private: but the kick comes from sharing this intimacy with the public. In the same spirit, as Varone shows (Chapter Six), the user of a latrine in a private house

12 Anderson 2011.

might share with the public of other potential users of the same space the squalid shortcomings of his defecation.

The sphere of the private stretches beyond houses and shops. Writing in funerary contexts is revealing, as Cinalli's case-study of Cyrene shows (Chapter Nine). Graves may indeed have clustered in typically public spaces, along main roads, but as Andrew Marvell knew, 'the grave's a fine and private place'. Equally, the sphere of the magical transcends the public/private distinction. Stern's study of Levantine synagogues (Chapter Ten), even if their sacrality was not defined in the way familiar in the pagan world, shows how within such space, curse tablets could be carefully buried, out of sight and irrecoverably (even under a threshold), so very much unseen and in this sense private, except to the magical powers supposed to harken to them. And even in the supposed case of the privacy of the domestic sphere, as Claire Taylor suggests (Chapter Three), privacy is not so much an inherent attribute as a quality to the construction of which writing may contribute.

One further category of writing in the private sphere bulks large in the evidence: the messages, both scratched and painted, and also stamped, on ceramic containers. Even though a minority of amphorae may carry legible writing, it is so deeply implicated in the different stages of commercial exchange that one may ask whether an amphora could have functioned at the primary moment of usage without writing. The workshop that produced the container itself may leave a scratch, or better a stamp. Then the producer of the contents of the amphora did well to indicate clearly the nature of the contents (wine, oil, *garum* in its many varieties and qualities, dates etc.) and his own name and or region. These messages are typically inked for durability. Perhaps at a later stage of shipment it might be needed to indicate the addressee of a shipment: when three amphorae are found in the same house with the name, inked in full, or scratched in abbreviation, of Sextus Pompeius Amarantus, it is a reasonable inference that he was the destination of the shipment and thus the manager of the bar in the corner of this property.[13] One further type of writing on containers must be hypothesised, but is yet to be attested. The bronze *signacula* commonly found in private spaces, bearing names in full or abbreviation on their characteristic concave surface cannot have been intended to seal flat surfaces, and are surely designed for the pitch or wax seals over the mouths of containers that guaranteed their contents against interference, contamination or fraud.[14]

Should we regard the inscribed amphora as public or private writing? The amphora is in itself private property, though of course this might include

13 Wallace-Hadrill 2011.
14 di Stefano Manzella 2011.

the private property of a public entity—the frequency of amphorae from Crete in Pompeii is surely linked to the fact that the municipium of Capua owned extensive land in Crete, bringing in an annual rent of over one million sesterces.[15] Labelling activities are inherently directed towards a public of sorts, a long string of individuals in the production, shipping and ultimate sales chain. But though played out under the public gaze, commerce is a sequence of private transactions, and William West is fully justified in treating the amphora labels that are found with remarkable precocity in archaic Crete as writing in the private sphere.[16]

The boundaries between public and private thus emerge as complex, and not always where modern experience would expect them to be. Industrialisation changed the world in many ways, shifting irrevocably the boundaries of public and private. One of the most significant transformations was the separation of the world of work from the world of residence. The richness of the historical directories of the city of New York allowed the precise charting of this movement of separation between the late 18th and mid 19th centuries. In 1790, under 5% of the members of the middle classes in the directories, and none of the elite, maintained separate homes and workplace. By 1840 the figure had risen for both classes to 70%. Even shopkeepers conform to this pattern, rising in the same period from just under 10% to over 70% who kept separate homes from their shops. That was to redefine the domestic sphere profoundly, not least in making the home distinctively a female sphere, opposed to the male sphere of the workplace.[17]

With the separation of home from workplace comes an idea of privacy as a value to be jealously guarded. The family was seen as gaining from its separation from the world of work and the gaze of the public. Indeed, it is to this we attribute what Richard Sennett identified as 'the fall of public man,' the progressive location of individual identity in the private sphere, not in an individual's relations with the community.[18] Roman domestic space knows no such separation. It is a place not only of residence and family values, but of work, of commerce, and, at the highest levels, of political activities, of weaving the webs of alliances and dependence on which patronage worked. It is for this reason that we would be wrong to look for any absolute separation between the uses of writing in public and private spheres, though contrasts there are indeed to be found. But it is in the crossovers that we can begin to appreciate what made ancient societies so unlike our own.

15 Rigsby 1976.
16 West 2014.
17 Wall 1994.
18 Sennett 1974.

Bibliography

Anderson, Michael. 2011. "Disruption or continuity? The spatio-visual evidence of post-earthquake Pompeii." In *Pompeii: Art, Industry and Infrastructure*, edited by Eric Poehler et al., 74–87. Oxford: Oxbow.

Camodeca, Giuseppe. 2011. "Gli archivi privati di *tabulae ceratae* e di papiri documentari a Pompei ed Ercolano." In *L'Écriture dans la maison romaine*, edited by Mireille Corbier and Jean-Pierre Guilhembet, 189–210. Paris: de Boccard.

di Stefano Manzella, Ivan. 2011. "*Signacula ex aere*: Antichi timbri di bronzo e le loro impronte." In *L'Écriture dans la maison romaine*, edited by Mireille Corbier and Jean-Pierre Guilhembet, 345–78. Paris: de Boccard.

Hales, Shelley. 2003. *The Roman House and Social Identity*. Cambridge: Cambridge UP.

Hartnett, J. 2008. "*Si quis hic sederit*: Streetside Benches and Urban Society in Pompeii." *American Journal of Archaeology* 112: 91–119.

Holston, James. 1999. "The modernist city and the death of the street." In *Theorizing the City: the New Urban Anthropology Reader*, edited by Setha M. Low, 245–76. Rutgers: Rutgers UP.

Laurence, Ray. 2007. *Roman Pompeii: Space and Society*, 2nd edition. London: Routledge.

Mouritsen, Henrik. 1988. *Elections, Magistrates and Municipal Elite: Studies in Pompeian Epigraphy*. Rome: L'Erma di Bretschneider.

Riggsby, A. M. 1997. "Public and private in Roman culture: the case of the cubiculum." *JRA* 10: 36–56.

Rigsby, K. J. 1976. "Capua and Cnossos." *TAPA* 106: 313–330.

Saliou, Catherine. 1994. *Les Lois de bâtiments: Voisinage et habitat urbain dans l'empire romain*. Beyrouth: Institut français d'archéologié du Proche-Orient.

———. 1999. "Les trottoirs de Pompéi: une première approche." *BABesch* 74: 161–218.

Sennett, Richard. 1974. *The Fall of Public Man*. New York: W. W. Norton.

Wall, Diana diZerega. 1994. *The Archaeology of Gender: Separating the Spheres in Urban America*. New York: Plenum.

Wallace-Hadrill, Andrew. 1994. *Houses and Society in Pompeii and Herculaneum*. Princeton: Princeton University Press.

———. 2011. "Scratching the surface: a case study of domestic graffiti at Pompeii." In *L'Écriture dans la maison romaine*, edited by Mireille Corbier and Jean-Pierre Guilhembet, 401–414. Paris: de Boccard.

West, William C. 2014. "Informal and Practical Uses of Writing in Graffiti from Azoria, Crete." In *ÖFFENTLICHKEIT — MONUMENT — TEXT. XIV Congressus Internationalis Epigraphiae Graecae et Latinae (2012). Akten*, edited by Werner and Peter Funke Eck, 483–484. Berlin: De Gruyter.

Zaccaria Ruggiù, Annapaola. 1995. *Spazio privato e spazio pubblico nella città romana*. Rome: Ecole Française de Rome.

PART 1

Graffiti and the Domestic Sphere

CHAPTER 2

Private Graffiti? Scratching the Walls of Houses at Dura-Europos

J. A. Baird

Modern understandings of graffiti, as something that is intrusive or out-of-place, have had a real effect on how we study ancient graffiti, particularly that inside "private" spaces.[1] Defining "privacy" is of course a contentious issue, and as has long been recognised, some of the internal, "private" spaces of the Roman house could indeed be quite "public," whether through visibility from the street or in the reception of visitors.[2] Nevertheless, the presence of graffiti inside houses is something which pushes us to question the way in which we have defined graffiti as a category: rather than being something illicit or subversive, the graffiti within houses at Dura-Europos show that the presence of scratching text or pictures into house walls was, actually, normal at the site. Further, those graffiti could have a range of purposes: ranging from the magical or sacred, to the utilitarian, or even decorative. This chapter explores these different elements of graffiti within houses, and addresses a number of questions: in what way were house walls just another surface on which marks could be made? Were the walls of houses active in the social life of house residents, rather than simply being a backdrop to daily life? And, as posed by Andrew Wallace-Hadrill, would these graffiti *be different* if they were not in a private space?

[*] I am grateful to Andrew Wallace-Hadrill for inviting me to present a paper at the session on which this volume is based, and the editors for the invitation to contribute to the volume itself. Discussions with Rebecca Benefiel and the other session participants also assisted greatly in writing this paper. Karen Stern kindly permitted me access to her *JRA* 2012 article before it was published. Claire Taylor read and commented on a draft, as did Dan Stewart. Any mistakes are, of course, my own.

[1] On the "internalization" of the prohibition against graffiti in household spaces by modern scholars, see Fleming 2001, 30, 171n5. On the graffiti at Dura being meaningful, and not acts of defacement, see Baird 2011, 56. For a recent study of writing in Roman houses, see the chapters in Corbier and Guilhembet 2011.

[2] Wallace-Hadrill 1994, 60.

Privacy in Durene Houses

At Roman Dura-Europos on the Syrian Euphrates, the architecture of the houses hints at a concern with isolating the interior life of the house from the public areas of the street and beyond. For instance, the street doors generally open into a vestibule, which is L-shaped so as to protect the courtyard from passing glances even when the exterior house door was open. Windows were placed high in the walls and consisted of a narrow slot on the exterior of the house. In one sense, the world of the house is private, inasmuch as even visual access to it is tightly regulated. There is also regulated access within the house, which might be seen to demarcate more and less private areas within. In smaller houses, ranges of rooms are organised via a central courtyard, with sets of locking doors able to reconfigure and control access within the structure. In larger houses, a number of courtyards seem to differentiate between more public parts of the house in which guests might be received, and more remote parts of the house which were only accessible to certain members of the household.[3]

If we wish to examine the dichotomy between "public" and "private" life, private may be shorthand for the internal space of the house; of course, the reality is the notion of privacy is much more nuanced and contextual. While accepting this to be the case, because the current volume deals broadly with inscriptions in private spaces, as a starting point I will discuss graffiti within houses. As will be shown, different graffiti within houses are in some cases linked to the degree of privacy (or permeability, in spatial terms) of particular spaces within those houses.

At Dura, far from graffiti being something that was out-of-place within houses, writing on walls inside such "private" structures was relatively commonplace; graffiti were recorded on walls of almost forty percent of the excavated houses.[4] A fifth of all of Dura's graffiti was found within the houses. Given that there is a high correlation between preserved wall height and preserved graffiti, this was probably an even more widespread practice than surviving evidence demonstrates. The abundant traces of graffiti in Durene houses

[3] Further on privacy in Durene houses, see Baird 2014. For an overview of Durene graffiti, Baird 2011, 49–68. For a study of Durene graffiti from the recently excavated houses of block C11, see Allag 2012.

[4] The number of houses is approximately 130 if each courtyard unit is treated independently; the number is considerably fewer if houses which intercommunicate internally are treated as single units. On this problem, see Baird 2012b, 149, 163.

were initially interpreted as signs of debasement and decline, as "... scrawls, scratches, and drawings ... so common in Dura wherever owners ceased to feel a pride in their buildings or neglected to guard them."[5]

Rather than trying to explain graffiti as something that was out of place in private houses, I want to re-frame Durene graffiti as a particular technique of writing or drawing: scratching the plaster of the walls. This is also an attempt to emphasize graffiti as a material practice within a particular spatial context, and not only as a text read and interpreted separately from architecture. The modern placement in volumes like *CIL* has tended to reinforce the textual status, but recent work such as Benefiel's has shown that consideration of these markings in their physical contexts, and examination of their relationship to other texts can be deeply informative.[6] Langner's corpus of pictorial graffiti is tremendously useful, but it too artificially separates images from texts and contexts.[7]

House Walls as "Surface"

Dura was a city of gypsum, mudbrick, and plaster. The plaster that coated house walls, on their interior and exterior, both protected the mudbricks and created a surface which lent itself it to scratching and painting.[8] The plaster, once dried, was a hard surface, requiring a sharp implement (not simply, say, a fingernail) to make a recognisable mark. Scratched words and images should thus be thought of as deliberate: tools were picked up and used to make scratched marks, in the same way a paintbrush was picked up and used to make a painting. The marks that were made had a wide variety, from utilitarian inventories in rooms perhaps used for storage, to acclamations, from religious scenes to little drawings of horses and birds. The ubiquitous availability of the surface of house walls for writing meant an accessibility that expensive parchments or papyri did not allow.

5 A reference to the proliferation of graffiti in House B8-H, Baur, Rostovtzeff, and Bellinger 1931, 136.
6 Benefiel 2011; Benefiel 2010.
7 Langner 2001. On the pictorial graffiti of Dura, Goldman 1999.
8 On the plaster of Dura and its composition, see Dandrau 1997. Paintings at Dura were not true fresco but painted directly on dry plaster surfaces; for an overview of Durene wall-painting, see Perkins 1973, 33–69.

Temporalising *Graffiti*

Scratching graffiti into a surface anchored writing to context in a way not possible with parchments or papyri, and while formal lapidary inscriptions had a narrow range of "acceptable" locations for their installation, graffiti could be made anywhere a person could reach.[9] The scratches of graffiti hold time in a number of ways: first, we can consider the performative aspect of writing. Graffiti, as something scratched into a plaster wall, had to be made *in situ*, not in a workshop or record office. Thus, graffiti allow us to consider the bodily act of writing on the part of an individual and the possibility that others saw this act being performed. This raises the question of graffiti as an embodied practice and as a memorial of that act (doubly memorializing when the text included a personal name, as is the case for many of the Durene graffiti).[10] Next, the continued existence of that graffiti over time raises the question of the memorial aspect of writing. Graffiti could speak for their makers when they were not there, and even interact on their writer's behalf with later readers, as we see when early graffiti are overwritten or added to by later ones. This duration in writing could also record human duration, for example in the way that graffiti accumulated in spaces where waiting seems to have occurred (on which, see below). The question of the duration of texts and images inevitably leads to that of audience: who made these texts, and who was the intended reader? To consider these related questions of privacy, surface, and time, I will consider three examples: first, I will discuss a type of text that frequently occurred at the site, and then examples of graffiti scratched in two Durene houses.

Case 1: Remembrance *Graffiti* at Dura

One type of graffiti which occurs throughout Dura, in both public and private contexts, are Greek *mnēsthē* texts. These graffiti could be described as having

9 Indeed, the ability of people to reach a certain height is a factor allowing the study of graffiti probably made by children: Huntley 2011. See also, more recently still, Garrafoni and Laurence 2013.

10 On questions of time, Lucas' writing on the temporality of manuscripts, when manuscripts are considered archaeologically, could similarly be applied to graffiti: "A manuscript ... incorporates not just the memory of a witness it also incorporates the memory of the act of writing. This doubling of memory-as both a mental (testimony) and material (trace) phenomenon—acknowledges the temporality of the historical document of the archaeological object...." Lucas 2010, 350.

a religious character, with over a fifth of those on the stone gate being acclamations of the formula "may so-and-so be remembered by the god": *mnēsthē* plus a name, e.g. Barlaas, Timarkos or Aurelios.[11] The same Greek formula is used with names that are Hellenic, Semitic, and Latin, and a Semitic version of the same formula also occurs at the site.[12] Less often, the text names "the writer" rather than a named individual.[13] Examples of this formula are found scratched, chipped, hammered, painted, or scratched and painted onto surfaces, very frequently in houses, but also in sanctuaries and public buildings.[14] Overall, this type of graffiti comprises almost 12 per cent of the total textual graffiti of the town, the largest proportion of any recognisable group.[15] The occurrence of one type of text across multiple contexts problematizes issues of public and private in defining graffiti. While these cluster in certain high traffic areas, they do not usually refer directly to other graffiti. However, we might see them in a different sort of dialogue, in which similar graffiti collect together, with people writing similar messages to those made before them in the same places. Ten per cent of the graffiti from the houses were the *mnēsthē* formula, but also found here were horoscopes, alphabets, lists of various types, accounts, and images including hunting scenes and ships.

In these *mnēsthē* graffiti, writing is not simply a way of making one's mark but a means of making a religious statement. Indeed, the recording of this formula is part of its invocation, and its continued physical presence, its materiality, ensures the act of remembrance, as does the possibility that the text could be read out loud. The physical presence of the text would seem to be an important part of its usefulness: the graffito was a means by which a text could speak for itself long after the writer has gone. The bodily act of writing the text enacted a dedication.[16] The notion that graffiti-writing is an act of subversion

11 Barlaas and Timarkos: Baur and Rostovtzeff 1931, 100, nos. H11 and H.14. Aurelios: Baur and Rostovtzeff 1929, 33, no. R.5. On this formula, Rehm 1940. At Ephesus, Taeuber 2005.
12 The Semitic version of the forumula is dkyr/zkyr.: Stern 2012, 178–181.
13 On acclamation in the Roman world, see Roueché 1984. For *mnēsthē* examples from Aphrodisias, see Chaniotis 2011.
14 The formula is also used in more formal carved lapidary inscriptions, and sometimes explicitly notes that the remembrance is to a god. See e.g. Rostovtzeff, Brown, Welles 1936, 129–130, no. 868, from the Mithraeum.
15 Thirty individual examples of this Greek text (or clusters of the text recorded together) were found in domestic contexts, and c.150 are known from the town more broadly. Numbers do not include the Semitic formulation.
16 "... writing... has an irreducible bodily component. We tend to forget this; writing is a habitual exercise of intelligence and volition which normally escapes the notice of the person exercising it because of the familiarity with the method...." Connerton 1989,

is belied in the ancient world by the many such graffiti which include the name of the author, although in fairness we have no way of knowing whether these are pseudonyms. That this formula occurs throughout the site, on interior and exterior surfaces, in public areas and private ones, indicate that such practices as are reflected in the graffiti are not easily spatially confined to particular types of spaces. With the question of privacy we are in a sense talking about audience—but if one of the audiences is the gods, perhaps the notion of privacy doesn't really deal with the right issues. These *mnēsthē* graffiti name and fix their writers in a particular place, tying them to the walls into which they scratched, and also placing them in relation to divine forces.[17] Writing one's name on a house wall may be even more significant if we consider that the form of houses was directly related to kinship patterns, and that changes and modifications that required the plastering of walls were sometimes the result of household transformation (e.g. the division of a house amongst heirs upon the death of a patriarch).[18] As the form of the house is related to the shape of the kin group within it, memorialising an individual on a house wall also— literally—cements that person into a relationship with that social group, a relationship that could further be recalled if the graffito was read aloud.

Case 2: The House of Lysias (D1)

One house where we can consider these issues is the House of Lysias (Fig. 2.1). A large, elite residence, this structure occupies the whole of a city block, insula D1 in the site nomenclature. It takes its title from the eponymous owner, named in a graffito found within the house.[19] The house belonged, it seems, to an elite family known from inscriptions elsewhere on the site, and is the largest excavated residence at the site save the palaces.[20] The house was organised around four interior courtyards. In the third century, in the final phase of the house's use, there were two entrances, with the main one opening

76–77. On the graffiti themselves as dedication (rather than commemorating a dedication), see Stern 2012, 178–181.

17 As discussed in Chmielewska 2007.
18 The division of a house between four brothers at Dura is discussed in *P. Dura* 19, which details the way in which a structure is physically reconfigured when it is inherited jointly by them. On the relationship between house form and kinship, see Baird 2014, chapter 6.
19 Graffito published in Frye et al. 1955, 147–148, no. 16.
20 The palaces in use in the Roman period included the large structure known as the "Strategeion" or "Redoubt palace," and the Roman Palace known as the "Palace of the Dux."

FIGURE 2.1 *Plan of the 'House of Lysias' (J. A. Baird, after N. C. Andrews; used by kind permission of the Yale University Art Gallery, Dura-Europos Archive).*

from the north side into the largest courtyard. This entrance vestibule included, unusually for the site, benches (room 13, on the right side of the plan; Fig. 2.2).[21]

In this entrance, several clusters of *mnēsthē* graffiti were found, with 8 separate texts.[22] We might easily imagine guests awaiting admittance sitting on the benches and scratching the texts, and the explanation of simple boredom for the appearance of graffiti is one that has been frequently made (at Dura, we could also look to the main gate of the city, which was covered in

21 The house of Lysias had been planned to appear as a fascicule of the ninth preliminary report, but this book never appeared. Notes, photographs, and plans, are however preserved in the Yale University Art Gallery Dura-Europos archive. An unpublished report is also available there which collates much of the archival documentation: Gunn 1965. A new study of the house has been undertaken by Segolene du Breil du Pontbriand, under the auspices of the Mission Franco-Syrienne d'Europos-Doura, including the unpublished Master's thesis: du Breil de Pontbriand 2006; du Breil de Pontbriand 2007, and recent fieldwork has been published in du Breil de Pontbriand 2012.

22 This is the largest group of such texts *in situ* from a house at Dura; at least 8 were recorded in C3-D, but these were all on fallen plaster.

FIGURE 2.2 *Photograph of Room D1–13, the north entrance to the 'House of Lysias,' from north (YUAG Glass negative i89a, 1935–1936 season; used by kind permission of the Yale University Art Gallery, Dura-Europos Archive).*

the marks of soldiers).[23] More productively, we might use these texts to think about where people spent time, and how these buildings were used. The graffiti cluster around the opening between rooms 13 and 13¹, and on the east wall of 13 above the bench (to the south of the door to room 20). The texts range from one which names Lysias in relation to an embassy around Dura (no. 18), several names including the repeated name of Lysias (nos. 19, 20), one that seems to give a price for wine in denarii (no. 21), one that refers to the death of Lysias (no. 23), and a number of *mnēsthē* texts (nos. 22, 25, and 26). Of the last group, three different names are given in no. 22 (Addaios, Aisaos, and Areaios), another in no. 25 (Herakles), and two more in no. 26 (Lysias and Addaois, whether these are the same or different individuals to those with the same names already given is not known).[24] Another pair of graffiti from D1–9, dated

23 Indeed, the original excavators at the site called those that scratched the graffiti into the gate "idlers": Welles 1951, 266.
24 Frye et al. 1955, 147–148.

to 159 CE also include the name Lysias, and were interpreted as recording the journey of Lysias, *epistates*, to a place called Beth-ilaha.[25]

A *mnēsthē* graffito was also found in the courtyard, room 1, as was a loose plaster fragment with a name, and a graffito was also found on the west door jamb between rooms 9 and 10.[26] The scripts clustered in the entranceway, room 13, were likely made by visitors to the house—and would have been so unremarkable both in presence and formulation that the guest had no doubt that their actions would not be considered a defacement. In this house the *mnēsthē* graffiti seem to sometimes be made by visitors in reverence to the house owner, so the name included in such graffiti might not be the act of the maker. Further, in (presumably) naming the head of the household and asking for the remembrance of Lysias, such graffiti were also about status. The practice of naming particular individuals is also socially connective, as argued by Taylor (this volume). These marks are part of the biography of the building: they were in visible places, and from the dated examples in other houses, it is clear some were allowed to remain as part of the fabric of the building for many years. Carved stone inscriptions, it has been argued, show a desire to "fix an individual's place within history, society, and the cosmos"—graffiti did this as well, but in a way that was more accessible to more of the population, and should be considered no less a part of the epigraphic habit.[27]

Karen Stern has shown that the same formula of remembrance graffiti cluster around the door of Dura's synagogue, and in parts of other sanctuaries, particularly in "areas of greatest sanctity... [including particularly] around altars and cultic niches."[28] That we see the same pattern in houses of these texts clustering around entranceways to houses, and specifically around doorframes, is unlikely to be a coincidence. In sanctuaries, graffiti "frequently and appropriately appeared in places of intensified holiness."[29] There is no reason to assume that when the same formulations occurred in houses they were

25 Frye et al. 1955, 147–148, no. 16. Kaizer proposes that this place was a transliteration of the Aramaic for 'House of the gods' and evidence of a journey to a Mesopotamian cult centre: Kaizer 2009, 239.

26 From the courtyard, Frye et al. 1955, 147–148, no. 27, Μν(ησθῆ) Λυσίας, and no. 28, ΜΑΣΘΑΤΗΣ. From the jamb: Frye no. 17, a fragmentary text including part of a date.

27 Woolf 1996, 29. Further on the epigraphic habit and graffiti, see Taylor 2011.

28 Stern 2012, 181.

29 Stern 2012, 183. On the remembrance graffiti of the Synagogue as *quid pro quo* for a good deed or donation to the Synagogue (and hence of unclear significance in domestic contexts), see Noy and Bloedhorn 2004, 138, 155, 155 n23.

casual or off-hand. That the formula could be used for other types of remembrance is also clear, in its use to "sign" the artisan's signature to moulded plaster cornices at Dura.[30]

Case 3: The House of Nebuchelus (B8-H)

Another house at Dura which we might use to consider the questions posed by this volume is the so-called "House of Nebuchelus," house B8-H (Fig. 2.3). The graffiti were so plentiful in this structure, at almost a hundred, that it was also known as the "House of the Archive."[31] The house has two attached shops which open into the same building (B8-9 and B8-8), and the house itself is unusual in having four rooms with benches (B8-H 2, 4, 5 and 13, although only three of these seem to have been in use in the final period), perhaps indicating the building had a commercial, or at least supra-domestic, use. The graffiti found in the house clustered in the entrance (B8-H7), and in rooms B8-H12 and B8-H5, both of which open off the courtyard.[32] These graffiti included horoscopes, accounts, *mnēsthē* texts, receipts, and inventories, as well as drawings of a boat, and a winged victory. Again in this house, the number and range of graffiti shows that graffiti were not just a casual scratch, nor an act of defacement, but one way the walls of the houses were active in the lives of their occupants, whether being used to invoke a god or to recall how much Aurelios owed you for those two jugs of wine. Again, in this house as in the House of Lysias, *mnēsthē* graffiti cluster in the entranceway (room 7), but also appear in other rooms.

30 The "Orthonobazus" cornices, signed as *mnēsthē* and the name Orthonobazus, which were found in a number of contexts including in house D5. Cumont 1926, 226–237; Baur, Rostovtzeff, and Bellinger 1933, 30–31; Shoe 1943.

31 This structure was also known as the "House of the Clothes Merchant." We might, in fact, question the domestic status of this building, with multiple attached shops and several reception rooms. Not all graffiti were visible in the final period; room 5 had gone out of use after a fire, and others (e.g. no. 197) were found under later layers of plaster. Preliminary publications were made in Baur, Rostovtzeff, and Bellinger 1933, 39, 79–145, 222; Rostovtzeff 1934, 47–49, 97. Expedition publications of various aspects of B8-H include Rostovtzeff and Welles 1931; Rostovtzeff 1935, 220 n78; Welles 1956, 472. For discussion of the texts, Ruffing 2000. While graffiti were common in Durene houses, the great number in this structure is unusual.

32 Room B8-H5 seems to have gone out of use following a fire, but the precise sequence is not well recorded. Baur, Rostovtzeff, and Bellinger 1933, 80.

FIGURE 2.3
Plan of B8-H (the 'House of Nebuchelus'), and adjacent shops (Henry Pearson, N. at top of plan; used by kind permission of the Yale University Art Gallery, Dura-Europos Archive).

A number of horoscopes were found scratched into the walls of this house, in the form of a circle divided into four quarters with diagrams of the horoscope, constellations and planets (Fig. 2.4). These, in addition to providing dates for the texts and birthdates for some of those whose horoscopes were read, show both people's interest in divination, and function to place the individual whose horoscope is recorded and their life span in relation to the cosmos (as horoscopes generally are made using the birth date of the person for whom they

FIGURE 2.4
Line-drawing of horoscope graffito from house B8-H (from Baur, Rostovtzeff and Bellinger 1933, no. 232).

forecast).[33] Further, the presence of horoscopes scratched into house walls can conjure for us aspects of Durene life otherwise unattested, for instance in the likely presence of professional astrologers, and the use of planetary tables that would have been necessary to make the horoscopes.[34] Such texts are usually found only on papyri, but Dura, with its unusually good preservation of plaster, perhaps indicates they might have been more widespread.

Graffiti relating to commercial transactions cluster in two other rooms, rooms 5 and 12. In this house, too, we can use the graffiti to see how spaces within houses were used, and perhaps where business transactions occurred.

33 Horoscopes were found in B8-H (nos. 232, 235, 236, 237, 238, 239), and C8-F (no. 302). The two houses in which horoscopes were found were quite close together, near the center of the city. On the C8 horoscope, Baur and Rostovtzeff 1931, 161–164; Johnson 1932, 1–15. On the B8 horoscopes, see Welles 1956, 472; Baur, Rostovtzeff, and Bellinger 1933, 95–96, 105–110. On ancient astrology, Barton 1994). On horoscopes in papyri, Evans 1999, 286–287.
34 Further on the horoscope of Alexander from this building, see Shayegan 2011, 345–347.

FIGURE 2.5 *Line-drawing recording a shipment, also found in house B8-H (from Baur, Rostovtzeff and Bellinger 1933, no. 227).*

Graffiti served a purpose in record-keeping, and the display of these records might also have served a social function (in the display of debts, for instance). In this house, the fabric of the building became a medium of record keeping and communication. For example, in room 12, in addition to the horoscopes, tabulations were found (no. 217), as was an inventory of textile items (no. 218), and a record of a shipment (no. 227) among many other texts including a number of business transactions, like receipts or records of shipment for items including wool and grain (Fig. 2.5).[35] Many texts were small and tidy, with letters a centimetre or two high. Texts attest to the business transactions of some of the people that used the structure, the extent of their contacts well outside Dura, the type of textiles and other goods that were traded, and presumably, worn and consumed locally. House walls were an available surface, one which could archive the information for easy use and reference, as well as displaying them, and even allowed for their editing, as items were scratched off when they had been paid or otherwise dealt with.[36] Parchments or papyri were expensive,

35 Texts of B8-H12 published as nos. 214–275 in Baur, Rostovtzeff, and Bellinger 1933.
36 E.g. lines fully scratching out no. 245.

needed to be kept and cared for, and could be easily destroyed, but house walls were ubiquitous and available for mark-making.[37]

Conclusion

First, to answer the question posed, "would these graffiti *be different* if they were not in a private space?" The answer, at Dura, is: It depends. Yes, graffiti would be different if they were not in 'private' spaces, because graffiti are toposensitive, and need to be understood in relationship to their architectural and social context. But, on the other hand, the answer could also be no: the *mnēsthē* graffiti of Dura show that similar marks could be made in sacred and public and domestic contexts, and that the appropriate architectural location for these was similar across these different environments.

I have often been annoyed by Rostovtzeff's nickname for Dura, the "Pompeii of the Syrian desert" (because Dura is nothing like Pompeii, and it is not in the desert).[38] Nonetheless, I think it is somewhat interesting to briefly compare the graffiti at these two very incomparable sites. For instance, we might contrast these graffiti with those recently discussed by Wallace-Hadrill, from Insula I.9 at Pompeii. There, he points to the banality of so many of the texts, and writes convincingly that, at Pompeii "…that graffiti as an ephemeral medium attracts self-consciously trivialising uses of the skills of writing. Writing for the Pompeians is not magic or sacred or privileged or special: it is part of the low-level, everyday life of a town."[39] At Dura there are many such banal texts, recording the price paid for a container of wine, or a little scratched drawing of a deer, but many of the graffiti, I think, *are* special. The medium may not be the carefully carved letters of lapidary inscriptions, but many of the graffiti recall these forms (scratching, for instance, a *tabula ansata* or other framing device around a *mnēsthē* text), and they are placed in visible locations, made often by named authors, and have a sacred meaning for them.[40] Even the

37 The technique of scratching the plaster was also deployed in more "official" contexts, for example in the city's archive building, the *Chreophylakeion*, in which scratched letters were used to label the niches in which documents were kept. For a recent re-excavation and clarification of the archaeology of the Chreophylakeion, see Coqueugniot 2012. For a description and photograph of the scratched labels on the niches, see Rostovtzeff, Bellinger, Brown, and Welles 1944, 169–176 and plate 20.2.

38 The comparison is often unhelpful and misleading: see full critique in Baird 2012a.

39 Wallace-Hadrill 2011, 410.

40 Of course, it could be argued the sacred *is* banal and mundane in the ancient world. I disagree that the use of a *tabula ansata* is necessarily "parodistic" of more official texts,

seemingly mundane graffiti have something to tell us about how people used spaces, how they lingered while waiting. The amount of religious graffiti is perhaps also special at Dura, and goes beyond these textual forms, to drawings of gods, scenes of sacrifice, and altars.[41] However, Dura *shares* with Pompeii other types of graffiti, including many abecedaria in public and private contexts throughout the site.[42]

Maura Heyn and Karen Stern, for the 'Temple of Bel' and Synagogue respectively, have shown that graffiti marks are not an act of defacement or subversion, but *normal* in the temples of Dura.[43] Beyond being normal, in the synagogue the practice may be viewed as a conscious way people chose to interact with the divine, and something that cults across the site seem to have in common.[44] In the houses, too, graffiti are normal or "everyday" but this also could mean something interesting in religious terms, or social or economic ones. Dura is exceptional because of the amount of preserved plaster at the site—but it is possible that, if we had more sites with as many preserved wall surfaces as at Dura, graffiti would be shown to be normal, too.[45] Graffiti also problematize a long-held assumption amongst many ancient historians that literacy can be directly related to class or social status.

The graffiti at Dura are also very different from the graffiti of sites like Pompeii, for instance in the proportion of religious texts, or in the complete lack of "erotic" graffiti. The range of graffiti shows the variety of concerns and interests of its makers, from the depiction of camel caravans[46] and horoscopes, to that of gladiators,[47] cataphracts and hunters, from intricate calendars[48] to

as has been argued for such texts at Pompeii: Kruschwitz and Campbell 2009, 60. Rather, the use of this device situates graffiti within the broader spectrum of written forms.

41 See for instance Goldman 1999, e.g. altar: E.10; sacrifice at altar F.6.
42 Alphabets are often believed to be evidence of teaching literacy (indeed, this was likely to be the case). See for instance Wallace-Hadrill 2011, 409. However, at Dura it is possible they served some other purpose, and are frequently found in religious contexts including a concentration in the Christian House Church. Kraeling, because of this group, believed they were apotropaic. Kraeling 1967, 89–90. For a list of Dura's alphabets, Rostovtzeff et al. 1952, 40, n42.
43 Heyn 2011; Stern 2012.
44 E.g. see discussion of the sanctuaries of Aphlad, Azzanthakona, Mithras, and the Christian building in Stern 2012.
45 Bagnall 2011.
46 Baur, Rostovtzeff, and Bellinger 1933, 221–2, pl. 23.2; Goldman 1999, no. G.23.
47 Rostovtzeff 1934, 38–9; Goldman 1999, nos. F.5 and G21.
48 Rostovtzeff et al. 1936, 40, 42–43, figure 2.

household inventories and simple names.[49] The graffiti of Dura allow us to see, more broadly, that notions of privacy are contextually specific, that we can learn about the use of space within houses and about the occupants of houses, and that we should be careful in letting Pompeian paradigms dominate our thinking.

Bibliography

Allag, Claudine. 2012. "Graffiti et corniches à Europos-Doura." Edited by Pierre Leriche, Segolene du Breil de Pontbriand, and Gaelle Coqueugniot. *Europos-Doura Varia* 1: 124–141.

Bagnall, Roger S. 2011. *Everyday Writing in the Graeco-Roman East*. Vol. 69. Berkeley: University of California Press.

Baird, J. A. 2012a. "Dura Deserta: The Death and Afterlife of Dura-Europos." In *Vrbes Extinctae: Archaeologies of Abandoned Classical Towns*, edited by Neil Christie and Andrea Augenti, 307–329. Aldershot: Ashgate.

———. 2012b. "Re-excavating the Houses of Dura-Europos." *Journal of Roman Archaeology*: 146–169.

———. 2011. "The Graffiti of Dura-Europos: A Contextual Approach." In *Ancient Graffiti in Context*, edited by J. A. Baird and Claire Taylor, 49–68. London: Routledge.

———. 2014. *The Inner Lives of Ancient Houses: An Archaeology of Dura-Europos*. Oxford: Oxford University Press.

Barton, Tamsyn. 1994. *Ancient Astrology*. New York: Routledge.

Baur, P. V. C., and M. I. Rostovtzeff. 1931. *The Excavations at Dura-Europos Conducted by Yale University and the French Academy of Inscriptions and Letters: Preliminary Report of Second Season on Work, October 1928–April 1929*. New Haven: Yale University Press.

———. 1929. *The Excavations at Dura-Europos Conducted by Yale University and the French Academy of Inscriptions and Letters: Preliminary Report of First Season of Work, Spring 1928*. New Haven: Yale University Press.

Baur, P. V. C., M. I. Rostovtzeff, and A. R. Bellinger. 1933. *The Excavations at Dura-Europos Conducted by Yale University and the French Academy of Inscriptions and Letters: Preliminary Report of Fourth Season of Work October 1930–March 1931*. New Haven: Yale University Press.

Benefiel, Rebecca. 2011. "Dialogues of Graffiti in the House of the Four Styles at Pompeii (Casa Dei Quattro Stili, I.8.17, 11)." In *Ancient* Graffiti *in Context*, edited by J. A. Baird and Claire Taylor, 20–48. London: Routledge.

49 Baur, Rostovtzeff, and Bellinger 1933, 153–7, no. 300/*SEG* 7.431 and no. 301/*SEG* 7.432.

———. 2010. "Dialogues of Ancient Graffiti in the House of Maius Castricius in Pompeii." *American Journal of Archaeology* 114: 59–101.

du Breil de Pontbriand, Segolene. 2012. "La résidence de Lysias à Europos-Doura: Un première approche." Edited by Pierre Leriche, Segolene du Breil de Pontbriand, and Gaelle Coqueugniot. *Europos-Doura Varia* 1: 77–92.

———. 2006. "La Residence De Lysias." Universite Paris I Pantheon-Sorbonne.

———. 2007. "La maison de Lysias: Une residence artistocratique a Europos-Doura." Universite Paris I Pantheon-Sorbonne.

Chaniotis, Angelos. 2011. "Graffiti in Aphrodisias: Images—Texts—Contexts." In *Ancient* Graffiti *in Context*, edited by Claire Taylor and J. A. Baird, 191–207, London: Routledge.

Chmielewska, Ella. 2007. "Framing [Con]text: Graffiti and place." *Space and Culture* 10.2: 145–169.

Connerton, Paul. 1989. *How Societies Remember*. Cambridge: Cambridge University Press.

Coqueugniot, Gaëlle. 2012. "Le *Chreophylakeion* et l'agora d'Europos-Doura: Bilan des recherches, 2004–2008." *Europos-Doura Varia* 1: 93–110.

Corbier, Mireille, and Jean-Pierre Guilhembet, eds. 2011. *L'Écriture dans la maison Romaine*. De Boccard.

Cumont, Franz. 1926. *Fouilles de Doura-Europos (1922–1923)*. Paris: Librairie Orientaliste Paul Geuthner.

Dandrau, Alain. 1997. "Gypse, plâtre et djousse." In *Doura-Europos Études IV*, 155–157. Beirut: Institut Français d'archéologie du proche-orient.

Evans, James. 1999. "The Material Culture of Greek Astronomy." *Journal for the History of Astronomy* 30: 237–307.

Fleming, Juliet. 2001. Graffiti *and the Writing Arts of Early Modern England*. London: Reaktion Books.

Frye, Richard N., J. Frank Gilliam, H. Ingholt, and C. B. Welles. 1955. "Inscriptions from Dura-Europos." *Yale Classical Studies* 14: 123–213.

Garrafoni, Renata Senna and Laurence, Ray. 2013. "Writing in Public Space from Child to Adult: The Meaning of Graffiti." In *Written Space in the Latin West, 200 BCE to AD 300*, edited by Gareth Evans, Peter Keegan and Ray Laurence, 123–134. London: Bloomsbury.

Goldman, Bernard. 1999. "Pictorial Graffiti of Dura-Europos." *Parthica* 1 (1999): 19–106.

Gunn, C. Douglas. 1965. "The House of Lysias in Block D-1." Yale University Art Gallery, Dura-Europos Archive, New Haven.

Heyn, Maura K. 2011. "The Terentius Frieze in Context." In *Dura-Europos. Crossroads of Antiquity*, 221–233. Boston: McMullen Museum of Art, Boston College.

Huntley, Katherine. 2011. "Identifying Children's Graffiti in Roman Campania: A Developmental Psychological Approach." In *Ancient* Graffiti *in Context*, edited by J. A. Baird and Claire Taylor, 69–89. London: Routledge.

Johnson, Jotham. 1932. *Dura Studies*. University of Pennsylvania.

Kaizer, Ted. 2009. "Religion and Language in Dura-Europos." In *From Hellenism to Islam: Cultural and Linguistic Change in the Roman Near East*, 235–253. Cambridge: Cambridge University Press.

Kraeling, Carl H. 1967. *The Christian Building*. New Haven: Dura-Europos Publications.

Kruschwitz, P., and V. L. Campbell. 2009. "What the Pompieans Saw: Representations of Document Types in Pompeian Drawings and Paintings (and their value for Linguistic Research)." *Arctos* 43: 57–84.

Langner, Martin. 2001. *Antike Graffitizeichnungen: Motive, gestaltung und bedeutung*. Wiesbaden: L. Reichert.

Lucas, Gavin. 2010. "Time and the Archaeological Archive." *Rethinking History* 14, no. 3: 343–359.

Noy, D., and H. Bloedhorn, eds. 2004. *Inscriptiones Judaicae Orientis*. Vol. *3: Syria and Cyprus*. Tübingen: Paul Mohr Verlag.

Perkins, Anne. 1973. *The Art of Dura-Europos*. Oxford: Clarendon Press.

Rehm, Albert. 1940. "ΜΝΗΣΘΗ." *Philologus* 94: 1–30.

Rostovtzeff, M. I. 1935. "Dura and the Problem of Parthian Art." *Yale Classical Studies* 5: 155–304.

———. 2007. "La maison de Lysias: Une residence artistocratique a Europos-Doura." Universite Paris 1 Pantheon-Sorbonne. 1934. *The Excavations at Dura-Europos Conducted by Yale University and the French Academy of Inscriptions and Letters: Preliminary Report of Fifth Season of Work, October 1931-March 1932*. New Haven: Yale University Press.

Rostovtzeff, M. I., A. R. Bellinger, F. E. Brown, and C. B. Welles. 1944. *The Excavations at Dura-Europos Conducted by Yale University and the French Academy of Inscriptions and Letters: Preliminary Report on the Ninth Season of Work, 1935–1936. Part 1, The Agora and Bazaar*. New Haven: Yale University Press.

———. 2007. "La maison de Lysias: Une residence artistocratique a Europos-Doura." Universite Paris 1 Pantheon-Sorbonne. 1952. *The Excavations at Dura-Europos Conducted by Yale University and the French Academy of Inscriptions and Letters, Preliminary Report of the Ninth Season of Work 1935–1936. Part III: The Palace of the Dux Ripae and the Dolicheneum*. New Haven: Yale University Press.

———. 2007. "La maison de Lysias: Une residence artistocratique a Europos-Doura." Universite Paris 1 Pantheon-Sorbonne.1936. *The Excavations at Dura-Europos Conducted by Yale University and the French Academy of Inscriptions and Letters: Preliminary Report of Sixth Season of Work, October 1932-March 1933*. New Haven: Yale University Press.

Rostovtzeff, M. I. F., E. Brown, and C. B. Welles. 1936. *The Excavations at Dura-Europos Conducted by Yale University and the French Academy of Inscriptions and Letters: Preliminary Report of the Seventh and Eighth Seasons of Work, 1933–1934 and 1934–1935*. New Haven: Yale University Press.

Rostovtzeff, M. I., and C. B. Welles. 1931. "La 'maison des archives' à Doura Europos." *Comptes Rendus. Académie des inscriptions et belles lettres*: 162–88.

Roueché, Charlotte. 1984. "Acclamations in the Later Roman Empire: New Evidence from Aphrodisias." *The Journal of Roman Studies* 74: 181–199.

Ruffing, Kai. "Die geschäfte des Aurelios Nebuchelos." *Laverna* 11: 71–105.

Shayegan, M. Rahim. 2000. *Arsacids and Sasanians: Political Ideology in Post-Hellenistic and Late Antique Persia*. Cambridge: Cambridge University Press.

Shoe, L. T. 1943. "Architectural Mouldings of Dura-Europos." *Berytus* 8: 20–23.

Stern, Karen. 2012. "Tagging Sacred Space in the Dura-Europos Synagogue." *Journal of Roman Archaeology*: 171–194.

Taeuber, H. 2005. "Graffiti." In *Hanghaus 2 in Ephesos. Die Wohneinheit 4: Baubefunde, Ausstattung, Funde*, edited by Hilke Thür, 132–44. Vienna: Austrian Academy of Sciences Press.

Taylor, Claire. 2011. "Graffiti and the Epigraphic Habit: Creating Communities and Writing Alternate Histories in Classical Attica." In *Ancient* Graffiti *in Context*, edited by J. A. Baird and Claire Taylor, 90–109. London: Routledge.

Wallace-Hadrill, Andrew. 1994. *Houses and Society in Pompeii and Herculaneum*. Princeton: Princeton University Press.

———. 2007. "La maison de Lysias: Une residence artistocratique a Europos-Doura." Universite Paris I Pantheon-Sorbonne.2011. "Scratching the Surface: A Case Study of Domestic Graffiti at Pompeii." In *L'écriture dans la maison romaine*, edited by Mireille Corbier and Jean-Pierre Guilhembet, 401–414. De Boccard.

Welles, C. B. 1951. "The Population of Roman Dura." In *Studies in Roman Economic and Social History in Honor of Allan Chester Johnson*, edited by Paul R. Coleman-Norton, 251–273. Freeport: Books for Libraries Press.

———. 2007. "La maison de Lysias: Une residence artistocratique a Europos-Doura." Universite Paris I Pantheon-Sorbonne. 1956. "The Chronology of Dura-Europos." *Eos* 48, no. 3: 467–474.

Woolf, Greg. 1996. "Monumental Writing and the Expansion of Roman Society in the Early Empire." *JRS* 86: 22–39.

CHAPTER 3

Graffiti in a House in Attica: Reading, Writing and the Creation of Private Space

Claire Taylor

Introduction

This chapter examines graffiti which appear inside a house in Attica in order to raise questions about writing, reading and the nature of private epigraphies. In investigating these inscriptions it is necessary to ask: what makes them private? On the face of it, the answer is simple: private might be thought of in terms of the location where the inscriptions were found, that is in a domestic context or relating to the household in some way. Alternatively private might be assessed in terms of production, that is, aligned with the concerns of the individual or the family as opposed to the state or other public body. In doing so, however, an implicit contrast is made with inscriptions in the public sphere: private is often considered distinct from political and unconnected with the official life of the community. However, we do not have to dig very deep to problematize this dichotomy and a gradation of public and private which pays close attention to context and nuances the social, political and economic factors which change over time seems more appropriate than a strict binary division.[1]

Although public and private are more slippery categories than at first seems to be the case, examining the type, location and quantity of writing defined in this way is useful not because it is constrained by this terminology, but because it highlights the flexibility of it, prompting questions about accessibility, visibility, power and privacy. This is demonstrated well by considering the idea of private space as seen in recent work on housing. Within ancient houses there were differing levels of "privacy," which could be controlled by architecture, lines of sight, the placing of furniture or other moveable objects, the types of

* I am grateful to John Ellis Jones for reading a draft of this paper and making a number of suggestions which have saved me from errors. All mistakes are my own.
1 See for example Wallace-Hadrill 1994, 17–38; Palyvou 2004, 207–17. For discussions of various factors which affect the use of space see Vlassopoulos 2007, 33–52; Nevett 2011, 576–96.

activities which were occurring, or the presence or absence of daylight.[2] A key conclusion of research on housing since the 1990s is that space is not binary nor is it static: teasing out the differing uses of space and how it was manipulated to negotiate privacy, accessibility and power has been a key component of understanding ancient buildings and their inhabitants.

In a similar vein "public" and "private" epigraphies can be analyzed, and this requires questions to be posed about the location of an inscription, the manner of its production and the audience who viewed it. By way of illustration, consider a grave marker. Is it a "private" monument because it was erected by a family rather than by a public body? Is it "public" because it vies for the attention of those outside the household, competing with other monuments to be noticed? What if it was set up not in a cemetery or along a busy road, but on the rural property of the deceased where it might be seen by only a limited numbers of passers-by? What about a curse tablet deposited into the grave after the funeral? Does its lack of visibility make it more private, or are its concerns with social control a public matter for the community at large?[3] Understanding the nature of "public" and "private" epigraphies, therefore, draws on questions about agency, monumentality, display, commemoration, competition and performance. It is the intersections with these key components of epigraphic interpretation which provide the tools not only to observe writing in different spatial contexts but to nuance analysis of what public and private mean within them.

My aim here, then, is twofold. First I wish to discuss some inscriptions from Attica in order to contribute to the debate about graffiti inside buildings. Writing which appears inside structures is a widespread phenomenon in the ancient world—as this volume shows. It provides evidence not simply about how a building was used, but also demonstrates, through the processes of reading and writing, an active and dynamic engagement with the structures themselves and one which can be assessed in addition to the architectural forms or building layout.[4] Although there are fewer examples of writing inside buildings in Attica than in other parts of the Graeco-Roman world (for very specific archaeological reasons discussed below), this chapter adds to the growing volume of evidence which suggests that this phenomenon should be considered not as a marginal, or marginalized, activity but as a significant part of the

2 Visibility: Wallace-Hadrill 1994, 44–50; activities/objects: Nevett 1999, 57–61; Allison 2004; light: Parisinou 2007, 213–23.
3 On curse tablets see Eidinow 2007.
4 On reading and writing as separate but linked processes see Milnor 2009, 288–319. See also Harris 2000.

cultural landscape. In addition, the case study under discussion here reveals that graffiti are found not just in urban centres such as Pompeii, Delos, or Dura-Europos (or even Athens)—as might be expected if modern graffiti practices are taken as our paradigm—but in rural areas too.

Secondly, I wish to use this example, in conjunction with similar graffiti from other sites in Attica, to examine how reading and writing were used to define the contours of privacy itself. The question which is at issue here is the extent to which ideas about private space should be re-thought as a result of the increasing focus on inscriptions and graffiti within houses and other buildings. What will become clear is that privacy and private space should not be confined to domestic contexts, but can be understood in terms of behavioral practice, isolation and commemorative activity.

Inside Writing: Euthydike's *Ergasterion* at Thorikos

In the Athenian deme of Thorikos in the south-east of Attica (Fig. 3.1) a workshop belonging to an *epikleros* (heiress) named Euthydike was marked with a boundary stone (*SEG* 50.187: "Gods! Boundary marker of the workshop and house and garden and slaves of the *epikleros* Euthydike daughter of Epicharinos").[5] Thorikos was a busy and active community central to the Athenian production of silver and lead and has rich archaeological and epigraphic finds: within the deme centre a number of residential and industrial buildings have been excavated, as well as mines, a large theater, a Mycenaean necropolis, and fortification walls which were erected during the Peloponnesian War (Xen. *Hell.* 1.2.1).[6] Epigraphic evidence provides insight into the religious life of the community (*SEG* 33.147)[7] and a number of graffiti line the streets.[8]

Euthydike's property, however, lay outside the deme center to the southwest. This large residential and industrial complex—the buildings were used for processing silver ore—dates to the late classical period and included a large central paved courtyard, an *andron* (identified by raised platforms for couches and an off-centre doorway) located off an anteroom, a room with a terracotta basin or bath, waterproof plaster and a tiled floor, a cistern, four external

5 Θε[οί]. ὅρος [ἐργ]αστηρίου καὶ οἰκίας καὶ κήπου καὶ ἀνδραπόδων καὶ Εὐθυδίκη[ς] Ἐπιχαρίνο[υ] θυγατρὸς ἐ[πι]κλήρου. On the epiklerate see Todd 1993.
6 In general see Mussche 1998. Settlement: Mussche 1968, 87–104; Nevett 2005, 83–98. Theater: Palyvou 2001, 45–58. Fortifications: van Rooy 1969.
7 Lupu 2005, 115–49.
8 Taylor 2011, 90–109; Bain 1994, 33–5.

FIGURE 3.1 *Map of southeast Attica showing Thorikos, with inset showing location of the ergasterion. Drawn by Thanasi Papapostolou.*

washing platforms, facilities for the smelting of ore and grinding of grain, drainage channels and a well containing black-glaze drinking vessels and remnants from the production of silver coins (Figure 3.2).[9] The paved floors, marble thresholds, waterproof plaster and presence of an *andron* suggests this was the property of a wealthy family involved in silver-mining.[10] The reference to the garden and the slaves of the property in the *horos* inscription provides further evidence for this interpretation.

Inside the building a number of inscriptions were found: the large central courtyard (c. 9 × at least 11m) contains five short texts incised into the floor on the paving slabs by a sharp object (Fig. 3.3). The texts appear to be name-graffiti and they are as follows:

9 Oikonomakou 1997, 87–8; 1998, 83–4; Jones 2007, 269–71. On the difficulties of identifying *andrones* and understanding their function see Nevett 2010, 45–57.
10 For the involvement of wealthy Athenians in processing ore see Bissa 2008, 267–71.

A-C: Washeries
a: Courtyard
b: 'Andron'
c: Anteroom
d: Room with basin
e: Well

FIGURE 3.2 *Plan of Euthydike's ergasterion. Adapted from Jones 2007, fig. 29.2.*

(i) Κηφισ-
(ii) Φιλοκ[ράτης]
(iii) Ε[-]
(iv) Τ
(v) Φι[λοκράτης]
 (*SEG* 52.243–7)

The name Philokrates is restored in (ii) and (v) because it also appears on a fragment of pottery (a beehive) found within the complex (*SEG* 44.240: Φιλοκράτου[ς]). It is also found on a rock-cut boundary inscription associated with another workshop 200m south of the complex (*SEG* 48.166: ὅρος ἐργ[αστηριου] Φιλοκ[ράτους] at Kavodokano; see Fig. 3.4).[11] The excavator, Maria Oikonomakou, restored text (i) as the demotic Kephisieus, but as Stroud points out in *SEG*, the word is abbreviated (see Fig. 3.3) and as such is more likely to be a personal name such as Kephisios.[12] Text (iii) seems to be part of a longer word, now eroded; text (iv) might be too, though could also be a single letter abbreviation.

11 Jones 2007, 269; Salliora-Oikonomakou 1996–1997, 136–7 with fig. 7.
12 This is not an uncommon name: 24 examples are known from Attica according to *LGPN* II. Other common Athenian names beginning with Kephis- include Kephisodotos, Kephisodoros, Kephisokles or Kephisophon.

FIGURE 3.3 *Line-drawing of inscription (i) in the courtyard. Drawn by Thanasi Papapostolou.*

Unlike in other parts of the ancient world such as Pompeii or Dura-Europos, writing inside houses does not readily survive from Attica (unless it is on moveable objects like pottery). This is because there are few standing walls or pieces of plaster extant in classical or hellenistic Athenian houses, which does not, of course, provide ideal conditions for the survival of this type of evidence.[13] But given the frequency of writing (often termed graffiti by modern scholars) on interior walls of houses in other parts of the ancient world, and given the ubiquity of writing in a wide variety of contexts in classical and hellenistic Attica, it would not be unreasonable to suggest that this was a more frequent phenomenon here than we have evidence for.[14] In fact, the writing at Euthydike's *ergasterion* is not unique: in Bau Y in the Kerameikos the phrase *Boubalion kale* ("Boubalion is beautiful") was written on a fragment of the plaster recovered from room A which has led to the building being interpreted as

13 Traces of paint have been found in recent excavation of a house at Halimous dated to the second half of the fourth century: *ADelt.* 56–59 (2001–2004), 464 and also in Thorikos House 1, rooms C and H (red plaster): Mussche 1998, 46–50. A graffito on a fragment of plaster, found in Bau Y in the Kerameikos, survives because it had fallen under the floor after the room was remodeled. See below for discussion.

14 On the terminology of graffiti see Baird and Taylor 2011, 3–7. For different contexts of writing in Athens compare Lambert 2012; Missiou 2011; Thomas 2009, 13–45. On its ubiquity across the ancient world see Bagnall 2011.

FIGURE 3.4 *Neighbouring* ergasterion *at Kavodokano. From Jones 2007, fig. 29.2.*

a tavern or brothel.[15] At the Golden Pig tower in the Agrileza valley, an inscription, which appears also to be an abbreviated name-graffito, has been found on a door jamb; presumably, given its height (just over 1 m off the ground), it was produced by someone seated at the entrance (*SEG* 54.387: Διόδ[ωρος?]).[16] Literary evidence also suggests that writing on outside walls of houses was not unusual (Ar. *Wasps* 98: "By Zeus, if he sees written on a door somewhere that Demos, the son of Pyrilampos is beautiful, he will write near it 'Kemos is beautiful'!").[17] Together these examples imply that writing on both interior and

15 Knigge 1993, 125–40. On the interpretation of this building's function see also Glazebrook 2011, 43–5. Given the frequency of *kalos* names as graffiti in Attica and the appearance of writing inside buildings generally across the ancient world, it is perhaps unwise to assume that the graffito alone provides firm evidence for building function.

16 Jones 1984–1985, 108; Salliora-Oikonomakou 2004, no. 141. Salliora-Oikonomakou connects this Diodoros with Diodoros of Paiania, father of Simon, owner of the Asklepiakon mine in Souriza (*Agora* XIX P26 lines 164–5, *SEG* 32.233). On towers in general in this region and their connection to the slave workforce see Goette 2000, 86–90; Morris and Papadopoulos 2005, 155–225.

17 A further, much later, example attests to the continuity of the practice: on the walls of a fifth- or sixth-century CE bath complex is "a rather clumsy scene with human figures, fish,

exterior walls of buildings would not have been uncommon in Attica. Placed in the context of the other case studies in this volume, we have a growing body of once-overlooked evidence for a form of writing which is frowned upon by, or culturally alien to, us today.

Like all such graffiti, those found in Euthydike's house raise some basic questions of interpretation: when were they produced, who wrote them and why? It is of course possible to dismiss short and fragmentary texts like these as not worthy of scholarly discussion. However, doing so perpetuates a value-laden discourse through which we set ourselves up as historical gatekeepers, judging what "deserves" to be considered as evidence, and by implication excluding what does not. This privileges the large- over the small-scale, the canonical over the eclectic, and the production of (both ancient and scholarly) elites over that of others. But ancient culture was not monolithic and it is the role of the historian not merely to collate examples of well-known and clearly defined phenomena, but also to shine a light into the less visible realms of the past in order to illuminate different and often competing experiences of the world. Using what is, on the face of it, an unprepossessing set of inscriptions from a building in the Attic countryside as the basis of an analysis is not designed to be an exercise in unsubstantiated speculation; on the contrary it raises broader questions about the processes of reading and writing, the relationship between texts and the structures they appear on, and the values ascribed to different types of epigraphy. A key question here is: should this writing be seen in terms of defacement or vandalism (or as short and unpromising), and therefore dismissed as "worthless," or should it be seen as an integral part of a building's structure, decoration or use?

Interpreting the Small-Scale: Possibilities and Suggestions

The aim of micro-historical analysis is to reduce the scale of observation in order to consider broad historical and cultural questions. In this sense, then, it is possible to suggest ways in which to interpret these inscriptions not only (or indeed, primarily) as a way to uncover "what life was like" in Euthydike's *ergasterion*, but rather in terms of the wider conclusions that can be drawn about writing inside houses and other structures in antiquity.[18] To start, let us review some suggestions about how these texts themselves can be interpreted and some problems in doing so. Whilst certainty cannot be assured,

 herons and crosses," which is interpreted not as part of the decoration of the baths, but as "a [later] refuge or martyr's memorial". See Parlama and Stampolidis 2000, 136.

18 For a discussion of microhistory and the changing of scale see Levi 1991, 97–119. As Levi says (p. 95): "For microhistory the reduction of scale is an analytical procedure."

the excavators are probably correct to consider the inscriptions at Euthydike's *ergasterion* to date from the period of inhabitation of the property (late classical) and to have been written by the owners of the names. The letter forms do not dispute this and it would be surprising (though of course not impossible) if the inscriptions were added later given the general decline of the area in the later hellenistic period: at this time there was little settlement activity at Thorikos.[19] The letters of all the inscriptions are quite large (5–10 cm) and it must be assumed that they were meant to be visible. The size of the letters is significant: in comparison to graffiti found in houses in Pompeii, these are much larger. There, most examples are 1–3 cm tall.[20] This is quite a considerable difference; these are not surreptitious texts.

It is possible that some of the inscriptions have had letters worn away (though not that of Κηφισ-) which would suggest that they were on the ground during the occupation of the house and walked over numerous times. The location of the writing in the courtyard—presumably an area of the house passed through regularly by those resident as well as being an area for receiving visitors—again underscores the suggestion that they were not intended to be hidden. It seems unlikely that these were masons' marks, however, nor given their size, location and the lack of other decoration in the courtyard, are they directly comparable with Roman mosaic artists' signatures.[21] Although it is possible that these paving slabs were reused stones (therefore inscribed before used as flooring), given the general investment in the property this seems doubtful too.

Oikonomakou connects the graffiti with the residents of the property: Philokrates, she suggests, was the *kyrios* (perhaps husband) of Euthydike, the *epikleros* mentioned on the *horos* inscription above and owner of the neighbouring complex.[22] She suggests that Philokrates and his family lived in this property (a building with architectural embellishment: paved floors, marble thresholds, and an *andron*), leaving the neighbouring *ergasterion* at Kavodokano to be inhabited by the workers.[23] This is possible: the neighbouring

19 Mussche 1998, 64–5.
20 See Benefiel, Chapter Five of this volume.
21 Mosaic floors are rarely found in the courtyards of houses in rural Attica at this time. In Roman examples, signatures on mosaics in Britain are between 7 and 30 cm tall (and frequently part of the decorative scheme). See Ling 2007, 63–91.
22 Oikonomakou 1997, 88. Philokrates is tentatively identified as the father of Epikrates of Eleusis (*Agora* XIX P9, line 36), though both names are common.
23 Salliora-Oikonomakou 1996–1997, 133–9. The workers might be predominantly slave, but there is clear evidence for citizens using their 'own bodily toil and labor' in the mining

property is large, but the presence of washing platforms directly adjacent to the compound with the graffiti suggests that a strict division of function was not always maintained (Figure 3.2).[24] Another explanation is that this is an example of a family consolidating properties over time, perhaps through the marriage of an *epikleros*. Although the north part of the building at Kavodokano (Figure 3.4) is not well-preserved, it is clear that there was architectural investment in these so-called 'workers' quarters': a marble threshold, a plaster-floored room, and olive presses have been found here too.[25] If the properties became one complex as a result of consolidation, Philokrates might have felt the need to demonstrate his presence in, or ownership of, the new space as well as the old.

Further consideration of the location of the inscriptions raises additional questions about the use of space. The inscriptions were found in the central courtyard—the most accessible part of the house and visible from most other rooms.[26] The courtyard led, via a side-door, directly to the four washeries implying that movement between the areas was separate, though not always impeded. In contrast to other houses at Thorikos, and more like houses in Athens, the rooms of this house were arranged around a central courtyard, rather than sequentially, with the "industrial" facilities mostly (although not exclusively) outside of the main building.[27] This suggests that access between the two parts of the property could be controlled if required. The centrality of the writing's location within the compound does not suggest that it was surreptitious; indeed it probably should be seen as being an integral part of the household since it seems to refer to members of the *oikos* and their friends or associates.

 industry ([Dem.] 42.20). It is difficult to detect archaeologically the division of slave and free populations within properties: Jones 2007, 278–9; Morris 1998, 208–10.

24 It is possible that these washing platforms were from an earlier phase of the property: Oikonomakou 1997, 88, but the *horos* inscription states that Euthydike's complex included both an *ergasterion and* a house. Other sites where divisions of residential and industrial buildings have been postulated include Spitharopousi: Kakavoyannis 2001, 380 and Agrileza (Compound D): Jones 2007, 275–6, though in other examples (Soureza Compounds 2 and 3) divisions are much less clear: Jones 2007, 271–3 with fig. 29.3.

25 Salliora-Oikonomakou 1996–1997, 133–9. Plaster floors are, however, common in ore-processing workshops.

26 The exact locations within the courtyard are not recorded and without this information it is difficult to assess their relationship to one another. Benefiel 2011, 20–48 has demonstrated the utility of reading graffiti in terms of a dialogue: this would not be out of the question here, but further information is needed to pursue this good avenue of exploration.

27 Nevett 2005, 85, 89.

Whilst the courtyards of Greek houses do not have the same quasi-public function as the *atria* of Roman houses, they were areas in which a variety of activities took place from weaving, to the storage and preparation of food, or perhaps even symposia.[28] This would ensure that these spaces were relatively "high-traffic" areas, places of mixing and contact between different members of the household and visitors to it. In Pompeii many houses have graffiti in atria, peristyles and vestibules; that is, in areas of the house in which lots of activity occurred and the same pattern appears to be true in Delos. The appearance of names written within this space might therefore serve to reinforce the social status of those living in the house: both visitors and inhabitants would be reminded of the bearers of the names as they passed through. It is usually assumed that Philokrates wrote his name himself, but this might not be the case. It is possible that friends or associates of his did so whilst waiting in the courtyard. This would imply that Philokrates was a man of high social importance.[29]

Alternatively the inscriptions might be seen as being connected to sympotic activities. Although symposia took place in *andrones*—and there appears to have been an *andron* in this house—this was not the exclusive venue for such activities and Athenian houses acquired such rooms relatively late.[30] The flexibility of courtyard space might indeed include entertaining guests. Some graffiti in Pompeii appear to have been connected with dining (names and greetings written on the walls at couch-height), and it is possible that the inscriptions in the house at Thorikos—and those in Bau Y—might be similarly viewed in this context.[31] Reclining on couches low to the ground during such entertainment might well provide the ideal conditions for the production of such short commemorative texts.

Mark-making and Commemoration

The inscriptions in Euthydike's house appear to be personal names, and name inscriptions such as these can have a commemorative function as well

28 On the flexibility of courtyards see Nevett 2010, 49, 61.

29 See the graffiti in the House of Lysias at Dura for a similar example (Baird this volume). I thank Baird for alerting me to this possibility. Of course, texts (i) and (v) might be restored differently. Indeed, they might refer to two people within the same family with the same, or cognate, name. Graffiti are found in high-status houses associated with the wealthy in Dura, Pompeii and Delos. This seems to be the case here too.

30 For *andrones* in non-domestic contexts see Morgan 2011, 267–90.

31 Benefiel 2011, 24–9.

as designating ownership or laying claim to territory. The writing of a name records a person's presence in a physical place (in this case the house) as well as within a community (the *oikos*, the workshop, the deme, etc.). These communities can be temporary or permanent, large or small; they are negotiated continually through the processes of both writing and reading. As I have argued elsewhere, naming is inherently socially connective over time and space, allowing those who see the inscription to think of the person named.[32] It links people together through the act of inscribing, responding in the present, or reading over a later period of time. When viewed in these terms, writing like this inside a building should not necessarily be seen as defacing the property or vandalising it ("tagging" in modern graffiti parlance). Indeed, its aim is both reception and recognition.[33] Interpreted in this way, these are texts which link Philokrates *et al* together as well as connect them through time with those who pass over the graffiti and read them.

Personal names are found inside houses in other parts of the Greek world (for example, in Delos),[34] and there are a number of graffiti recording names found on buildings, or close to them, in other area of Thorikos: Εὐφρόσ[υνος] appears on the stylobate of the Doric building (*SEG* 44.25), Κρέων is found on the rock-face by a mine entrance (*SEG* 40.262), Σοσία[ς] λατόμι[ον] close to a quarry by the theater (*SEG* 40.263), Ζωῖλος, Ἀντιδίκε and possibly a non-Greek name were written at the Cliff farm (*SEG* 26.137, 53).[35] Elsewhere in Attica, names are also common forms of writing, such as on the Barako hill near Vari (*SEG* 55.84–5: the graffiti "mostly consist of personal names"), on Hymettos (*SEG* 31.149: Κεθήγου) and Mont Michel (*SEG* 28.208: Χαιρεστράτου).[36] Added to these are the numerous texts which record *kalos* names, sexual feelings, footprints, or phalluses which have a similar commemorative—and socially connective—function, and images which record boats, animals and faces.[37] It follows, then, that the inscriptions which are found inside houses in Attica may be viewed much like these personal texts.

32 Taylor 2011, 93–9.
33 On these terms see Chmielewska 2007, 153. Ignoring or passing over is as much a part of reception and recognition as noticing and interacting with these texts.
34 See Zarmakoupi, chapter four of this volume; also Le Dinahet 2001, 104–6, no. 1a/b, Bruneau 1978, 146–7 (House VI L), Siebert 1988, 761 (maison des sceaux). See also at Ephesos: Taeuber 1999, 527–9.
35 See Langdon and Watrous 1977, 170–3.
36 Langdon 1980, 108–9, no. 1; 2005, 179; Ober 1981, 68–73.
37 See Taylor 2011, 90–109; Langdon 1991, 309–12; 1985, 257–70; 2004, 201–6; Langdon and van de Moortel 2000, 85–9.

Writing short texts like names, therefore, was clearly a common activity which occurs in numerous different contexts: not only does writing like this survive on hillsides, in streets, by mines, on moveable objects, and the like, it is also found *inside* domestic structures. These are short texts for sure, but they are deliberately so; in the case of text (i) above abbreviation is used to communicate meaning which implies a familiarity with writing conventions. Writing, particularly the writing of short texts like these, is increasingly found in many different contexts across Athens and Attica (as well as across the ancient world). As historians, archaeologists and epigraphers become more attuned to notice such evidence, the evidence for (certain types of) literacy increases.[38]

Writing and Privacy: Reading "Private" Space

The inscriptions in Euthydike's house raise questions about the relationship between reading, writing and privacy, which can be further enhanced by comparison of these texts with personal name graffiti from non-domestic contexts. As is evident from the examples above, especially those found on the Barako hill near Vari and on Hymettos, this is a type of writing which is found in both public and private contexts (as well as on objects): there is nothing inherently different about writing names within a domestic building. Perhaps it is due to patterns of survival and preservation, but many examples of Attic name-graffiti have been found at sites which appear relatively isolated. This is surprising given the "urban" context of many examples of graffiti in the ancient world (see Pompeii, Dura, etc.) and the association of graffiti—Philokrates' included—with busy or visible spaces. How can we resolve this tension? As mentioned above, "private" epigraphies can be thought of both in terms of location (where texts are placed) as well as in terms of production (who made them). We might, then, consider privacy as a factor in the production or consumption of these inscriptions.

Privacy, however, can be defined in a number of ways. It can be restrictive—a way to control access and maintain status ("privacy *from*")—or liberating, providing space for the negotiation of personal identities and social freedoms ("privacy *for*").[39] Writing, as can be seen by the name-inscriptions highlighted already, can be used to restrict access, demonstrate ownership and differentiate spatial contexts. But it can also be used to provide information, to advertise intimacies, and connect with others. Both types of privacies can be seen in the

38 See n. 14 above.
39 Schoeman 1992, 72–5; Kasper 2005, 69–92.

Attic material: the inscriptions in Euthydike's house might, on the face of it, by thought of as the former, whereas those on Hymettos might be considered as the latter.

Even if graffiti are thought to have required privacy for their production, they then become documents for wider consumption (compare, for example, curse tablets, which by the nature of the deposition, are not). Considering writing as a practice which is akin to, but separate from, reading is therefore useful in this context.[40] If graffiti are found in isolated places it might mean that the act of writing those texts (or drawing those images) had more significance than the act of reading or viewing them since they would have been seldom seen, but the volume of graffiti found on Hymettos and on the Barako hill outside Vari suggests that this is not the case here. Indeed, the writing inside Euthydike's house is, as discussed above, large in size and appears to be in the most frequented part of the building—the courtyard. An audience seems, therefore, important to the creation or reception of these texts. Writing might create space, but it is the act of reading which defines it.

Often graffiti can be viewed as being in dialogue with one another, responding to previous markings in different ways—clear enough in the clusters on Hymettos and at Vari, even if it is impossible to tease out temporal distinctions with exactitude.[41] This suggests that people returned frequently to these places, deliberately responded to the texts and images there, and shaped the response(s) of those who came in the future. Although not enough evidence survives to say the same about the texts in the courtyard of Euthydike's house, it would not be unreasonable to view them in a similar light. Read in this way, these texts might refer to privacy not *from* outsiders but privacy *for* the articulation of certain types of behaviour.

Certainly, writing a name is a simple act which is at the same time ephemeral and memorializing. But as the examples from non-domestic contexts show it is less anti-social than a product of socialization and writing inside houses should be seen in this way too. This type of writing plays with notions of privacy: it centers on an individual but it is also socially connective, situating the writers and readers within—or outside—a community. Isolation in terms of the built environment is not necessarily the same as isolation in terms of people; name-graffiti are the marks of people claiming continuity with a place and those who passed through it, in some cases over a long period of time. Writing therefore plays a role in the creation and negotiation of private space. It defines privacy in terms of access (who is permitted to be in a space)

40 Baird and Taylor 2011, 7–8, 10–11; Milnor 2009, 293; Macdonald 2005, 52.
41 Taylor 2011, 97.

but also in terms of information (who is connected to whom, who is in love with whom, who hates whom, etc.) and, in some contexts, seeks to subvert the private by making information about others public (sexual insults are frequent amongst Attic graffiti). Writing creates a personal landscape in which Athenians navigated their concerns and desires, negotiated power, and articulated social hierarchies.

Conclusion

The appearance of inscriptions on the floor of the courtyard in a property at Thorikos suggests that writing on house interiors should be expected within the Athenian context, even though the evidence is scarce. Judging from the *horos* found at the neighbouring property and the beehive fragment in this one, defining ownership seems to have been a concern of Philokrates, but the courtyard inscriptions appear to have a different, or perhaps enhanced, function. These seem to be a way of commemorating a time or an occasion or the presence of a group of people within that space. The fact that they appear within the house suggests that this was a way of defining a private area, but their appearance in the most visible and accessible part of the house questions whether privacy was a primary motivation and whether the audience was exclusively the members of the household. As such it seems that these were not illicit writings, nor were they designating ownership in any simple sense, but instead these were texts which proclaimed that their authors were part of a group or community of some sort.

Comparison with name-graffiti elsewhere suggests that private space was not always defined through built structures. Instead the practices of reading and writing were used to negotiate ideas of privacy and construct personal landscapes too. Graffiti inside structures in Attica shows how writing itself was used to construct, and lay claim to, private spaces.

Bibliography

Allison, Penelope M. *Pompeian Households: An Analysis of Material Culture*. Los Angeles: Cotsen Institute of Archaeology, 2004.
Bagnall, Roger S. *Everyday Writing in the Graeco-Roman East*. Berkeley: University of California Press, 2011.
Bain, David. "?Bo.tiades ὁ πρωκτός: An Abusive Graffito Found Thorikos." *ZPE* 104 (1994): 33–35.

Baird, J. A., and Claire Taylor. "Introduction: Ancient Graffiti in Context." In *Ancient Graffiti in Context*, edited by J. A. Baird and Claire Taylor, 1–17. London: Routledge, 2011.

Benefiel, Rebecca R. "Dialogues of Graffiti in the House of the Four Styles at Pompeii (*Casa Dei Quattro Stili*, I.8.17, 11)." In *Ancient* Graffiti *in Context*, edited by J. A. Baird and C. Taylor, 20–48. London: Routledge, 2011.

Bissa, Erietta M. A. "Investment Patterns in the Laurion Mining Industry in the Fourth Century BCEE." *Historia* 57.3 (2008): 263–73.

Bruneau, Philippe. "Deliaca (11)." *BCH* 102, no. 1 (1978): 109–71.

Chmielewska, Ella. "Framing [Con]text: Graffiti and Place." *Space and Culture* 10 (2007): 145–69.

Eidinow, Esther. *Oracles, Curses and Risk among the Ancient Greeks*. Oxford: Oxford University Press, 2007.

Glazebrook, Allison. "Porneion: prostitution in Athenian civic space," in *Greek Prostitutes in the Ancient Mediterranean*, ed. Allison Glazebrook and Madeleine Henry, 34–59. Wisconsin: University of Wisconsin Press, 2011.

Goette, Hans Rupprecht. *Ὁ ἀξιόλογος δῆμος Σούνιον. Landeskundliche Studien in Südost-Attika*. Rahden: M. Leidorf, 2000.

Harris, Roy. *Rethinking Writing*. London: Continuum, 2000.

Jones, John Ellis. "Laurion: Agrileza, 1977–1983: Excavations at a Silver Mine Site." *Archaeological Reports* 31 (1984–1985): 106–23.

———. "'Living above the Shop': Domestic Aspects of the Ancient Industrial Workshops of the Laurion Area of Attica." In *Building Communities: House, Settlement and Society in the Aegean and Beyond*, edited by Ruth Westgate, Nick Fisher and James Whitley, 267–80. London: British School at Athens, 2007.

Kakavoyannis, Evangelos. "The Silver Ore-Processing Workshops of the Lavrion Region." *ABSA* 96 (2001): 365–80.

Kasper, Debbie V. S. "The Evolution (or Devolution) of Privacy." *Sociological Forum* 20.1 (2005): 69–92.

Lambert, S. D. *Inscribed Athenian Laws and Decrees 352/1–322/1 BCE: Epigraphical Essays*. Leiden: Brill, 2012.

Langdon, Merle. "Some Inscriptions in Lavreotiki, Southern Attica." *Athens Annals of Archaeology* 11 (1978 [1980]): 108–15.

———. "Hymettiana I." *Hesperia* 54.3 (1985): 257–70.

———. "Two Hoplite Runners at Sounion." *Hesperia* 60.3 (1991): 309–12.

———. "Hymettiana V: A Willing Katapygon." *ZPE* 148 (2004): 201–06.

———. "A New Greek Abecedarium." *Kadmos* 44 (2005): 175–82.

Langdon, Merle, and Aleydis van de Moortel. "Newly Discovered Greek Boat Engravings from Attica." In *Down to the River to the Sea. Proceedings of the English International Symposium on Boat and Ship Archaeology, Gdansk 1997*, edited by T. Litwin, 85–89. Gdansk: Polish Maritime Museum, 2000.

Langdon, Merle, and L. Vance Watrous. "The Farm of Timesios: Rock-Cut Inscriptions in South Attica." *Hesperia* 46.2 (1977): 162–77.

Le Dinahet, M.-T. "Les Italiens de Délos: compléments onomastiques et prosopographiques." *Revue des Études Anciennes* 103.1–2 (2001): 103–23.

Lupu, Eran. *Greek Sacred Law*. Leiden: Brill, 2005.

Macdonald, M. C. A. "Literacy in an Oral Environment." In *Writing and Ancient near Eastern Society: Papers in Honour of Alan R. Millard*, edited by Piotr Bienkowski, Christopher Mee and Elizabeth Slater, 49–118. New York: T&T Clark, 2005.

Milnor, Kristina. "Literary Literacy in Roman Pompeii." In *Ancient Literacies. The Culture of Reading in Greece and Rome*, edited by William A. Johnson and Holt N. Parker, 288–319. Oxford: Oxford University Press, 2009.

Missiou, Anna. *Literacy and Democracy in Fifth-Century Athens*. Cambridge: Cambridge University Press, 2011.

Morgan, Janett. "Drunken Men and Modern Myths. Re-Viewing the Classical Andron." In *Sociable Man. Essays on Ancient Greek Social Behaviour in Honour of Nick Fisher*, edited by Stephen D. Lambert, 267–90. Swansea: The Classical Press of Wales, 2011.

Morris, Ian. "Remaining Invisible: The Archaeology of the Excluded in Classical Athens." In *Women and Slaves in Greco-Roman Culture: Differential Equations*, edited by S. Murnaghan and S. R. Joshel, 193–220. London, 1998.

Morris, Sarah P., and John K. Papadopoulos. "Greek Towers and Slaves: An Archaeology of Exploitation." *AJA* 109.2 (2005): 155–225.

Mussche, Herman F. "Le Quartier Industriel." In *Thorikos I: 1963. Rapport préliminaire sur la premiere campagne de fouilles*, edited by Herman F. Mussche, Jean Bingen, J. Servais, R. Paepe and Tony Hackens, 87–104. Brussels: Comité des fouilles belges en Grèce, 1968.

———. *Thorikos: A Mining Town in Ancient Attica*, Fouilles de Thorikos. Gent: Comité des fouilles belges en Grèce, 1998.

Nevett, Lisa C. *House and Society in the Ancient Greek World*. Cambridge: Cambridge University Press, 1999.

———. "Between Urban and Rural: House-Form and Social Relations in Attic Villages and Deme Centers." In *Ancient Greek Houses and Households. Chronological, Regional and Social Diversity*, edited by Bradley A. Ault and Lisa C. Nevett, 83–98. Philadelphia: University of Pennsyvania Press, 2005.

———. *Domestic Space in Classical Antiquity*. Cambridge Cambridge University Press, 2010.

———. "Towards a Female Topography of the Ancient Greek City: Case Studies from Late Archaic and Early Classical Athens (c. 520–400 BCE)." *Gender & History* 23.3 (2011): 576–96.

Ober, Josiah. "Rock-Cut Inscriptions from Mt. Hymettos." *Hesperia* 50.1 (1981): 68–77.

Oikonomakou, Maria. "Ἀνασκαφικές εργασίες: Λαυρεωτική." *ADelt* 52 (1997): 84–90.

———. "Ανασκαφικές εργασίες: Λαυρεωτική." *ADelt* 53 (1998): 83–84.

Palyvou, Clairy. "Notes on the Geometry of the Ancient Theater of Thorikos." *AA* (2001): 45–58.

———. "Outdoor Space in Minoan Architecture: 'Community and Privacy'." In *Knossos: Palace, City, State*, edited by Gerald Cadogan, Eleni Hatzaki and Adonis Vasilakis, 207–17. Athens: British School at Athens, 2004.

Parisinou, Eva. "Lighting Dark Rooms: Some Thoughts About the Use of Space in Early Greek Domestic Architecture." In *Building Communities: House, Settlement and Society in the Aegean and Beyond*, edited by Ruth Westgate, Nick Fisher and James Whitley, 213–23. London: British School at Athens, 2007.

Salliora-Oikonomakou, Maria. "Δύο αρχαία εργαστήρια στην περιοχή του Θορικού." *ADelt* 51–52 A (1996–1997): 125–40.

———. *Ο αρχαίος δήμος του Σουνίου. Ιστορική και τοπογραφική επισκόπηση* Athens: Ministry of Culture, Archaeological Receipts Fund, 2004.

Schoeman, Ferdinand D. *Privacy and Social Freedom*. Cambridge: Cambridge University Press, 1992.

Siebert, G. "Rapport sur les travaux de l'école française en Grèce en 1987: Délos, Quartier de Skardhana: la Maison des Sceaux." *BCH* 112 (1988): 755–67.

Taeuber, Hans. "Graffiti und *Dipinti* aus den Hanghäusern von Ephesus." In *100 Jahre Österreichische Forschungen in Ephesos: Akten Des Symposions Wien 1995*, edited by Herwig Friesinger and Fritz Krinzinger, 527–29. Vienna: Verl. der Österreichischen Akademie der Wissenschaften, 1999.

Taylor, Claire. "Graffiti and the Epigraphic Habit: Creating Communities and Writing Alternate Histories in Classical Attica." In *Ancient* Graffiti *in Context*, edited by J. A. Baird and Claire Taylor, 90–109. London: Routledge, 2011.

Thomas, Rosalind. "Writing, Reading, Public and Private 'Literacies': Functional Literacy and Democratic Literacy in Greece." In *Ancient Literacies. The Culture of Reading in Greece and Rome*, edited by William A. Johnson and Holt N. Parker, 13–45. Oxford: Oxford University Press, 2009.

van Rooy, C. A. "Fortifications in South Attica and the Date of Thorikos." *Acta Classica* 12 (1969): 171–80.

Vlassopoulos, Kostas. "Free Spaces: Identity, Experience, and Democracy in Classical Athens." *CQ* 57.1 (2007): 33–52.

Wallace-Hadrill, Andrew. *Houses and Society in Pompeii and Herculaneum*. Princeton: Princeton University Press, 1994.

CHAPTER 4

The Spatial Environment of Inscriptions and Graffiti in Domestic Spaces: The Case of Delos

Mantha Zarmakoupi

Introduction

The port-city of Delos became an important commercial base connecting the eastern and western Mediterranean after 167 BCE, when the Romans made it a "duty free" port under Athenian dominion.[1] Delos was home of the sanctuary of Apollo since the archaic period and, due to its advantageous geographical position in the center of the Aegean world, commanded a huge cult network that intertwined religious with economic and political activities. After the grant of the statute of *ateleia* by the Roman senate, Delos became an intermediary in Rome's commercial relations with the Hellenistic East and attracted merchants from the Italian peninsula, western and southern Asia Minor as well as from places further abroad.[2] In order to house the growing population,[3] the small settlement that clustered around the main sanctuary area expanded and new residential neighborhoods

1 Hatzfeld 1912; Zalesskij 1982; Reger 1994.
2 Tréheux gives 68 ethnics from Antioch, 64 from Berytos, 2 from Laodicea in Phoenicia, 47 from Alexandria, 35 from Laodicea in Syria, 32 from Hieropolis, 31 from Tyre, 23 from Sidon, 16 from Ascalon and 12 from Salamis: Tréheux 1992. The largest ethnic contingent of the island was, however, Roman-Italian. Hatzfeld estimated that of 231 *Rhomaioi* recorded on the island, 88 were freeborn, 95 were *liberti*, and 48 were slaves. Rauh's survey in 1993 of inscriptions published since 1919 contains an additional 300 *Rhomaioi* whose names can be split, in similar proportions to those found by Hatzfeld, between freeborn (118 or 40%) and slave-born (freedmen and slaves combined, 182 or 60%): Hatzfeld 1912. See discussion in Rauh 1993, 30–32.
3 From a population of about 1,500 to 2,000 in the period of the independence, it gained an estimated amount of 20,000 to 30,000 at its peak, during the period of the second Athenian dominion. See: Rauh 1993, 27. However there is no firm evidence—inscriptions give evidence for 1,200 citizens and a population of about 6,000 at the beginning of the first century BCE.

were created.[4] The new neighborhoods developed around the sanctuary center and where good natural ports were created to complement the activities of the main port, overloaded by the maritime traffic going through the island in this period.[5]

After the sacks of 88 and 69 CE by the troops of Mithridates and the pirate Athenadoros, however, Delos ceased to be an economic center. Triarius, the legatus of Lucullus stationed on the island, built a wall in 69 BCE in order to protect the island from the pirate Athenadoros.[6] The wall of Triarius reduced the settlement around the area of the sanctuary. Delos was occupied through the imperial period and, after a prosperous period between the end of the 3rd century CE and the beginning of the 7th century CE,[7] was in the following centuries ruined and deserted.[8] Due to the abandonment of the island, the houses of the late Hellenistic period have been well preserved even though Delos was an inexhaustible resource for marble and stone for the surrounding islands. Excavated in the late 19th and early 20th centuries, the Delian houses are prime examples of Hellenistic housing.[9]

Studies of the Delian houses have hitherto focused on typological analyses of their architecture and have not attempted to contextualize writing in private space.[10] This paper discusses stone inscriptions and *graffiti* found in the late Hellenistic houses of Delos. In discussing their location

4 On urban growth of the island during this period see: Bruneau 1968; Papageorgiou-Venetas 1981. On the port and dockside structures see also: Duchêne and Fraisse 2001. The comprehensive study on the urban growth of the island by Papageorgiou-Venetas (1981) has been rightly criticized for misapplying modern urban planning principles and quantitative methods: Scranton 1982; Bruneau 1984; Kreeb 1984.
5 Bruneau 1968, 658–664.
6 Maillot 2005.
7 Orlandos 1936; Kiourtzian 2000, 47–60.
8 Delos was ravaged in 727 by the iconoclast emperor Leo the Isaurian, in 769 by the Slaves and in 829 by the Saracens coming from Crete (the Arab inscription in the Porticus of Philip attests their passage—wrongly dated according to Bruneau and Ducat, 2005). On the graffiti from this period, see Vallois 1923, 167–169.
9 Publications of the individual neighborhoods: Plassart 1916 (Stadion District); Chamonard 1922–24 (Theater District); Bruneau et al. 1970, and Siebert 2001 (North District). Studies of all the houses: Bruneau 1995a; Trümper 1998; Trümper 2005; Trümper 2007; Trümper 2010; Tang 2005; Nevett 2010, 63–88, ch. 4.
10 For an overview of the scholarship see: Zarmakoupi 2013a, "The study of the Delian houses".

and architectural setting I will address the ways in which individuals appropriated space in order to complement or even inflect the messages that they were trying to communicate. The spatial choices as well as visual strategies employed by owners and occupants of Delian houses shed light not only on the nature of the message that is being communicated but also on the use and private or public nature of the spaces in which the message is being displayed.

The study of stone inscriptions in houses points to the inadequacy of the modern opposition between private and public, to describe the use of domestic spaces in antiquity. Stone inscriptions, which by their nature are formal, underline the public character of some areas of the house. The notions of private and public existed in antiquity but were distinct from our own.[11] As a less formal use of writing, *graffiti*, on the other hand, indicate the more interactive use of inscriptions. Unlike modern *graffiti*, which for us denote an abuse of space,[12] the ancient *graffiti* were perceived as a flexible means of communication and clustered in the most "public" areas of the house.[13] Both kinds of writing shed light on the ways in which domestic space was used.

The Inscriptions in the Late Hellenistic Houses of Delos

Stone inscriptions were found in 26 "houses",[14] out of which three were probably not houses but meeting places of religious-trade associations (house II A

[11] On the notions of private and public in the Roman house see: Wallace-Hadrill 1994, 17–37; Dickmann 1999, 41–48. See also discussion in Wallace-Hadrill 2014. For a discussion of these notions in Delian houses see: Trümper 2003. For an introduction to domestic writing culture, see: Corbier 2012. On the notions of public and private in ancient Greece see de Polignac and Schmitt-Pantel 1998 and other articles of the 23rd volume of *Ktema* (1998). For the relationship between writing and public space, see Rizakis 2014.

[12] Langner 2001, 19–20. Recent studies address the literary value of graffiti. See, for example, the study of graffiti poetry found in Pompeii by Kristina Milnor (2014, 45–96).

[13] See, for example, Benefiel 2010 and 2011.

[14] Bruneau lists 16 houses, as he only lists inscriptions that relate to religious subjects: Bruneau 1970, 640–641. Birgit Tang lists 13 houses, in which she includes the two possible religious associations, House IIA of the Stadion District and House of Hermes (Bruneau does not include these in his list): Tang 2005, 56. The list of Bruneau and the list of Tang overlap on five instances. The total number must thus be amended to 24 houses. To this number I add the House of Fourni and the House of Kerdon.

of the Stadion District,[15] the House of Hermes,[16] and the House of Fourni[17]) and one housed a sculptor's workshop (the House of Kerdon[18]). I will discuss three stone inscriptions, which attest the identity of the house owners. The two are on statue-bases and record the dedication of the statues to the house owners: the house of Kleopatra and Dioskourides in the Theatre District (*ID* 1987)[19] and the house of Quintus Tullius (Q. Tullius Q. f.) in the Stadion District (*ID* 1802).[20] In the third instance the inscription is on a statuette-base and records the dedication of the statuette to Artemis Soteira by Spurius Stertinius (*ID* 2378) from House E, located to the east of the Peribolos of the Sanctuary of Apollo.[21]

15 It is possible that this house served as an early location of the synagogue later located at the southeast of this area (GD 80; see Trümper 2004). GD plus a number indicates the numbering of the monuments in the Guide de Délos (Bruneau and Ducat 2005). A dedication to "God Most High" found in GD 80 uses the epithet ὕψιστος to refer to God, an epithet that has been identified as referring to the Jewish deity (*ID* 2328: Λυσίμαχος ὑπὲρ ἑαυτοῦ Θεῷ Ὑψίστῳ χαριστήριον. "Lysimachos for himself [to] God most High [for a] votive/thank-offering"). In house II A another inscription mentions Lysimachos in a dedication to the "prayer hall" (proseuchē): *ID* 2329: Ἀγαθοκλῆς καὶ Λυσίμαχος ἐπὶ προσευχῇι. "Agathokles and Lysimachos for the prayer hall [proseuchē]". The interpretation of this inscription as a dedication to the prayer hall in addition to the direct access to the well from the court, which is a unique feature in Delos and has been only attested at the synagogue, has led to the hypothesis that this is an early location of the synagogue. See: Plassart 1913, 205, n. 1; Plassart 1916, 234–247. Against this interpretation: Mazur 1935, 21; Bruneau 1982, 499–504, who posits that this is a Jewish house but not a synagogue; Matassa 2007. See discussion in McLean 1996; Runesson et al. 2008, 128–129. Noy et al. (2004, 210–242, nos. Ach 60–71) collect evidence for Jews and Samaritans on Delos and discuss the archaeological evidence concerning the synagogue. The texts that presented dedications to Theos Ypsistos are Ach 60–63, cf. Ach 64/65. Van der Horst (2005, 71–72) points out that these texts are probably not related to Judaism. See also SEG 54 (2004) 712.
16 SEG 13 (1956) 425. For the inscription, along with other finds, from this house see: Marcadé 1953; Kreeb 1988, 200–215.
17 For an overview of the reliefs and inscriptions found in the House of Fourni see: Trümper 2006, 122–130.
18 For the inscription from this house see: Jardé 1905, 53; Kreeb 1988, 190.
19 SEG 35 (1985) 885. Roussel 1908, 432, no. 46; Roussel 1987, 38, no. 12; Chamonard 1922–24, 40, 218; Kreeb 1988, 17–21.
20 SEG 32 (1982) 812. Plassart 1916, 205–207; Bruneau 1982, 503, n.90; Rauh 1993, 198–200; Kreeb 1988, 169–170.
21 Roussel and Bizard 1907, 459, fig. 16; Bizard 1907, 496; Bruneau 1970, 204; Kreeb 1988, 196–197. See also discussion on the dedications of Stertinius on Delos in McClain and Rauh 1996.

FIGURE 4.1 *Plan of House III.1 or House of Kleopatra and Dioskourides, Theater District.*

The first inscription (*ID* 1987) was found in situ in house III 1 (or House of Kleopatra and Dioskourides, Fig. 4.1) of the Theater District with the accompanying statue group.[22] The inscription was dedicated by Kleopatra to her husband Dioskourides of the demos of Myrrhinous (modern Merenda in the territory of Athens), and refers to a gift that Dioskourides made to the temple of the god of Apollo during the period that Timarchos of Athens was archon of Delos (138/137 BCE):

22 For more on sculpture-inscription ensembles in homes, see the chapter of Elisabeth Rathmayr in this volume (chapter 8). She also discusses the inscriptions from the house of Kleopatra and Dioskourides in the Theatre District (*ID* 1987) and from House E, located to the east of the Peribolos of the Sanctuary of Apollo (*ID* 2378).

FIGURE 4.2 *Statue group and inscribed base, House III.1, Theater District.*

Κλεοπάτρα Ἀδράστου ἐγ Μυρρινούττης θυγάτηρ τὸν ἑαυτῆς
ἄνδρα Διοσκουρίδην Θεοδώρου ἐγ Μυρρινούττης ἀνατεθεικότα
τοὺς δελφικοὺς τρίποδας τοὺς ἀργυροῦς δύο ἐν τῶι τοῦ Ἀπόλλωνος
ναῶι παρ' ἑκατέραν παραστάδα, ἐπὶ Τιμάρχου ἄρχοντος Ἀθήνησιν.

"Kleopatra, daughter of Adrastos of Myrrhinous, set up this image of her husband Dioskourides, son of Theodoros of Myrrhinous, who dedicated the two Delphic tripods of silver by each doorpost in the temple of Apollo, in the archonship of Timarchos in Athens."

The statue group features both Kleopatra and Dioskourides, although their heads are not preserved.[23] The statue group and the accompanying inscription were prominently displayed in the courtyard of the house, blocking an earlier entrance to room F, and were placed so as to be viewed from the entrance of the house.[24] The monument (statue group and inscribed base), however, was designed to make an impact on the visitor that had already entered the house, as the door of the house would have been closed (Fig. 4.2). As Chamonard, and more recently Nevett, noted, the interiors of Delian houses were not designed to be seen by passers-by.[25] In fact, except for a few cases (e.g., the House of the Trident), Delian houses were not influenced by the layout of Italian houses.[26]

23 Marcadé 1969, 134, 325–328, pls. LXV, LXVI and LXVIII; Kreeb 1988, 20, Fig. 2.3.
24 Kreeb 1985, 53–55; Kreeb 1984, 323–325, figs. 6–7.
25 Chamonard 1922–24, 163–91 (ch. 6); Nevett 2010, 63–88 (ch. 4).
26 Bruneau 1995a; Nevett 2010, 63–88 (ch. 4).

FIGURE 4.3 *Plan of House IC or House of Quintus Tullius, Stadion District.*

The second inscription (*ID* 1802) comes from House IC in the Stadion District (Fig. 4.3). The inscription is bilingual, in Greek and Latin, and records a dedication of a statue by three freedmen, Heracleon, Alexandros and Aristarchos, to their patron (Q. Tullius Q. f.).[27] The patron and his freedman Heracleon are known from other inscriptions. Quintus Tullius is Apolloniastes (priest of Apollo) in 125 BCE (*ID* 1730).[28] This inscription must be dated later, as Plassart has pointed out, since Heracleon appears as a slave in a dedication of Competaliastes dated to 97/96 BCE (*ID* 1761).[29] The inscription in House IC, or House of Quintus Tullius, reads as follows:

[Κόιντον Τύλλιον - - - -]πον Κοίντου υἱὸν
[Κόιντος Τύλ]λιος ['Ηρα]κλέων καὶ Κόιντος
Τύλλιος Ἀλέξανδρος καὶ Κόιντος Τύλλιος
Ἀρίσταρχος οἱ Κοίντου τὸν ἑαυτῶν πάτρωνα
ἀρετῆς ἕνεκεν καὶ καλοκαγαθίας τῆς εἰς ἑαυτούς.

27 Ferrary et al. 2002, 218, nos. 4–7.
28 Hatzfeld 1912, 86, Tullii, no. 2; Ferrary et al. 2002, 218, no. 3.
29 Plassart 1916, 206; Hatzfeld 1912, 86, Tullii, no. 1; Ferrary et al. 2002, 218, no. 8.

[Q. Tullium Q. f- - -pum]
Q. Tullius Q. l. A[ristarchus]
Q. Tullius Q. l. Ale[xander]
Q. Tullius Q. l. He[racle]o̲ [p]a̲tr̲o̲[nem]
suom honoris et be[nef]i̲ci cau[sa]

In Greek: "[(To) Q. Tullius- - -]pus son of Q., Q. Tullius Heracleon and Q. Tullius Alexandros and Q. Tullius Aristarchos (dedicated) to their patron, honoring his virtue and benefaction toward them."

In Latin: "(To) Q. Tullius son of Q., Q. Tullius Aristarchos and Q. Tullius Alexander and Q. Tullius Heracleon (dedicated) to their patron, for his virtue and benefaction."[30]

The Greek freedmen of Quintus Tullius dedicated the statue with inscriptions in both Greek and Latin. Studies of the language used in dedicatory inscriptions to Italians or Romans have shown that the use of Greek answered the wishes of the Italian community to integrate linguistically in Delian society.[31] The use of Greek by the freedmen may also indicate their desire to emphasize their own, Greek, identity. It is interesting to note that the Greek inscription places Heracleon first and Aristarchos third, while the Latin one changes the position of Aristarchos with Heracleon. It is possible that in the case of the Latin inscription the freedmen wished to underline their relative relation to their patron, while in the Greek one they wished to emphasize their own feelings—as Touloumakos suggested.[32] Bilingual inscriptions seem to have served as a means to project some sort of collective corporate identity of the Italian *negotiatores* at Delos.[33] The freedmen of Quintus Tullius, who conducted business on behalf of their patron on Delos—probably on the ground

30 Plassart 1916, 207. *ID* 1802, Inv. E 775.
31 Touloumakos 1995; 119–120, 125. Adams 2002; Adams 2003, 642–662; Hasenohr 2007. The analysis of the use of Latin by Romans or Italians has shown that it was used as a means of underlining the specificity of their ethnic group. Italian *magistri* used Latin in their dedicatory inscriptions during their appointment in order to underline the official character of the dedications while the bilingualism of the inscriptions points to particular occasions. However, the former *magistri* used Greek only in their dedicatory inscriptions. After leaving office, they conform to the local language and expressions. The only exception to this is the Agora of the Italians, where it seems that there was a desire to underline the official character of this place of reunion, even if the building was privately funded. See Hasenohr 2007.
32 Touloumakos 1995, 90.
33 Adams 2002. See also Hasenohr 2007 and 2008.

floor of the house,[34] wished to underline this aspect of their identity, which largely depended on their economic activities.

The inscription came from the upper floor of the house, probably from the north balcony around the courtyard (c), as it was found in the upper layers of the rubble in room (g) close to its south wall.[35] The inscription, as well as the accompanying (missing) statue, would have been visible to visitors of the house, as the reception rooms were located on this floor.[36] Access to the upper floor was granted through vestibule (a), at the south part of the courtyard. The reception rooms were located at the north area of the upper floor, beyond the north balcony where the inscription and statue were probably set up. Arriving at the south balcony around the courtyard, a visitor would have seen the inscription and statue base set at the north balcony across the opening of the courtyard below.

The third inscription (*ID* 2378) comes from House E, which was accessed from the street at the east of the Peribolos of the sanctuary of Apollo. The inscription featured on a stone that formed the basis of a niche located in the vestibule of the house and on which a statuette was fixed with a dowel (missing). It reads:

Σπόριος Στερτένιος
Ἀρτέμιδι Σωτείραι.

Spurius Stertinius
to Artemis Soteira.

The house must have belonged to Spurius Stertinius, who dedicated the statuette to the goddess Artemis Soteira. The *gens Stertinia* is known from several inscriptions and Spurius Stertinius dedicates votive offerings to several deities.[37] His worship of Artemis Soteira is also documented on a votive relief

34 For the ways in which the ground floor of this house accommodated the economic activities of the owners see Zarmakoupi (2013a and forthcoming).

35 Kreeb 1988, 169.

36 The second floor was added at a later phase of the house, at which time the rooms to the north of the courtyard, which must have been used as reception rooms at the first phase, were used for storage. By the construction of the second floor the lighting and ventilation of these rooms was reduced and the upper floor now offered more attractive alternatives for such reception rooms. Zarmakoupi 2013b.

37 On Spurius Sertinus see Hatzfeld 1912, 81, Stertinii, no. 5; Courby 1912, 114–115; Ferrary et al. 2002, p. 216, Stertinii, nos. 5 and 6. On Spurii, with previous bibliography, see: Buraselis 1996, 55–59.

found in the temple of Aphrodite, which was not too far from the house.[38] In both inscriptions Spurius Stertinius uses the local Greek language, but in the inscription on the votive offering found in the temple of Aphrodite he identifies himself as Ῥωμαῖος. The use of ethnic Ῥωμαῖος appears on Delos only in Greek inscriptions,[39] and the public display of the votive offering in the temple of Aphrodite can be the explanation for the inclusion of the adjective Ῥωμαῖος in the inscription—as Elisabeth Rathmayr suggests.[40] It is interesting nonetheless that Spurius Stertinius uses the Greek language in the private context of his house. The inscription, however, did not feature in a secluded area of the house. Located in the vestibule, on the left hand side upon entering the house, at a distance of 2.10 m from the entrance, and at a height of 1.30 m, the inscription was in the most accessible and frequented area of the house, and thus highly visible.

We notice that in all three cases, the house of Kleopatra and Dioskourides, the house of Quintus Tullius, and the house of Spurius Stertinius, the inscriptions (and accompanying statues, or statuette) were placed in areas dedicated for passage within the most public areas of the houses. In all three cases, the inscription and statue, or statuette, were set in such a way so as to be immediately visible upon entering the space that they were set. The monument of Kleopatra and Dioskourides was visible from the entrance to the courtyard of the house, the monument of Quintus Tullius was visible from the south balcony, from where one gained access to the upper floor, and the niche in the vestibule of the house of Spurius Stertinius was immediately visible upon entering the house. In all three cases, the statues, or statuette, and inscriptions underscored the owners' actions and respectable statuses. In the case of the House of Kleopatra and Dioskourides, the inscription underlined to visitors the gift of Dioskourides to the temple of Apollo as well as the Athenian descent of the couple. In the case of the house of Quintus Tullius, the bilingual inscription set up by his freedmen emphasized the collective identity of *negotiatores* on Delos, which largely depended on their economic activities. In the case of the house of Spurius Stertinius, the dedication to Artemis Soteira reminded to visitors the votive offering that the house owner made to the same goddess in the sanctuary of Aphrodite, which was not too far from the house, while the

38 Marcadé 1969, 214–215, pl. 40. See Rathmayr, this volume, chapter 8, Text no. 10.

39 The Latin synonym *Romanus* is never found in Latin inscriptions at Delos. See Adams 2002, 109. Two adjectives are used: Ῥωμαῖος and Ἰταλικός in Greek, *Italicus* in Latin. See: Solin 1982, 113–117; Le Dinahet 2001; Adams 2002; Adams 2003, 651–658.

40 See Rathmayr in this volume, chapter eight.

The *Graffiti* in the Late Hellenistic Houses of Delos

The *graffiti* found in the Delian houses were numerous, but they were often not documented fully before they were weather-beaten and deteriorated beyond conservation or recovery. They were originally published in excavation reports and only the representations of ships were treated in more detailed publications.[41] The recent study of ancient *graffiti* by Langner compiled a catalogue of the published *graffiti*, which is almost complete.[42] Langner documents *graffiti* in twenty-three houses, and this number can be amended to twenty-four.[43]

Early on the *graffiti* were discarded as posthumous to the original occupation of the houses.[44] The numerous representations of ships prompted the suggestion that the soldiers of the fleet of Mithridates,[45] Athenadoros[46] or Triarius[47] wrote the *graffiti* on the walls of abandoned houses, as they were longing to go back home, or even that fishermen passing through Delos inscribed these *graffiti* after the island was abandoned.[48] Bruneau questioned this interpretation as early as 1978: "Mais c'est peut-être une idée trop moderne de penser que les habitants réguliers d'une maison répugnaient autant que nous à écrire et dessiner sur les murs."[49] Langner's comprehensive treatment of the subject as well as the recent studies of *graffiti* in Pompeii and other sites have shown that *graffiti* were indeed not perceived in the same way as today.[50] The modern perception of *graffiti*, however, has remained the predominant view in the

41 See brief account in: Bruneau 1965, 108, n. 3; Bruneau 1975, 286–287; and Bruneau 1978, 147. On graffiti representing ships: Basch 1973; Basch 1987; and Basch 1989.
42 Accompanying CD in: Langner 2001.
43 A *graffito* in room (h) of House 1C in the Stadion District (now lost) was omitted (documented in Plassart 1916, 201).
44 Severyns 1927; van Berchem 1962, 312–3; Basch 1973, 67.
45 Bruneau 1978, 147.
46 Basch 1973, 67.
47 van Berchem 1962, 313.
48 Basch 1973, 67.
49 Bruneau 1978, 149.
50 See Langner's review of the modern ideas about graffiti: Langner 2001, 19–20. For an overview of the recent scholarship on ancient graffiti see: Baird and Taylor 2011. Pompeii's rich collection of graffiti has enabled their study in context (Benefiel 2008, 2010 and 2011) as well as analyses of their literary value (Milnor 2009, 2011, and 2014).

THE SPATIAL ENVIRONMENT OF INSCRIPTIONS AND GRAFFITI 61

FIGURE 4.4 *Plan of House of Dionysos, Theater District.*

case of Delos, so *graffiti* were not taken into account in recent comprehensive publications of the houses.[51]

Graffiti have been found in houses of all sizes on Delos, but it is interesting to note that they were found in some of the wealthiest ones. The impressive House of Dionysos in the Theater District (Fig. 4.4), for example, featured several *graffiti* in exedra (l) that opened onto the south side of the courtyard, as well as in entrance room (a). The *graffiti* in exedra (l) were located on the east wall of the room. Four large transport ships were prominently displayed on the wall, around which the rest of the *graffiti* clustered (Fig. 4.5).[52]

The other *graffiti* included two horses, one generic four-legged animal,[53] one pair of horses,[54] a circle-rosette,[55] as well as an illegible text. The four transport-ships that dominated the wall are made in confident clear lines as well as the circle-rosette, while the *graffiti* of the horses and the four-legged animal seem sketchier. It seems likely that the ships were drawn first, around

51 E.g. Trümper 1998.
52 Four graffiti of transport-ships: Langner 2001, no. 2209.
53 Langner 2001, nos. 1411–1413.
54 Langner 2001, no. 1408.
55 Langner 2001, no. 76.

FIGURE 4.5 Graffito *of ship in exedra (l), House of Dionysos.*

which the other *graffiti* clustered almost in conversation to them.[56] The *graffiti* of the four large transport-ships dominate the wall and seem to be perceived as decoration of the white-plastered room.

Another example of a well-to-do house, prominently featuring *graffiti* in its most public areas, is House II in the Insula of the Jewelry (Îlot des Bijoux) (Fig. 4.6). This seemingly modest house, in terms of ground plan,[57] was in fact one of the richest houses of Delos. This is where a large amount of jewelry was found, from which in fact the insula takes its name. The *graffiti* appeared on the interior of the walls of portico (F) around the small courtyard (G) and in room (H) that opened on to the portico.[58] Four *graffiti* of ships were on the south wall of the west wing of the portico, one on the south wall of the north wing of the portico, and another six on the west wall of the west wing of the portico.[59] They were all placed from a minimum height of 0,41 m to a maximum

56 For other types of conversations among graffiti at Pompeii, see Benefiel 2010 and 2011.
57 The ground plan of the Delian houses can be highly deceiving since in many of these seemingly modest houses the upper floor was lavishly decorated.
58 Langner 2001, nos. 1875, 1916, 1941, 1978, 1981, 2035, 2151–2154, 2201.
59 South wall of the west wing of the portico: *graffito* no. 1875 (of transport ship with sail) at the far left, at a height of ca. 0.92 m (with inscription ΑΛΕΞΑΣΕΠΟΙΗΣΕΝ: Daux 1965, 984)—Daux states that the *graffito* of the ship below the text is posterior to the establishment of the staircase; *graffito* no. 1916 (sailing ship) at a height of 0.86 m; *graffito* no. 1941 (ship) at a height of 0.83 m; *graffito* no. 2153 (boat) at a height of 0.85 m. West wall of the west wing of the portico: *graffito* no. 1978 at a height of 0.94 m; *graffito* no. 1981 (sailing ship) at a height of 0.41 m; *graffito* no. 2035 (sailing ship) at a height of 0.74 m; *graffito* no. 2151

THE SPATIAL ENVIRONMENT OF INSCRIPTIONS AND GRAFFITI 63

FIGURE 4.6 *Plan of House II, Insula of the Jewelry.*

height of 1,30 m. Access to the portico was granted at the south end of the west wing through the vestibule (J) and courtyard (G), where also the staircase to the upper floor was located. We note that most of the *graffiti* clustered in the area around the staircase, at the west wing of the portico, the area of the house that must have been most frequented by members of the household and visitors alike.

A comparison between the displays of the *graffiti* of ships in the two houses is interesting here. In the House of Dionysos the *graffiti* were placed high up on the east wall of the exedra (l) (size: 5 × 4,60 m) that opened at the south side of the courtyard (Fig. 4.7). Somebody walking in the south wing of the narrow portico (c) (width 1.50 m) around the courtyard, from the west towards the east side, would have had a pleasant overview of the *graffiti* on the east wall of the exedra, which would have been ca. 3.5 m away from him/her. In the case of House II in the Insula of the Jewelry, the *graffiti* were on the inside west and

(boat) at a height of ca, 0.65 m; *graffito* no. 2152 (boat) at a height of 1.30 m; *graffito* no. 2154 at a height of 1.06 m. South wall of the north wing of the portico: *graffito* no. 2201 features two ships on the poros stone of the portico wall, at a height of ca. 1.10 m (still *in situ*).

FIGURE 4.7 *S. courtyard, House of Dionysos, Theater District.*

south walls of the west wing of portico (F), which had a pleasant width of 3 m (Fig. 4.8).

Upon entering the wide portico through the courtyard, which at this side of the house had no openings, one's eyes would have been attracted by the *graffiti* located at a height lower than eye-level. Turning all the way to the left, in order to take the staircase to the upper floor, one's eyes would have also been directed to the *graffiti* that were next to the steps on the south wall of the west wing of the portico. It seems that the position of the *graffiti* was chosen relative to the distance from which they would have been viewed as well as in relation to the direction of one's sightline as one was walking in the house.

In both the House of Dionysos and House II in the Insula of the Jewelry, *graffiti* clustered in areas of the house that were used for passage or opened onto such areas and were placed in such a way so as to be perceived by somebody walking in these areas. Another example is the House ID in the Stadion District (Fig. 4.3). In this house, *graffiti* were concentrated in vestibule (a) and in staircase room (c) that led to the upper floor.

FIGURE 4.8 *W. portico, House II, Insula of the Jewelry.*

Upon entering the house, to the right from the entrance, in front of the latrines, appeared a graffito of a transport-ship with 36 oarsmen (Fig. 4.9).[60] Next to the ship were written a large number of names, including greetings in both Greek and Latin and presenting different letter heights, a fact that suggests different authors.[61] One name is ΗΛΙΟΦΩΝ. That same name appears in Latin just outside this house, where it is inscribed on the altar of the *Lares Compitales*, just to the right of the entrance.[62] The concentration of the names and greetings, as well as the repetition of the name of Ἡλιοφῶν, suggests a continuing conversation among the different authors, similar to that found in the House of the Four

60 Langner 2001, no. 1906; Plassart 1916, 224.
61 Plassart 1916, 224, n. 1.
62 Plassart 1916, 211. The *graffito* features under one of the persons represented on the south elevation of the altar (final state): HELIOFO, *CIL* 12 2 (2) 2652. Plassart speculated that it may also read HELIODO(RUS) but favored the first interpretation because of the *graffito* documenting the name ΗΛΙΟΦΩΝ inside the house. The Greek form of this name (Ἡλιοφῶν) appears only in this case on Delos. It occurs in 6 more cases, see *LGPN* vols. I, IIIa, IV, and Va (http://clas-lgpn2.classics.ox.ac.uk/cgi-bin/lgpn_search.cgi?name=Ἡλιοφῶν). On Ἡλιόδωρος see *LGPN*, s.v. (http://clas-lgpn2.classics.ox.ac.uk/cgi-bin/lgpn_search.cgi?name=Ἡλιόδωρος).

FIGURE 4.9 *Entrance, House ID, Stadion District.*

Styles in Pompeii.[63] In the staircase room (c), *graffiti* of ships appeared on the north wall, opposite the staircase that led to the upper floor.[64] The concentration of the *graffiti* in this area of the house is thought provoking. This house was modified at a second phase: the reception rooms of the house to the north of the courtyard were broken down into smaller rooms to form two groups of

63 Benefiel 2011, 20–48.
64 Langner 2001, nos. 1915, 1984, 2081, 2082. On the north wall of room (c): *graffito* no. 1915 of a sailing ship to the right at a height of 1.20 m; *graffito* no. 1984 of a sailing ship at a height of ca. 1.80 m; *graffito* no. 2081 of a sailing ship at a height of ca. 1.20 m; *graffito* no. 2082 of a sailing ship at a height of ca. 1.20 m (graffiti nos. 2081–2 are together, one on top of the other); *graffito* no. 2161 of a sailing ship at a height of ca. 1.20 m.

FIGURE 4.10 *Plan of House of the Lake.*

rooms that served as storage and guest rooms.[65] The clustering of the *graffiti* in the area of the entrance and the staircase suggests that these spaces were the most frequented areas of the house. Is the clustering of the *graffiti* associated with the change of the function of the rooms at the north of the courtyard? It is possible that when the rooms to the north of the courtyard changed function, reception rooms were created on the upper floor—to which members of the household as well visitors were going, leaving their marks in the vestibule and the staircase.

The House ID in Stadion District as well as the House of Dionysos in the Theater District and the House II in the Insula of the Jewelry are but a few examples that feature *graffiti* in areas of the house that were used for passage or opened onto such areas. There were, of course, *graffiti* in more private areas of the houses. In the House of the Lake (Fig. 4.10), for example, the north wall of the small triangular room (c) that opened to the courtyard through a narrow opening featured the following textual graffito:

65 While the north-west group of rooms was possibly used for storage, the rooms of the north-east one, which were smaller and featured niches, were possibly rented out as guest rooms. Zarmakoupi 2013b.

Ἥδ'ἐστὶν ἡ χθὼν
Ἀντιοχέα, σῦκα καὶ
ὕδρω πολύ. Μαίαν-
δρε σωτὴρ σῷζε
κα<ὶ> ὕδρω δίδου.[66]

Here is the Antiocheian land,
rich in fruit and
in water.
O Meander savior,
save (me)
and give water.

Next to and above the text were inscribed *graffiti* of four transport-ships. Chamonard and Severyns propose that a slave from Karia wrote this graffito, who during an arid period on Delos was longing for the rich soil around the river Meander.[67] Bruneau suggested that the representation of ships in the adjacent *graffiti* further underscored the desire for a return to home.[68]

Is the longing of slaves or even merchants for their faraway homes the explanation for the frequency of *graffiti* representing ships in the houses of Delos? This cannot be, surely, the only explanation. Representations of ships were also associated with a variety of textual *graffiti* that did not express the desire of return to a homeland, but were merely playful. For example, in the House of Dionysos, on the same wall of exedra (1), on which the *graffiti* of the four big transport-ships appeared, there was also the following textual graffito:

66 *SEG* 3 (1927) 672. I have changed the κα[ὶ] to κα<ὶ> because it seems on the pictures and the transcriptions that the inscriber forgot this letter. Couve 1895, 474; Chamonard 1922–24, 422–3, fig. 249 (with the additions of F. Mayence and L. Bizard); Severyns 1927, 234–8, no. 1; Langner 2001, 95 and n. 606, no. 2207. According to Severyns, the text is written in iambic tetrameter up to πολύ and in iambic trimeter. The poetic style of the text is confirmed by the term χθών, which is very rare in prose. There is no equivalent text in literary sources. Langner points to a Greek inscription from Rome, an epigram on a tomb for a Syrian (IG XIV 1890, 11), where the terms ἡδύς, χθών, ὕδωρ are also attested. This inscription is not dated.
67 Chamonard 1922–24, 422–3; Severyns 1927, 234–8.
68 Bruneau 1978, 149.

Δημήτριος
[τ]υφλ[ὸ]ς οὐδὲ
βλέπει οὐθὲν
παί[σ]ων ἀσ-
τραγάλους
[ἀ]πέκα[[ψ]]ψε αὐτῷ
Ἑρμίας ἀσ[τρ]αγάλους.
Φλέγ[ω] αὐτῷ,
[Ἑρ]μίας[69]

This graffito dates to the first century BCE. The name Ἑρμίας is often attested on Delos during the first and second centuries BCE[70] and the form οὐθὲν points to the same date, as it stops being used in the 1st century CE.[71] The graffito has been amended by Severyns and can be loosely translated: "Demetrios is totally blind (by the game of the dice) that he sees nothing but the dice (not even that Ermias is burning with love for him); Ermias stole the dice from him; I burn for him, Ermias." Severyns questioned whether such a "crude" graffito would have featured in one of the most beautiful rooms of such an aristocratic house. It seems however, that the sensibilities of the owners were not offended by such playful texts and the Anthologia Palatina provides plenty of examples. Playful *graffiti* featured in prominent areas of Pompeian houses as well. Another example from Delos is found in House VI L in the Theater District. In this case a graffito playing around the notion of smell and perfume featured on the east wall of room (e) that opened onto courtyard (b) of the house.[72]

Appearing next to a variety of playful *graffiti* and in the most prominent spaces of the Delian houses, the representation of ships must have been popular images of the period. Graffiti representing ships were not only widespread on Delos, but also in Pompeii, Ostia, and Alexandria—among other places. Many of these *graffiti* represent transport-ships, and it is possible that whoever drew the *graffiti* made reference to the world of commerce on which these

69 Chamonard 1906, 552–553, fig. 20, and 1922, 204; Severyns 1927, 238–43. Line 4. Chamonard interprets as παί[ζ]ων. Severyns argues that this is not the participle of παίζω, but of παίω, which is not very convincing. It is probably a confusion between Ζ and Σ, which is not so often attested in private inscriptions by illiterate people in the Hellenistic period (see Threatte 1980, 547–548).
70 See LPGN.
71 I would like to thank Elena Martina Gonzalez for pointing this out.
72 Bruneau 1978, 146–7.

port-cities depended. Sea commerce and trade were important strands of the economic landscape of these port-cities, and the representations of ships must have formed part of a shared widespread imagery. Another possibility is that the *graffiti* of ships denoted wishes for εὔπλοια—for a fair voyage—but no mention of the word εὔπλοια has been attested in association with them.[73]

In room (h) of the House of Quintus Tullius in the Stadion District (Fig. 4.3), a graffito of a boat and a horse was followed by a dedication:

Μνησ [---]
Ἐκ{π}άγαθος
[... about 3–4 ...] ΠΑΓΑΘΩ.[74]

It is possible that Ἐκπάγαθος is a misspelling of Ἐπάγαθος. The name Ἐπάγαθος is attested on Delos in an inscription for a slave or a freedman dated to 74 BCE (Π. Σερουίλιος Ἐπάγαθος, *ID* 1758)[75] as well as in an inscription for a freedman found in the southern extremity of the Portico of Philip (Μ. Καικίλιος Ἐπάγαθος, *ID* 1961).[76] A terracotta figurine of a clothed Egyptianizing "Oriental Aphrodite" (Inv. no. A2498) was also found in this room and points to the appeal and integration of Egyptianizing religion in the multicultural community of Delos.[77] The graffito of ships might be then related to the Egyptian cults and their marine character and the Egyptian commercial diaspora, responsible for the spread of Egyptianizing cults from centers like Delos to Italy and the west.[78]

73 For a list and discussion of εὔπλοια inscriptions see Sandberg 1958.
74 Plassart 1916, 201.
75 Hatzfeld 1912, 77, Servilii no. 2; Ferrary et al. 2002, 214, Servilii n. 2.
76 Roussel and Hatzfeld 1910, 417, no. 81; Hatzfeld 1912, 22, Caecilii no. 5; Ferrary et al. 2002, 191, Caecilii n. 4. Μ. Καικίλιος Ἐπάγαθος was possibly a gladiator. Bruneau (1995b, 48) mentions that this inscription might also date to the imperial period.
77 Laumonier 1956, 146, pl. 42, no. 387; Barrett 2011, 335–336, 500–501, figs. F1, F2 and D19. The figurine shows some influence from Egyptian iconography and as many other Egyptianizing figurines from Delos points to the appeal and integration of Egyptianizing religion in the multicultural community of Delos. See Barrett 2011. For a discussion of the location of the figurine see Zarmakoupi 2013b.
78 Huzar 1962, 173–174; Tran Tam Tinh 1964, 15–29; Malaise 1972, 268–311. For a discussion about the marine character of Egyptian cults see Rizakis 2002 (120–122) and Martzavou 2010 (186–187).

Conclusions

This brief analysis of the *graffiti* in the Delian houses is consistent with recent studies of *graffiti* in the houses of Pompeii and villas around the bay of Naples, which have shown that *graffiti* were concentrated in areas of the house dedicated for passage, as well as spaces where people had access frequently and gathered.[79] As discussed in this paper the Delian *graffiti* were surely not contemporarily perceived to be damaging the decoration of the houses but rather complementing it. The large ship *graffiti*, which were accompanied by small texts, *graffiti* of animals of geometrical shapes, featured prominently on the walls of the Delian houses and complemented their decoration.[80] Similar to the honorary and dedicatory inscriptions discussed above—but surely not sharing the monumental character of the inscriptions with their accompanying statue groups—*graffiti* and especially clusters of *graffiti* featured in areas of the house where they could be seen by both the members of the household as well as visitors. The majority of the attested *graffiti* were, in fact, in the most frequented and accessible parts of the house: on the walls of the vestibule (e.g., House of ID in the Stadion Quarter, House of Dionysos in the Theater Quarter), of the courtyard (e.g., House IIA in the Stadion Quarter, House of the Tritons in the Insula of the Tragic Actors) or of rooms opening onto the courtyard (e.g., House of the Lake, House III K in the Theater District). Whereas the textual *graffiti* with their greetings and playful messages promoted communications among the people passing through and gathering in the most frequented areas of the house, the *graffiti* of ships formed part of a popular imagery that made reference to the world of commerce on which the port-city of Delos and its population depended.

While the *graffiti* in the Delian houses communicated informal private messages that shed light on the personal sensibilities and religious affiliations of the house occupants as well as the function of domestic spaces, the inscriptions present us with public language use and point to the public function of the houses. In the house of Quintus Tullius, for example, the bilingual inscription set on the upper floor of the courtyard underscored the economic

79 Benefiel 2011; Baldwin, Moulden, Laurence 2013.
80 Another way of complementing the decoration of the houses was to repeat the fresco decoration of the house. For example, a *graffito* on the façade of the house that is located opposite to the entrance to the House of the Hill copies the trumpet-player that features in the painting that decorates the same wall. Langner 2011, no. 1145.

activities of the owner, whereas the graffito of a boat and a horse with the dedication of Ἐκπάγαθος in room (h)—taken together with the Egyptianizing figurine—point to some kind of religious function of this room. The language and content of the inscriptions in the Delian houses emphasized the public actions, respectable statuses as well as the identity of the owners—for example the inscription in the House of Kleopatra and Dioskourides underlined the gift of Dioskourides to the temple of Apollo and the bilingual inscription in the House of Q. Tullius made reference to the collective corporate identity of the Italian *negotiatores* at Delos. Featuring in the public areas of the house— for example, the vestibule and courtyard—inscriptions formed part of the social staging of the house owner. Inscriptions were immediately visible upon entering the public areas of the house and their placement is paradigmatic of the visual strategies employed to promote the identity of the house owner in the domestic sphere on late Hellenistic Delos, as well as late Republican Italy and Roman Ephesos and Pergamon.[81]

Bibliography

Adams, James Noel. 2002. "Bilingualism at Delos." In *Bilingualism in Ancient Society: Language Contact and the Written Text*, edited by J. N. Adams, Mark Janse, and Simon Swain, 103–27. Oxford: Oxford University Press.

———. 2003. *Bilingualism and the Latin Language*. New York: Cambridge University Press.

Baird, J. A., and Claire Taylor. 2011. *Ancient Graffiti in Context*. Vol. 2, *Routledge Studies in Ancient History*. New York and London: Routledge.

Baldwin, Eamonn, Helen Moulden, and Ray Laurence. 2013. "Slaves and Children in a Roman Villa: Writing and Space in the Villa di San Marco at Stabiae." In *Written Space in the Latin West, 200 BCE to AD 300*, edited by Gareth Sears, Peter Keegan, and Ray Laurence, 153–66. London, New Delhi, New York, Sydney: Bloomsbury.

Barrett, C. E. 2011. *Egyptianizing Figurines from Delos: A Study in Hellenistic Religion*. Vol. 36, *Columbia studies in the classical tradition*. Leiden: Brill.

Basch, Lucien. 1973. "Graffites Navals à Délos." *Bulletin de Correspondance Hellénique. Supplément* 1: 65–76.

———. 1987. *Le Musée Imaginaire de la Marine Antique*. Athens: Institut Hellénique pour la préservation de la tradition nautique.

81 See Rathmayer, chapter eight in this volume.

———. 1989. "Les *Graffiti* de Délos." In *Tropisi: Proceedings of the 1st International Symposium on Ship Construction in Antiquity. Piraeus, 30–August—1 September 1985*, edited by Harry E. Tzalas, 17–23. Athens: Hellenic Institute for the Preservation of Nautical Tradition.

Benefiel, Rebecca. 2008. "Amianth, a Ball-Game, and Making one's Mark: CIL IV 1936 and 1936A." *Zeitschrift für Papyrologie und Epigraphik* 167: 193–200.

———. 2010. "Dialogues of *Graffiti* in the House of Maius Castricius at Pompeii." *American Journal of Archaeology* 114, no. 1: 59–101.

———. 2011. "Dialogues of *Graffiti* in the House of the Four Styles at Pompeii (Casa Dei Quattro Stili, I.8.17,11)." In *Ancient Graffiti in Context*, edited by J. A. Baird and Claire Taylor, 104–99. New York and London: Routledge.

van Berchem, Denis. 1962. "Les Italiens d'Argos et le Déclin de Délos." *Bulletin de correspondance hellénique* 86, no. 1: 305–13.

Bizard, Léon. 1907. "Descriptions des Ruines (pl. XIV)." *Bulletin de Correspondance Hellénique* 31: 471–503.

Bruneau, Philippe. 1965. *Les Lampes*. Vol. 26, *Exploration Archéologique de Délos*. Paris: De Boccard.

———. 1968. "Contribution à l'Histoire Urbaine de Délos à l'Époque Hellénistique et à l'Époque Impériale." *Bulletin de Correspondance Hellénique* 92, no. 2: 633–709.

———. 1970. *Recherches sur les Cultes de Délos à l'Époque Hellénistique et à l'Époque Impériale*. Vol. 217, *Bibliothèque des Écoles Françaises d'Athènes et de Rome*. Paris: De Boccard.

———. 1975. "Deliaca." *Bulletin de Correspondance Hellénique* 99, no. 1: 267–311.

———. 1978. "Deliaca (II)." *Bulletin de Correspondance Hellénique* 102, no. 1: 109–171.

———. 1982. "Les Israélites de Délos et la Juiverie Délienne." *Bulletin de Correspondance Hellénique* 106, no. 1: 465–504

———. 1984. "Review of: *Délos: Recherches Urbaines sur une Ville Antique* by A. Papageorgiou-Venetas." *Gnomon* 56: 733–37.

———. 1995a. "La Maison Délienne." *RAMAGE. Revue de l'Archéologie Moderne et d'Archéologie Générale* 12: 77–118.

———. 1995b. "Deliaca (X)." *Bulletin de correspondance hellénique* 119: 45–54.

Bruneau, Philippe, Claude Vatin, U. Bezerra de Meneses, G. Donnay, E. Lévy, A. Bovon, G. Siebert, V. R. Grace, M. Savvatianou-Pétropoulakou, E. Lyding Will, and T. Hackens. 1970. *L'Îlot de la Maison des Comédiens*. Vol. 27, *Exploration Archéologique de Délos*. Paris: De Boccard.

Bruneau, Philippe, and Jean Ducat. 2005. *Guide de Délos*. 4th improved and revised edition. Athens: École Française d'Athènes.

Buraselis, Kostas. 1996. "Stray Notes on Roman Names in Greek Documents." In *Roman Onomastics in the Greek East: Social and Political Aspects. Proceedings of the

International Colloquium on Roman Onomastics, Athens, 7–9 September 1993, edited by Athanassios D. Rizakis, 55–63. Athens: Research Centre for Greek and Roman Antiquity, National Hellenic Research Foundation.

Chamonard, Joseph. 1906. "Fouilles de Délos (1904): Fouilles dans le quartier du Théâtre." *Bulletin de correspondance hellénique* 30: 485–606.

———. 1922–24. *Le Quartier du Théâtre: Étude sur l'Habitation Délienne à l'Époque Hellénistique*. Vol. 8, *Exploration Archéologique de Délos*. Paris: De Boccard.

Corbier, Mireille. 2012. "Présentation. L'Écrit dans l'Espace Domestique." In *L'Écriture dans la Maison Romaine*, edited by Mireille Corbier and Jean-Pierre Guilhembet, 7–46. Paris: De Boccard.

Courby, Fernand. 1912. *Le Portique d'Antigone ou du Nord-Est et les Constructions Voisines*. Vol. 5, *Exploration Archéologique de Délos*. Paris: Fontemoing.

Couve, Louis. 1895. "Fouilles de Délos." *Bulletin de Correspondance Hellénique* 19: 460–516.

Daux, Georges. 1965. "Chronique des Fouilles et Découvertes Archéologiques en Grèce en 1962." *Bulletin de Correspondance Hellénique* 89, no. 2: 683–1007.

Dickmann, Jens-Arne. 1999. *Domus frequentata: anspruchsvolles Wohnen im pompejanischen Stadthaus*. Vol. 4, *Studien zur antiken Stadt*. Munich: Verlag Dr. Friedrich Pfeil.

Duchêne, Hervé, and Philippe Fraisse. 2001. *Le Paysage Portuaire de la Délos Antique: Recherches sur les Installations Maritimes, Commerciales et Urbaines du Littoral Délien*. Vol. 39, *Exploration Archéologique De Délos*. Athens: École française d'Athènes.

Ferrary, Jean-Louis, Claire Hasenohr, Marie-Thérèse Le Dinahet, in collaboration with Marie-Françoise Boussac. 2002. "Liste des Italiens de Délos." In *Les Italiens dans le Monde Grec: IIe siècle av. J.-C.-Ier Siècle ap. J.-C.: Circulation, Activités, Intégration: Actes de la Table Ronde, École Normale Supérieur, Paris, 14–16 mai 1998, Bulletin de Correspondance Hellénique. Supplément* 41, edited by Christel Müller and Claire Hasenohr, 183–239. Paris: École française d'Athènes.

Hasenohr, Claire. 2007. "Les Italiens à Délos: Entre Romanité et Hellénisme." *Pallas. Revue d'Études Antiques* 73, Identités Ethniques dans le Monde Grec Antique: 221–232.

———. 2008. "Le Bilinguisme dans les Inscriptions des *Magistri* de Délos." In *Bilinguisme Gréco-Latin et Épigraphie*, Actes du Colloque Organisé à l'Université Lumière-Lyon 2 (17–19 mai 2004), edited by Frédérique Biville, Jean-Claude Decourt and Georges Rougemont, 55–70. Lyon: Maison de l'Orient et de la Méditerranée-Jean Pouilloux.

Hatzfeld, Jean. 1912. "Les Italiens Resident à Délos." *Bulletin de Correspondance Hellénique* 36: 5–218.

Huzar, Eleanor G. 1962. "Roman-Egyptian Relations in Delos." *The Classical Journal* 57: 169–78.

Jardé, André. 1905. "Fouilles de Délos, Exécutées aux Frais de M. le Duc de Loubat (1904)." *Bulletin de Correspondance Hellénique* 29: 5–54.

Kiourtzian, Georges. 2000. *Recueil des Inscriptions Grecques Chrétiennes des Cyclades: De la Fin du IIIe au VIIe Siècle après J.-C.* Paris: De Boccard.

Kreeb, Martin. 1984. "Review of: *Délos. Recherches Urbaines sur une Ville Antique* by A. Papageorgiou-Venetas." *Göttingische gelehrte Anzeigen* 236: 139–56.

———. 1984. "Studien zur figürlichen Ausstattung delischer Privathaüser." *Bulletin de Correspondance Hellénique* 108, no. 1: 317–43.

———. 1985. "Zur Basis der Kleopatra auf Delos," *Horos* 3: 41–61.

———. 1988. *Untersuchungen zur figürlichen Ausstattung delischer Privathäuser.* Chicago: Ares Publishers.

Langner, Martin. 2001. *Antike Graffitizeichnungen: Motive, Gestaltung und Bedeutung.* Wiesbaden: L. Reichert.

Laumonier, A. 1956. *Les Figurines de Terre Cuite.* Vol. 23, *Exploration Archéologique de Délos.* Paris: E. de Boccard.

Le Dinahet, Marie-Thérèse. 2001. "Les Italiens de Délos: Compléments Onomastiques et Prosopographiques." *Revue des Études Anciennes* 103: 103–23.

Maillot, Stéphanie. 2005. *Le Système de Défense Établi par le Légat Triarius dans l'île de Délos en 69 av. J.-C.* Académie des Inscriptions et Belles Lettres. Mémoire de Troisième Année. Paris: École Française d'Athènes.

Malaise, M. 1972. *Les Conditions de Pénétration et de Diffusion des Cultes Égyptiens en Italie.* Vol. 22, *Études Préliminaires aux Religions Orientales dans l'Empire Romain.* Leiden: E. J. Brill.

Marcadé, Jean. 1953. "Les Trouvailles de la Maison Dite de l'Hermes, à Délos." *Bulletin de Correspondance Hellénique* 77: 497–615.

———. 1969. *Au Musée de Délos. Étude sur la Sculpture Hellénistique en Ronde Bosse Découverte dans l'Île.* Vol. 215, *Bibliothèque des Écoles Françaises d'Athènes et de Rome.* Paris: De Boccard.

Martzavou, Paraskevi. 2010. "Les Cultes Isiaques et les Italiens entre Délos, Thessalonique et l'Eubée." *Pallas. Revue d'Études Antiques* 84: 181–205.

Matassa, Lidia. 2007. "Unravelling the Myth of the Synagogue on Delos." *Bulletin of the Anglo-Israel Archaeological Society* 25: 81–115.

Mazur, Belle D. 1935. *Studies on Jewry in Greece.* Athens: Hestia.

McClain, T. Davina, and Nicholas K. Rauh. 1996. "Signs of a woman's influence? The dedications of the Stertinian *Familia* at Delos." *Aevum, Rassegna di Scienze Storiche-Linguistiche e Filologiche* 70: 47–68.

McLean, B. Hudson. 1996. "The place of cult in voluntary associations and Christian Churches on Delos." In *Voluntary associations in the Graeco-Roman world*, edited by J. S. Kloppenborg, and S. G. Wilson, 186–225.

Milnor, Kristina. 2009. "Literary Literacy in Roman Pompeii: the Case of Virgil's Aeneid." In *Ancient Literacies: the Culture of Reading in Greece and Rome*, edited by William A. Johnson and Holt N. Parker, 288–319. Oxford: Oxford University Press.

———. 2011. "Between epitaph and epigram: Pompeian *graffiti* and the Latin literary tradition." *Ramus* 40: 198–222.

———. 2014. *Graffiti and the Literary Landscape in Roman Pompeii*. Oxford, New York: Oxford University Press.

Müller, Christel, and Claire. Hasenohr, eds. 2002. *Les Italiens dans le Monde Grec: IIe siècle av. J.-C.-Ier Siècle ap. J.-C.: Circulation, Activités, Intégration: Actes de la Table Ronde, École Normale Supérieur, Paris, 14–16 mai 1998, Bulletin de Correspondance Hellénique*. Supplément 41. Paris: École française d'Athènes.

Nevett, Lisa C. 2010. *Domestic Space in Classical Antiquity*. Cambridge: Cambridge University Press.

Noy, David, Alexander Panayotov, and Hanswulf Bloedhorn (eds.) 2004. *Inscriptiones Judaicae Orientis* I. Texte und Studien zum antiken Judentum 101. Tübingen: Mohr Siebeck.

Orlandos, Anastase K. 1936. "Délos Chrétienne." *Bulletin de Correspondance Hellénique* 60, no. 1: 68–100.

Papageorgiou-Venetas, Alexandre. 1981. *Délos: Recherches Urbaines sur une Ville Antique*. Berlin: Deutscher Kunstverlag.

Plassart, André. 1916. "Fouilles de Délos, Exécutées aux Frais de M. Le Duc De Loubat (1912–1913): Quartier des Habitations Privées à l'Est du Stade (pl. V–VII)." *Bulletin de Correspondance Hellénique* 40: 145–256.

———. 1913. "La Synagogue Juive de Délos." *Mélanges Holleaux, Recueil de Mémoires Concernant l'Antiquité Grecque Offert à Maurice Holleaux en Souvenir de ses Années de Direction à l'École Française d'Athènes (1904–1912)*, 201–15. Paris: Picard.

Polignac, François de and Pauline Schmitt-Pantel 1998. "Public et Privé en Grèce Ancienne: Lieux, Conduites, Pratiques. Introduction." *Ktema* 23: 5–13.

Rauh, Nicholas K. 1993. *The Sacred Bonds of Commerce: Religion, Economy, and Trade Society at Hellenistic Roman Delos, 166–87 BC*. Amsterdam: J. C. Gieben.

Reger, Gary. 1994. *Regionalism and Change in the Economy of Independent Delos, 314–167 BC* Vol. 14, Hellenistic Culture and Society. Berkeley: University of California Press.

Rizakis, Athanasios D. 2002. "L'Émigration Romaine en Macédoine et la Communauté Marchande de Thessalonique: Perspectives Économiques et Sociales." In *Les Italiens dans le Monde Grec: IIe siècle av. J.-C.-Ier Siècle ap. J.-C.: Circulation, Activités, Intégration: Actes de la Table Ronde, École Normale Supérieur, Paris, 14–16 mai 1998,*

Bulletin de Correspondance Hellénique. Supplément 41, edited by C. Müller, and Claire Hasenohr, 109–32. Paris: École française d'Athènes.

———. 2014. "Writing, Public Space and Publicity in Greek and Roman Cities." In *Öffentlichkeit—Monument—Text: XIV Congressus Internationalis Epigraphiae Graecae et Latinae, 27.-31. Augusti MMXII, Akten*, edited by Werner Eck and Peter Funke, together with Marcus Dohnicht, Klaus Hallof, Matthäus Heil, and Manfred G. Schmidt, 77–89. Berlin, Boston: De Gruyter.

Roussel, Pierre. 1908. "Les Athéniens Mentionnés dans les Inscriptions de Délos (pl. IV) [Contribution à la Prosopographia Attica de J. Kirchner.]" *Bulletin de Correspondance hellénique* 32: 303–444.

———. 1987. *Délos, Colonie Athénienne. Reimpression Augmentée de Compléments Bibliographiques et des Concordances par Philippe Bruneau, Marie-Thérèse Couilloud-Le Dinahet, Roland Etenne*. Paris: De Boccard.

Roussel, Pierre, and Léon Bizard. 1907. "Fouilles de Délos, Exécutées aux Frais de M. le Duc de Loubat (1904). Inscriptions (Suite)." *Bulletin de Correspondance Hellénique* 31: 421–70.

Roussel, Pierre and Jean Hatzfeld 1910. "Fouilles de Délos Exécutées aux Frais de M. le Duc de Loubat. Décrets, Dédicaces et Inscriptions Funéraires (1905–1908) II." *Bulletin de Correspondance Hellénique* 34, no. 1: 355–423.

Runesson, A., D. D. Binder, and B. Olsson. 2008. *The ancient synagogue from its origins to 200 CE: A source book*. Leiden; Boston: Brill.

Sandberg, Nils. 1954. *ΕΥΠΛΟΙΑ: Etudes Épigraphiques*. Acta Universitatis Gotoburgensis. Göteborgs Universitets Arsskirft 60. Göteborg: Wettergren & Kerbers Förlag.

Scranton, Robert L. 1982. "Review of: *Délos. Recherches Urbaines sur une Ville Antique* by A. Papageorgiou-Venetas." *Journal of the Society of Architectural Historians* 41, no. 1: 55.

Severyns, Albert. 1927. "Deux "*Graffiti*" de Délos." *Bulletin de Correspondance Hellénique* 51: 234–43.

Siebert, Gérard. 2001. *L'Îlot des Bijoux, l'Îlot des Bronzes, la Maison des Sceaux*. Vol. 38, *Exploration Archéologique De Délos*. Athens: École Française d'Athènes.

Solin, Heiki. 1982. "Appunti sull'Onomastica Romana a Delo." In *Delo e l'Italia, Opuscula Intsituti Romani Finlandiae II*, edited by Filippo Coarelli, Domenico Musti, and Heikki Solin, 101–17. Rome: Bardi.

Tang, Birgit. 2005. *Delos, Carthage, Ampurias: The Housing of Three Mediterranean Trading Centres*. Rome: L'Erma di Bretschneider.

Threatte, Leslie. 1980. *The Grammar of Attic Inscriptions I. Phonology*. Berlin-New York: De Gruyter.

Touloumakos, J. 1995. "Bilingue [griechisch-lateinische] Weihinschriften der römischen Zeit." *Tekmeria* 1: 79–129.

Tran Tam Tinh, V. 1964. *Essai sur le Culte d'Isis à Pompéi*. Paris: De Boccard.

Tréheux, Jacques. 1992. *Inscriptions de Délos, I. Les Étrangers, à l'Exclusion des Athéniens de la Clérouchie et des Romains*. Paris: De Boccard.

Trümper, Monika. 1998. *Wohnen in Delos: Eine Baugeschichtliche Untersuchung zum Wandel der Wohnkultur in hellenistischer Zeit*. Vol. 46, Internationale Archäologie. Rahden: Verlag Marie Leidorf.

———. 2003, "Material and Social Environment of Greco-Roman Householfs in the East: The Case of Hellenistic Delos." In *Early Christian Families in Context: An Interdisciplinary Dialogue*, edited by David L. Balch and Carolyn Osiek, 19–43. Grand Rapids Michigan, Cambridge, UK: William B. Eerdmans Publishing Company.

———. 2004. "The oldest original synagogue in the diaspora." *Hesperia* 73: 513–98.

———. 2005. "Modest Housing in Late Hellenistic Delos." In *Ancient Greek Houses and Households: Chronological, Regional, and Social Diversity*, edited by Bradley A. Ault, and Lisa C. Nevett, 119–39. Philadelphia: University of Pennsylvania Press.

———. 2006. "Negotiating Religious and Ethnic Identity: The Case of Clubhouses in Late Hellenistic Delos." *Hephaistos* 24: 113–40.

———. 2007. "Differentiation in the Hellenistic Houses of Delos: The Question of Functional Areas." In *BUILDING COMMUNITIES: House, Settlement and Society in the Aegean and Beyond*, Vol. 15, *British School at Athens Studies*, edited by Ruth Westgate, Nick Fisher, and James Whitley, 323–34. London: The British School at Athens.

———. 2010. "Η Κατοικία στην Υστεροελληνιστική Δήλο (Houses in Late Hellenistic Delos)." *Αρχαιολογία και Τέχνες* (*Archaeology and the Arts*) 114: 16–27.

Vallois, René. 1923. *Le Portique de Philippe*. Vol. 7, *Exploration Archéologique de Délos*. Paris: De Boccard.

Van der Horst, Pieter W. 2005. "*Inscriptiones Judaicae Orientis*: A Review Article." *Journal for the Study of Judaism* 36, 65–83.

Wallace-Hadrill, Andrew. 1994. *Houses and Society in Pompeii and Herculaneum*. Princeton: Princeton University Press.

———. 2014. "Inschriften in privaten Raum: Introduction." In *Öffentlichkeit—Monument—Text: XIV Congressus Internationalis Epigraphiae Graecae et Latinae, 27.-31. Augusti MMXII, Akten*, edited by Werner Eck and Peter Funke, together with Marcus Dohnicht, Klaus Hallof, Matthäus Heil, and Manfred G. Schmidt, 481–482. Berlin, Boston: De Gruyter.

Zalesskij, N. N. 1982. "Les Romains à Delos (de L'Histoire du Capital Commercial et du Capital Usuraire Romain)." In *Delo e l'Italia, Opuscula Intsituti Romani Finlandiae II*, edited by Filippo Coarelli, Domenico Musti, and Heikki Solin, 21–49. Rome: Bardi Editore.

Zarmakoupi, Mantha. 2013a. "The city of late Hellenistic Delos and the integration of economic activities in the domestic sphere." *CHS Research Bulletin* 1, no. 2.

http://nrs.harvard.edu/urn-3:hlnc.essay:ZarmakoupiM.The_City_of_Late_Hellenistic_Delos.2013.

———. 2013b. "The Quartier du Stade on Late Hellenistic Delos: A Case Study of Rapid Urbanization (fieldwork Seasons 2009–2010)." *ISAW Papers* 6. http://dlib.nyu.edu/awdl/isaw/isaw-papers/6/preprint/

———. forthcoming. "Les maisons des négociants italiens à Délos: Structuration de l'espace domestique dans une société en mouvement." *Cahiers "Mondes Anciens."* http://mondesanciens.revues.org

CHAPTER 5

The Culture of Writing Graffiti within Domestic Spaces at Pompeii

Rebecca R. Benefiel

As the previous chapters have demonstrated, graffiti appear within domestic spaces in cities throughout the Greco-Roman world.[1] They are not a product of any one particular locale, culture, or chronological period. Although their particular expression might vary according to time and place, e.g. the popularity of *mnesthe* inscriptions[2] is a product of the eastern Mediterranean, the habit of writing on walls is a phenomenon attested from east to west and through the ancient world. Nowhere is this phenomenon more amply attested than at Pompeii. The light pumice stones that rained down on Pompeii during the eruption of Vesuvius in 79 CE did not flatten the city but filled it to such a height as to seal off more or less the entire first floor of the town, safeguarding within not only artifacts and architecture but also the plaster that covered virtually every wall surface, inside buildings and out.[3] As a result, Pompeii provides not only our best view of a Roman city in microcosm, from its grand public monuments to its well-worn roads; it also gives us acres and acres, and neighborhood after neighborhood of residential dwellings, complete with their graffiti *in situ*.

Pompeii thus offers our best option for understanding the scale and scope of the habit of writing graffiti—both across the ancient city *and* inside homes, an idea that is often jarring to modern audiences. How extensive was this graffiti habit? Reaching an answer requires evaluating the evidence from different perspectives. This chapter offers an inroad, beginning by looking broadly at the

* My thanks go to Antonio Varone and Jennifer Baird for stimulating discussions on the nature of ancient graffiti, and to Molly Swetnam-Burland and David Petrain for their comments and continued conversations on this topic. This research has been generously supported by two Lenfest summer grants from Washington & Lee University.
1 I follow the original definition of the term 'graffiti': marks that are *scratched into* a wall-surface (cf. Benefiel 2010, 59 n. 1; Baird in chapter two of this volume). For discussion of the shift in definition of the term graffiti, see Baird and Taylor 2011, and Keegan 2014.
2 Regarding *mnesthe* inscriptions, see Baird 2011, and chapter two in this volume.
3 For more on the eruption and its effects, see Sigurdsson et al. 1982, and the chapters in Guzzo and Peroni 1998.

presence of graffiti within the city at large, then refocusing the field of vision and moving in closer, to the city-block, to the single house, to individual clusters of graffiti. First, the big picture. Where and how often do these scratched inscriptions appear? And, how does the habit of writing inside homes compare to writing in more public spaces? An overall snapshot reveals that graffiti were found throughout the ancient city, but the ratio of graffiti in the public vs. the private sphere does not conform to modern expectations. Following this brief discussion of graffiti across Pompeii, a survey of two individual city-blocks then provides a mid-range perspective onto the distribution and density of these handwritten wall-inscriptions and underscores how frequently graffiti might be found within domestic spaces. Finally, we move into close-range and examine graffiti in three of the most well-inscribed residences at Pompeii, addressing questions that the topic of graffiti often elicits: How did graffiti impact the interior decoration of the house? And who was involved in writing and reading graffiti? Throughout, the underlying aims of this chapter are to explore the idea of the culture of writing on walls and to understand how graffiti appear within the epigraphic landscape of the ancient city.

Graffiti in Pompeii

Where did graffiti appear in the city of Pompeii? One likely response upon hearing this question might be to imagine the facades of buildings fronting the city's streets. In Pompeii these were often covered with painted inscriptions, or *dipinti* (Fig. 5.1). A visitor to the site today can find a few fragments of these inscriptions still *in situ*, now protected under plexiglass, although in most places fragments are all that remain. Those texts were professionally painted, and sought to communicate information to the public—such as the names of candidates running for political office or the date of gladiatorial spectacles—and were therefore posted in public spaces where they might be seen by a wide audience.[4] Graffiti, by contrast, were handwritten inscriptions that could be created by anyone with use of a sharp implement. They appeared on facades too, but they were smaller and scratched in, not painted, and so less visible. Still, almost 1700 examples of incised wall-inscriptions were found on building facades along the city's streets; another two hundred

4 The painted electoral posters, or *programmata*, and the local government and society they illuminate, have been the subject of studies by Biundo 2003, Chiavia 2002, Franklin 2001, Mouritsen 1988, and Castrén 1975. Sabbatini Tumolesi 1980 provides the most thorough analysis of the advertisements for gladiatorial games.

FIGURE 5.1 Dipinti *along the Via dell'Abbondanza. (Su concessione del Ministero per i Beni e le Attività Culturali. Reproduction prohibited.)*

examples appeared on the funerary monuments bordering the roads leading into town. Yet these exterior locations are not where the bulk of graffiti are found.

Where, then, do other graffiti appear? Public buildings account for nearly 1000 examples. The campus or *palaestra* beside the amphitheater (II.7) holds the greatest quantity of any single location, with more than 400 messages.[5] More than 200 graffiti were found in the basilica on the town's forum (VIII.1),

5 The textual graffiti of the campus are recorded at *CIL* IV.8518–8814 and 9279–9245. If one counts the individual messages, which are often combined under one entry number (e.g. *CIL* IV.8625 a, b, c, d), the total number is 402. This does not separate out single markings or letters, which, if appearing on the same column, are combined in *CIL* entries (e.g. *CIL* IV.8585).

In addition to these, Langner (2001) records a total of 92 graffiti drawings that appeared within the campus. Inscribed drawings are not given their own entries in *CIL*, although brief mention of such is made within the entries of nearby text; this occurs more consistently in the later fascicles of *CIL* IV. The total number of graffiti in this building, then, including both text and drawings, is 494.

where the traces of many more texts were noted, unfortunately illegible already at the time of excavation.[6] The theater complex in the southern part of the city (VIII.7) and the purpose-built brothel at VII.12.18 contained more than 100 messages each. Other public buildings with significant quantities include the Building of Eumachia, also on the forum, and the city baths.

In terms of general location, however, the largest category of graffiti—more than 3000 examples—come from the interiors of Pompeian houses. These represent nearly half of all the incised wall-inscriptions in the city. This characteristic, namely, the fact that ancient wall-inscriptions appear—and appear regularly—in domestic contexts, is completely alien to our own, contemporary experience of what we call graffiti. But these numbers reveal that it was clearly a component of the culture of writing in first century Pompeii.

The Distribution of Graffiti—A View of Two *Insulae*

If graffiti appear in such great numbers, both across the city in general and within houses in particular, what does this imply? How often would a Pompeian encounter this type of writing in homes, in public spaces, and on the street? Here, the setting of the city as a whole is too large a canvas. Instead, one must zoom in for a closer view. The city-block, or *insula*, which contained multiple properties and a mix of residential and other types of buildings, offers a more convenient framework to address these queries (Fig. 5.2).

So, how often do graffiti appear within homes? Do they appear only in certain types of domiciles? And how many might be found within a single residence?

Andrew Wallace-Hadrill has recently provided analysis of the epigraphic landscape of one such city-block, or *insula*, by surveying the various kinds of writing that were part of the daily life of Pompeians. He marshaled the various types of writing found within *Regio* I, *Insula* 9—*dipinti*, labeled *amphorae*, and graffiti—and in so doing pieced together a lived-in environment where writing was a part of the daily scene.[7] This richly detailed picture of electoral notices

6 Cf. the note at *CIL* IV.1774–1777 (about graffiti on the exterior of the basilica): *In eo muro praeter has multae extant inscriptiones, sed, ut in corroso tectorio, mutilatae et oblitteratae omnes.*

7 Wallace-Hadrill 2011. Several other kinds of writing in the Roman house, in the capital and across the empire, are addressed in the recent volume edited by Corbier and Guilhembet 2011.

FIGURE 5.2 *Plan of Pompeii highlighting two city-blocks under discussion, I.9 and VI.15 (based on Dobbins and Foss 2007, Map 2).*

passed frequently, labeled goods being received, and individuals creating their own notes and messages is based on a thorough archaeological knowledge of the area, the result of a decade long study of *Insula* 1.9 by the British School at Rome and the University of Reading.[8] In this area of workshops, bars, and modest to large houses, it is useful to see the trader using writing as means of communication and transaction for himself and clients and to recognize that writing is not restricted to a single social class. Wallace-Hadrill concludes with a salient point and one that should be underscored: in Pompeii, writing "is part of the low-level, everyday life of the town."[9]

His discussion provides an excellent background against which to take a closer look at the custom of writing on walls. *Regio* 1, *Insula* 9 lies to the south of the via dell'Abbondanza (Fig. 5.3), one of the major streets of town, and includes eight distinct properties: three small workshop/houses (1.9.8, 9, and 10), and five other medium to large residences (300–400 sq m), some of which are connected to retail space or *tabernae*. In order to understand the habit of writing graffiti alongside the presence of other sorts of text, let us look more closely at the epigraphic corpus of 1.9 through the statistics compiled by Wallace-Hadrill, which I reproduce in summary format here (Table 5.1):

[8] Wallace-Hadrill 2005; Fulford and Wallace-Hadrill 1999; Berry 1998 and 1997. Additional materials, such as numbers of inscribed *amphorae*, were recovered during the British study and excavations of this *insula*. See Table 5.1.

[9] Wallace-Hadrill 2011, 410.

TABLE 5.1　*Epigraphic material from I.9*

Property	*Programmata*	Labeled *amphorae*	Graffiti[10]
I.9.1–2	10	3	1
I.9.3–4	7	1	7
I.9.5–7	3	17	20
I.9.8	0	8	2
I.9.9	0	16	6
I.9.10	0	2	0
I.9.11–12	3	71[11]	3
I.9.13	4	3	9

FIGURE 5.3　*Detail of city-blocks to the south of the Via dell'Abbondanza (from Eschebach and Müller-Trollius 1993).*

10　I have condensed the graffiti statistics, which he subdivides according to class of inscription: alphabets, numbers, names, dates, and messages. See Wallace-Hadrill 2011, Table 4. Additional figural graffiti have been discovered since the publication of *CIL* IV. Those will be discussed shortly, below.

11　Initial excavations during the 1950s revealed 56 labeled *amphorae*, while the British excavations of the 1990s recovered an additional 15 examples; Wallace-Hadrill 2011, 406–408.

Just as the properties in this block strive for real estate along the important via dell'Abbondanza to the north (entrances 1 through 6 cluster on the northern, short side of this *insula*, Fig. 5.3), so the campaign posters likewise concentrate along this major road. The numbers in the table above make clear that there is a preference for posting *programmata* in certain locations, namely along the more important streets running east-west (or, southwest-northeast) through town. Those would have been locations with higher traffic where such posters would have reached a wide audience.[12] In this block, *programmata* do not appear along the secondary streets that run north-south.

By contrast, labeled *amphorae* are found in every property in *Regio* I, *Insula* 9. It should be noted that the numbers in the table above refer only to *amphorae* with labels and do not include what could be significant numbers of similar containers that did not bear inscriptions.[13] This valuable assessment makes clear that products carrying labels could be found not only in commercial establishments, not only in houses of the wealthy, but even, as occurs here, in every property in the block. Mary Beard has called attention specifically to labeled *amphorae*, along with wax tablets, as important markers for understanding literacy. She emphasizes that these types of items make clear that reading and writing would have been integral for many people in Pompeii.[14] With posters along busy streets and labels on common items, it is clear that text was present in the daily lives of Pompeians. How often, then, would residents create their own text and messages by writing on the walls?

12 For more on the distribution of *programmata*, see the work of Henrik Mouritsen (1988) and Ray Laurence (1994; 2nd ed. 2007). Their studies have inspired new projects that offer spatial analysis of the archaeology and epigraphy of the city. For a recent topographical study of various street activity across Pompeii, e.g., see Viitanen, Nissinen, and Korhonen 2012. The dissertations of Fanny Opdenhoff (at Heidelberg), Polly Lohmann (Munich), and Jacqueline DiBiasie (Texas), currently in progress or recently completed, aim to refine further our understanding of the distribution of *dipinti* and graffiti across Pompeii.

13 For example, Wallace-Hadrill notes that of the sixty *amphorae* shown in an excavation photograph stacked in the northwest corner of the atrium at 1.9.12, eight were published as having labels (2011, 407). This high number of *amphorae* of course points to the commercial activity taking place at this property.

14 Beard 2008, 185: "From [wax tablets and labeled *amphorae*] it is clear that for many people well below the level of wealthy inhabitants reading and writing must have been integral to the way they organised their lives, and to their ability to do their jobs and earn their living."

What Wallace-Hadrill's analysis reveals here is worth underlining: graffiti are found in nearly every property within this block. Their numbers may be modest, with even a single example recorded in certain buildings. Still, the presence of graffiti characterizes not some, not many, but nearly *all* the properties of 1.9.[15] The specificity of *CIL* permits the separate articulation of *tabernae* from the residences behind them, which allows us to evaluate the distribution of graffiti by type of property. It is therefore possible to determine that graffiti are found in all three categories of property present here: *tabernae*, workshops, and houses. Graffiti occur in both *tabernae* of this block (at 1.9.4 and 1.9.11), in two of the three workshops (1.9.8 and 1.9.9, also likely used as residences), and in five houses (1.9.1, 1.9.3, 1.9.5, 1.9.12, and 1.9.15). The only property in the *insula* not to yield any graffiti at all is the workshop-house at 1.9.10 (Fig. 5.4).[16]

The categories of property, however, yield divergent quantities of graffiti. The four *tabernae* and workshops feature only a couple of examples each, with six in total.[17] The houses account for the other 40+ graffiti within the *insula* (or 78%), and range from one or two graffiti in a house to as many as twenty-one in the Casa del Frutteto at 1.9.5. These numbers are based on *CIL*, which focused on texts not drawings. If we add in the figural incised wall-inscriptions, or graffiti drawings, which Martin Langner's collection has now made possible,[18] the houses assume even greater numbers. Four drawings appeared within the Casa del Frutteto at 1.9.5, raising its total to 25, while eight drawings have been

15 It is impossible to determine when the graffiti were inscribed. Only a handful of examples across Pompeii include internal dating criteria. This overview thus provides a snapshot in time, namely, that in the year 79 CE graffiti were present, often in modest numbers, yet in nearly *all* the properties of 1.9.

16 The numbers on this map differ slightly from those given by Wallace-Hadrill since he grouped together all graffiti associated with a single property, while I am separating out graffiti in *tabernae* as well as those found inside a property from those found on the building exterior. The graffiti in 1.9 are: *CIL* IV.8228, 9990–10027, 10050–10051, and Giordano and Casale 1991, no. 124.

17 *Tabernae*: 1 graffito in 1.9.4, 2 in 1.9.11; workshops: 2 graffiti in 1.9.8, 2 graffiti in 1.9.9. See previous note.

18 The project of the *Corpus Inscriptionum Latinarum* concentrated on recording the text of inscriptions. Thus, in *CIL* IV, a drawing might be included if there was an accompanying text. Otherwise, graffiti drawings might be noted, but this occurred sporadically. Langner's collection of graffiti drawings from across the Roman world (*Antike* Graffiti*zeichnungen*: *Motive, Gestaltung, und Bedeutung*, 2001) is therefore a most welcome and useful resource for any study of ancient graffiti.

FIGURE 5.4
Distribution of graffiti *in* Insula *1.9 (adapted from Dobbins and Foss 2007, Map 3). Grey shading signifies the presence of* graffiti *within a building. A star represents the presence of a* graffito *on the facade.*

recorded in the Casa di Cerere at I.9.13, giving it a total of 17 graffiti.[19] One additional drawing, a sketch of a man's head in profile, appeared in the context of an electoral *programma* outside the same house.[20]

This returns us to the question of exterior versus interior locations. In this regard *Insula* I.9 presents a striking picture, with a much higher quantity of graffiti found inside buildings (56 examples), compared to the few that appear on building exteriors (5). Even when we restrict the analysis to textual graffiti, this ratio remains roughly the same, with more than 90% of the messages in this block written inside buildings (48) rather than on building facades (4 examples). In this city-block, then, there was much greater activity taking place indoors, when it came to scratching messages and notes on the walls, than along the city's streets. The total numbers of graffiti in *Insula* I.9 are quite modest, however, and reveal a collection of writing (and drawings) in just one corner of the city.

Let us then turn to a different area of the city and briefly survey another city-block for comparison. *Insula* 15 of *Regio* VI provides a useful study because

19 At I.9.5: Langner 2001, nos. 250, 292, 453, and 501 (heads); at I.9.13: Langner 2001, nos. 215, 385 (heads), 861–864 (gladiators), 2316 (column capital), and 2519 (fragmentary).

20 Langner 2001, no. 246 (briefly mentioned in the note at *CIL* IV.9837).

it is largely residential, lies in a different area of the city, and contains a substantial number of graffiti. This *insula* lies in the northern section of town just within the Porta Stabia and was excavated at the very end of the nineteenth century.[21] It is larger in size than I.9, occupying some 4700 sq m, in contrast to the 3040 sq m of I.9.[22] *Insula* VI.15 is mostly residential, with a small *fullonica* or laundry establishment (VI.15.3), a one-room shop (VI.15.10), a modest workshop (VI.15.21), two hot-food establishments and stables at its northernmost end (VI.15.13–15 and VI.15.16–18), and ten houses.[23] These houses include the large residences of the Casa dei Vettii (at VI.15.1, 27, the largest house in the block) and Casa di Pupius Rufus (VI.15.6), and several smaller to medium sized-residences that range in size from 150 to 350 sq m.[24]

With a total of 138 examples, *Insula* VI.15 contains more than twice the number of graffiti of I.9, yet the distribution patterns of the graffiti within these two *insulae* are similar in several respects. First, graffiti are again found in the vast majority of properties. Eleven of the fifteen distinct properties in VI.15 contain graffiti within their interiors (Fig. 5.5). Even with the overwhelmingly residential nature of the *insula*, it is possible to identify graffiti within different categories of property here too. Examples occur within one of the two *tabernae* (VI.15.16–18), the small workshop (VI.15.21), and nine of the ten houses. As before, the *taberna* and workshop again contain small numbers of graffiti, with two and three instances, respectively,[25] while the houses contain a broader range, from a minimum of three to a maximum of fourteen instances.

21 Excavated 1876 and 1895–1900: Eschebach and Müller-Trollius 1993, 218.
22 Measurements taken from http://www.mainstreetmaps.com/ITALY/Pompeii/, downloaded 17 July 2013.
23 Eschebach and Müller-Trollius (1993, 223) note that VI.15.23 may have been an inn. Little is known about this building.
24 The Casa dei Vettii is the largest house of the block at 1165 sq m, followed by the Casa di Pupius Rufus (VI.15.6, 24, 25) at 750 sq m. The houses at VI.15.2, VI.15.6, and VI.15.7–8 measure between 250 and 350 sq m; those at VI.15.9, VI.15.11–12, VI.15.19–20, and VI.15.22 fall between 120 and 210 sq m. All measurements are from http://www.mainstreetmaps.com/ITALY/Pompeii/, downloaded 17 July 2013.
25 The *taberna* with stables at VI.15.16–18, however, contained six graffiti drawings as well. These will be discussed below.

FIGURE 5.5
Distribution of graffiti *in* Insula VI.15 *(adapted from Dobbins and Foss 2007, Map 3). Grey shading signifies the presence of* graffiti *in a building. A star represents a* graffito *on the facade. Numbers beside a star denote a cluster of* graffiti.

The average number of graffiti per house is nearly the same, with 8 graffiti per house in *Insula* I.9 and just a fraction more, 8.4 graffiti per house, in *Insula* VI.15.[26] Yet when one looks closer, a slightly different distribution pattern through the block emerges. In *Insula* I.9, the number of graffiti among the houses ranges from a minimum of 1 to a maximum of 21 in the Casa del Frutteto (1.9.5), which contains roughly as many as the other four houses combined (Table 5.2).[27] In *Insula* VI.15, the spread is somewhat tighter. Five houses contain between nine and fourteen graffiti, and the other four houses are stepped from three to six examples, so there is no one house that stands out with significantly more than the others (Table 5.3). It is also evident that there is no correlation between size of residence and number of graffiti. The houses in I.9 are roughly

26 These statistics are based only on the textual graffiti recorded by *CIL* IV, and do not take into account the figural graffiti, since their documentation was so sporadic. Langner 2001 was able to locate and collect more than two hundred examples of figural graffiti not mentioned in *CIL*, but many more must have vanished before they were recorded.

27 When figural graffiti are considered as well, the Casa del Bell'Impluvio (1.9.13) and the Casa del Frutteto both contain significantly more than the other three houses.

THE CULTURE OF WRITING GRAFFITI

TABLE 5.2 *Density of* graffiti *in I.9*

[Bar chart showing graffiti counts by house: I.9.1 ≈ 2; I.9.3 ≈ 7; I.9.5 ≈ 20; I.9.12 ≈ 1; I.9.13 ≈ 9]

the same size but contain varying numbers of writings, while the tiny Casa del Compluvio at VI.15.9, one of the smallest houses in VI.15, contains nine graffiti, as many and nearly as many as the larger houses to its south.

The number of drawings is likewise comparable:

TABLE 5.3 *Density of* graffiti *in VI.15*

[Bar chart "Number of Graffiti" vs "House Number (VI.15.x)" with bars: 1 ≈ 13; 2 ≈ 8; 5 ≈ 14; 6 ≈ 13; 8 ≈ 6; 9 ≈ 9; 12 ≈ 3; 20 ≈ 4; 22 ≈ 5. Legend: Graffiti in VI.15]

Langner records thirteen figural graffiti in *Insula* I.9 and eleven in *Insula* VI.15. These numbers should be treated with caution, however, and taken as minimums rather than absolutely. Figural graffiti were occasionally represented in the *Corpus Inscriptionum Latinarum* vol. IV with a line-drawing, but only if the design was accompanied by associated text. In other cases, figural graffiti might be mentioned in a note if they were nearby textual inscriptions but would not be reproduced. If the drawings were not located near text, they might not receive even a note. As the wall-plaster of the ancient city has

weathered and crumbled over the centuries from exposure to sun and rain, drawings have surely disappeared without documentation.[28] So, for example, *CIL* had noted seven of the thirteen drawings that Langner collects for I.9; the other six examples were detected subsequent to *CIL*'s publication and all come from a single cubiculum.[29] We must acknowledge, therefore, that gaps exist in our documentation of figural graffiti.

What we can do with this material is use it as a baseline. So, in *Insula* I.9, graffiti drawings occur within two houses, with one additional example on a building exterior in a campaign poster. In *Insula* VI.15, drawings similarly appear in three locations: the *taberna* at VI.15.16 where a cluster of six images appear, outside the Casa del Principe di Napoli at VI.15.8 where one drawing appears on either side of the door, and between the shops at VI.15.10 and 11 where the word *Surretinas* is drawn twice in the shape of a boat.[30] Together these examples show that, like textual graffiti, incised drawings might appear in a range of spaces, including houses, drinking establishments, and exterior locations. The repetition of certain motifs also points to subject matter that people liked to draw. In these two *insulae*, heads are drawn more than any other design and, with eleven examples, represent nearly half of the combined total of twenty-four drawings. This was one of the four most popular images that Langner detected for graffiti across the Roman world (heads, athletes, animals, and ships). In Pompeii, the preference for sketching heads was even stronger, with this subject drawn more often than any other.[31] Finally, the small groups of drawings that we have in these two *insulae* point to present but limited activity. Drawings were another type of addition to the inscribed landscape of Pompeii, and certainly there will have been more examples that have now disappeared; nevertheless, the small groups that we do have recorded, here with no more than six drawings in any one location, suggest it is unlikely that there were overwhelming numbers of drawings on the walls in the private sphere of Pompeii.[32]

28 The archaeological site also suffered damaged in the bombing of the Second World War. See García y García 2006.

29 Langner 2001, nos. 861–864, 2316, 2519; *PPM* II 222, Fig. 76, 77; De Vos 1976, 55 Pl. 52.

30 VI.15.16: Langner 2001, nos. 125, 432, 433, 2488, 2492, and 2493 (a compass-drawn circle, two heads, a hand, and two drawings of a foot; VI.15.8: Langner nos. 117, 1837 (compass-drawn circle and head); to the left of VI.15.11: Langner nos. 21, 22, 525 (*Surretinas* in the shape of a boat twice, head).

31 Langner 2001, 75, Abb. 31 and 84, Abb. 40.

32 Greater numbers of figural graffiti did appear in public spaces. The corridor between the theaters, for example, featured numerous drawings of boats (Langner (2001) lists more

In these ways, the two city-blocks of I.9 and VI.15 are comparable. The main point on which they differ, beyond the total number of graffiti they feature, is the ratio of interior to exterior locations. As we have seen above, *Insula* I.9 featured only a handful of graffiti on the building facades along the city's streets. Instead, more than 90% appeared within interiors. The situation is different in *Insula* VI.15, where the ratio is nearly 3:2, in a comparison of interior vs. exterior locations. This city-block features 81 graffiti (roughly 59%) inside buildings and another 57 on building facades.[33] These exterior graffiti are spread along three sides of the *insula* (the city walls lie to the north). The densest clustering appears along the vico di Mercurio, the road to the south, where fifteen graffiti appear in a relatively short stretch of road (see Fig. 5.5).[34] The two north-south roads on either side of the *insula* feature generous numbers of graffiti as well, with twenty-four along the vico del Labirinto to the west and eighteen along the vico dei Vettii to the east. On either road, the graffiti are not limited to one or two spots but are scattered among several locations.

Whether this disparity between *Insulae* I.9 and VI.15 reflects a different level of activity in the two locations—or merely a matter of documentation—remains to be seen. The points on which the two *insulae* agree, however, are significant:

1) Graffiti are found *inside* a great majority of properties at Pompeii.
2) Graffiti are found in all categories of property (*tabernae*, workshops, residences, public buildings).
3) Graffiti are regularly found in residences, in varying quantities.

Further research is needed to determine the percentage of graffiti in residences overall. But in the fifteen residences of these two *insulae* (five in I.9 and ten in VI.15), graffiti are found in all but one, or 93%. Even if we include in this total the three workshops that may have also functioned as domiciles (1.9.8, 9, and 10) and the property at VI.15.13–15 that may have offered limited housing

than thirty, cf. Index p. 159), and the enormous campus/palaestra beside the amphitheater held nearly 100 figural graffiti scattered among 400 textual examples.

33 Inclusion of graffiti drawings brings these numbers to a total of 87 interior graffiti vs. 62 exterior graffiti, nudging the total to 58% interior vs. 42% exterior.

34 *CIL* notes three graffiti were located near the corner of the *insula*, while another twelve appeared along its southern side.

TABLE 5.4 *Number of graffiti in I.9 and VI.15*

	with 1–3 graffiti	4–6	7–9	10+
No. of houses in I.9 and VI.15	3	3	4	4

behind retail space and a *thermopolium*, graffiti still occur in sixteen of nineteen properties, or 84%. It does not seem unreasonable to estimate, then, that at least 60–70% of Pompeian homes, and perhaps more, may have had some writing on their walls.

The density of graffiti inside homes likewise offers more for consideration. In these two blocks, the numbers of graffiti within residences point not so much to distinct groupings but rather more or less to a continuum, as is summarized in the table above (Table 5.4). Even finding a cutoff for categories seems arbitrary. Four residences, for example, contain more than ten graffiti, but if the cutoff is lowered by one, that number is almost doubled, to a total of seven residences that hold nine graffiti or more.

Still, altogether the numbers of graffiti in these two *insulae* are modest: a handful of examples in several houses, a few more in others. The Casa di Cerere at I.9.5 seems as though it might be remarkable for containing as many as twenty examples of graffiti. But, in fact, it is one of more than thirty residences across Pompeii to do so, and some of those houses contain significantly more. What we have in *Insulae* VI.15 and I.9, then, are modestly inscribed spaces that reveal the consistent frequency with which one might find graffiti inside houses. For the final section of this chapter, let us turn to consider a few of these more heavily inscribed Pompeian homes, narrowing our scope one more time to arrive at a close-up perspective of graffiti within the individual house.

Highly Inscribed Pompeian Residences

Of the thirty houses that contain twenty graffiti or more, a small subgroup of six houses stands out and can be described as "highly inscribed" residences, since they each contain more than sixty examples.[35] The abundance of

35 J. A. Baird in chapter two of this volume discusses a house at Dura-Europos, the House of Nebuchelus (also known as the House of the Archive), which stands out for featuring as many as one hundred graffiti.

FIGURE 5.6 *Plan of Pompeii showing the locations of highly inscribed residences (based on Dobbins and Foss 2007, Map 2).*

material in these highly inscribed locations allows one to look for various trends or conventions governing graffiti in domestic contexts. In the current setting, I propose two basic questions that can help us better understand the phenomenon of writing on walls in the domestic sphere: Where did graffiti appear and what sort of visual impact did they have on interior decoration? And, who was involved in writing and reading graffiti?

Three residences provide material for consideration: the Casa delle Nozze d'Argento, the Casa di Maius Castricius, and the Casa di Paquius Proculus (Fig. 5.6). These houses are particularly well-preserved, and the majority of graffiti are still visible *in situ*. The other three "highly inscribed" residences include the Casa del Trittolemo at VII.7.5 and the house at IX.2.26, both of which were excavated earlier and are less well preserved today, as well as the Casa del Menandro at I.10.4, which is receiving its own detailed study by Antonio Varone and Henrik Mouritsen. All six houses are large, although they range in size. They are located in different areas of the city and were excavated at different times. A brief introduction to these three houses follows.

The Casa delle Nozze d'Argento (The House of the Silver Wedding) is the largest house of this group and, at nearly 1800 sq m in size, it is one of the largest houses in Pompeii.[36] Located in the northern section of town at V.2.i,

36 *PPM* vol. III, 676–772. A comprehensive study of the house appears in the *Häuser in Pompeji* series (Ehrhardt 2004). This house easily falls within Andrew Wallace-Hadrill's

this residence was outfitted grandly with a private bath complex and two peristyles, the second of which ran the full length of the property. It was also one of three houses in Pompeii to contain a formal Corinthian oecus, where free-standing columns on pedestals within the room supported a sort of canopy above the room and heightened the formality of the space.[37] The owner of this impressive residence has been identified as Lucius Albucius Celsus, a candidate who stood for aedile in the later years of the city.[38] The residence was excavated in 1893, the year marking the silver wedding anniversary of the Italian king, and was named for that occasion.

The Casa di Maius Castricius stood at the western edge of town (VII.16 *Ins. Occ.* 17) and occupied some of Pompeii's best real estate, with spectacular views out over the Bay of Naples.[39] Built into the city's fortification walls, it stood four stories high, with a large garden below the walls and three floors of living space built within and above. It too featured a private bath complex, a double peristyle, and a number of reception rooms. This house was brought to light relatively recently, during excavations of the *insula occidentalis* in the 1960s, and its wall and ceiling frescoes were painstakingly pieced back together and restored *in situ*. The name of the house derives from a nearby inscription in Oscan.[40]

The Casa di Paquius Proculus at I.7.1 opens off the Via dell'Abbondanza, and is smaller than the other two, yet still grand, measuring nearly 800 sq m, with a partial second story above and additional space in a basement level at the

fourth quartile (1994), which includes houses of 350–3000 sq m. (Only two from his sample of 234 houses were larger than 2000 sq m.)

37 The other two houses with a Corinthian oecus were the Casa del Meleagro and the Casa del Labirinto. For a full description of this particular room, also called *oecus tetrastylus*, see Ehrhardt 2004, 114–122. Andrew Wallace-Hadrill explains this kind of space: "[W]hat matters about the columns ... is not their structural function but their ability to transport the diners into a world of luxury and monumentality" (1994, 22).

38 Ehrhardt provides the most comprehensive discussion on the inhabitants of the house, and suggests that Albucius Celsus inherited the home from his father, who himself had been elected duovir in the year 33/34 (2004, 267–270; his duumvirate is datable on the basis of *CIL* X.901 and 902). The initial identification of homeowner was made by Della Corte (1965, 104) and Mouritsen accepts this attribution, while rightly arguing against many of Della Corte's other less tenable identifications (e.g. 1988, 17–19, 57).

39 On this residence, see *PPM* vol. VII (1997), 887–946; Varriale 2006, 2009; Benefiel 2010.

40 Varriale 2006, 421.

FIGURE 5.7 *Mosaic decoration, atrium, I.7.1 (Casa di Paquius Proculus). (Su concessione del Ministero per i Beni e le Attività Culturali. Reproduction prohibited.)*

rear of the house.[41] A significant investment was clearly outlaid for the elaborate mosaic decoration that ran throughout its atrium (Fig. 5.7). This house was uncovered during the excavations of the Via dell'Abbondanza in the first quarter of the twentieth century. The careful attention paid to building facades during the early part of those excavations has left us with one of the most politically and epigraphically active hotspots in the city, with more than thirty political *programmata* of all shapes, sizes, and appearances.[42]

41 Spinazzola 1953, 297–314; *PPM* vol. I (1990), 483–552. This house also appears in the *Häuser in Pompeji* series: Ehrhardt 1998.
42 *CIL* IV.7196–7216. See Varone and Stefani 2009, 69–76, for excavation photos of this heavily postered façade. The house was originally called the Casa di Pansa (Spinazzola 1953). For the challenges of identifying the individual Paquius Proculus, see Della Corte 1926.

Location of Graffiti and Impact on Interior Decoration

These three houses feature between seventy and eighty graffiti each. Where did these large numbers of writing and drawings appear? And, closely tied to that question, how did they affect the interior decoration or the visual experience of the space? To begin, the distribution of graffiti in these residences makes clear: they are not hidden in remote or out-of-the-way places but appear in the core spaces of the home. They are at the center, not the periphery.

In the Casa di Maius Castricius, for example, the main living space on the third floor presents dense concentrations in central, well-trafficked areas of the house (Fig. 5.8). Fewer graffiti or none at all are found in the smaller rooms at its margins. The most *heavily* inscribed spaces are all locations where people would frequently be passing: the vestibule, the central peristyle, and the stairway to living space above.[43]

The distribution of graffiti in the houses of Paquius Proculus and the Silver Wedding follows along the same lines. Nearly all of the graffiti in the House of Paquius Proculus appear in either the vestibule or the peristyle of the house. The Casa delle Nozze d'Argento does not have the same deep, narrow *fauces* at its entrance as the other two houses and differs in the fact that no graffiti are found in its vestibule. In it, however, the peristyle is again a favored place for writing, featuring as many as thirty-nine examples, more than half of the incised texts in this house.[44] Others appear in the atrium and a large group occurs in the central oecus at the back of the peristyle but, as at the House of Maius Castricius, graffiti are not found in small rooms at the edges of the house. Rather, they appear in central locations where people were spending time.

Not only would people be passing these spots frequently, graffiti also tend to cluster in some of the most *visible* locations in the house. The largest concentration of messages in the Casa di Maius Castricius appears at the entrance to room 7, directly on the sightline from the entrance of the house. In the Casa delle Nozze d'Argento, a large cluster of graffiti in the peristyle occurs at a similar location (a central column in the front of the peristyle). A person writing here could have been visible to anyone in the front of the house, or the back of the house, or even to anyone on the street outside. It may be that the objective was to post graffiti where people would see them. But what these locations also suggest is that writing graffiti was not an activity one carried out in secret.

So, what was the effect of graffiti appearing in these central, well-trafficked locations where people would frequently be spending time? In the three

43 For further discussion, see Benefiel 2010, esp. 69–74.
44 *CIL* IV.4159–4197.

FIGURE 5.8 *Distribution of* graffiti *through the main floor of VI.16.17, Casa di Maius Castricius (reprinted from Benefiel 2010, fig. 11).*

houses discussed here, despite the large quantity of inscribed messages, the visual impact of graffiti was minimal. In the House of Maius Castricius, there appears to have been a clear desire to avoid inscribing over the wall-painting. Messages are tucked in beside images, next to a visual element such as a candelabrum or placed between bands of color, but are not written across them. This desire to avoid damaging or interfering with wall-painting may also explain in part the high numbers of graffiti inscribed on columns. In the Casa delle Nozze d'Argento, nearly half of the graffiti in the peristyle (17 of 39) appear on columns (Fig. 5.9). The Casa di Paquius Proculus boasts even greater numbers, with 27 of the 38 graffiti in the peristyle, or 71%, appearing on columns. Columns were often fluted, but beyond that their decoration was limited to white paint, or white for the upper and red paint for the lower portion of the column. They therefore provided an easy option for a writer to avoid figural wall-painting. At the same time, with their simple, single-color plaster, columns also offered an uncluttered surface that may have made texts easier to find and read.[45] The Casa di Paquius Proculus offers further support that columns may have been seen as an appropriate or attractive place to write.

45 I thank Andrew Wallace-Hadrill for this observation.

FIGURE 5.9 *Peristyle columns in v.2.i (Casa delle Nozze d'Argento), with detail of graffito on column. (Su concessione del Ministero per i Beni e le Attività Culturali. Reproduction prohibited.)*

Seventeen graffiti appear in the vestibule, the narrow hallway leading into the atrium.[46] Rather than an even distribution through the space, however, all but three texts were inscribed on the pilasters that stood at the front and back of the vestibule. Such heavy concentration suggests that the pilasters, similar in form to columns, were the preferred place to write.

Secondly, the way that graffiti are laid out also suggests a certain level of respect—not only for existing wall-decoration but also for other graffiti. A panel of plaster detached from the stairway in the House of Maius Castricius provides useful illustration, both for its layout and for the quality of its preservation (Fig. 5.10).[47] This wall fragment includes twelve messages written

46 *CIL* IV.8067–8082.

47 Since it was detached from the wall and placed in storage, this panel is better preserved than many of the other graffiti left in the house. A cluster of seventeen graffiti appeared at the entrance to room 7 in this house too, and it is possible to detect traces of most of these, which show a similar pattern of taking unoccupied space. Unfortunately, damage to the surface of the plaster has reduced the visibility of these inscriptions considerably.

FIGURE 5.10 Enchanced photograph of graffiti found on wall plaster in stairway, VII.16.17, Casa di Maius Castricius (reprinted from Benefiel 2010, fig. 9).

by various hands. Among these are several multiple-line epigrams in cursive script, a quotation of literature, and three texts written in capital letters.[48] Here, the graffiti tend to respect each other's space, and are arranged to a certain extent vertically, more or less in two columns, with one text below another. The quotation from Lucretius (Sua{v}e mari magno, Lucr. II.1), for example, appears to have been fitted into the space remaining near graffiti already present. Antonio Varone judged that this quote, written at the extreme left of the panel, was inscribed subsequent to the name, Byzantia, that stands to its left.[49] It was inserted into the free space in front of it, and barely squeezed in, to the point that the two messages just barely touch. This tendency for texts not to overlap is a characteristic of graffiti in Pompeian residences that does not hold true for other sites. The handwritten wall-inscriptions in *tabernae* of Pozzuoli or on the Palatine Hill at Rome, for example, include a palimpsest of writing and drawings that overlap and cut across each other and suggest additions being made over an extended period of time (Fig. 5.11).[50]

Yet the main reason that ancient graffiti convey such a limited impact on interior decoration is their small size. The graffiti on the panel from the House of Maius Castricius, for example, range in size from 2cm to less than half a centimeter tall. Indeed, most of the messages inscribed around the peristyle

48 Varone 1990, a-m. See also Benefiel 2010, esp. 67–69.
49 Varone 1990, 152.
50 Pozzuoli: Guarducci 1971 (=AE 1972.78); Iodice 1993; Langner 2001, 124–129. Palatine: Solin and Itkonen-Kaila 1966.

FIGURE 5.11 *Layout of graffiti found in a* taberna *at Pozzuoli (Langner 2001, Abb. 68).*

of that house are smaller than one centimeter tall. This small size results in the texts blending more or less into their surroundings. In fact, they are nearly invisible to someone standing more than three feet away.[51] Graffiti in the vestibule are larger, averaging 3.5cm in height. Still, even at 3cm, these are relatively small and some are easy to miss, even when you are looking for them. The Casa delle Nozze d'Argento contains graffiti of similar sizes, with nearly all the graffiti on the peristyle walls smaller than 1 cm. Graffiti in a back exedra were larger, but no message was taller than 4 cm.

Larger graffiti that are difficult to ignore do exist, such as a message disparaging a certain Martha in the latrine of the Casa del Centenario.[52] There the letters stand as large as 7cm high and the message takes up nearly the whole length of the room. However, graffiti of this size are only rarely found inside houses. The tombs along the main streets into town did hold graffiti that were substantially larger than those inscribed inside houses. Outside the Porta Nocera, for example, funerary monuments held inscribed messages that included letters heights as large as 8cm, 10cm, and even 14cm high.[53]

Who was Involved?

Who, then, was writing the graffiti in these houses? Fortunately, for the sake of this question, anonymity was not a key feature of ancient graffiti. Individuals signed their names after inscribing a quotation of literature, completing a drawing, or when writing hello to their friends. Names account for a high

[51] This also makes it extremely difficult to reproduce ancient graffiti in photographs.
[52] *CIL* IV.5244: *Marthae hoc trichlinium / est nam in trichilino / cacat.* For corrected reading of this message, see Varone, chapter six in this volume.
[53] E.g. *CIL* IV.10229, 10232a–b, 10233, 10235, 10240, 10246a–k.

percentage of graffiti in the city at large and indeed of the graffiti in domestic spaces, allowing us at least a foggy glimpse of who was participating in writing on the walls.[54]

The individuals responsible for posting graffiti in these houses appear to have been a mix of both residents and visitors. Both men and women were involved to a certain extent, although, as one might expect, men are better represented. And it appears that inscribed messages were not the work of just one or two individuals, or even a handful. Numerous people were involved. The highly inscribed houses contain on average the names of 15–20 people.

It is possible to identify a few of these individuals. A graffito in the vestibule of the Casa di Paquius Proculus gives the name of Cucuta, along with his title of record-keeper for the emperor Nero: *Cucuta ab rationibus / Neronis Augusti* (*CIL* IV.8075) (Fig. 5.12). His name appears twice just outside of the house as well, near the entrance, and is there again linked with Nero.[55] The name Cucuta is otherwise unattested in Pompeii, so it is likely that these three clustered messages identify an imperial attendant from Rome. Cimber, another uncommon name, likewise appears in the vestibule of this house. This name too occurs in Pompeii only three times: twice in the vestibule of Paquius Proculus and once on the exterior of II.1.10, where it is associated with the name of another imperial slave (*Sagitta imperatoris / servos* (!) *Pompeianolus*).[56] In the vestibule of this house, Cimber's name is repeated in the same manner as Cucuta's— appearing once at the very entrance to the house and then again at the rear of the vestibule and entrance to the atrium. Other graffiti in the Casa di Giulio Polibio, located at IX.13.1–3 across the street and one block away, have been linked with a visit of the emperor Nero to Pompeii.[57] It may not at all have been a bad thing to have the signature of a member of the imperial retinue at one's house to suggest that one had hosted an associate of the emperor. Many of the other graffiti in this vestibule present names too, perhaps those of clients and visitors. The texts of Cucuta and Cimber suggest that even those who had little everyday connection with the residence could and did write on the walls.

54 Langner 2001, 21–26. Cf. Benefiel 2008, Franklin 1986 and 1978, for individuals posting their names in public spaces. Matteo Della Corte used the names in painted and incised wall-inscriptions to propose identifications for the inhabitants of homes (*Case ed Abitanti di Pompei*, 1965), albeit often overreaching his evidence, cf. Mouritsen 1988, 13–23.
55 *CIL* IV.8065: *Cucuta*, and 8066: *Cu(cuta) / Cucuta Ner(onis)*.
56 *CIL* IV.10082b; *CIL* IV.10082a: *Cimber*.
57 Giordano 1974. For more on the popularity of Nero and Poppaea at Pompeii, see Magaldi 1936 and Van Buren 1952.

FIGURE 5.12　*Line-drawing and photograph of* graffito *naming Cucuta, in the vestibule of 1.7.1 (Casa di Paquius Proculus). (Su concessione del Ministero per i Beni e le Attività Culturali. Reproduction prohibited.)*

It is more difficult to identify residents who are involved in writing graffiti. Yet, we have at least one example in the Casa di Maius Castricius, where a graffito states: *Romula cum suo hic habitat* ("Romula lives here with her (male companion)"). This, of course, could have been written by someone other than Romula, but even if she did not inscribe this message, there is evidence that she was nevertheless involved in the activity that concerned writing and reading these messages. Another message in the same area directly addresses her and wishes her well, with *Romula va(le)* ("Take care, Romula").[58] We can assume that the writer of this message expected her to read it. Greetings like these (as well as those expressed with *salutem* or *feliciter*) were common among the graffiti of Pompeii, and were one way written expression might confirm or strengthen relationships.

This material also allows us to draw some observations about the participation of the two sexes. More men than women are named among graffiti

58　The sentiment *Romula cum suo hic habitat* was inscribed twice in the same location (Benefiel 2010, nos. 29–30 = Solin 1975, nos. 36–37). Roughly 10cm away appeared the wish, *Romula va(le)* (Benefiel 2010, no. 33 = Solin 1975, no. 40).

throughout the city, but the graffiti habit was not an exclusively male activity. Romula was one of four different women named in the house of Maius Castricius, who appeared alongside the names of twelve men. The Casa delle Nozze d'Argento contains even more graffiti naming women, with a total of seven female and fifteen male names, but it is worth noting that these names are expressed in different ways. Often, the name of a male stands alone. It is an assertion of identity and of presence, and, one might assume, a declaration of the ability to write. In this house, by contrast, female names tend to occur in messages where the individuals named are being talked about—or talked to. So, for example, a cluster of graffiti concerning women appears on a column at the front of the peristyle.[59] Three graffiti here directly address a woman:

Sittia, te voco, Sittia	Sittia, I'm calling you, Sittia
Spe(n)dusa va(le)	Good wishes to Spendusa
Sabina fel(l)as. No(n) belle faci\<i\>s	Sabina, you suck it. But you're not doing it right.[60]
Dom(i)na	Mistress

Women do not always appear in the graffiti of a space, however. Female names are completely absent from the Casa di Paquius Proculus, although as many as twenty male names are inscribed there.

Conclusion

It would appear, then, that there was some understanding that domestic spaces permitted inscribed messages of a certain size and appearance. Walls inside homes were not the same as public spaces. One did not scrawl a message in recklessly large letters or write just anywhere. Most messages were modest; some might even be characterized as discreet. The large spaces of these luxurious residences, the high ceilings and open-air peristyles, further lessened the visual impact of these inscribed messages. Thus, even when a house does hold 50, 60, or even 70 graffiti, there is not the sense that the walls are covered with writing. A visitor might run across a message or two occasionally, but if he was not looking for them, it was likely quite possible to miss the writings on the wall.

59 *CIL* IV.4184–4187.
60 Trans. Varone 2002, 77. This third example will no doubt pique the reader's attention, but it should be noted that, despite its presence, the other three texts convey neutral or positive messages to female addressees.

Yet, fifty examples and more does testify to an active practice of writing in houses, and the quantity of names included points to numerous individuals taking part in the writing and reading of such messages. Women are represented in smaller numbers than men but still appear to be involved in the process, even if in these houses they were more often the recipient of a message rather than a writer identifying himself. The locations that feature graffiti tend to be passageways or central, open interior spaces that would have held visitors, guests, or clients. Messages were not written in dark corners but in the spaces where people were passing or spending time.

There do, therefore, appear to be certain conventions governing graffiti in domestic spaces. Still, the most important characteristic to recognize may simply be the regular presence of graffiti in Pompeian homes. Larger homes that belonged to the city's elite like the Casa delle Nozze d'Argento or that of Paquius Proculus would have hosted numbers of clients and visitors. The number of poetic verses that appear on the panel from the Casa di Maius Castricius points to an ongoing dialogue of quotation, innovation, and one-upmanship, a social conversation that was extended through written communication. The larger number of graffiti in these residences may point to a greater amount of social engagement taking place here. Yet, as we have seen with *Insulae* 1.9 and VI.15, writing on the walls was not limited to the larger houses of town. Messages appeared in smaller houses too. They might appear in smaller numbers, but what is remarkable to see is how frequently they appear—in house after house, and block after block. One, two, or even a handful of graffiti in an individual property might not tell us much. Someone wrote their name, copied out a few letters of the alphabet, kept track of a certain quantity of material. But taken in the aggregate, these individual properties can throw into relief the recurring presence of graffiti within the ancient city. The populace was writing on the walls of public buildings, in taverns and workshops, in semi-public places like brothels. And they were writing at home. We should remember that there were varying levels of literacy among the population of the ancient city.[61] In a modest house, with a modest number of texts incised on the walls, particularly considering their small size, it was likely quite possible to go about one's business and not notice the writing in one's environment. But for one who could read and who knew where to look, writing was very much a part of the urban landscape.[62]

[61] See esp. Thomas 2009 and Woolf 2009. For more on the ongoing debate regarding literacy in the Roman world, see Harris 1989, Humphrey 1991, Bowman and Woolf 2004, and Johnson and Parker 2009.

[62] Support for the reproduction of maps in this article was provided by the Class of 1956 Provost's Faculty Development Endowment at Washington and Lee University.

Bibliography

Baird, J. A. 2011. "The Graffiti of Dura-Europos: A Contextual Approach." In *Ancient Graffiti in Context*, edited by J. A. Baird and Claire Taylor, 49–68. New York: Routledge.

Baird, J. A., and Taylor, Claire. 2011. "Ancient Graffiti in Context: Introduction." In *Ancient Graffiti in Context*, edited by J. A. Baird and Claire Taylor, 1–17. New York: Routledge.

Beard, Mary. 2008. *The Fires of Vesuvius. Pompeii Lost and Found*. Cambridge, Mass.: Belknap Press of Harvard University Press.

Benefiel, Rebecca. 2010. "Dialogues of Graffiti in the House of Maius Castricius at Pompeii." *American Journal of Archaeology* 114 (1): 59–101.

———. 2008. "Amianth, a Ball-Game, and Making One's Mark." *Zeitschrift für Papyrologie und Epigraphik* 167: 193–200.

Berry, Joanne. 1997. "The conditions of domestic life in AD 79: a case-study of houses 11 and 12, Insula 9, Region I." *Papers of the British School at Rome* 65: 103–125.

———. 1998. *Unpeeling Pompeii. Studies in Region I of Pompeii*. Rome-Milan: Electa.

Biundo, Raffaella. 2003. "La propaganda elettorale a Pompei: la funzione e il valore dei programmata nell'organizzazione della campagna." *Athenaeum* 91: 53–116.

Bowman, Alan, and Greg Woolf, eds. 2004. *Literacy and Power in the Ancient World*. Cambridge: Cambridge University Press.

Castrén, Paavo. 1975. *Ordo Populusque Pompeianus. Polity and Society in Roman Pompeii*. Rome: Bardi Editore.

Chiavia, Catherine. 2002. *Programmata. Manifesti elettorali nella colonia romana di Pompei*. Torino: Zamorani.

Corbier, Mireille, and Jean-Pierre Guilhembet, eds. 2011. *L'Écriture dans la Maison Romaine*. Paris: De Boccard.

De Vos, Mariette. 1976. "Scavi Nuovi sconosciuti (I 9, 13): pitture e pavimenti della Casa di Cerere a Pompei." *Mededelingen van het Nederlands Instituut te Rome* (= *Papers of the Netherlands Institute in Rome. Antiquity*) 38: 37–76, plates 35–61.

Della Corte, Matteo. 1926. "Publius Paquius Proculus." *Journal of Roman Studies* 16: 145–154.

———. 1965. *Case ed Abitanti di Pompei*. 3 ed. Naples: Fausto Fiorentino Editore.

Ehrhardt, Wolfgang. 1998. *Casa di Paquius Proculus (I 7, 1.20)*, *Deutsches Archäologisches Institut. Häuser in Pompeji*. Munich: Hirmer.

———. 2004. *Casa delle Nozze d'argento (V 2, i)*, *Häuser in Pompeji*. München: Hirmer Verlag.

Eschebach, Liselotte, and Müller-Trollius, Jürgen. 1993. *Gebäudeverzeichnis und Stadtplan der antiken Stadt Pompeji*. Köln: Böhlau Verlag.

Franklin, James L., Jr. 1978. "Notes on Pompeian Prosopography: Programmatum Scriptores." *Cronache Pompeiane* 4: 54–74.

———. 1986. "Games and a Lupanar: Prosopography of a Neighborhood in Ancient Pompeii." *Classical Journal* 81: 319–328.

———. 2001. *Pompeis Difficile Est. Studies in the Political Life of Imperial Pompeii*. Ann Arbor: University of Michigan Press.

Fulford, M. F. and Wallace-Hadrill, Andrew. 1999. "Towards a history of pre-Roman Pompeii: excavations beneath the House of Amarantus (I.9.11–12)." *Papers of the British School at Rome* 67: 37–144.

García y García, Laurentino. 2006. *Danni di guerra a Pompei. Una dolorosa vicenda quasi dimenticata, Studi della soprintendenza archeologica di Pompei*. Rome: L'Erma di Bretschneider.

Giordano, Carlo. 1974. "Iscrizioni graffite e dipinte nella Casa di C. Giulio Polibio." *Rendiconti della Accademia di archeologia lettere e belle arti* n.s. 49: 21–28.

Giordano, Carlo, and Angelandrea Casale. 1991. "Iscrizioni pompeiane inedite scoperte tra gli anni 1954–1978." *Atti della Accademia Pontaniana* n.s. 39: 273–378.

Guarducci, Margherita. 1971. "Iscrizioni greche e latine in una taberna a Pozzuoli," In *Acta of the Fifth International Congress of Greek and Latin Epigraphy, Cambridge, 1967*, Oxford: Blackwell, 219–223.

Guzzo, Piero Giovanni, and Peroni, R., ed. 1998. *Archeologia e vulcanologia in Campania: atti del convegno, Pompei, 21 dicembre 1996*. Naples: Arte tipografica.

Harris, William V. 1989. *Ancient Literacy*. Cambridge, MA: Harvard University Press.

Humphrey, J. H., ed. 1991. *Literacy in the Roman World*. Ann Arbor, MI: Journal of Roman Archaeology.

Iodice, Silvana Valeria. 1993. "Via Pergolesi. La taberna 5," *Bollettino di Archeologia* 22: 110–112.

Johnson, William A., and Holt N. Parker, ed. 2009. *Ancient Literacies: The culture of reading in Greece and Rome*. Oxford: Oxford University Press.

Keegan, Peter. 2014. *Graffiti in Antiquity*. London and New York: Routledge.

Langner, Martin. 2001. *Antike Graffitizeichnungen: Motive, Gestaltung und Bedeutung, Palilia, 11*. Wiesbaden: L. Reichert.

Laurence, Ray. 1994. *Roman Pompeii: Space and Society*. 2nd ed. rev. 2007. London-New York: Routledge.

Magaldi, Emilio. 1936. "Echi di Roma a Pompei." *Rivista di Studi Pompeiani* 2: 25–100.

Mouritsen, Henrik. 1988. *Elections, Magistrates and Municipal Élite: Studies in Pompeian Epigraphy, Analecta Romana Instituti Danici, Supp 15*. Rome: L'Erma di Bretschneider.

Pugliese Caratelli, Giovanni, ed. 1990–2003. *Pompei: Pitture e Mosaici*. 11 vols. Rome: Istituto della enciclopedia italiana.

Sabbatini Tumolesi, Patrizia. 1980. *Gladiatorum paria. Annunci di spettacoli gladiatorii a Pompei, Tituli, 1*. Rome: Edizioni di Storia e Letteratura.

Sigurdsson, H., Cashdollar, S. and Sparks, S. R. J. 1982. "The eruption of Vesuvius in AD 79: Reconstruction from historical and volcanological evidence." *American Journal of Archaeology* 86: 39–51.

Solin, Heikki. 1975. "Die Wandinschriften im sog. Haus des M. Fabius Rufus." In *Neue Forschungen in Pompeji und den anderen vom Vesuvausbruch 79 nach Christi verschütteten Städten*, edited by Bernard Andreae und Helmut Kyrieleis, 243–266, Abb. 225–244. Recklinghausen: Bongers.

Solin, Heikki, and Marja Itkonen-Kaila. 1966. Graffiti *del Palatino. 1: Paedagogium*, Helsinki: Institutum Romanum Finlandiae.

Spinazzola, Vittorio. 1953. *Pompei alla luce degli scavi nuovi di Via dell'Abbondanza (anni 1910–1923)*. 3 vols. Rome: Libreria dello Stato.

Thomas, Rosalind. 2009. "The Origins of Western Literacy: Literacy in Ancient Greece and Rome." In *The Cambridge Handbook of Literacy*, edited by David R. and Nancy Torrance Olson, 346–361. Cambridge: Cambridge University Press.

Van Buren, A. W. 1952. "Pompeii, Nero, Poppaea." In *Studies Presented to David Moore Robinson*, edited by G. E. Mylonas and D. Raymond, 970–974. St. Louis.

Varone, Antonio. 1990. "Iscrizioni/Inscriptions." In *Rediscovering Pompeii*, edited by Luisa Franchi Dell'Orto and Antonio Varone, 148–153. Rome: L'Erma di Bretschneider.

———. 2002. *Erotica Pompeiana. Love inscriptions on the walls of Pompeii*. Rome: L'Erma di Bretschneider.

Varone, Antonio, and Grete Stefani. 2009. *Titulorum Pictorum Pompeianorum qui in CIL Vol. IV collecti sunt Imagines*. Rome: L'Erma di Bretschneider.

Varriale, Ivan. 2006. "VII 16 Insula Occidentalis 17 Casa di Maius Castricius." In *Pompeii (Regiones VI–VII): Insula Occidentalis*, edited by Masanori and Pappalardo Umberto Aoyagi, 419–503. Naples: Valtrend.

Varriale, Ivan. 2009. "Nuove osservazioni sulla Casa VII 16, *Insula Occidentalis*, 17 a Pompei." In *Vesuviana. Archeologie a Confronto. Atti del Convegno Internazionale (Bologna, 14–16 gennaio 2008)*, edited by Antonella Coralini, 463–475. Bologna: Ante Quem.

Viitanen, Eeva-Maria, Laura Nissinen, and Kalle Korhonen. 2012. "Street Activity, Dwellings and Wall Inscriptions in Ancient Pompeii: A Holistic Study of Neighbourhood Relations." In *Proceedings of the Twenty-Second Annual Theoretical Roman Archaeology Conference (TRAC 2012)*, edited by Annabel Bokern, Marion Bolder-Boos, Stefan Krmnicek, Dominik Maschek and Sven Page, 61–80. Oxford: Oxbow.

Wallace-Hadrill, Andrew. 1994. *Houses and Society in Pompeii and Herculaneum*. Princeton: Princeton University Press.

———. 2003. "Domus and Insulae in Rome: Families and Housefuls." In *Early Christian Families in Context: An Interdisciplinary Dialogue*, edited by David L. Balch and Carolyn Osiek, 3–18. Grand Rapids, MI: Eerdmans.

———. 2005. "Sequence and chronology: Excavation and standing structures in Pompeii Insula I.9." In *Nuove Ricerche Archeologiche a Pompei ed Ercolano (Atti del*

convegno internazionale, Roma 28–30 Novembre 2002), edited by Piero Giovanni and Guidobaldi Maria Paola Guzzo, 101–108. Napoli.

———. 2011. "Scratching the surface: a case study of domestic graffiti at Pompeii." In *L'Écriture dans la Maison Romaine*, edited by Mireille Corbier and Jean-Pierre Guilhembet, 401–414. Paris: De Boccard.

Woolf, Greg. 2009. "Literacy or Literacies in Rome?" In *Ancient Literacies. The Culture of Reading in Greece and Rome*, edited by William A. Johnson and Holt N. Parker, 46–68. Oxford: Oxford University Press.

PART 2

Discourses of Public and Private

∴

CHAPTER 6

Newly Discovered and Corrected Readings of *iscrizioni "privatissime"* from the Vesuvian Region

Antonio Varone

Among the inscriptions of a private character, namely those that do not come from an official source of public power, those that perhaps best and most clearly represent the reality of the ancient world are the graffiti. This is due especially to their nature, removed as though from any logic of representation and tied only to the immediate manifestation of a thought or of a spontaneous sentiment. In this particular setting, I will focus on a specific category of inscriptions from the Vesuvian area, dealing with the theme of human waste. The selection of epigraphic examples includes both those in the realm of simple satisfaction of a bodily need as well as those in the sphere of prohibitions relative to such activities. These inscriptions, then, involve content belonging to a very restricted private sphere, which nevertheless is deliberately made public either through self-gratification for its own sake or following the lines of behavioral norms. The incised graffiti, in fact, are scratched not only in private spaces where they address only a restricted number of people, e.g., inside private houses or even more restricted areas in such houses, spaces frequented by those persons to whom access was granted. They also appear in fully public locations, such as roads and public buildings, including the basilica and theaters, and in such locations they address a more general, collective audience.

The importance of graffiti for our understanding of the ancient world is in fact due, in major part, to the direct connection it provides between the one who expresses a thought and the one who reads it, even if that person does so two thousand years later. This occurs without intermediaries of any type owing to format, to formulas, to stylistic conventions of a stone-cutter, or to the errors of a copyist. This is not even to mention in some cases the wishes of the one who commissions an inscription, or any changes made by "editors." This direct communication gives us a picture that is not constructed but is

* I wish to thank Peter Keegan and Rebecca Benefiel for their suggestions and the latter, in particular, for also taking on the task of translating this article from the original Italian.

rather spontaneous and real—a picture of the activity of groups of individuals fully participating and revealing the lifestyles, customs, habits, and passions of an entire era.

Graffiti stand in contrast to the more numerous inscriptions on stone, which are inscribed with a chisel on marble or other durable material, and which present clearly the desire to preserve information for a period of time in an official, determined, and well-thought-out manner. Such inscriptions often celebrate the virtues or merits of some individual. In graffiti, the only guiding force is inspiration and the feeling of the moment. In this manner, the sacred occurs alongside the profane, politics mix with religious sentiment, commerce with superstition, the concrete with the ideal, myth with history, the ethical with the disdainful.

These graffiti, distant as they are from grand historical episodes, and from the occasions that mark the key moments of human events, instead together seize the brief and secondary episodes of life's path, including moments that might even be banal. These nevertheless succeed in connoting with clear immediacy an entire scenario unfolding before them and, precisely thanks to this, begin to illuminate it.

We should not forget that much important knowledge comes from graffiti. To speak of just the Vesuvian area, two graffiti found in the servants' quarters of the Casa di Giulio Polibio (IX.13.1–3, room 22), and therefore likely traced by a member of the *familia* to be read by others who would be frequenting the house, inform us of a visit that the emperor Nero made to this Campanian city and of the gifts that he brought with him, including one on behalf of his wife Poppaea destined for the sanctuary of Venus.[1] In addition, graffiti that are true and correct metrical compositions, often of erotic inspiration, document an alternative system of cultural transmission. The authors of these compositions for various reasons never fully reached the summit of popularity, but their works were well integrated into the cultural atmosphere of the era. One thinks of Tiburtinus who signed the verses found on the external wall of the small theater in order to allow a more general audience of educated people to read them.[2] Here, one sees a precursor, albeit in a peripheral environment,

1 Giordano 1974, 21–28, nos. 5 and 4, respectively.
2 *CIL* IV.4966–4973 with add. p. 705 = I^2 2540*a–c* with add. p. 1017 = *CLE* 934–5 = *ILLRP* 1125*a–c*. These are illustrated in Varone 2012, 399–403. The inscriptions are preserved in the Museo Nazionale di Napoli on a panel without inventory number.

of the neoteric poetry that would shortly thereafter triumph in Roman culture of the late Republic.[3]

And so it is always with a certain emotion and hopeful apprehension that a decoder approaches the field of excavation and sees traces that a stylus or some other writing instrument has left on the wall. The examination of these traces, the *ductus*, the handwriting, the analysis of markings I have defined elsewhere as "extraneous"[4]—all this must be investigated as thoroughly as possible to recover that message put in a bottle and entrusted to the sea of time, which one imagines can be quite valuable or at least illuminating.

By chance this happened to me at Stabiae in the Villa San Marco, during the recent excavations conducted there in 2008–2009. These excavations brought to light numerous graffiti that will enrich the next fascicle of *CIL* vol. IV,[5] and they have allowed us to recover this particular pearl, which I present here. It was found on the wall of a room that was not fully excavated, but which was later revealed to be a latrine,[6] and was written in a sure hand in well-traced out capital letters, which denote a certain familiarity with writing on the part of its author (Fig. 6.1):[7]

Cacavi et culu non extersi

I shit and I did not wipe my ass.

This was accompanied by a drawing, below, of a head in profile facing left (the self-portrait of the author of the heroic gesture?). The drawing appears to mock anyone who had used a bit of time and care to decrypt the "precious" message that emerged from the mists of the past (Fig. 6.2).

3 For the copious bibliography on these, see Varone 2004, 86–87 with note on p. 96; Cugusi 1966, 24–25, 305–306.
4 Varone 2008, 125.
5 This fascicle is currently in preparation. In this regard, the inscriptions of the villa di San Marco at Stabiae, previously edited in Varone 1999, deserve a new analysis and organization into a comprehensive volume, particularly now after the significant discoveries of new material during recent excavation campaigns, including those that explored also the villa di Arianna and that of the so-called "second complex." I hope to complete this volume in the near future.
6 On the archaeological exploration of the latrine (now numbered room 73), which was already explored during the Bourbon excavations of the eighteenth century and which was present on the plan of Weber, see the preliminary report of Bonifacio 2010, 171.
7 The inscription is 63 cm long, with a letter height that ranges from a minimum of 3 cm, for the letters *NO* of *non*, to a maximum of 7 cm, for the first two C letters in *Cacavi*.

FIGURE 6.1 *Stabiae. Villa San Marco. Inscription in the latrine (73):* Cacavi et culu non extersi.

FIGURE 6.2 *Stabiae. Villa San Marco. Detail of the previous inscription showing the profile of a man turned to the left.*

Obviously this inscription will not change the fate of humanity, but it does show, on the one hand, the disappearance of the final "—m" of the accusative, a characteristic that was deeply rooted in spoken Latin already in the first century AD.[8] At the same time, it also enriches Latin terminology with the expression *extergere culum* ("to wipe the ass"), which appears here for the first time.[9]

In this regard, the epigraphist might recall another message,[10] also found isolated in a latrine but this time at Herculaneum, in house v.30, which was read by Della Corte as follows:

Ex sept(em)

From seven.

The inscription unfortunately is no longer extant and the only documentation of it that exists is the line drawing made by Della Corte (Fig. 6.3). That tracing is nevertheless sufficiently clear to convey to me that the original reading should instead be understood as:

Exsêtri

Here, one recognizes that the penultimate letter is not a "T" but an "R" written at an angle. Once that is accepted, there is no difficulty in realizing that the visual joke is nothing other than an anagram of the word *extersi* (*I wiped myself*), made by a person who was accustomed to playing with language. This is one example of the type of word-game that is well attested among Vesuvian wall inscriptions, the subject of which was comprehensively treated by Margherita Guarducci several years ago.[11] It is also possible that this kind of joke was not made only for simple self-satisfaction, but also that it had an apotropaic significance, given the vulnerability to the spiritual forces of evil that the ancients ascribed to one sitting on the latrine, as has been recently strongly argued by Gemma Jansen.[12]

8 Cf. Väänänen 1966, 71–77.
9 Cf. *ThLL*, s.v. *extergeo* (v 2, coll. 2009, 72–2010, 60) and *culus* (IV, col. 1339, 42–60).
10 *CIL* IV.10580.
11 Guarducci 1978. Cf., e.g. *CIL* IV.659–660a: *suilimea* (= *Aemilius*); 4621: *Bseurlyl* (= *Beryllus*); 6826: *posprui* (= *propius*); 5086: *anumrub* (= *Urbanum*), etc.
12 Jansen 2011, 165–166, 174, 176. See also Clarke 2006, 293–302.

FIGURE 6.3 *Herculaneum. Latrine in the house at Insula v.30. The line-drawing of the inscription,* CIL IV.10580, *by Della Corte, gives the reading:* ex sept(em), *which is here corrected to* exsetri, *an anagram of* extersi.

Our author therefore succeeded in accomplishing that operation which the writer at the villa in Stabiae had not done. For us there remains the comfort in knowing that *extergere culum* ("to wipe the arse") was a customary operation that was accomplished with a sort of *spongia longa* ("a sponge on a stick"),[13]

13 Paul. ex Fest. s.v. *peniculi*, p. 208 (Müll.): *peniculi spongiae longae propter similitudinem caudarum appellatae.*

an instrument mentioned by both Seneca[14] and Martial,[15] and whose use is confirmed by the shape of the holes in the seats of latrines, which were made of durable material and are visible, for example, at Ostia.

It is surprising, in the eyes of modern-day observers, to see to what extent private matters, indeed very private matters of daily life, might be publicized among the graffiti and done so with a complacency that is almost precisely proportional to the reluctance that we in the modern-day feel and on account of which we aim to skirt such issues. Defecation in the ancient Roman world was a fact that, being inherently tied to the human body and the physical dimension, was treated with no reluctance whatsoever. Nor was it treated with the modesty that we in the modern age express, bound by custom to classify it among those things that are "inconvenient" and which we therefore treat with an elegant silence.

Yet this is a characteristic that is found repeatedly in the world of graffiti. In the most famous parietal inscriptions, such as those from the latrine of the baths of the Sette Sapienti at Ostia[16] or those recently discovered by Paola Chini in the public latrine under via Garibaldi at Rome,[17] the aspects relative to defecation, acts which occurred in those very spaces, are treated in a didactic manner. It is almost as though they were precepts for good and healthy living, albeit at Ostia delivered with decidedly humorous effect, while in the Vesuvian area we find instead the quote as an end unto itself. There is no other purpose than that of the externalization of the satisfaction of a personal need or the pretext, as we will see, to make of the theme a path to a savory or even piercing irony.

I note in this regard the rather formal message left in a refined style of handwriting, which one might call almost pompous, by none other than a famous doctor to his own contemporaries (and inadvertently to posterity) in the latrine of the luxurious Casa della Gemma in Herculaneum (Ins. Orientalis I, nr. 1), where he was likely a guest:[18]

14 Sen. *Epist. ad Lucil.* VIII 70, 20: *ibi lignum id quod ad emundanda obscena adhaerente spongia positum est totum in gulam farsit et interclusis faucibus spiritum elisit.*
15 Mart. XII 48, 5–7: *Lauta tamen cena est: fateor, lautissima, sed cras nil erit, immo hodie, protinus immo nihil, quod sciat infelix damnatae spongia virgae.*
16 For an analysis of these, see the recent treatment of Koloski-Ostrow and Moormann 2011, 178–181.
17 Cf. Chini 1997.
18 *CIL* IV.10619. Image reproduced in Varone 2012, 500. Cf. Gasperini 1973, 338, and Solin 1973, 272. As Keegan has suggested to me, one could also imagine that the inscription was created by a member of the *familia* as a memory of a visit to the house by so distinguished a personage, and one who was also the author, according to Maiuri (1958, 475, n. 136),

Apollinaris medicus Titi imp(eratoris) | hic cacavit bene

Apollinaris, doctor of the emperor Titus, shat well here.

The attention to defecation that is registered by the graffiti certainly is surprising, characterizing with crisp immediacy an entire scenario, as if giving us the cadence of a daily sigh of the society at that time.

Still another graffito relevant to this topic comes from Pompeii and was inscribed above the painting of a ship dedicated, as a sort of *ex voto*, to ΑΦΡΟΔΕΙΤΗ CΩZOYCA.[19] It was placed outside the entrance to the house at I.13.9 and is now preserved at Boscoreale, in the Museo dell'Uomo e dell'Ambiente nel Territorio Vesuviano (Fig. 6.4).[20] In this case I believe it refers to a "deposit of material" that two jokers have deposited stealthily in an alley of Pompeii, probably taking advantage of the darkness of night, reporting a saying that one issues to the other. The graffito, with the imprecise reading given by Della Corte, reads:[21]

Lesbiane, cacas scribisque salute

Lesbianus, you shit and you write 'greetings.'

By contrast, the reading that I offer substitutes a final "T" for the impossibility of an "S" at the end of the word *scribit* and incorporates the two "V" letters exactly as they are written in the final word. This seems to restore a more accurate sense for this mocking inscription (Fig. 6.5):

Lesbiane, cacas. Scribit qui valuit

Lesbianus, you shit. He who writes has already done that.

of a medical work used as a reference by Marcellus Empiricus. If so, one could think of similar inscriptions, found in other houses that, rather than a direct record of a distinguished guest, might be an indirect memory of such a visit, as, for example: *Cucuta ab ra[t]ioni[b]us Neronis Augusti* (*CIL* IV.8067–8068), found in the so-called Casa di Paquio Proculo (I.7.1, 20). The list of Vesuvian inscriptions found in latrines is given by Jansen 2011, 192 n. 61–62.

19 *CIL* IV.9867. See the image reproduced in Varone and Stefani 2009, 158. On this inscription, likely designed by the same *pictor,* see Varone, in *CIL* IV *Suppl.* 4, 1, 1540, where one should add Gasperini 1973, 338.
20 Inv. 20607.
21 *CIL* IV.10070. See the image of it reproduced in Varone 2012, 88. On the inscription, see also Catalano 1963, 270 n. 138; Solin 1973, 266, 273–274.

READINGS OF ISCRIZIONI PRIVATISSIME 121

FIGURE 6.4 *Boscoreale, Museo dell'Uomo e dell'Ambiente. The inscription* CIL *IV.10070, found on the façade of the house at 1.13.9 in Pompeii, and the new line-drawing proposed by the author.*

FIGURE 6.5 *Boscoreale, Museo dell'Uomo e dell'Ambiente. Detail of the final part of inscription* CIL *IV.10070. It reads:* <scri>bit qui valuit.

The writer, a comfortably literate man, perhaps an experienced inscriber, as is demonstrated by his fluid cursive lettering, realizes that Lesbianus was intent on satisfying his bodily needs and starts the complaint: "Lesbianus, you're shitting. I see you!" But then comes immediately the reassuring conclusion: "He who writes was already able to do it," which makes clear his complicity.

In order to understand the meaning of such a joking address, it is worth remembering the many messages, mild or sometimes even threatening, found along the streets of Pompeii and even outside the city, which tend to discourage *cacatores* from following through with their intentions. These, written by citizens who lived in the area or possessed properties there, address a general audience and issue warnings to whoever would have in mind the idea to defecate there.

One example appears along the western side of the alley to the east of the Casa del Moralista between *insulae* III.4 and III.5, where two enormous inscriptions[22] painted in red letters warn: *Cacator cave malum* ("Shitter, watch out for what might happen to you").[23] Other similar inscriptions[24] also try to discourage those with bad intentions, brandishing the threat of religious *fascinum*[25] or of divine wrath.[26] It is even possible to find a message promising something more concrete, as in the following inscription, written in rather accomplished capital letters that denote a cultured hand, which presents a metrical rhythm (Fig. 6.6):[27]

22 With well formed capital letters, but certainly not professionally lettered, as were those of the *programmatum scriptores*. The inscriptions stand more than a meter high and each measures ten and a half meters long.

23 *CIL* IV.7714, 7715. For a photo of the latter, see Varone and Stefani 2009, 276. It is possible to see only a part of *CIL* IV.7714 in the same volume, page 274. On these inscriptions, see now Jana Kepartovà in *CIL* IV *Suppl.* 4.1, 1496.

24 *CIL* IV.3782, in the alley between *insulae* IX.5 and IX.8. *CIL* IV.3832, found in the corridor that leads to the latrine of the *caupona* at IX.7.21–22. For a detailed interpretation of the figure referred to in the inscription, made at a later point, see De Salvia 1999, 131–140. *CIL* IV.4586, on the south side of *insula* VI.15, in charcoal. *CIL* IV.5438, in the extraurban building in contrada Civita, scavo D'Aquino, made in charcoal in a *tabula ansata dealbata*. *CIL* IV.7716, about which, see below.

25 Jansen 2011, 170–171.

26 *CIL* IV.7716: *Cacator, cave malum | aut si contempseris habeas | Iove iratum* ("Shitter, watch out for misfortune, or if you don't care, you'll endure the wrath of Jupiter"). This inscription was painted in the same road between *insulae* III.4 and III.5, on the east side, facing *CIL* IV.7714 with letters about 1 ½ meters high and occupying a length of more than 7 ½ meters. On this theme, see, e.g., also *CIL* VI.13740, discussed below. On the inscription, see now Kepartovà in *CIL* IV *Suppl.* 4.1, 1496.

27 *CIL* IV.7038 = *CLE* 1934. The central part is in fact a hexameter. The inscription was painted at the southeast corner of *insula* V.6, to the east of entrance c. See it depicted in Varone and Stefani 2009, 307. For bibliography and analysis, see now *CIL* IV *Suppl.* 4.1, 1413–1414.

Stercorari | ad murum | progredere: si | presus fueris poena | patiare necese | est. Cave.

Defecator, continue on to the wall(s of the city).
If you are caught, you will suffer punishment. Watch out.

or in the following, real poem, which is in fact not playful, as it would seem at first sight, but a true masterpiece of colloquial and sarcastic threat. Marked with pen and ink to the left of the house at III.5.4 (near the previous inscriptions),

FIGURE 6.6 *Painted inscription from Pompeii, issuing a warning to* defecatores, CIL *IV.7038.*

Cf. also, CIL III.1966 (from Salona in Dalmatia): *quisqu(e) in eo vico stercus non pos(u)erit aut non cacaverit aut non miaverit is habeat illas propitias; si neglexerit viderit* ("Whoever refrains from placing dung in this area or defecating or urinating, may he have these (= triple Hecate) favorable; but if he neglects the warning, watch out!"); CIL VI. 29848b: (from Rome): *duodecim deos et Deanam et Iovem Optumum Maximu habeat iratos quisquis hic mixerit aut cacarit* ("Whoever urinates or defecates here, may he have the twelve gods and Diana and Jupiter angry"); CIL VI.13740: *qui hic mixerit aut cacarit, habeat deos superos et inferos iratos* ("He who urinates or defecates here, may he have the gods above and below angry").

the verse is expressed in a fluid manner certainly by a man of culture who was inspired by similar compositions written on tombs:[28]

> *Hospes, adhuc tumuli ni meias, ossa prec[antur]*
> *Nam, si vis uic gratior esse, caca.*
> *Urticae monumenta vides, discede, cacator.*
> *Non est hic tutum culu aperire tibi.*

> Oh, traveller, these bones pray that you do not urinate near this tomb.
> Indeed, if you're in the mood to do it, shit.
> You see the funerary monument of Urtica; depart, shitter.
> It's not safe for you to open your asshole here.

Near the Porta Vesuvio another inscription instead urges:[29]

> *Cacator sic valeas | ut tu hoc locum trasea.*

> If you must shit, good luck to you if you by pass by this place.

I believe the large number of long snakes (*agathodaemoni*) placed at corners of streets provide the best proof that defecation in public places was a "social" problem very much alive in the society of two thousand years ago. These were

28 CIL IV.8899. Depicted in Varone and Stefani 2009, 278. The inscription paraphrases funerary poetry concerning safekeeping of the tomb, and in particular CIL VI.2357 = CLE 838: *Hospes, ad hunc tumulum ne meias, ossa precantur | tecta hominis, <set> si gratus homo es, misce, bibe, da mi.* ("Traveler, the buried bones of this man ask you to not urinate on this tomb; and if you wish to do me a favor, mix some wine, drink it and give some to me.") There exists an extensive bibliography on the Pompeian inscription. Here I cite in particular, regarding the various interpretations, not always in agreement: Colin 1951, 140–141; Schubring 1962, 244; Väänänen 1966, 58, 88, 117; Cèbe 1966, 172 and n. 4; Lebeck 1976, 287–291; Koenen 1978, 85–86; Gigante 1979, 230–232; Varone 1991–92, 245; Jansen 2011, 191 n. 37. Cf. in addition Petronius 71.8 (*ne in monumentum meum populus cacatum currat*) and CIL VI.13740 (... *qui hic mixerit aut cacarit habeat deos Superos et Inferos iratos*, "He who urinates or defecates (here) will incur the wrath of the gods above and the gods of the underworld").

29 CIL IV.6641, painted by the same *pictor* in a *tabula* placed next to the depiction of two *agathodaemoni* snakes on either side of an altar at the center, on the north side of *insula* v.6, at the entrance to the city from the porta Vesuvio, depicted in the photograph published in Varone and Stefani 2009, 308. On the inscription, concerning which, I confirm the accurate reading of Mau, in particular for *trasea*, see now Volker Weber, in CIL IV Suppl. 4.1, 1407, and Jansen 2011, 170–171.

employed to make the space sacred, so that within the sphere of *pietas* it might avoid being smeared with filth, as is suggested by the testimony of Persius.[30]

Irony and sarcasm seem, in fact, to be closely related to the theme of defecation. This is also found in the latrine of the Casa del Centenario, where two inscriptions, if not three, corroborate this statement. The first, an absolutely gratuitous inscription, written in rough capital letters, has the sole purpose of invoking nothing less than the canonical formulas of due process to assert a most banal truth. The message reads (Fig. 6.7):[31]

> *Quodam quidem testis eris quid senserim | ubi cacaturiero veniam | cacatum.*
>
> I will call you as a witness in the most solemn manner,
> when the desire to shit will come to me and I will take myself to the bathroom to do it.

FIGURE 6.7 *Pompeii. Latrine of the Casa del Centenario. Detail of* CIL IV.5242.

30 Cf. Pers. *Sat.*, I, 112–114: «*Hic,*» *inquis,* «*veto quisquam faxit oletum*». *Pinge duos anguis:* «*Pueri, sacer est locus, extra meiite*» ("Here," you say, "I prohibit anyone from making a stink." Paint two serpents: "Guys, this place is sacred. Piss somewhere else."). On this issue, see also the summary by Weber, in *CIL* IV *Suppl.* 4,1, 1267 ad 813.

31 *CIL* IV.5242. Depicted in Varone 2012, 435–436.

For this inscription, however, the issue of the accuracy of the verbal formula *cacaturiero*, read by Mau and supported by Väänänen, must be raised.[32] In principle, it does not present difficulties. The verb *cacaturio,—ire* is used once by Martial,[33] alongside an equally unusual *cenaturio* and the future perfect, that offers a perfect stem of the verb that is not otherwise attested, although it relates via the rule of anteriority to the simple future *veniam*. I do not think therefore that it is appropriate to correct such a reading, but it seems clear that the first R of *cacaturiero* can be read as such only in a forced manner.[34] Nor have I found other sensible readings possible, without identical forcing. In any case, the periphrastic future verbal formula implicit in such a verb heightens the solemnity sought for the expression, which plays precisely on verbal moods and tenses that were certainly not common in spoken language, to bring the popular form into the halls of forensic practice. And as a gloss for this game I would be inclined to read the nearby inscription as well, made by another hand, as also understood in the forensic sense of the term, namely a text written that is presented to a panel of judges to be put on record:[35]

Memoria

Memory.

The second (or third) inscription is a true sarcastic mockery of a poor girl, probably a servant, to whom a little mishap seems to have happened in the middle of a feast. The inscription was likely written by another inhabitant of the house, perhaps by another slave himself, who mercilessly ridicules his colleague:[36]

32 Väänänen 1966, 104, 122. See also *ThLL* III 1, col. 4, 75–77 s.v. *cacaturio*; Risch 1954, 188; Thomas 1959, 816.
33 Martial XI.77.3.
34 For example that *cacaturus ero*, which does not support the requisite number of letters, even with a different reading of the markings.
35 *CIL* IV.5243. Depicted in Varone 2012, 435–436.
36 *CIL* IV.5244 = *CLE* 15 (Engström); illustrated in Varone 2012, 435. A rich bibliography exists for this inscription, in part collected in Varone 1979, 85 no. 10, to which should be added Solin 1983, 725, 730; Parma 1983-4, 306–307; Lacerenza 2001, 99–103. The possibility that Martha could belong to the Jewish population, which would cast a shadow on this inscription in terms of antisemitism, was put forcefully in doubt by Solin and was decisively refuted by Lacerenza. I believe more simply that the message takes a dig at Martha, a put-down that took place among individuals who worked together, and ignores any racial reference.

READINGS OF ISCRIZIONI PRIVATISSIME 127

Marthae hoc trichilinium | est nam in trichilino | cacat.

This is the triclinium of Martha for she shits in the dining room.

It should be noted, however, that the reading given by Mau in the second line, *trichiliñio*, with the link between the "N" and "I" must be corrected, the presumed "I" being instead an extraneous mark on the wall. The reading of *trichilinium* in the first line, however, is confirmed (Fig. 6.8).

FIGURE 6.8 *Pompeii. Latrine of the Casa del Centenario. Detail of* CIL IV.5244.

I conclude this discussion with a variation on the theme, offering an inscription written in elegant letters by a cultured individual, that is humorous and salaciously ironic, and which takes the reality of a wrongdoing and dissolves it in laughter, attempting, as is possible, to rise to the heights of winged poetry:[37]

> *Miximus in lecto, fateor, peccavimus | hospes. Si dices quare: nulla matella fuit.*

> We peed in the bed. I admit it, we made a mistake, dear host.
> If you ask why, there was no bedpan.

Such an inscription appears emblematic of the approach that was taken regarding human waste in the Roman world. One could speak of it easily or even joke about it in a manner that made the "physical" dimension of man the principal point of reference.

As is evident from these examples, in the Vesuvian area, the private, even the intimately private, can deliberately be made public thanks to graffiti, and often only perhaps to that inherent *Italum acetum* ("Italic vinegar"),[38] or rather, to a sense of humor all their own, which at this point I would call "Latin."

Bibliography

Bonifacio, Giovanna. 2010. "Ufficio Scavi di Stabia. Notiziario 2009." *Rivista di Studi Pompeiani*, n.s., 21: 171–175.

Catalano, Vergilio. 1963. "Case, abitanti e culti di Ercolano." *Annali del Pontificio Istituto Superiore di Scienze e Lettere S. Chiara* 13: 213–342.

Cèbe, Jean-Pierre. 1966. *La caricature et la parodie dans le monde romain antique des origines à Juvenal*. Paris: E. de Boccard.

Chini, Paola. 1997. "Graffiti inediti nella forica di via Garibaldi a Roma." In *Preatti del XI Congresso Internazionale di Epigrafia Greca e Latina* (Roma 18–24 settembre 1997), 557–567. Roma: Edizioni Quasar.

37 *CIL* IV.4957 with add. p. 705 = *CLE* 932, found at Pompeii outside the inn at VIII.7.6, near the porta Stabia, and now lost. The interpretation given by Bücheler for this quite famous inscription is not convincing and has been rejected, as early as Mau, and now by many other authors who have considered it subsequently. One refers now only to Courtney 1995, 88–89, 295 n. 73.

38 Hor., *Sat.* I .7.32.

Clarke, John. 2006. "Forica Security: The Apotropaic Pygmy-Other in an Imperial Latrine at Ostia." In *Kalathos: Studies in Honour of Asher Ovadiah* (*Assaph*: Studies in Art History, 10–11), edited by Sonia Mucznik, 293–302. Tel Aviv: Department of Art History, Tel Aviv University.

Colin, Jean. 1951. "Nouveaux graffites de Pompéi." *L'Antiquité Classique* 20: 129–142.

Courtney, Edward. 1995. *Musa Lapidaria: A Selection of Latin Verse Inscriptions* (American Classical Studies, 36). Atlanta: Scholars Press.

Cugusi, Paolo. 1996. *Aspetti letterari dei Carmina Latina Epigraphica*. 2nd ed. Bologna: Pàtron.

De Salvia, Fulvio. 1999. "Su una *interpretatio Pompeiana* del motivo di 'Horo sui coccodrilli.'" *Rivista di Studi Pompeiani*, n.s., 10: 131–140.

Gasperini, Lidio. 1973. "Review of *Corpus Inscriptionum Latinarum*, voluminis quarti supplementi pars tertia, Lieferung 4 (Berlin 1970)." *Giornale Italiano di Filologia* 25, n.s. IV 3: 336–339.

Gigante, Marcello. 1979. *Civiltà delle forme letterarie nell'antica Pompei*. Napoli: Bibliopolis.

Giordano, Carlo. 1974. "Iscrizioni graffite e dipinte nella Casa di C. Giulio Polibio." *Rendiconti dell'Accademia di Archeologia, Lettere e Belle Arti di Napoli* 49: 21–28.

Guarducci, Margherita. 1978. "Dal gioco letterale alla crittografia mistica." *Aufstieg und Niedergang der Römischen Welt 11.16*, edited by Hildegard Temporini and Wolfgang Haase, 1736–1773. Berlin-New York: W. de Gruyter.

Jansen, Gemma C. M. 2011. "Interpreting Images and epigraphic Testimony." In *Roman Toilets: Their archaeology and Cultural History* (Babesch Supplementa, 19), edited by Gemma C. M. Jansen, Ann Olga Koloski-Ostrow and Eric M. Moormann, 165–176. Leuven: Peeters.

Koenen, Ludwig. 1978. "Urticae monumenta." *Zeitschrift für Papyrologie und Epigraphik* 31: 85–86.

Koloski-Ostrow, Ann Olga and Eric M. Moormann. 2011. "The paintings of Philosophers in the Baths of the Seven Sages in Ostia." In *Roman Toilets: Their archaeology and Cultural History*, edited by Gemma C. M. Jansen, Ann Olga Koloski-Ostrow and Eric M. Moormann, 178–181. Leuven: Peeters.

Lacerenza, Giancarlo. 2001. "Per un riesame della presenza ebraica a Pompei." *Materia giudaica* 6.1: 99–103.

Lebek, Wolfgang D. 1976. "Romana simplicitas in lateinischen Distichen aus Pompei." *Zeitschrift für Papyrologie und Epigraphik* 22: 287–292.

Maiuri, Amedeo. 1958. *Ercolano. I nuovi scavi* (1927–1958). Roma: Istituto Poligrafico dello Stato.

Parma, Aniello. 1983–4. "Schede epigrafiche. Puteoli. Inedita." *Puteoli* 7–8: 306–307.

Risch, Ernst. 1954. "Der Typus *parturire* im Lateinischen." *Indogermanische Forschungen* 61: 187–195.

Schubring, Konrad. 1962. "Epigraphisches aus kampanischen Städten." *Hermes* 90: 239–244.

Solin, Heikki. 1973. "Review of *Corpus Inscriptionum Latinarum*, voluminis quarti supplementi pars tertia, Lieferung 3–4 (Berlin 1963–1970)." *Gnomon* 45: 258–277.

———. 1983. "Juden und Syrer im westlichen Teil der römischen Welt: Eine ethnisch-demographische Studie mit besonderer Berücksichtigung der sprachlichen Zustände." In *Aufstieg und Niedergang der Römischen Welt II.29*, edited by Hildegard Temporini and Wolfgang Haas, 587–789. Berlin-New York: De Gruyter.

Thomas, François. 1959. "Review of V. Väänänen, *Le latin vulgaire des inscriptions pompéiennes*" (2nd ed., Berlin: 1959)." *Latomus* 18: 815–817.

Väänänen, Veikko. 1966. *Le latin vulgaire des inscriptions pompéiennes*. 3rd ed. Berlin: Akademie-Verlag.

Varone, Antonio. 1979. *Presenze giudaiche e cristiane a Pompei*. Napoli: M. d'Auria.

———. 1991–2. "Review of L. Canali, G. Cavallo (eds.), Graffiti *latini*" (Milano: 1991). *Rivista di Studi Pompeiani*, n.s. 5: 241–246.

———. 1999. "I graffiti della villa di San Marco a Stabia." In *La villa S. Marco a Stabia*, edited by Alix Barbet and Paola Miniero Forte, 345–362. Napoli: Centre Jean Bérard.

———. 2003/4. "Love Poems from the Popular Tradition in Pompeian Graffiti." In *L'archeologia nel mondo mediterraneo* (Atti Convegno Internazionale Tokyo: aprile 2004). *KODAI* 13/14: 85–101.

———. 2008. "Inseguendo un'utopia. L'apporto delle nuove tecnologie informatiche alla lettura 'obiettiva' delle iscrizioni parietali." In *Voci inaspettate: Esperienze di studio sui* graffiti *antichi* (Atti della giornata di studio Roma 7 marzo 2003), edited by Olof Brandt, 125–135. Uppsala: Istituto Svedese di Studi Classici.

———. 2012. *Titulorum graphio exaratorum, qui in C.I.L. vol. IV collecti sunt, Imagines*. Roma: L'Erma di Bretschneider.

Varone, Antonio, and Grete Stefani. 2009. *Titulorum Pictorum Pompeianorum qui in CIL vol. IV collecti sunt: Imagines*. Roma: L'Erma di Bretschneider.

CHAPTER 7

Honos clientium instituit sic colere patronos— A Public/Private Epigraphic Type: *Tabulae* of Hospitality and Patronage

Francisco Beltrán Lloris

In a familiar passage of the *Naturalis historia* dedicated to bronze statues, Pliny underscores the rapid diffusion, starting from Greece, of the habit of honoring individuals through these public images. And he characterizes this practice as a *humanissima ambitio—scil.*, "a most civilized sense of rivalry"—, whose aim was to ensure that the memory and the honors of the men remained permanently fixed, and not only as part of their tombs, but also in the forums, concluding: *mox forum et in domibus priuatis factum atque in atriis: honos clientium instituit sic colere patronos*.[1]

The words of the naturalist reflect a clear gradation characterizing the spaces of representation based upon their prestige and accessibility, a gradation about which modern historians are not always aware: in the first place, forums were privileged stages of public honors for the most prominent members of the community and, in consequence, were strictly regulated by the local authorities which, as well, set themselves up as arbiters of the competition among the elites;[2] secondly, the cemeteries, also public spaces, but subordinate as a result of being accessible to as many as were equipped with

* The editors and the author would like to thank Bradley J. Bitner for his careful and nuanced translation into English of this chapter.

1 *Excepta deinde res est a toto orbe terrarum humanissima ambitione, et in omnium municipiorum foris statuae ornamentum esse coepere propagarique memoria hominum et honores legendi aeuo basibus inscribi, ne in sepulcris tantum legerentur. Mox forum et in domibus priuatis factum atque in atriis: honos clientium instituit sic colere patronos*; Plin. *NH* 34.17. On honorific statues, see Lahusen 1983.

2 On the placement of statues in the forum, see Zimmer 1989, especially those from Cuicul and Thamugadi. Pliny the Elder also records that in 158 BCE the censors acted to remove from the forum the statues of those magistrates that had not been placed by initiative of the Senate or the People (*NH* 34.30), a move that had precedent—already in 179 BCE M. Aemilius Lepidus cleared the forum of statues and military standards, Liv. 40.51.3—and that was later renewed by Claudius (Dio 60.25.2–3); on the management of these initiatives in the imperial era, see Kolb 1993, 28–32.

the financial means for erecting a funerary monument, as evidenced, for example, by the predominance of the freedmen in the epigraphic record of many *necropoleis*;[3] and finally, the homes of notables, private spaces in principle, whose atria, nevertheless, were transformed into small forums by the desire of clients to honor their patrons.

The emergence of this type of commemoration, usually public, in domestic spaces with restricted access, and the resulting transformation of specific areas of the dwellings of notables into places of representation[4]—occasionally on a truly impressive scale[5]—was heightened from the beginning of the Principate. As is well-known, Augustus and his successors tended to constrain and restrict, in their own interest, the possibilities of commemoration for senators in the public spaces at Rome:[6] thus clients, freedmen, soldiers or provincial and Italian cities found in the great houses of notables a suitable place to honor them. In this context, the final phrase of the Plinian citation acquires its full meaning.

For this reason, senators and knights ought to have welcomed an innovation not properly Italian or Roman in origin, but developed instead by provincial cities, those of Africa and Spain above all, by which, instead of—or in addition to—erecting statues of patrons and public guests in their forums, they bestowed upon them a bronze inscription bearing the decree, thus the handles for transporting them that some of the bronzes exhibit (Fig. 7.1).[7]

The first testimonies of these *tabulae hospitales et patronatus* date to the 60s BCE: specifically, the *tessera* attesting *hospitium* between Cornelius Balbus

3 Mouritsen 2005, 52.
4 Eck 2010, 102–108, and 2010a, 214–223. On writing in domestic spaces, see Corbier and Guilhembet 2011.
5 If one believes Juvenal, for example, in the vestibule of a mansion of a certain Aemilius visitors were greeted by a bronze, triumphal chariot and an equestrian statue of the owner: *huius enim stat currus aeneus, alti quadriiuges, in uestibulis, atque ipse feroci bellatore sedens curuatum hastile minatur eminus et statua meditatur proelia lusca* (VII 125–128). See Eck 2010a, 218–219.
6 Eck 2010b.
7 On *tabulae hospitales et patronatus*, in addition to the classic studies of Harmand 1957 and Nicols 1980, see: Beltrán 2003; 2010; 2012; 2013; Beltrán and Pina 2013. For Africa, Díaz 2012. On the display of the tablets in domestic spaces see now, Cimarosti 2012, and Badel and Le Roux 2011. There is presently in process a study bringing together contributions concerning hospitality inscriptions and their edition that, with the title *"Hospitium fecit"* and under the direction of F. Beltrán and B. Díaz, will be published at Rome.

FIGURE 7.1 *Tablet of hospitality and patronage from* Baetulo *on behalf of Q. Licinius Silvanus Granianus, 98 CE (AE 1936, 66; Museo Municipal de Badalona; photo by the author).*

and Gades mentioned by Cicero[8] and the tablet of Curubis (Korba), a peregrine city of Africa Proconsularis, on behalf of one G. Pomponius, which is the oldest preserved example.[9] These tablets must have been a quite recent phenomenon, as Cicero appears surprised to receive from the people of Syracuse about

8 Cic. *Balb.* 41–42; Beltrán, 2015 a. *Tessera* is the technical name that designates the support of these covenants of hospitality and patronage, regardless of whether they are inscribed on bronze plaques or on *tesserae* strictly speaking: this is evidenced by the fact that they are called *tessera* on the tablets themselves from the beginning (*CIL* VIII.10525, 59–46 BCE) until the fourth century CE (*CIL* VI.1684, 321 CE).

9 *CIL* VIII.10525; 59–46 BCE.

70 BCE a *hospitium publicum* that *non modo tum scripserunt, uerum etiam in aere incisum nobis tradiderunt*:[10] in reality, it must have been a *proxenia* decree akin to those issued in duplicate between the end of the second century and the mid-first century BCE by Greek cities on Sicily and in southern Italy for the purpose of honoring their *proxenoi* with the presentation of a bronze tablet and the display of a copy in the local *bouleuterion*,[11] that in certain cases involved senators and other figures resident at Rome[12] and that, therefore, began in those years to be known among the Roman elites.

If during the final stages of the Republic these hospitality inscriptions are exceptional, by contrast, from the time of Augustus and in keeping with the progressive marginalization of senators from Rome's public spaces, numerous *clarissimi* and *equites* were honored in this manner by the cities of Africa and Spain.[13] These inscriptions, typically provincial and encountered above all in peregrine cities, adopted from the Greek models the characteristic—unique in the whole of Latin epigraphy—of being made in duplicate with the aim that one copy would be exhibited in a public place in the city and the other would be delivered by certain *legati* to the patron or the guest for him to display in the domestic space of his choice.[14] If throughout the Principate the practice of honoring patrons and public guests with hospitality tablets and patron-

10 Cic. *Verr.* II 4.145.
11 The Ciceronian passage Verr. II 2.112 probably also alludes to a *proxenia* related to the Sicilian community of Thermai Himeraiai: *cuius de meritis in rem publicam Thermitanorum Siculosque uniuersos fuit aenea tabula fixa Thermis in curia, in qua publice erat de huius beneficiis scriptum et incisum.*
12 On these decrees of *proxenia*, see Beltrán 2010: *IG* XIV 952–953, from the beginning of the first century BCE, granted by Agrigentum (Agrigento) and Melita (Malta) in favor of the Syracusan Demetrios, son of Diodotos; or *IG* XIV 612, granted by Rhegium (Reggio Calabria) to the praetor Cn. Aufidius T. f. about 100 BCE.
13 For Africa, Díaz 2012; in general, see the bibliography cited in note 7. So, for example, L. Domitius Ahenobarbus, governor of Proconsularis, by the peregrine cities of the *pagus Gurzensis*, in the region of Susa, in 12 BCE (*CIL* VIII.68; *PIR*² D 128); another governor, A. Vibius Habitus, by the colony Assura (Zafour) in 16/17 CE (*AE* 1913, 40; *PIR*¹ V 384); and the military tribune G. Silius Aviola by Apisa maius (Tarf ech-Chena), Siagu (Ksar ez Zit), Themetra (Souani el-Adari) and Thimiliga in 26–27 CE (*CIL* V 4919–4922); in Hispania Citerior, M. Licinius Crassus Frugi, probably governor, by the *ciuitas Bocchoritana* (Port de Pollença) in 10 BCE (*AE* 1957, 317; *PIR*² L 189); C. Asinius Gallus, probably also governor, by the *ciuitas Lougeiorum*, in the Asturian territory, in 1 CE (*AE* 1984, 553; *PIR*² A 1229); and an otherwise unknown M. Atilius Vernus again by the *ciuitas Bocchoritana* in 6 CE (*CIL* II.3695); and in Baetica, a certain Q. Marius Balbus by Lacilbula (Grazalema) in 5 CE (*CIL* II.1343), to many others that followed in the subsequent decades.
14 Beltrán 2010.

age decrees on the part of the provincial cities of Africa and Spain gradually lost momentum, by contrast during the fourth century CE many Italian cities adopted the custom.

In contrast to the Greek models that stipulate the deposit of the *proxenia* decree in the local *bouleuterion*, there is no explicit reference in the Roman inscriptions to the locus of display for the corresponding civic copy, although the fact that a good number of tablets have appeared in those communities that conferred them confirms their display within them. It is probable that, just as among the Greeks, they were posted at the seat of the local senate or in some place in the forum; this is suggested by an inscription from Praeneste dating to the early third century, in which it is decided by decree of the decurions that a statue of the consul Q. Insteius [- - -][15] *cum tabulis hospitalibus ante curiam uel in porticibus fori*, should be transferred perhaps from its previous placement within the curia itself:[16] in fact, some of the tablets found in the issuing cities come securely[17] or quite probably[18] from the forum.

In terms of the patron's copy, certain inscriptions make explicit its location in the home[19] or have themselves been recovered in a domestic context that should correspond to the dwelling of the guest or patron, in the provinces[20] as

15 *PIR*² I 29.
16 *CIL* XIV.2924.
17 So, for example, *AE* 1962, 287, unearthed from the forum of Munigua (Mulva), in Baetica, together with the *epistula Titi ad Muniguenses* (*AE* 1962, 288); the same occurs with the fragment from Bilbilis (Calatayud), in Hispania Citerior (*HEp* 7, 1093).
18 This is the case, for example, with the fragment from Volubilis, in Mauritania Tingitana, from the first century CE (*IAM* 2, 488); Chatelain 1941.
19 *CIL* VI.3828: [tabulamque / de ea re con]*scriptam in domu sua poni pe*[rmittat] (from the Thracian colony Deultum—Debelt, Bulgaria—on behalf of the governor Avidius Quietus, 84 CE); *CIL* VI.1492: *tabula / hospitali incisa hoc decreto in domo / sua posita, permittat* (from Ferentinum—Ferentino—on behalf of T. Pomponius Bassus, 101–102 CE); *AE* 1937, 121: *ut hanc scripturam nostram aere in*[cisam] / *tabula hospitali suscipiat et in aedibu*[s suis lo]/*co sacrari praecipiat feliciter* (from the *pagani et uicani Forulani* on behalf of C. Sallius Pompeianus Sofronius, 335 CE);... Or wherever the patron wished: *AE* 1937, 119: *hunc honorem ob*{b}*latum a no*/{no}*bis sus*{us}*cipiat patronatus aere inciso tabula hospiti et / ubi iusserit confrequentari praecipiat* (from Amiternum—San Vittorino, L'Aquila—on behalf of C. Sallius Pompeianus Sofronius, 325 CE).
20 From Corduba (Córdoba), in Baetica, comes the tablet granted in the fourth century CE to Flavius Hyginius by Tipasa, close to Argel (*CIL* II.2210 = *CIL* II²/7.276). In Cirta (Constantine), in Mauritania Cesariense, was found the tablet issued in 55 CE by Tupusuctu (Tikalt, Argelia) to the *legatus pro praetore* Q. Iulius Secundus (*CIL* VIII.8837), who may perhaps have been resident there during the course of his duties (about which, see Díaz 2012, 11). A late exemplar (364–367 CE) from Thamugadi (Timgad), in Numidia

well as in Italy[21] or Rome.[22] In this latter category falls the case of the tablet granted by *Ferentinum* to *T. Pomponius Bassus* in AD 101–102,[23] found on the Quirinal, together with marble and bronze statues, still "intagliata e fitta in una colonna" (Ligorio), surely from the atrium of the house (Fig. 7.2);[24] and, especially, those dating to late antiquity appearing in the house of the Valerii

 (*AE* 1913, 25), appeared in the ruins of a house (Cagnat and Ballu 1912) that could have been that of the person honored with the *tabula patronatus*, Aelius Iulianus, a notable from the city known from other inscriptions and included in the decurional *album* (*CIL* VIII.2403; additionally 2383 and *AE* 1894, 108).

21 The tablets already mentioned constitute the most striking case, namely, those offered by four African cities to the knight C. Silius Aviola (*CIL* V.4919–4922) in 26–27 CE, which appeared in Zanano, Val Trompia, in the north of Italia, near Brescia, where this military tribune must have been resident; see Gregori 1991; Condina and Foraboschi 2000; Díaz 2012, 21–22. In addition, the tablet *AE* 1913, 40 should be mentioned = Marchetti 1912 (16/17 CE), from *colonia Iulia Assuritana* on behalf of A. Vibius Habitus, cos. suf. 8 CE (*PIR*¹ V 0384), lacking a precise provenance, even if Marchetti (1912, 116–117) deduces from the facts that it was in the possession of B. Chiovitti, director of excavations in the province of Molise, and that there exists an inscription dedicated to one C. Vibius C.[f.] Postumus pr. procos. (*CIL* IX.730), cos. 5 CE (*PIR*¹ V 392), who is identified as a connection of Habitus, in Larinum, that this city would probably be the place of origin of the inscription and the place of residence of the Vibii.

22 A tablet related to Hispania, particularly to the *conuentus Cluniensis* that named as patron in 222 CE the *legatus legionis* C. Marius Pudens Cornelianus (*PIR*² M 317), was found on the Aventine, near Santa Prisca (*CIL* VI.1454 and 31659), where he must have made his residence (Eck 1995), in one of the areas of Rome in which is attested a high concentration of senatorial residences (Eck 2010a, 224–225). From the Esquiline comes the tablet from the Roman colony Deultum, in Thrace (*CIL* VI.3828 *add*. pp. 4765–4766 and VI.31692 = *AE* 1950, 4) conferred in 84 CE upon T. Avidius Quietus, friend of Plutarch and cos. suf. in 93 CE (*PIR*² A 1410), even if the inscription probably did not appear at its original site of display, but rather in the deposit of a metal-working craftsman, since together with it were found eleven more fragments of bronze plaques (Eck 1995a; 2010a, 217).

23 Found in the Quirinal (*CIL* VI.1492); Pomponius Bassus was suffect consul in 94 CE and attended in Lazio to the *alimenta* instituted by Trajan in 101 (*PIR*² P 705), the moment at which he must have established the bonds with Ferentinum that motivated its grant of patronage.

24 Situated at the confluence of the *Alta Semita* and the *cliuus Salutis*, Eck 1995b, 161–162 and 2010a, 216–217, evaluating the possibility that it was the same as that of Cicero's friend, T. Pomponius Atticus.

FIGURE 7.2 *Tablet of patronage from* Ferentinum *on behalf of T. Pomponius Bassus, 101–102 CE* (CIL VI.1492; *Museo Archeologico di Firenze; photo: E. Cimarosti*).

on the Celio,[25] at their actual sites of display from the Ospedale dell'Addolorata and adjacent areas.[26]

25 Behind the *Alta Semita* and the Esquiline, the Celio and the Aventine are the *regiones* with the highest concentration of senatorial examples in Rome, Eck 2010a, 224–225.

26 Guidobaldi 1995a; Barbera, Palladino and Paterna 2005, no. 47 and 2008. In the hospital complex of San Giovanni-Addolorata are also preserved the remains of the *horti* of *Domitia Lucilla*, mother of Marcus Aurelius (Liverani 1996) and of the house of the brothers Quintilii (Liverani 1995).

This mansion constitutes a rare example of continuity in terms of the occupation of a great senatorial residence by the same family,[27] but the temporary presence of a branch of the Aradii with their kinsmen is that which interests us here:[28] the sprawling mansion was endowed with, insofar as we know and among other rooms, a portico or peristyle, a large rectangular *aula* with an *opus sectile* pavement, gardens, fountains and an atrium.

In particular, among the many and rich materials unearthed during the sixteenth and seventeenth centuries,[29] six bronze plaques and four stone pedestals displayed in the atrium of the house stand out:[30] the plaques affixed to the columns—thus their curved sections—are *tabulae patronatus* or *tabulae hospitales*, dating to 321 and 322 CE, with which six African cities honored Q. Aradius Rufinus Valerius Proculus, *signo Populonius*,[31] *praeses* of Byzacenae in 321 CE (Fig. 7.3 and 7.4);[32] the four stone pedestals were dedicated to his brother L. Aradius Valerius Proculus, *signo Populonius*,[33] *praefectus urbi* in 337–338 CE, who was named patron, sometime after 340 CE,[34] by the *corpus*

27 As emphasized by Eck 2010a, 238–239, senatorial homes changed ownership frequently; along the same lines, Hillner 2003, 129–145.

28 The Aradii possessed a family house in *regio* I near the present Via di Porta Latina (Guidobaldi 1995) that they occupied for nearly two centuries and in which is attested the presence of the founder of the Roman branch of the family, a man of African origin (Corbier 1982, 689–691), Q. Aradius Rufinus Optatus Elianus (*PIR*² A 1016 o 1017), in the third century CE, as well as several of his descendants of the fourth century such as L. Aradius Valerius Proculus s. *Populonius* (*PLRE* I Proculus 11), *praefectus urbi* in 337–338 CE and 351–352 CE and consul in 340 CE, and his son Aradius Rufinus (*PLRE* I Rufinus 11), *praefectus urbi* in 376 CE (Panciera 1986 and 1987), from whom a certain Proculus is also attested epigraphically in the house of the Valerii. From all this it would appear that he was linked by marriage to the house of the Valerii—surely between Aradius Rufinus (*PLRE* I Rufinus 10), *praefectus urbi* in 312–313 CE and father of the two Aradii attested in the house of the Valerii (*PLRE* I Proculus 11 and 12), and the daughter of Valerius Maximus (*PLRE* I Maximus 48), *praefectus urbi* in 319–323 CE, but that, later, the Aradii returned to their family home near the Via di Porta Latina.

29 Barbera, Palladino and Paterna 2008, 80–81, point to numerous statues, busts and paintings, among other materials.

30 Found in 1554 and 1561: *CIL* VI.1684–1689 and 1690–1693.

31 *PLRE* I Proculus 12.

32 321 CE: of patronage, *CIL* VI.1684 (Cululis; Ain Jeloula), 1687 (Hadrumetum; Susa), 1688 (*ciuitas Faustinaniensis*); of hospitality and patronage, 1685 (Thaenae; Thyna) and 1689 (Mididi, Henchir Mididi), all from Byzacenae; 322 CE; *CIL* VI 1686 (Zama Regia, Jama), Africa proconsular, of patronage.

33 *PLRE* I Proculus 11.

34 Since it attests his consulship, it was obtained after that date; *PLRE* I Proculus 11.

FIGURE 7.3
Tablet of hospitality and patronage from Thenas *on behalf of Q. Aradius Rufinus Valerius Proculus, 321 CE* (CIL VI.1685; Museo Nazionale di Napoli; photo: E. Cimarosti).

FIGURE 7.4
Tablet of hospitality and patronage from Zama Regia *on behalf of Q. Aradius Rufinus Valerius Proculus, 322 CE* (CIL VI.1686; Museo Nazionale di Napoli; photo: E. Cimarosti).

suariorum et confectuariorum (sic),[35] the *ordo et populus Puteolanorum*[36] and the *collegium suariorum* (Fig. 7.5),[37] and, at an undetermined date, the *collegium pistorum*.[38]

There appeared in the house other inscriptions such as a bidental with the label *fulg(ur) d(ium)*[39] and two inscriptions related to members of the Valeria family: one on a pedestal dedicated by a knight to L. Valerius Publicola Balbinus Maximus, consul in 256 CE,[40] and another on an overlay belonging to a bronze oil lamp addressed to Valerius Severus,[41] *praefectus urbi* in 382 CE.[42]

FIGURE 7.5
Pedestal of the corpus suarorium et confectuariorum *(sic) for L. Aradius Valerius Proculus, after 340 CE* (CIL VI.1693; *photo:* Corpus Inscriptionum Latinarum—BBAW).

35 CIL VI.1690. The usual term for pig-butcher is *confectorarius*.
36 CIL VI.1691.
37 CIL VI.1693.
38 CIL VI.1692.
39 Barbera, Palladino and Paterna 2008, 94–95.
40 CIL VI.1531, found in the Villa Casali, on the other side of the Via di S. Stefano Rotondo; PIR¹ V 121.
41 ILCV 1592: *dominus legem / dat Valerio Seuero / Eutropi uiuas*; Barbera, Palladino and Paterna 2008, 81 fig. 6.
42 PLRE I Severus 29.

One may understand, accordingly, that this striking concentration of inscriptions dedicated to the brothers Aradii in an atrium of the house was intended to emphasize the presence of this new branch of the family in the Valerii residence; their clients were transforming, just as Pliny indicated in the passage that opened these pages, this notionally private domestic space into a small forum that would serve as a space of specific representation for the branch of the Aradii in the family home of the Valerii: in it, significantly, the cities of Africa—from which the Aradii also came—show themselves to be clinging to the old local tradition of hospitality and patronage tablets, while Puteoli and the urban associations of bakers, breeders, and pig butchers opt instead for traditional pedestals and statues. In either case, all of these unequivocally highlight the elevated dignity and the broad social relations enjoyed by the brothers Aradii, and which they, through these inscriptions and honors, were able to exhibit before the eyes of those who visited their mansion.

These cases illustrate, on the one hand, the irruption of the public in what had traditionally been private, domestic spaces, a phenomenon so well expressed by Pliny and encouraged by the progressive marginalization of the traditional spheres of self-representation which, from the time of Augustus, were allowed to senators and knights at Rome. Many of these individuals, most likely, would prefer these tablets of bronze—a metal endowed with obvious symbolic value—,[43] that they were able to display in the *atria* and vestibules of their houses in order to embody their social position in combination with the traditional *imagines*, statues, triumphal ornaments, military honors and other status symbols, rather than the erection of a statue in the forum of a remote, provincial city.

Finally, this illustration demonstrates how the border between public and private, so essential for understanding the development of Roman epigraphic culture,[44] despite being clear in most cases, is much more difficult to pinpoint in others.

The public display of epitaphs such as that of the fictional Trimalchio[45] or that on the pyramid of Cestius[46] or of the bronzes bearing the Flavian municipal laws is indisputable;[47] this is evident also from the clearly private character

43 Beltrán 1999. Presently there is a doctoral thesis of V. Simón (Zaragoza) in the final stages of preparation which treats the Latin, bronze inscriptions of the Roman West.
44 Beltrán, 2015 b.
45 Petr. *Sat.* 71, where he orders a clock to be set up along with his epitaph so that anyone who looks at the time *uelit, nolit nomen meum legat*.
46 *CIL* VI.1374.
47 The provision of the lex Irnitana concerning its inscription on brone and public display (Irn. § 95), indicates *in aes incidatur et in loco celeberrimo eius municipii figatur ut d(e) p(lano) r(ecte) l(egi) p(ossit)*.

of many labels on *instrumenta*—consider, for example, those on subterranean lead pipes—, from some domestic graffiti or from curse tablets.[48] By contrast, on other occasions one might question the search for notoriety in light of certain inscriptions that were notionally public such as those funerary ones placed in small tombs with restricted access[49]—or, even on the interior of a sarcophagus—,[50] which, despite the search for permanence implied by the use of stone, could actually only be read by very few people. Finally, certain areas of those domestic spaces, although enclosed in notionally private precincts, were actually open to numerous people who frequented the homes of senators and other notables[51]—associates, friends, clients, freedmen, provincial delegations,...—, so that while not being strictly public, were they neither properly private.

Tablets of hospitality and patronage clearly illustrate this ambiguity by means of their exceptional duplication, as they were intended to be viewed both in the forums, public spaces *par excellence*, as well as in notionally private spaces such as the home: *mox forum et in domibus priuatis factum atque in atriis: honos clientium instituit sic colere patronos.*

Bibliography

Ameling, Walter, and Johannes Heinrichs, eds. 2010. *Monument und Inschrift*. Berlin-New York: De Gruyter.

Badel, Christophe, and Patrick Le Roux. 2011. "Tessères et *tabulae* dans l'espace domestique." In *L'Écriture dans la maison romaine*, edited by Mireille Corbier and Jean-Pierre Guilhembet, 167–188. Paris: de Boccard.

48 These inscriptions whose sole addressees were the gods.

49 One illustrative example is the necropolis of the Via Triumphalis, in the Vatican; see Steinby 2005 and Liverani and Spinola 2006, 44–47, fig. 41; on epitaphs publicly exposed and those of restricted access, see Eck 1987.

50 P. Paquius Scaeva had his epitaph recorded with his *cursus honorum* and with that of his wife inside his sarcophagus in Histonium (*CIL* IX.2845–2846; Brandenburg 1978, 280–283); three freedmen dedicated an epitaph in Rome on his behalf to his Manes, *CIL* VI.1483, an inscription that had traditionally been understood as related "ad cenotaphium uel aram sepulcralem confectum," *PIR*² P 126 (L. Petersen), but perhaps was not. On this, see now Beltrán, 2014.

51 On suitable spaces for receiving such visitors, Vitr. 6.5.2: *uestibula regalia alta, atria et peristyla amplissima, siluae ambulationesque laxiores... bybliothecas, basilicas non disimili modo quam publicorum operum magnificencia comparatas, quod in domibus eorum saepius et publica consilia et priuata iudicia arbitriaque conficiuntur.*

Barbera, Mariarosaria Sergio Palladino, and Claudia Paterna. 2005. "La domus dei Valerii a Roma." *Fasti Online: Documents & Research* 47. www.fastionline.org/docs/FOLDER-it-2005-47.pdf.

———. 2008. "La domus dei Valerii sul Celio alla luce delle recenti scoperte." PBSR 76: 75–98.

Beltrán Lloris, Francisco. 1999. "Inscripciones sobre bronce: ¿un rasgo característico de la cultura epigráfica de las ciudades hispanas?" *XI Congresso Internazionale di Epigrafia Greca e Latina* (Roma, 18–24 settembre 1997), *Atti* II, 21–37. Roma: Edizioni Quasar.

———. 2003. "Una variante provincial del *hospitium*: pactos de hospitalidad y concesión de la ciudadanía local en la Hispania Tarraconense." In *Epigrafía y sociedad en Hispania durante el Alto Imperio: estructuras y relaciones sociales. Acta Complutensia* IV, edited by Sabine Armani, Benedicte Hurlet-Martineau, and Armin U. Stylow, 33–56. Alcalá de Henares: Servicio de Publicaciones de la Universidad de Alcalá.

———. 2010. "El nacimiento de un tipo epigráfico provincial: las tábulas de hospitalidad y patronato." ZPE 175: 273–286.

———. 2012. "Hospitium municipal y ciuitas honoraria: Una relectura de la tésera de hospitalidad de Herrera de Pisuerga." ZPE 181: 245–259.

———. 2013. "*Hospitium publicum* municipal en la Hispania Tarraconense," In *Debita verba. Estudios en homenaje al profesor Julio Mangas Manjarrés*, edited by R. M. Cid and E. García, 173–187. Oviedo.

———. 2014 [2011]. "El enigmático sarcófago de Publio Paquio Esceva (CIL IX 2845–2846)", *Salduie* 11, 2011, 27–35.

———. 2015 a. "The hospitium publicum of Gades and Cornelius Balbus", in Foreign clientelae in the Roman Empire. A reconsideration, edited by M. Jehne and F. Pina, 141–151. Historia Einzelschriften 238, Stuttgart.

———. 2015 b. "The Epigraphic Habit in the Roman World." In *The Oxford Handbook of Roman Epigraphy*, edited by Christer Bruun and Jonathan Edmonson, 131–148. Oxford-New York: Oxford University Press.

Beltrán Lloris, Francisco, and Francisco Pina Polo. 2013. "Clientela y patronos en Hispania," *Tarraco Biennal. 1er Congrés Internacional d'Arqueologia i Món Antic. Govern i societat a la Hispània romana. Novetats epigràfiques. Homenatge a Géza Alföldy*, 51–61. Tarragona.

Brandenburg, Hugo. 1978. "Der Beginn der Stadtrömischen Sarkophag-Produktion der Kaiserzeit." *JdI* 93: 277–327.

Cagnat, René, and Ballu, Albert. 1912. "Séance de la commision de l'Afrique du nord, 10 décembre 1912." *Bulletin Archéologique du comité des travaux historiques et scientifiques*, cclxxxv–cclxxxvi.

Chatelain, M. Louis. 1941. "Bronze épigraphique trouvé à Volubilis." *Publications du Service des Antiquités du Maroc* 6: 36–38.

Cimarosti, Elena. 2012. "Hoc decreto in domo sua posita (CIL VI 1492). La tabula esposta in casa del patrono: Qualche proposta per una sua identificazione." *Instrumenta*

scripta IV. *Nulla dies sine littera. La escritura cotidiana en la casa romana. Sylloge Epigraphica Barcinonensis* 10, 287–308.

Condina, Fulvia, and Daniele Foraboschi. 2000. "Africa-Brescia: andata e retorno? Ancora su Silio Aviola." In *L'Africa romana* 13, edited by Mustapha Khanoussi, Paola Ruggeri, Cinzia Vismara, 1309–1319. Roma: Carocci.

Corbier, Mireille. 1982. "Les familles clarissimes d'Afrique Proconsulaire (Ier–IIIe siecle)." *Epigrafia e ordine senatorio* II, 685–754. Roma: Edizioni di storia e letteratura.

Díaz Ariño, Borja. 2012. "Las tábulas de hospitalidad y patronato del norte de África." *MEFRA* 124.1 (http://mefra.revues.org/184).

Eck, Werner. 1987. "Römische Grabinschriften. Aussageabsicht uns Aussagefähigkeit im funerären Kontext." *Römischer Gräberstraßen*, 61–83. München: Verlag der Bayerischen Akademie der Wissenschaften. = "Iscrizioni sepolcrali romane. Intenzione e capacità di messaggio nel contesto funerario," *Tra epigrafia, prosopografia e archeologia. Scritti scelti, rielaborati ed aggiornati*, Roma 1996, 227–249.

———. 1995. "Domus: C. Marius Pudens Cornelianus." In *Lexicon topographicum Vrbis Romae* (*LTUR*) II, edited by Eva Margareta Steinby, 138. Roma: Quasar.

———. 1995a. "Domus: T. Avidius Quietus." In *Lexicon topographicum Vrbis Romae* (*LTUR*) II, edited by Eva Margareta Steinby, 67. Roma: Quasar.

———. 1995b. "Domus: T. Pomponius Atticus." In *Lexicon topographicum Vrbis Romae* (*LTUR*) II, edited by Eva Margareta Steinby, 161–162. Roma: Quasar.

———. 2010. "Ehrungen für Personen hohen soziopolitischen Ranges im öffentlichen und privaten Bereich." In *Monument und Inschrift*, edited by Walter Ameling and Johannes Heinrichs, 95–125. Berlin-New York: De Gruyter.

———. 2010a. "*Cum dignitate otium*. Senatorische Häuser im kaiserzeitlichen Rom." In *Monument und Inschrift*, edited by Walter Ameling and Johannes Heinrichs, 207–249. Berlin-New York: De Gruyter.

———. 2010b. "Senatorische Selbstdarstellung und kaiserzeitliche Epigraphik." In *Monument und Inschrift*, edited by Walter Ameling and Johannes Heinrichs, 1–43. Berlin-New York: De Gruyter.

Euzennat, Maurice, Jean Marion, and Jacques Gascou. 1982. *IAM: Inscriptions antiques du Maroc: 2, Inscriptions latines*. Paris: Editions du Centre national de la recherche scientifique.

Gregori, Gian Luca. 1991. "Gaio Silio Aviola, patrono di Apisa Maius, Siagu, Themetra e Thimiliga." *L'Africa romana* 8, edited by Attilio Mastino, 229–236. Sassari: Gallizzi.

Guidobaldi, Federico. 1995. "Domus: Aradii." In *Lexicon topographicum Vrbis Romae* (*LTUR*) II, edited by Eva Margareta Steinby, 36–37. Roma: Quasar.

———. 1995a. "Domus: Valerii." In *Lexicon topographicum Vrbis Romae* (*LTUR*) II, edited by Eva Margareta Steinby, 207. Roma: Quasar.

Harmand, Louis. 1957. *Le patronat sur les collectivités publiques des origines au Bas-Empire*. París: Presses universitaires de France.

Hillner, Julia. 2003. "The senatorial family house in Late Antique Rome." *JRS* 93: 129–145.
Kolb, Anne. 1993. *Die kaiserliche Bauverwaltung in der Stadt Rom.* Stuttgart: F. Steiner.
Lahusen, Gotz. 1983. *Untersuchungen zur Ehrensatatuen in Rom: Literarische und epigraphische Zeugnisse.* Roma: G. Bretschneider.
Liverani, Paolo. 1995. "Domus: Quintilii Condianus et Maximus." In *Lexicon topographicum Vrbis Romae (LTUR)* II, edited by Eva Margareta Steinby, 168. Roma: Quasar.
———. 1996. "Horti Domitiae Lucillae." In *Lexicon topographicum Vrbis Romae (LTUR)* III, edited by Eva Margareta Steinby, 58–59. Roma: Quasar.
Liverani, Paolo, and Giandomenico Spinola. 2010. *Le necropoli vaticane: La città dei morti di Roma.* Milano: Jaca Book.
LTUR II: Steinby, Eva Margareta, ed. 1995. *Lexicon topographicum Vrbis Romae*, Roma: Quasar.
LTUR III: Steinby, Eva Margareta, ed. 1996. *Lexicon topographicum Vrbis Romae*, Roma: Quasar.
Marchetti, Maria. 1912. "Tessera ospetale." *Bullettino della Commissione Archeologica comunale di Roma* 1912: 113–151.
Mouritsen, Henrik. 2005. "Freedmen and Decurions: Epitaphs and Social History in Imperial Italy." *JRS* 95: 38–63.
Nicols, John. 1980. "*Tabulae patronatus*: a study of the agreement between patron and client community." *Aufstieg und Niedergang der römischen Welt* II.1. Berlin-New York: De Gruyter.
Panciera, Silvio. 1987. "Ancora sulla famiglia senatoria 'africana' degli Aradii." *L'Africa romana* 4, edited by Attilio Mastino, 547–572. Sassari: Dipartimento di Storia, Università degli Studi di Sassari.
———. 1986. "Due famiglie senatorie di origine africana ed una di origine italica: Aradii, Calpurnii e Suetri alla luce di una nuova iscrizione urbana." *L'Africa romana* 3, edited by Attilio Mastino, 251–262. Sassari: Gallizzi.
Steinby, Eva Margareta. 2005. *La necropoli della Via Triumphalis: Il tratto sotto l'Autoparco Vaticano.* Roma: Quasar, 90–95.
Zimmer, Gerhard. 1989. *Locus datus decreto decurionum.* München: Verlag der Bayerischen Akademie der Wissenschaften.

CHAPTER 8

The Significance of Sculptures with Associated Inscriptions in Private Houses in Ephesos, Pergamon and Beyond

Elisabeth Rathmayr

This chapter focuses on the relationship between sculptures and associated inscriptions in private dwellings.[1] Using Terrace House 2 at Ephesos, one of my main research projects, as a starting point, I will discuss significant examples of this relationship drawn from Hellenistic dwellings in Delos and from houses in the eastern and western Roman Empire. In order to provide a comprehensive analysis of the function of these sculpture-text ensembles, the following investigation will consider only those monuments whose exact locations in the various houses are known to us. *Inter alia*, I will discuss in what ways the messages of the different media, sculpture and text, are congruent or complementary. In this regard, I will also examine if one medium can give us more information than the other. Finally, I would like to explore the issue of possible differences between these kinds of ensembles in the private and in the public realm.

Ephesos

I begin with the inscriptions from Dwelling Unit 6 in Terrace House 2 (Figs. 8.1 and 8.2). All are related to sculptures and therefore provide a useful point of entry into consideration of the relationship between sculpture and inscribed text in private spaces.[2] A short overview of Terrace House 2 will help to

* The present chapter is based on a presentation delivered during the seminar "Inschriften in privaten Räumen," part of the XIV Congressus Internationalis Epigraphiae Graecae et Latinae (CIEGL Berlin, 2012). I appreciate very much the opportunity to outline the content of my paper ("Statuen und Inschriften im privaten Wohnbereich") in more detail than possible in the CIEGL congress papers (Rathmayr, 2014 d) and would like to thank the editors for their invitation to participate in this volume.

1 Concerning this theme, see e.g. Eck 2010; von Hesberg 2005; Gehn 2012.
2 For the context see Rathmayr 2009; Rathmayr 2014 a, 384–387 (peristyle 31a and room 36); for the inscriptions see Taeuber 2014, 342 f.

FIGURE 8.1 *Town plan of Ephesos (ÖAI 2005 based on Klotz 2001, numbering of the objects after Scherrer 1995; adaptations by Chr. Kurtze/ÖAI, markings by I. Adenstedt/ÖAW).*

contextualize the discussion which follows. Terrace House 2 defines an area in the centre of the Hellenistic-Roman town of Ephesos.[3] It is bordered to the north by the Curetes Street, which was a main thoroughfare and processional road; to the south lies the so-called Hanghausstrasse, and in the east and west the building complex is flanked by steep and narrow alleys.

The area of Terrace House 2 was already developed in the Hellenistic period. These earlier structures were destroyed in early imperial times (first quarter of the 1st century CE) and Dwelling Units 1 to 7 were built as peristyle houses in the second quarter of this century (= Building Period I).[4] Extensive reconstructions and new decorations (primarily of the walls) can be observed in all seven Dwelling Units in the early Hadrianic and in the late Severan period (= Building Periods II and IV). Building Period III refers to a period in the middle of the 2nd century AD when Apsidal Hall 8 was constructed in Dwelling

3 For Terrace House 2: Krinzinger 2010; Thür 2005; Krinzinger 2002; Thür and Rathmayr 2014; Rathmayr, in print.
4 For the Hellenistic development and the erection of the Wohneinheiten (WE) (= Dwelling Units), see Thür 2005, 96; Ladstätter 2002, 81–83, 426 f.; Thür 2014 a; Rathmayr et al., 2014, 833–836; Rathmayr, in print c, chap. IV.1.

FIGURE 8.2 *Layout plan of Terrace House 2 (K. Koller, ÖAW 02/01, after ÖAI PlanNr. 1963–1 4/97).*

Unit 6. It was built on areas of the neighboring Dwelling Units 4 und 5; therefore, Building Period III can be attested here as well. All dwellings (Dwelling Units 1–7) were destroyed by a series of earthquakes in the 3rd quarter of the 3rd century CE and not rebuilt for residential purposes afterwards.

Dwelling Unit 6, the focus of this section, belongs to the largest house in this complex (Fig. 8.3). It was accessible through a large entrance area from Curetes Street, while all the other units were entered from the alleys on the sides and from the so-called Hanghausstrasse in the south. A connecting door, which existed between Dwelling Units 6 and 7 from Building Period I to IV,[5] suggests that these dwellings were owned and occupied by the same family.

5 The connection is situated in the upper storey: through doors in room 32b the units were connected to each other; see Thür 2014 b, 101 f.; Rathmayr, in print, chap. IV.2.1.

THE SIGNIFICANCE OF SCULPTURES 149

FIGURE 8.3 *Layout plan of Dwelling Unit 6 in Terrace House 2 (made by I. Adenstedt after H. Thür and E. Rathmayr, ÖAW).*

Members of this family are known through inscriptions found in Unit 6 itself, which will be discussed below, as well as from texts stemming from the public sphere of Ephesos. Family members can be traced back to the late Hellenistic/early imperial period.[6] The family was local and attained citizenship under the Flavian dynasty. Gaius Flavius Furius Aptus, known from texts in Dwelling Unit 6, held offices in the first half of the 2nd century CE. He must have been part of the *ordo equester*, since his son Titus Flavius Lollianus Aristobulus made his way into the *ordo senatorius*, which was, as far as we know, the highest

6 For the family of C. Fl. Furius Aptus and the family tree see Rathmayr 2009; Rathmayr 2014 c, 846–849.

honor the family attained. Gaius Flavius Furius Aptus was priest of *Dionysos Oreios Bakchios pro poleos, alytarch*[7] and presumably *neokoros*, a priest probably within the Emperor cult.[8] The high social rank C. Fl. Furius Aptus had achieved was presumably the reason for the enormous rebuilding program in his house. Among others, the newly built large Apsidal Hall 8 and Marble Hall 31 should be mentioned. The architecture and sumptuous marble decoration of these halls recall building concepts known from imperial villas and palaces in Rome and Italy.[9] Additionally, C. Fl. Furius Aptus also initiated a sculptural program.[10]

Through inscriptions found *in situ* in his house, three sculpture-text ensembles can be reconstructed, which shall now be discussed in greater detail. One is situated on the rear parapet wall built between the intercolumniations of the southern colonnade of the peristyle 31a and served as part of a fountain (Figs. 8.3 and 8.4).[11]

This wall is divided by axial pillars carried out with mouldings on top and bottom, recalling statue bases well known from the public realm of Ephesos.[12] The text (Text 1) is engraved on the top moulding of the central pillar at a height of 1.30 m and therefore was legible to the literate viewer. Next to the name of C. Fl. Furius Aptus, the inscription registers his priesthood in the cult of *Dionysos Oreios Bakchios pro poleos*, whose sanctuary was situated outside the urban area of Ephesos.[13] The sculptures that were associated with this text are indicated by traces on the top of the parapet wall. Imprints of a round object with a diameter of around 0.20 m fixed by clamps in the central intercolumniation above the inscription indicate that a cylindrical base once stood here.[14]

7 These officials were responsible for security and order during the festival and agon of the Olympia; see Lehner 2004, esp. 83–89. 154. 166. 232.

8 *IEph* no. 502, 502A, 1099 (Alytarch), 1267 (priest of Dionysos), 834 (Neokoros?); for the Neokoroi see Burrell 2004, 3–6, esp. 5 f.; for the other offices see Cramme 2001, 58, 150 with fn 559, 279 f.; Lehner 2004, Agonistik (http://edoc.ub.uni-muenchen.de/archive/00003261/01/LehnerMichael.pdf), esp. 83–89, 115, 154, 166; Remijsen 2009, 129–143.

9 Large halls (some with an apsis on one side) decorated with marble floors and walls and furnished with luxurious fountains are well known from the imperial palaces of Nero and the Flavian Emperors; see for example Hoffmann and Wulf 2004.

10 Rathmayr 2014 a, 392–396.

11 The fountain was erected in building period II in the Early Hadrianic period; see Thür 2014 c, 128.

12 For statue bases from Ephesos, see Aurenhammer and Sokolicek 2011.

13 The place of the sanctuary is unknown.

14 Cf. a portrait bust from Ephesos, now in the Selçuk Museum (inv. no. 742+2359), which shows two clamp-holes on the sides of the lower torus of the base. This indicates that it must have been fixed in exactly the same way as the base/sculpture on the fountain.

THE SIGNIFICANCE OF SCULPTURES 151

FIGURE 8.4 *Peristyle 31a, view onto the rear wall of the fountain with inscription 1 (Elisabeth Rathmayr/ÖAW).*

In the imprints of the lateral intercolumniations, dowel holes and clamps denote that statue plinths were fixed in these positions.[15] Since the subject of the sculptures should have corresponded to the texts, they might have depicted Gaius Flavius Furius Aptus in his role as a priest and the god Dionysos.[16] But although one might imagine that Dionysos was presented in the center, I favor a portrait bust of Gaius Flavius Furius Aptus flanked by under life-size statues of Dionysos on each side.[17] This contention is supported by the facts that (1) since a cylindrical base can be reconstructed in the central place and due to the fashion of combining portraits with busts in the private sphere, a portrait

15 Each plinth can be reconstructed with a maximum length of 0.67 m and a maximum depth of 0.17 m.
16 Both names are in the nominative case, whereas in Greek inscriptions names of persons who were honoured both in texts and statues generally occur in the nominative or the accusative case; see recently Ma 2013, 21–30.
17 For a reconstruction see Thür and Rathmayr, 2014, pl. 38; the fragment of a hand holding a grape which was found in peristyle 31a could have belonged to one of these statues; see Rathmayr 2014 a, 397 f. cat. no. S 10 pl. 147.

bust should have stood here; and (2) gods and heroes were only very seldom shown in bust form, but rather as statues and statuettes.[18]

When reconstructing the statues of Dionysos, it is appropriate to imagine that they were worked as pendants. This representational approach was probably used a second time elsewhere in this house, as will be discussed shortly. Concerning the effect of the sculptures on the parapet wall, it might be of importance that in the same building period when they were installed (building period II, when Gaius Flavius Furius Aptus was the house owner), the vestibule leading into this main display area was transformed as well. Whereas before it had led into the eastern hall of the peristyle 31a, an inner vestibule (room 31c) was newly built in Building Period II; this inner vestibule opened directly opposite the middle intercolumniation with the possible portrait bust of Gaius Flavius Furius Aptus. Therefore, the house owner presented himself in such a way that clients and other visitors were immediately confronted by him, a *modus operandi* which quite often can be observed in ancient houses. Focus on the sculptures and text was enhanced by the attachment of high barriers behind the ensemble.[19] Both sculptures and text were put here to convey particular messages to the audience, whereby the text could naturally be more specific and detailed. Only by the text are we informed about the name and priesthood of Gaius Flavius Furius Aptus; house-ownership of this person is also implied. In general, except for gods, heroes, emperors and people of high rank, it was not possible to convey names of individuals through portraits/sculptures, although the use of clothes, shoes and attributes could refer to certain offices. As a result, having only the text in peristyle 31a, we do not know if Gaius Flavius Furius Aptus wanted to appear in his house only in his priesthood; nor can we deduce if there were other inscriptions describing further offices. The inscription may indicate that certain activities concerning the cult and the association which organized the cult took place in Dwelling Unit 6.[20] In the inscriptions from the public sphere of Ephesos, he is mentioned as an

18 For the sculptures from the Ephesian Terrace Houses, see Christof 2002; Rathmayr 2002; Rathmayr 2005; Rathmayr 2014 a; Rathmayr, in print a, chap. XVII; Aurenhammer 2003.

19 Furthermore, from this building period, initiated by Gaius Flavius Furius Aptus, onwards a separation between the peristyle and its south hall was indented: a bath was installed in the east hall, and the west hall was parted from the south hall by a big marble door, which is still *in situ*; see Thür 2014 b, 128.

20 For this interpretation see Thür 2014 d, 849–853.

alytarch[21] and very likely is also named *neokoros* in a text inscribed on a statue base, which was set up in his honor by the Boule and Demos of Ephesos.[22]

Let us now consider two other sculpture-text ensembles in Dwelling Unit 6 related to Gaius Flavius Furius Aptus. Both statue bases have surviving inscriptions and were found *in situ* in room 36 (Figs. 8.3 and 8.5).[23] This large room is situated in the rear part of the house and was accessible from an extension of the south hall of peristyle 31a. Due to its size, furnishing, and location at an interface, the room would have functioned as a distribution area to rooms 36a and to the Apsidal Hall 8, with its annex rooms 8a, 8b, and 8c.[24] The decoration of room 36 reflects the décor of the neighboring rooms. A large marble riveted water basin is installed in the floor at the center of the room, and the floor and the main zones of the walls are decorated with colorful marbles as well. In the uppermost zones, parts of wall paintings have survived; these presumably also covered the vaulted ceiling.[25] On its south side a staircase spans nearly the entire width of the room and leads to the large Apsidal Hall 8, which was presumably used for receptions and *convivia*. The inscribed statue bases flank this staircase: the eastern one stands on its second step, while the western base is placed upon a marble plinth, which is set on the floor. Due to these differences in the setup, both bases reached the same height of around 0.80 m. The texts (Texts 2 and 3) are inscribed on their front sides, between the top and bottom mouldings; traces for fixing the statue plinths are visible on the top surfaces. Since both texts honor Aphrodite in her role as a maritime goddess and since the two bases do not only interrelate in their placement, format, and height, but also in the themes of the inscriptions, it is logical to assume that pendant statues of Aphrodite in the Anadyomene type had been arranged here.[26] A torso fragment of an under life-size marble statue of this type was found nearby and could originate from one of these statues.[27] In both texts Aphrodite is adored. But while in one inscription the genealogy and the substance of Aphrodite Anadyomene is praised extensively, in the other, the adoration of the goddess is shorter. Here, the major part of the text deals with two individuals: Gaius and Perikles. These two on one hand, are under the goddess' protection,

21 *IEph* no. 502, 502A, 1099.
22 *IEph* no. 834, 9–10: Γάϊον [Φλά]ου[ιο]ν Φούριον ["Απτον νε]ωκό[ρ]ον.
23 For a new publication of the texts see Taeuber, 2014, 343 cat. no. IST 2 and IST 3 pl. 126.
24 Thür 2014 b, 77–82 (room 36); Rathmayr 2010.
25 For these decoration elements see: Koller 2014, 233; Zimmermann 2014, 287 f.
26 For the detail pertaining to this view, see Rathmayr 2014 a, 386 f.
27 Rathmayr 2014 a, 386 f. 406 cat. no. S 46 pl. 157.

FIGURE 8.5 *Statue bases with inscriptions 2 and 3 in room 36 (Niki Gail, ÖAI).*

while on the other hand they appear in their roles as hosts and guests. Based on the inscription discussed above in the court and due to the fact that bases and inscriptions were set up in the period when Gaius Flavius Furius Aptus was the landlord of Dwelling Unit 6 it is very likely that the Gaius from the text can be identified with this homeowner. Perikles does not appear in other inscriptions from Ephesos in the period in question; however, based on this text he must have been a close friend of Gaius Flavius Furius Aptus.[28] Like the sculpture-text ensemble in peristyle 31a, these inscriptions also give us information that could not have been provided by the sculptures alone. Without the texts, the bust and statues could only have been evaluated as decorative and/or religious objects.

Additionally, the veneration for Aphrodite and Dionysos by Gaius Flavius Furius Aptus is reflected by the decoration of room 8a, a side room of the Apsidal Hall 8. As already mentioned, both the Apsidal Hall 8 and the side rooms (8a–c) can be related to the rebuilding undertaken by Gaius Flavius Furius Aptus. Room 8a has a unique stucco décor, which covers the lunettes and the vaulted ceiling. In addition, general Dionysiac and Aphrodisian motifs are

28 A Perikles is not attested by any other text from the period in question, but perhaps through one graffito on a wall painting from building period II in room 42 of Dwelling Unit 6; for this graffito see Taeuber, 2014, 336 GR 234 pl. 107.

shown on the ceiling, Therefore, it is likely that Aphrodite and Dionysos are depicted as an amorous couple in the lunette opposite the room entrance.[29]

In conclusion, the sculpture-text ensembles in Dwelling Unit 6 seem to have served an important role as part of the decorative and biographical functions of the house. Without them we would not know the owners of the house, nor their social status in Ephesian society and their preference for certain gods (Dionysos and Aphrodite). Here, it should be clear that the inscriptions provide more detailed information than the sculptures could have conveyed, although both should be treated as a unit. Besides decorative functions, the statues can be evaluated as a visual and decorative tool to catch the attention of visitors (guests, clients). The house owner, who commissioned the sculptures, was presumably also responsible for the content of the texts. The ensembles are always placed on axis with the entrances. In one case, this axial orientation can be seen opposite the main door from the inner vestibule to peristyle 31a; in the other case, it occurs opposite the door into room 36. By this spatial differentiation a guest or visitor was first confronted with the ensemble in the court, where Gaius Flavius Furius Aptus received them with his full name and as priest of Dionysos, while in the other ensemble, located in the rear and more private part of the house, he is only named by his *praenomen* and together with a friend, who is likewise identified solely by his name, Perikles. Despite this humble gesture, Gaius and his friend point out their high rank. Referring to themselves as guests and hosts (Text 3), they emphasize their ability in reaching the social level of inviting people and of being invited by the same elite to which they belonged.

Pergamon

In order to show that the examples of Dwelling Unit 6 in Ephesos do not stand alone, I will next discuss sculpture-text ensembles from the so-called Attaloshaus in Pergamon,[30] a residence named after the *consul suffectus* Gaius Claudius Attalos Paterklianos,[31] whose acme can be dated into the first quarter

29 For this new interpretation see Rathmayr, 2014 b, 324–329 pl. 97–102; for another interpretation of the lunette see Strocka 2013, 85–94.
30 The dwelling was excavated at the beginning of the 20th century, but until now has not been published contextually; for the architecture and the finds see Conze 1918, 248–250; Dörpfeld 1907; Radt 1988, 120–124; Wulf 1999, 168–169.
31 For the identification between Attalos and Gaius Claudius Attalos Paterklianos, see Hepding 1907, 364–365.

of the 3rd century CE.[32] The house, a peristyle house like Dwelling Unit 6 in Ephesos, was built in the Hellenistic period. Several construction phases can be noticed in the Roman imperial period,[33] during which the main entrance led from the main street in the east into a large staircase opening onto the eastern hall of the peristyle (Fig. 8.6).[34]

For the purposes of this chapter it will repay our attention to focus on the peristyle court and the rooms adjacent to its western hall as they appeared in the late 2nd–early 3rd century CE—the large room 45, a small *exedra*-like room 43 and a niche 42, both north of room 45.[35] The peristyle was two-storied with a Doric order on the ground floor and an Ionic order on the upper floor.[36] The northern hall of the ground floor had a mosaic pavement, while the western hall, which opened to the rooms discussed here, had marble flooring.[37] Due to the fact that the intercolumniations in the northwest were closed by 2 m high barriers,[38] these halls and the affiliated rooms could not be seen at first glance. The large room 45 has a room-wide doorway and a high-lying central niche on the opposite wall,[39] which housed a sculpture in the fashion of an *aedicula*. One function of the room is indicated by a so-called *triclinium* floor, comprising a marble pavement in the central area and mosaic flooring alongside the walls. Directly to the west of the room, the *exedra* 43 was built in the course of walling up the entrance to the staircase 41, which previously led to the upper floor.[40] In the rear part of this exedra, a base with a fragment of a marble plinth and a foot of an over life-size statue was discovered.[41]

32 PIR² C 800; Leunissen 1989, 202; Swain 1991; I.Tralleis no. 54: in this inscription a noble woman was honoured, among others from her clique who are mentioned, including T. Flavius Vedius Antoninus, Flavius Damianus and also C. Claudius Attalos Paterklianos.
33 Wulf 1999, 168 f.
34 Dörpfeld 1907, 176.
35 The room numbers follow the plan on plate 14 by Dörpfeld 1907 (here Fig. 8.6).
36 Dörpfeld 1907, 177–180.
37 Dörpfeld 1907, 183.
38 Dörpfeld 1907, 177.
39 The niche is situated 3 m above the floor; it had an architectural marble framing consisting of two Corinthian pilasters (height 1.99 m) spanned over by an entablature (width 1.32 m); see Dörpfeld 1907, 180, fig. 3.
40 Dörpfeld 1907, 172 f.
41 Dörpfeld 1907, 172 f.; Radt 1988, 124; concerning the statue, Hepding 1907, 363, 387 footnote 1, made the point that a larger than life-size marble head, which was found in the house and which once was crowned with a metal wreath, might have belonged to this cult statue.

FIGURE 8.6 *Layout plan of the Attalos house in Pergamon (after Dörpfeld 1907, 167–189 pl. 14).*

A herm, found standing *in situ* to the west of the entrance to this room, must bear some relation to this sculpture.[42] Its bronze head, which does not survive, was fixed by dowels onto the top of the shaft.[43] On the front side, just below the missing head, a text is still legible (Text 4). It tells us that a person named Attalos, who held the highest office of a consul, dedicated a statue to a goddess (θεῶν πανυπείροχον),[44] whose servant (πρόσπολός)—i.e. priest—he claimed to be.[45] The text not only enables us to identify Gaius Claudius Attalos Paterklianos as the owner of the house and the initiator of the rebuilding in rooms 41, 43, and 45, as well as of the installation of niche 42 described above, but also to propose a correspondence between the goddess named in the text and the goddess that was depicted in the statue found in the *exedra* 43. Thanks to the text and the archaeological remains, we can even specify the *exedra* as a

42 Dörpfeld 1907, 173; for the inscription, Hepding 1907, 361–366 Nr. 117 Abb. 10; the herm measures: width 0.31 m, height 1.70 m, depth 0.26 m; the sockle on which it is standing measures: height 0.33 m, length 0.49 m, depth 0.37 m, so altogether the height of the herm without the head is 2.03 m.

43 Hepding 1907, 361–366 Nr. 117 Abb. 10.

44 Hepding 1907, 361–366 Nr. 117 suggests Mater Deum Magna Idaea.

45 Likewise Dörpfeld 1907, 172 f.

household shrine, wherein cult practice is testified by the remains of many used clay lamps.[46] On the other side of this herm, a smaller wall niche is situated (no. 42 on Fig. 8.6), which also might have performed a function within the cult in question.[47] Therefore, the house owner Claudius Attalos Paterklianos was not only present in the text on the herm, but also in the portrait that belonged to it.[48] While the bronze head must have been newly produced, the herm itself was reused—confirmed by the facts that the text naming Attalos overwrites an older one and a previously existing penis was chiselled off.[49] While pointless to speculate why this occurred, the action is certainly not unusual: the reuse of sculpture is a phenomenon that is seen quite often in the 3rd century CE.

In addition to this herm, a second example was found in room 45, a place used for dining.[50] This latter herm was inscribed with the following inscription (Text 5): "Have your fair share of food, don't spare the wine. Enjoy Attalus' feast, O friends of mine," and thus presented a personalized version of a line from the *Odyssey*,[51] adapted in such a way as to present Claudius Attalos Paterklianos as a host of splendid parties. Therefore, it is likely that a bronze portrait head of him was inserted in this herm as well. Here too there was reuse similar to that already observed in relation to the other herm, with overwriting of an older, no longer readable text. The fact that the penis on this herm was not chiselled off might be explained by the differentiating self-display of Claudius Attalos Paterklianos, which was adjusted to the various places where the sculpture-text ensembles were set up. When he appeared as a priest, such exposure might not have been appropriate, whereas his depiction in the role of a host could have hinted at the Dionysian components of such festivities. Since the find-spot allowed for parties such as those suggested in the inscription, it is reasonable to propose that the herm was erected either here or at the entrance area of this *triclinium*.

In addition to these sculpture-text ensembles, two other inscriptions, each associated with sculptural imagery, probably belonged to this house

46 Cult practice is evident by many ceramic lamps which were found in the rear part of the *exedra*; see Dörpfeld 1907, 172 f.; Heimerl 2001, 85 cat. nos. 481 (dog?), 483 (lion), 1115 (2 busts with a lance in between), 1125 (head of Medusa), 1126 (Amor riding on a panther) and 1131 (lion?). In my opinion the themes on the lamps are far too heterogeneous to reconstruct a cult of Cybele as proposed by Heimerl.
47 For this niche see Dörpfeld 1907, 173.
48 That the herm carried a portrait of him is indicated by the fact that his name occurs in the nominative case.
49 Hepding 1907, 361–366 Nr. 117 Abb. 10.
50 Hepding 1907, 366, no. 118 notes that it was found here.
51 Hom. *Od.* 12.23: ἀλλ' ἄγετ' ἐσθίετε βρώμην καὶ πίνετε οἶνον.

and possibly dated to the building alterations undertaken by Claudius Attalos Paterklianos as well. This assumption is based on the find-spots of both inscriptions near the house[52] as well as on the subject matter of the texts and the sculpture. One of these inscriptions belongs to an architrave fragment;[53] the other, which will be discussed below, appears on the hermshaft of Hermes Propylaios. The inscription on the architrave fragment reads: [χαίρετον, εἰ φίλοι ἄνδρες] / ἱκάνετον· εἰ δ' ἀθέμισ[τοι /- - -] (Text 6),[54] and alludes to another Homeric verse (*Iliad* 9.197).[55] Based on this message of welcome and the type of the architectural piece, it would have fit very well at the entrance of the house—perhaps as part of the door lintel. Just as with the previous text from room 45, one of the works from the classical canon most commonly cited in the ancient world was used here as well. Yet in both inscriptions the Homeric poems were not quoted word-for-word, but were rather adapted for certain aims. Above all, they served to underpin and foreground the self-representation of Claudius Attalos Paterklianos as the owner of the house, who adjusted them accordingly to those places where they best performed this function. These Homeric allusions indicate the extent to which Claudius Attalos Paterklianos esteemed classical Greek culture and held it in high regard. Due to the fact that the same method was used in these inscriptions—an adaptation of Homeric text—and because these, as all inscriptions forming integral elements of sculptural ensembles, are connected to their settings, both the attribution to one and the same building and client should be beyond doubt. The contents of the texts and the sculptures, as well as the affiliations to the family of Claudius Attalos Paterklianos, indicate that Attalos was or wanted

52 They were found in Magazin 10, which is situated at the end of the slope on which the Attalos House is built. Based on their finding location and on the fact that there is no other house nearby on the hillside, it is very probable that these objects fell down from the house of Attalos; for the finding spots and this interpretation see Dörpfeld 1907, 185; Gierke 1995, 188.

53 According to Schröder, Schrader and Kolbe 1904, 176, no. 21, it is a block of white marble of unclear function. On the left side and at the bottom are joint planes, the top and the rear are smoothed, the right side is broken and on the top is a clamp hole. On the front is a fillet with the inscription underneath. It measures 0.22 m (height), 0.15 m (depth), 0.65 m (length). The height of the letters is 0.04 m, and the writing is said to be imperial. As a unit, the block is described as an architrave by Hepding 1907, 366.

54 The form ἱκάνετον is a dual which is attested only once more, in Homer *Il.* 9.197–198: χαίρετον· ἢ φίλοι ἄνδρες ἱκάνετον ἦ τι μάλα χρεώ, οἵ μοι σκυζομένῳ περ Ἀχαιῶν φίλτατοί ἐστον. There and in this inscription the dual is used, even though in both cases more than two people are addressed. See Merkelbach 1999.

55 Likewise Merkelbach 1999.

to appear as a person—like so many other men of his status and period—with a great interest in the classical and later Greek culture.[56]

The other object, found at the same place as the architrave, claims by its inscription to have been a statue of Hermes by the famous sculptor Alkamenes of the late 5th century BCE (Fig. 8.7).[57] According to the text on the front (Text 7), it was erected by one Pergamios. Claiming to be a copy of the famous and well-known classical work, and thereby an ideal stimulus to intellectual discourse, this sculpture-text ensemble would have fitted perfectly into the context of the previously mentioned configurations installed by Claudius Attalos Paterklianos in his home. The herm format and the content of the text support a location in an entrance area (house or room entrance).[58] Unfortunately, it is not known when the dedicator Pergamios lived and if he belonged to the clique of Claudius Attalos Paterklianos. But since Altmann favored a date for the text in the (earlier) 3rd century CE, Pergamios could have been a friend of Attalos.[59] Besides, the fact that Pergamios is named only with his name supports the assumption that the sculpture-text ensemble in question stood in a private context.

Outside the urban area of Pergamon, in the village of Sindel, another herm bearing an inscription with the name of one Attalos was found.[60] It was discovered in the ruins of a well-preserved antique bathing complex. Based on the herm text, the bath is thought to be part of a countryside villa of Claudius Attalos Paterklianos.[61] But as the letter forms of text on this herm are dated

56 As also mentioned by Swain 1991.
57 For the inscription see Altmann 1904, 179–186, pl. 18–21, fig. 19; for the last line of the text "γνῶθι σαυτόν" see Bousquet 1956, 567–573; for the discussion concerning whether the herm is a copy of Alkamenes or not see recently Krämer 2001, 9–11.
58 The attribution to one or the other position in the house depends on the translation of the passage: τὸν πρὸ πυλῶν εἵσατο Περγάμιος; see Dörpfeld 1907, 185; a place in the peristyle on the ground floor is preferred by Gierke 1995, 188.
59 The herm itself being a Roman copy is dated in the 2nd century CE; see summarizing Krämer 2001, 9–11; Gierke 1995, 188. As both the dating of the copy and the dating of the inscription cannot be as precise as we wish, it cannot be sure if text and sculpture were created at the same time, or if the inscription is secondary.
60 Schröder, Schrader and Kolbe 1904, 165–167, fig. 15: Ἄτταλος εἰκόνα ἣν θῆκεν / Νύμφαισιν ἄγαλμα / ἀΐδιον λουτρῶν ὄφρ' ἀπό- / λαυσιν ἔχοι.
61 Sommerey 2008, 158 with fn 105 fig. 1 citing the dating of Hepding 1907, 365 fn 1, with respect to the 2nd century CE, but omitting that pertaining to the first half of the same century.

FIGURE 8.7 *Alkamenes-Herme*
(*after Radt 1988, fig. 30*).

to be earlier than the acme of the consul Claudius Attalos Paterklianos,[62] this inscription should be related to another person with the same name.

To summarize, Claudius Attalos Paterklianos represented himself in his house in Pergamon through the medium of sculpture-text ensembles. He set up herm-shafts combined with bronze portraits of his head and frontal texts underneath his portraits. Whereas in one text his offices (consulship, priesthood/veneration of a specific goddess) are named, in the other he presents himself as a splendid host. In the latter, he adapts verses from Homer, and the same is true for a text on an architectural block which might be reconstructed at the entrance of the house. The copy of the Alkamenes herm set up by one Pergamios could have stood in an entrance area, either of the house or a room, and shows the same sophisticated, intellectual way of addressing classical works as the other ensembles related to the consul.

And Beyond

The self-display of house owners in prominent locations in their homes—in the court and/or with a visual axis to entrance areas—is a phenomenon

[62] Altmann 1994, 165–167 dates the text to the period of the kings of Pergamon; Hepding 1907, 365 fn 1 prefers a date in the first half of the 2nd century CE.

known not only from the Roman imperial period, but also from Hellenistic dwellings in Delos and atrium houses from the late republican period in Italy. Let us consider a few examples drawn from this range of display contexts.

The so-called house of Kleopatra and Dioskurides in Delos was rebuilt during the second quarter of the 2nd century BCE in favour of the new residents. Kleopatra and Dioskurides are known from an inscription on a statue base found in the peristyle of their home (Text 8), and from other inscriptions in Delos as well.[63] The text not only informs us about the names of the house owners (Kleopatra and Dioskurides) but also that the wife had erected the ensemble on her husband's behalf. In addition we are told that both spouses originated from Attica and that Dioskurides had dedicated votive offerings in the sanctuary to Apollo on the island. By instancing an eponymous office (the Archonate of a certain Timarchos), a well-known practice from inscriptions in the public sphere, the text can be precisely dated (137/138 BCE). However, it is not certain if this time designation is related to the dedication of the inscription and statues, to the votive offerings, or to both.[64] While it does not emerge from the text that Dioskurides' wife was honoured as benefactress with a statue as well, the sculptural remains consist of life-size marble statues of both spouses. They were found standing side by side on the inscribed base, though unfortunately their heads did not survive (Fig. 8.8). The statues follow the representational fashion of the period: Kleopatra is depicted in the Pudicitia type and Dioskurides in the Himation.[65]

The base was erected on what was at one time the threshold of a room associated with the peristyle. This placement was so important to Kleopatra and Dioskurides that they amended the perspectival configuration of the peristyle doorway. This alteration was chosen because it provided a visual axis to the main entrance of the house. In this way, visitors and guests were aware of the owners immediately on entering their house. While this effect was also incorporated in the houses at Ephesos and Pergamon (see previous discussion), differences can be observed in the Delian sculpture-text ensemble. Unlike the Ephesian and Pergamene examples, at Delos:

(a) the portraits were combined with life-size statues, not with a herm or a bust,
(b) texts were located lower than eye level, and

63 Inscription on statue base: *ID* 1987. Other inscriptions: Kreeb 1988, 19.
64 As already mentioned by Kreeb 1988, 19.
65 For the use of these statue types for portraits see e.g. Eule 1998, 15 f.; Ma 2013, 267 f.

THE SIGNIFICANCE OF SCULPTURES 163

FIGURE 8.8 *Sculpture-text ensemble in the house of Kleopatra and Dioskurides in Delos, view from the house entrance (Elisabeth Rathmayr 2012).*

(c) the statue of Kleopatra complementing the inscription is not mentioned in the text, albeit that here the text gives much more detailed information than the statues could have provided.

The fact that both Dioskurides and Kleopatra were represented in portrait statues makes clear that the aim of the homeowners was to be recognised as a couple who, as foreigners, had reached a high status in their new home town—a fact confirmed by the inscription.[66] This high rank in Delian society is indicated by the fact that Dioskurides was allowed to dedicate precious votive offerings (silver tripods) in the main sanctuary of the town, and that

66 Such dedications mostly date from a specific occasion and had to be permitted; see Kreeb 1988, 19 with footnote 85 and other lit.

these were placed at the entrance of the temple, where they were visible to the public at large.

Elsewhere at Delos, a statuette base with an inscription that records a dedication to a deity was discovered *in situ* in a niche in the vestibule[67] of house E (Text 9).[68] Although the statuette, which was fixed to the base with a dowel, no longer exists, the text—on the front at a height of 1.30 m—is still legible. It is short and states that one Spurius Stertinius dedicated a statuette to Artemis Soteira, clearly a goddess of special importance to him. Due to the fact that this sculpture-text ensemble was set up in a dwelling, we can assume that the house belonged to Spurius Stertinius and that he performed cult to the goddess there. The special worship of Spurius Stertinius for Artemis Soteira is also evident in a second dedication, involving again sculpture and text, found in the area of the temple of Aphrodite (Text 10).[69] That ensemble comprises a relief showing the goddess combined with an inscription underneath the figure.[70] In contrast to the inscription in his house, this text identifies Spurius Stertinius' filiation and provenance—he had come from Rome. Including these details in the inscription might relate to the public nature of the context where the relief was presented.[71] For that same reason, perhaps, Spurius Stertinius did not employ his native Latin tongue, but the more common Greek language.

The self-display of house owners in their own homes in the form of sculpture-text ensembles is not only a phenomenon of the Greek East, but also occurs in the West. Here we can find them in certain dwellings of the Vesuvian towns, dating to late republican and early imperial times. For example, a herm with a portrait head was found in the atrium of a dwelling in Pompeii (VIII.4.15).[72] An inscription at the top of the herm shaft, *C. Cornelio Rufo* (Text 11), gives the name of the person portrayed in the bust. The fact that the

67 The height of the niche of 0.25 m predetermined the size of the statuette; for the measures of the niche see Kreeb 1988, 196 f.
68 *ID* 2378.
69 It shows the goddess in a frontal position, dressed with a short Chiton, holding a torch in each hand and with a dog at her side; Delos Mus. inv. no. A 3236; Marcadé 1969, 214, pl. 40.
70 It looks like the figure of Artemis is standing on a base with the text on the front; therefore, maybe the (cult) statue of the goddess is depicted on this relief.
71 Filiations are also omitted in the Ephesian and Pergamene inscriptions, whereas a filiation is mentioned on a sculpture-text ensemble standing in the club-house of the Poseidoniasts at Delos. The building was used for the cult of certain deities and meetings of a particular association, and, therefore, it was open to a broader group of people. See Kreeb 1988, 24, 106 cat. no. S 1.2; *ID* 2325; Trümper 2007, 119–122.
72 Mattusch 2008, 105 cat. no. 14. According to Eck 2010, 117, only three portrait herms in the dwellings of Pompeii were found; all of them with very short texts with just the minimum

name is given in the dative suggests that this was a dedication; it was probably made by one of his clients.[73] Because of the text, in combination with a portrait head and the position of the ensemble (next to the opening into the *tablinum* and opposite the main entrance of the house)—elements that have already been noticed in other houses—Cornelius Rufus can be identified as the owner of this house. This placement was aligned towards the entrance of the house, so that it might greet visitors; within the atrium it was situated in the main representation and communication zone of the dwelling, where also household cult took place.[74] While this setting can be compared with that of Kleopatra and Dioskurides in their home at Delos, the content of the texts and the choice of the sculptures depicting the house owners are different. Not only was the Pompeian text limited to include the fewest elements, giving simply the house owner's name, but also the sculpture was reduced insofar as it only displays the portrait of the dedicand.[75] Another variation pertaining to the Pompeian example is that responsibility for this ensemble apparently did not reside with the house owners but their client(s).

In addition to the example from Pompeii, house owners in the western part of the Roman Empire had chosen portrait statues and portrait busts for representing themselves as well. In the town of Volsinii a bronze inscription from 224 CE (Text 12) was found in the *atrium* of a dwelling that had been destroyed and abandoned after a big fire in 270 CE.[76] The text informs us that Ancharia Luperca was elected by the council of the *collegium fabrum* (builders) to become a *patrona* of the association which had already honoured her husband the *primipilaris* Laberius Gallus as *patronus*. Like her husband Ancharia Luperca was additionally honoured with a bronze statue which was erected at the meeting place of the association beside a statue of her husband. Apart from the honorific statues that were set up here to be "visible for all in the public view" as is said in the inscription (line 17), a *tabula patronatus*

information required; see also Dickmann 1999, 119–121, among these, two are dedicated by clients, as is mentioned in the texts of these herms.

73 Dickmann 1999, 121; for ensembles which were erected by *liberti* in the houses of their masters see for instance a bilingual text on a statue base found in dwelling St I C in Delos: Kreeb 1988, 169 cat. no. S 11.1; I.Delos no. 1802.
74 Dickmann 1999, 114–121, with previous bibliography; Hesberg 2005, 38–40.
75 On the meaning of herm shafts combined with portrait heads, see Wrede 1986, 71–77.
76 Stevenson 1882, 157–181, pl. S (plan of the house with the find-spots of bronze plate and head); Buchicchio 1970, 35 f.; Dahmen 2001, 97 with n. 868, 193 Kat. 184 with Tab. 184; Neudecker 1988, 79. *CIL* XI.2707, where the measures of the tablet with the inscription are given: height 0.70 m, width 0.48 m.

was attached to a wall and displayed in their home.[77] The *tabula* referred to in the inscription can be identified with the bronze inscription discovered in the house. Therefore, the house was very likely the home of Ancharia Luperca and Laberius Gallus.

It is possible that a similar inscription was placed in the *schola* somehow in connection with the portrait-statues (on their bases?), as a reminder of the council's decision and in order to keep the names of the honoured at the forefront of community attention. We may also assume that the text found in their home was associated with sculptures. A bronze bust of a *togatus* with a height of 0.19 m, was found in the same dwelling and may have depicted Laberius Gallus.[78] This is supported not only by the bronze material, used for both the bust and inscription, but also by the dating of the bust.[79] As suggested by the ensembles previously listed, the *atrium* of the house of Laberius Gallus and Ancharia Luperca, where both inscription and bust were found, likely reflects their original place of display.

Conclusion

While other examples of sculpture-text ensemble exist,[80] dating not only to Hellenistic and imperial times but also to late antiquity,[81] the length of this study precludes further discussion. In conclusion, I would like to highlight a few characteristics of these sculpture-text ensembles. They were set up by the owners of houses (Ephesos/Texts 1–3; Pergamon/Texts 4–6; Delos/Text 9), by family members (Delos/Text 8), close friends (Pergamon/Text 7?), members of associations and clients (Pompeii/Text 11; Volsinii/Text 12). The sculptures connected with the texts showed portraits of homeowners and close family members, as well as deities held in high esteem by the owners (Ephesos/Texts 1–3; Pergamon/Text 4; Delos/Text 9). In the examples from Ephesos and Pergamon,

77 On the phenomenon of the *tabula patronatus* in Roman Spain, see Beltrán Lloris (chapter seven in this volume).

78 The initial publication of this house (Stevenson 1882, 180 f.) thought that both bust and inscription formed an ensemble.

79 Dahmen 2001, 193 cat. no. 184, dates the ensemble in question to the middle of the 3rd century CE; Goette 1990, 151 L53 prefers a date in the Late Severan Period.

80 These will be collected as part of a larger project ("Town residences—Representation of elites in the private sphere. An archaeological-epigraphical study of Hellenistic and Roman Imperial period dwellings in Greece and Asia Minor") planned by the author and Veronika Scheibelreiter-Gail/Austrian Academy of Sciences, Vienna.

81 See e.g. Gehn 2012; Guidobaldi 2000; Niquet 2000, 25–33.

where the evidence indicates that more than one such ensemble was set up under the same person, the monuments are linked to one another—part of a program in which the homeowners represented themselves.

Some inscriptions mention offices held by the homeowners (e.g. priesthood, consulship, membership of associations; Ephesos/Text 1; Pergamon/Text 4), honours conceded to them (Delos/Text 8, Volsinii/Text 12), their ancestry and provenance (Delos/Texts 8 and 10; Volsinii/Text 12). Furthermore, the homeowners are represented in their roles of hosts and guests in particular inscriptions (Ephesos/Text 3; Pergamon/Text 5), reflecting the socio-political importance of *convivia* in this period. A singular feature among the examples given above is the inclusion of eponymous offices in the inscription from Delos (Delos/Text 8), which otherwise occurs regularly in public texts. We also find it in the case of the *tabula patronatus* from the house in Volsinii (Text 12). But in distinction from the Delian example this text was not initiated by the homeowners but by an association honoring important people of their hometown.

Concerning the positions of the texts, some of them are placed at a legible height (Ephesos/Text 1; Pergamon/Texts 4–5, Delos/Text 9) but others are displayed lower than eye level (Ephesos/Texts 2–3; Delos/Text 8). In any event, the texts surely did not draw the eye of the visitors, at least at first sight; this function was achieved by the sculptures alone. The placement of the sculptures was always planned with a view to attracting the attention of visitors or guests. In those cases where ensembles carrying a portrait of the house owners stood opposite the entrances, landlords could welcome visitors even when they were not in residence (Ephesos/Text 1; Delos Text 8; Pompeii/Text 11). As a result, through their portraits and texts, the house owners were omnipresent in their homes. Besides acting as eye-catchers, the sculptures also had religious and decorative functions and could even communicate an easily understandable content to visitors. Combined with the texts, further information could be communicated, explicitly or otherwise. In the case of the late Severan Attalos House at Pergamon, for instance, both texts and sculptures led us to the assumption that the house owner had like so many other people of his day a deep interest in classical and later Greek culture.

While one can observe many similarities between sculpture-text ensembles in the Roman East and West, a main difference—at least compared to the situation at Rome from Augustus onwards—lies in the fact that in the capital the political upper class was allowed to set up such monuments almost only in their homes,[82] whereas in the Roman East we find them both in the private and public realm. Homeowners like Gaius Flavius Furius Aptus in Ephesos,

82 For this see Alföldy 2005, 56–60; Alföldy 2001, 12–16.

Gaius Claudius Attalos Paterklianos in Pergamon, Kleopatra and Dioskurides as well as Spurius Stertinius in Delos are not only well known from the aforementioned inscriptions in their houses, but also by inscriptions from public and sacred realms.[83] Family members and friends were honored by them in honorific monuments and they themselves achieved such honors from friends and public institutions,[84] in sanctuaries they appeared as dedicators (cf. Delos/ Text 10). Therefore it seems that in the Greek East private and public or sacred spheres respectively were connected with each other very closely even under the rule of the Roman emperors.

Inscriptions

Text 1: *IEph* 1267 (Hadrianic). Ephesos, Terrace House 2, Dwelling Unit 6, peristyle 31a, on rear wall of a fountain.

> Διόνυσος Ὄρειος Βάκχιος πρὸ πόλεως
> οὗ ἱερᾶται Γάϊος Φλάβιος Φούριος Ἄπτος.

Dionysos Oreios Bakchios outside the town, whose priest is Gaius Flavius Furius Aptus. (translation: Elisabeth Rathmayr)

Text 2: *ÖJh* 53, 1981/82, no.140.1 (Hadrianic). Ephesos, Terrace House 2, Dwelling Unit 6, room 36, on the eastern base.

> Ζηνὸς καλλιγόνοιο καὶ εὐτέ-
> κνοιο Διώνης ἁβροτάτη
> μακάρων χαῖρε θεὰ θύγατερ.
> ὄντως ἀφρογενής τε καὶ ἐκ πόν-
> τοιο βέβηκας χαιτάων παλά-
> μαις κύματα πεμπομένη.

Daughter of fair-siring Zeus and Dione, mother of beauty,
tenderest always of all blissful divinities, hail!
Truly born in foam and out of the sea you arrive,

[83] See the inscriptions and the literature given above when discussing these examples; for the importance of honorific statues in the public sphere see recently Ma 2013.

[84] For a coexistence of public and private monuments in public spaces in the Hellenistic period, see recently Ma 2013, 233–239.

sending with your arms surges of waves from your hair. (translation: Stefan Hagel)[85]

Text 3: *ÖJh* 53, 1981/82, no.140.1 (Hadrianic). Ephesos, Terrace House 2, Dwelling Unit 6, room 36, on the western base.

Γάϊον καὶ Περικλῆα σάω πολύολβε
Κυθήρη ἠμὲν ἐπὶ ξεινῆς ἠδ' ἄρ'
ἐνὶ σφετέρῃ
ξεῖνον ξεινοδόχον τέ. σὲ γὰρ περί-
αλλα θεάων τείουσιν προφρόνως
πάντα σεβιζόμενοι.

Gaius and Pericles, O Cythera, provider of riches,
guard, both when they are abroad and when they stay in their homes,
both as guests and as hosts. For it is you of all goddesses whom they honour first and foremost, paying you worship and awe. (translation: Stefan Hagel)

Text 4: *MDAI(A)* 32, 1907, 361 no. 117 (Severan). Pergamon, dwelling of the consul Attalos Paterklianos, herm *in situ* in the peristyle court.

Ἄτταλος οὗτος
ὁ τήνδε θεῶν
πανυπείροχον
εἵσας,
Ῥωμαίων ὕπατος,
πρόσπολός ἐστι θεᾶς.

Attalos, he who set up the supreme divinity's image,
he, the consul of Rome, serves as the goddess's priest. (translation: Stefan Hagel)

Text 5: *MDAI(A)* 32, 1907, 366 no.118 (Severan). Pergamon, dwelling of the consul Attalos Paterklianos, herm found in the debris of the house.

85 At this point I want to thank Stefan Hagel from the Institute for the Study of Ancient Culture at the Austrian Academy of Sciences in Vienna for translating some of the texts into English.

ὦ φίλοι, ἐσθίετε βρώμην
καὶ πείνετε οἶνον,
Ἀττάλου εὐφροσύνοις
τερπόμενοι θαλίαις.

Have your fair share of food, don't spare the wine,
Enjoy Attalos' feast, O friends of mine. (translation: Stefan Hagel)

Text 6: *MDAI(A)* 29, 1904, 176 no. 21 (Severan). Pergamon, architectural piece, found on the way from the Lower Agora to the gymnasium in magazine no. 10.

[χαίρετον, εἰ φίλοι ἄνδρες] ἱκάνετον· εἰ δ' ἀθέμισ[τοι /———].

Welcome, friends—if you are! But if you are wicked offenders... (translation: Stefan Hagel)

Text 7: *MDAI(A)* 29, 1904, 179–186 (2nd century AD), copy of the Hermes Propylaios by the sculptor Alkamenes, found on the way from the Lower Agora to the gymnasium in magazine no. 10.

εἰδήσεις Ἀλκαμένεος
περικαλλὲς ἄγαλμα,
Ἑρμᾶν τὸν πρὸ πυλῶν
εἵσατο Περγάμιος.
{²vacat}
γνῶθι σαυτόν.

Know that what you see is Alkamenes' beautiful statue,
Hermes, whom at the doors Pergamius has set up.
Know yourself. (translation: Stefan Hagel)

Text 8: *ID* 1987 (c. 138/137 BCE), Delos, in the house of Kleopatra and Dioskurides, on a statue base.

Κλεοπάτρα Ἀδράστου ἐγ Μυρρινούττης θυγάτηρ τὸν ἑαυτῆς
ἄνδρα Διοσκουρίδην Θεοδώρου ἐγ Μυρρινούττης ἀνατεθεικότα
τοὺς δελφικοὺς τρίποδας τοὺς ἀργυροῦς δύο ἐν τῶι τοῦ Ἀπόλλωνος
ναῶι παρ' ἑκατέραν παραστάδα, ἐπὶ Τιμάρχου ἄρχοντος Ἀθήνησιν.

Kleopatra, the daughter of Adrastos from the [attic Demos] Myrrhinoutte, [placed here] her husband Dioskurides, the son of Theodoros from Myrrhinoutte, who dedicated two silver tripods beside the *antes* of the temple of Apollo. Under the *archon* Timarchos from Athens. (translation: Elisabeth Rathmayr)

Text 9: *ID* 2378 (Hellenistic), Delos, Dwelling E at the Peribolos street, inscription on a statuette *basis* found in the niche of the vestibule.

Σπόριος Στερτένιος
Ἀρτέμιδι Σωτείραι.

Spurius Stertinius to Artemis Soteira. (translation: Elisabeth Rathmayr)

Text 10: *ID* 2379 (Hellenistic), Delos, inscription on a votive relief dedicated to Artemis Soteira, found in the sanctuary of Aphrodite.

Σπόριος
Στερτίνιος Σπορίο[υ]
Ῥωμαῖος Ἀρτέμιδι
Σωτείρᾳ.

Spurius Stertinius, son of Spurius, a Roman, to Artemis Soteira. (translation: Elisabeth Rathmayr)

Text 11: *CIL* X.864 (1st century AD), Pompeii, honorary inscription on a marble herm.

C. Cornelio Rufo

To Gaius Cornelius Rufus

Text 12: *CIL* XI.2702 (AD 224), Volsinii/Etruria, honorary inscription on a bronze tablet.

Ap(pio) Claudio Iuliano II co(n)s(ulibus) | L(ucio) Bruttio Crispino | X Kal(endas) Feb(ruarias) | in schola collegi(i) fabrum civitatis Volsiniensium quem coegerunt || T(itus) Sossius Hilarus et Caetennius Onesimus q(uin)q(uennales) ibi idem q(uin)q(uennales) verba fecer(unt) | quanto amore quantaque adfectione Laberius Gallus p(rimi)p(ilaris) v(ir) e(regius)

erga | coll(eg)ium n(ostrum) agere instituerit beneficia eius iam dudum in nos | conlata confirmant et ideo Anchariam Lupercam uxorem | eius filiam Anchari quondam Celeris b(onae) m(emoriae) v(iri) cuius proles et || prosapia omnibus honoribus patriae n(ostrae) sincera fide func|ta est in honorem eorum et pro morum eius castitatae | et iam priscae consuetudinis sanctitatae patronam | collegi(i) n(ostri) cooptemus statuam etiam ei aeream iuxta eun|dem Laberium Gallum maritum suum in schola collegi(i) n(ostri) || ponamus q(uid) d(e) e(a) r(e) f(ieri) p(laceret) u(niversi) i(ta) c(ensuerunt) recte et merito retulisse | q(uin)q(uennales) n(ostros) ut Anchariam Lupercam honestam matronam sanc|t(a)e indolis et disciplinae caerimoni(i)s etiam praedit feminam | in honorem Laberi Galli p(rimi)p(ilaris) e(gregii) v(iri) mariti eius patroni collegi(i) | n(ostri) et in memoriam Anchari quondam Celeris patris eius || dignissimam patronam cooptemus statuamque ei aeream | in schola collegi(i) n(ostri) iuxta eundem Laberium Gallum maritum | suum ponamus ut eius erga{a} nos pietas et nostra erga eam vo|luntas publica etiam visione{m} conspiciatur tabulam quo|que patrocinalem in domo eius adfigi.

In the year that Appius Claudius Julianus, for the second time, and Lucius Bruttius Crispino were consuls, ten days before the Kalends of February (20 January, AD 224):

In the meeting-place (*schola*) of the association (*collegium*) of builders (*collegium fabri*) of the city of Volsinii, which Titus Sossius Hilarus and Caetennius Onesimus, presidents (*quinquennales*) convened, the same presidents made the following motion:

Laberius Gallus, a centurion of the first military unit in the legion (*primipilaris*) and a distinguished man made it his practice to act towards our association with much love and affection. This is confirmed by his benefactions that he has showered on us for a long time. For these reasons, let us choose his wife, Ancharia Luperca—the daughter of the late Ancharius Celer of sacred memory—as patronness of our association, whose progeny and family served in all magistrate offices of our city with sincerity and in a faithful manner. Let us choose her in their honor and because of the chastity of her way of life and the purity of her sacred habits. We shall also erect a bronze statue for her in the meeting-place of our association beside that of her husband, Laberius Gallus.

When this matter was put to the vote, all unanimously decided that our presidents had rightly and justly proposed that we should choose Ancharia Luperca, an honorable matron of a pure character and way of life, as a most worthy patroness, endowed with reverence, in honor of her husband Laberius Gallus—a centurion of the first military unit in

the legion, a distinguished man and a patron of our association—and in memory of her father, the late Ancharius Celer. We also decided that we should erect a bronze statue of her in the meeting-place of our association beside that of her husband, Laberius Gallus, so that her goodwill, her devotion towards us, and our goodwill towards her will be visible for all in the public view, and also that a patron's plaque (*tabula patronatus*) be attached to a wall in her house. (revised translation: J. S. Kloppenborg, in: http://philipharland.com/greco-roman-associations/332-election-of-a-patroness-by-an-association-of-builders/)

Bibliography

Alföldy, Geza. 2001. "Pietas immobilis erga principem." In *Inschriftliche Denkmäler als Medien der Selbstdarstellung in der römischen Welt*, edited by Geza Alföldy and Silvio Panciera, 11–46. Stuttgart: Steiner.

———. 2005. "Örtliche Schwerpunkte der medialen Repräsentation römischer Senatoren." In *Senatores populi Romani: Realität und mediale Präsentation einer Führungsschicht: Kolloquium der Prosopographia Imperii Romani vom 11.–13. Juni 2004*, edited by Werner Eck and Matthäus Heil, 53–72. Stuttgart: Steiner.

Altmann, Wilhelm. 1904. "Die Einzelfunde." *Mitteilungen des Deutschen Archäologischen Instituts, Athenische Abteilung* 29: 179–186.

Aurenhammer, Maria. 2003. "Skulpturen aus Stein und Bronze." In *Hanghaus 1 in Ephesos: Funde und Ausstattung*, Forschungen in Ephesos VIII 4, edited by Claudia Lang-Auinger, 153–208. Wien: Verlag der österreichischen Akademie der Wissenschaften.

Aurenhammer, Maria, and Alexander Sokolicek. 2011. "The Remains of the Centuries: Sculptures and Statue Bases in Late Antique Ephesus: The Evidence of the Upper Agora." In *Archaeology and the Cities of Asia Minor in Late Antiquity*, edited by Ortwin Dally and Christopher Ratté, 43–66. Ann Arbor: Kelsey Museum of Archaeology, University of Michigan.

Bousquet, Jean. 1956. "Inscriptions de Delphes", *Bulletin de Correspondance Hellénique* 80: 547–597.

Buchicchio, Fabiano Tiziano. 1970. "Note di topografia antica sulla Volsinii Romana." *Mitteilungen des Deutschen Archäologischen Instituts, Römische Abteilung* 77: 17–45.

Burrell, Barbara. 2004. *Neokoroi: Greek cities and Roman Emperors*. Leiden: Brill.

Christof, Eva. 2002. "Skulpturen." In *Das Hanghaus 2 von Ephesos: Die Wohneinheiten 1 und 2: Baubefund, Ausstattung und Funde*, Forschungen in Ephesos VIII 8, edited by Friedrich Krinzinger, 656–667. Wien: Verlag der Österreichischen Akademie der Wissenschaften.

Conze, Alexander. 1912. *Stadt und Landschaft*. Berlin: G. Reimer.

Cramme, Stefan. 2001. "Die Bedeutung des Euergetismus für die Finanzierung städtischer Aufgaben in der Provinz Asia." PhD diss., Universitat zu Köln.

Dahmen, Karsten. 2001. *Untersuchungen zu Form und Funktion kleinformatiger Porträts der römischen Kaiserzeit*. Münster: Scriptorium.

Dickmann, Jens-Arne. 1999. *Domus frequentata: Anspruchsvolles Wohnen im pompejanischen Stadthaus*. München: Verlag Dr. Friedrich Pfeil.

Dörpfeld, Wilhelm. 1907. "Die Arbeiten zu Pergamon 1904–1905: Die Bauwerke." *Mitteilungen des Deutschen Archäologischen Instituts, Athenische Abteilung* 32: 167–189.

Eck, Werner. 2010. "Ehrungen für Personen hohen soziopolitischen Ranges." In *Monument und Inschrift: Gesammelte Aufsätze zur senatorischen Repräsentation in der Kaiserzeit*, edited by Walter Ameling and Johannes Heinrichs, 97–126. Berlin-New York: De Gruyter.

Eule, Cordelia J. 1998. *Hellenistische Bürgerinnen aus Kleinasien: weibliche Gewandstatuen in ihrem antiken Kontext*: Istanbul: TASK.

Gehn, Ulrich. 2012. "Ehrenstatuen in spätantiken Häusern Roms." In *Patrons and Viewers in Late Antiquity*, edited by Stine Birk and Birte Poulsen, 15–30. Aarhus: Aarhus University Press.

Gierke, Michael. 1995. "Herme des Hermes Propylaios." In *Standorte. Kontext und Funktion antiker Skulptur. Ausstellungskatalog Berlin*, edited by Klaus Stemmer, 187–189 cat.-no. B 48. Berlin: Freunde & Förderer der Abguss-Sammlung Antiker Plastik.

Goette, Hans Rupprecht. 1990. *Studien zu römischen Togadarstellungen*. Mainz am Rhein: P. von Zabern.

Guidobaldi, Frederico. 2000. "Vivere come consoli a Roma e nelle province: arredi scultorei, argenti e marmi colorati." In *Aurea Roma: Dalla città pagana alla città cristiana*, edited by Serena Ensoli and Eugenio La Rocca, 134–136. Rome: L'Erma di Bretschneider.

Heimerl, Andreas. 2001. *Die römischen Lampen aus Pergamon: vom Beginn der Kaiserzeit bis zum Ende des 4. Jhs. N. Chr*. Berlin: Walter de Gruyter.

Hepding, Hugo. 1907. "Die Arbeiten zu Pergamon 1904–1905: Die Inschriften." *Athenische Abteilung* 32: 241–377.

von Hesberg, Henner. 2005. "Die Häuser der Senatoren in Rom: gesellschaftliche und politische Funktion." In *Senatores populi Romani: Realität und mediale Präsentation einer Führungsschicht: Kolloquium der Prosopographia Imperii Romani vom 11.–13. Juni 2004*, edited by Werner Eck and Matthäus Heil, 19–52. Stuttgart: Steiner.

Hoffmann, Adolf, and Ulrike Wulf, eds. 2004. *Die Kaiserpaläste auf dem Palatin in Rom: Das Zentrum der römischen Welt und seine Bauten*. Mainz: Philipp von Zabern.

Koller, Karin. 2014. "Marmorausstattung." In *Das Hanghaus 2 in Ephesos: Die Wohneinheit 6: Baubefund, Ausstattung, Funde*, Forschungen in Ephesos VIII 9, edited by Hilke Thür and Elisabeth Rathmayr, 227–254. Wien: Verlag der Österreichischen Akademie der Wissenschaften.

Krämer, Edith. 2001. *Hermen bärtiger Götter. Klassische Vorbilder und Formen der Rezeption*. Münster: Scriptorium.

Kreeb, Martin. 1988. *Untersuchungen zur figürlichen Ausstattung delischer Privathäuser*. Chicago: Ares Publishers.

Krinzinger, Friedrich, ed. 2002. *Das Hanghaus 2 von Ephesos: Studien zu Baugeschichte und Chronologie*. Wien: Verlag der Österreichischen Akademie der Wissenschaften.

———, ed. 2010. *Hanghaus 2 in Ephesos: Die Wohneinheiten 1 und 2: Baubefund, Ausstattung und Funde*, Forschungen in Ephesos VIII 8. Wien: Verlag der Österreichischen Akademie der Wissenschaften.

Ladstätter, Sabine. 2002. "Hellenistische Bebauung." In *Das Hanghaus 2 von Ephesos: Die Wohneinheiten 1 und 2: Baubefund, Ausstattung und Funde*, Forschungen in Ephesos VIII 8, edited by Friedrich Krinzinger, 81–83. Wien: Verlag der Österreichischen Akademie der Wissenschaften.

Lehner, Michael F. 2004. "Die Agonistik in Ephesos der römischen Kaiserzeit." PhD diss., LMU München.

Leunissen, Paul M. M. 1989. *Konsuln und Konsulare in der Zeit von Commodus bis Severus Alexander*. Amsterdam: J.C. Gieben.

Ma, John. 2013. *Statues and Cities. Honorific Portraits and Civic Identity in the Hellenistic World*. Oxford: University Press.

Marcadé, Jean. 1969. *Au musée de Délos: etudes sur la sculpture hellénistique en ronde bosse découverte dans l'ile*. Paris: E. de Boccard.

Mattusch, Carol C. 2008. *Pompeii and the Roman Villa: art and culture around the Bay of Naples*. Washington, D.C.: National Gallery of Art.

Merkelbach, Reinhold. 1999. "Wie Claudius Attalus Paterclianus von Pergamon seine Gäste begrüsste." In *Steine und Wege, Festschrift für Dieter Knibbe zum 65. Geburtstag*, edited by Peter Scherrer, Hans Taeuber and Hilke Thür, 319. Wien: Österreichisches Archäologisches Institut.

Neudecker, Richard. 1988. *Die Skulpturenausstattung römischer Villen in Italien*. Mainz am Rhein: P. von Zabern.

Niquet, Heike. 2000. "Monumenta virtutum titulique: senatorische Selbstdarstellung im spätantiken Rom im Spiegel der epigraphischen Denkmäler." Stuttgart: F. Steiner.

Radt, Wolfgang. 1988. *Pergamon: Geschichte und Bauten, Funde und Erforschung einer antiken Metropole*. Köln: DuMont.

Rathmayr, Elisabeth. 2002. "Skulpturen Wohneinheit 1." In *Das Hanghaus 2 von Ephesos: Die Wohneinheiten 1 und 2: Baubefund, Ausstattung und Funde*, Forschungen in Ephesos VIII 8, edited by Friedrich Krinzinger, 333–342. Wien: Verlag der Österreichischen Akademie der Wissenschaften.

———. 2005. "Skulpturen Wohneinheit 4." In *Hanghaus 2 in Ephesos: Die Wohneinheit 4: Baubefund, Ausstattung, Funde*, Forschungen in Ephesos VIII 5, edited by Hilke Thür, 207–229. Wien: Verlag der österreichischen Akademie der Wissenschaften.

———. 2009. "Das Haus des Ritters C. Flavius Furius Aptus: Beobachtungen zur Einflussnahme von Hausbesitzern an Architektur und Ausstattung in der Wohneinheit 6 des Hanghauses 2 in Ephesos." *Istanbuler Mitteilungen* 59: 307–336.

———. 2010. "Atria in Ephesos? Zu Verteilerbereichen in Peristylhäusern anhand von Beispielen in ephesischen Wohnbauten." In *Städtisches Wohnen im östlichen Mittelmeerraum 4: Jh. v. Chr.–1. Jh. n. Chr.: Akten des Kolloquiums vom 24.–27. Oktober 2007 an der Österreichischen Akademie der Wissenschaften*, edited by Sabine Ladstätter and Veronika Scheibelreiter, 215–220. Wien: Verlag der Österreichischen Akademie der Wissenschaften.

———. 2014a. "Skulpturenfunde." In *Das Hanghaus 2 in Ephesos: Die Wohneinheit 6: Baubefund, Ausstattung, Funde*, Forschungen in Ephesos VIII 9, edited by Hilke Thür and Elisabeth Rathmayr, 367–434. Wien: Verlag der Österreichischen Akademie der Wissenschaften.

———. 2014b. "Stuckdekorationen der Räume 8a und 36c." In *Das Hanghaus 2 in Ephesos: Die Wohneinheit 6: Baubefund, Ausstattung, Funde*, Forschungen in Ephesos VIII 9, edited by Hilke Thür and Elisabeth Rathmayr, 324–329. Wien: Verlag der Österreichischen Akademie der Wissenschaften.

———. 2014c. "Die Besitzerfamilie." In *Das Hanghaus 2 in Ephesos: Die Wohneinheit 6: Baubefund, Ausstattung, Funde*, Forschungen in Ephesos VIII 9, edited by Hilke Thür and Elisabeth Rathmayr, 846–849. Wien: Verlag der Österreichischen Akademie der Wissenschaften.

———. 2014d. "Zur Bedeutung von Skulpturen und mit diesen in Zusammenhang stehenden Inschriften im privaten Raum, dargestellt an Wohnhäusern in Ephesos und Pergamon." Congress papers of the XIV Congressus Internationalis Epigraphiae Graecae et Latinae in Berlin 2012.

———. (ed.). Forthcoming. *Das Hanghaus 2 in Ephesos: Die Wohneinheit 7: Baubefund, Ausstattung, Funde*, Forschungen in Ephesos VIII 10. Wien: Verlag der Österreichischen Akademie der Wissenschaften.

———. Forthcoming a. "Skulpturen Wohneinheit 7." In *Das Hanghaus 2 in Ephesos: Die Wohneinheit 7: Baubefund, Ausstattung, Funde*, Forschungen in Ephesos VIII 10, edited by Elisabeth Rathmayr, chapter XVII. Wien: Verlag der Österreichischen Akademie der Wissenschaften.

———. Forthcoming b. "Baustrukturen der hellenistischen Periode." In *Das Hanghaus 2 in Ephesos: Die Wohneinheit 7: Baubefund, Ausstattung, Funde*, Forschungen in Ephesos VIII 10, edited by Elisabeth Rathmayr, chapter IV.1. Wien: Verlag der Österreichischen Akademie der Wissenschaften.

———. Forthcoming c. "Rekonstruktion der Bauphasen der Wohneinheit 7." In *Das Hanghaus 2 in Ephesos: Die Wohneinheit 7: Baubefund, Ausstattung, Funde*, Forschungen in Ephesos VIII 10, edited by Elisabeth Rathmayr, chapter IV. Wien: Verlag der Österreichischen Akademie der Wissenschaften.

Rathmayr, Elisabeth, et al. 2014. "Hellenistische Baustrukturen, Rekonstruktion der Bauphasen, Zerstörung und Nachnutzung, Konstruktive Details." In *Das Hanghaus 2 in Ephesos: Die Wohneinheit 6: Baubefund, Ausstattung, Funde*, Forschungen in Ephesos VIII 9, edited by Hilke Thür and Elisabeth Rathmayr, 833–836. Wien: Verlag der Österreichischen Akademie der Wissenschaften.

Remijsen, Sofie. 2009. "The *alytarches*, an Olympic *agonothetes*." *Nikephoros* 22:129–143.

Schröder, B., H. Schrader and W. Kolbe. 1904. "Die Inschriften," *Mitteilungen des Deutschen Archäologischen Instituts, Athenische Abteilung* 29:152–178.

Sommerey, Kai Michael. 2008. "Die Chora von Pergamon: Studien zu Grenzen, Siedlungsstruktur und Wirtschaft." *Istanbuler Mitteilungen* 58:135–170.

Stevenson, Henry. 1882. "Scavi di Bolsena." *AdI (Annali dell'Instituto di corrispondenza archeologica)* 54:157–181.

Strocka, Volker Michael. 2013. "Die Athena-Marsyas-Gruppe des Myron in Stuck." *Archäologischer Anzeiger*, 1. Halbband 2013: 85–94.

Swain, Simon. 1991. "Arrian the Epic Poet." *Journal of Hellenic Studies* 111: 211–214.

Taeuber, Hans. 2014. "Graffiti und Steininschriften." In *Das Hanghaus 2 in Ephesos: Die Wohneinheit 6: Baubefund, Ausstattung, Funde*, Forschungen in Ephesos VIII 9, edited by Hilke Thür and Elisabeth Rathmayr, 331–346. Wien: Verlag der Österreichischen Akademie der Wissenschaften.

Thür, Hilke. 2005. *Hanghaus 2 in Ephesos: Die Wohneinheit 4: Baubefund, Ausstattung, Funde*, Forschungen in Ephesos VIII 5. Wien: Verlag der österreichischen Akademie der Wissenschaften.

———. 2014a. "Zur Datierung der Bauphasen—Anmerkungen zur Methodik." In *Das Hanghaus 2 in Ephesos: Die Wohneinheit 6. Baubefund, Ausstattung, Funde*, Forschungen in Ephesos VIII 9, edited by Hilke Thür and Elisabeth Rathmayr, 13–15. Wien: Verlag der Österreichischen Akademie der Wissenschaften.

———. 2014b. "Baubefund." In *Das Hanghaus 2 in Ephesos: Die Wohneinheit 6: Baubefund, Ausstattung, Funde*, Forschungen in Ephesos VIII 9, edited by Hilke Thür and Elisabeth Rathmayr, 29–120. Wien: Verlag der Österreichischen Akademie der Wissenschaften.

———. 2014c. "Rekonstruktion der Bauphasen." In *Das Hanghaus 2 in Ephesos: Die Wohneinheit 6: Baubefund, Ausstattung, Funde*, Forschungen in Ephesos VIII 9, edited by Hilke Thür and Elisabeth Rathmayr, 121–140. Wien: Verlag der Österreichischen Akademie der Wissenschaften.

———. 2014d. "Die WE 6: Vereinshaus eines dionysischen Kultvereins?" In *Das Hanghaus 2 in Ephesos: Die Wohneinheit 6: Baubefund, Ausstattung, Funde*, Forschungen in Ephesos VIII 9, edited by Hilke Thür and Elisabeth Rathmayr, 849–853. Wien: Verlag der Österreichischen Akademie der Wissenschaften.

Thür, Hilke, and Elisabeth Rathmayr, eds. 2014. *Das Hanghaus 2 in Ephesos. Die Wohneinheit 6. Baubefund, Ausstattung, Funde*, Forschungen in Ephesos VIII 9. Wien: Verlag der Österreichischen Akademie der Wissenschaften.

Trümper, Monika. 2007. "Negotiating religious and ethnic identity: The case of clubhouses in late Hellenistic Delos." In *Zwischen Kult und Gesellschaft: kosmopolitische Zentren des antiken Mittelmeerraumes als Aktionsraum von Kultvereinen und Religionsgemeinschaften*, edited by Inge Nielsen, 113–133. Augsburg: Camelion Verlag.

Wrede, Henning. 1986. *Die antike Herme*. Mainz am Rhein: P. von Zabern.

Wulf, Ulrike. 1999. *Die Stadtgrabung. Die hellenistischen und römischen Wohnhäuser von Pergamon*, Berlin: De Gruyter.

Zimmermann, Norbert. 2014. "Wandmalerei." In *Das Hanghaus 2 in Ephesos: Die Wohneinheit 6: Baubefund, Ausstattung, Funde*, Forschungen in Ephesos VIII 9, edited by Hilke Thür and Elisabeth Rathmayr, 273–324. Wien: Verlag der Österreichischen Akademie der Wissenschaften.

PART 3

Place and Space

∴

CHAPTER 9

Painted and Charcoal Inscriptions from the Territory of Cyrene: Evidence from the Underworld

Angela Cinalli

> κατήφησεν δὲ Κυρήνη
> πᾶσα τὸν εὔτεκνον χῆρον ἰδοῦσα δόμον.
> CALL. *Epigr.* 22, vv. 5–6

In the journey through the written material within the private spaces of the ancient world, the funerary sphere cannot be neglected. The tomb is the sign (σῆμα)[1] of departure from the world of the living and it contains a double value: an intrinsic one, in determining a new spatial arrangement for the deceased and the necessity to commemorate him, and an extrinsic one, in representing his social role and identity. The meaning for the burial is reflected in its inscriptions: the σῆμα is expressed through these words and thereby breaks the silence of death.

More than half a century ago, François Chamoux commented that no other ancient city but Cyrene was able to astonish the visitors' sight through the outstanding spectacle of its necropolis.[2] The uniqueness of this city of the dead, a vanguard of Cyrenaean history and identity, led travelers over the centuries to traverse the site in every direction and record it. This evocative cemetery surrounds the city of Cyrene, extending to a radius of about two kilometers. It comprises more than 1400 monumental tombs filling the *widian* terraces. Through funerary architecture and decorative and epigraphic patterns, this

* I am grateful to Prof. Rebecca Benefiel for involving me in this project and for reviewing my English. I would also like to thank Prof. Oliva Menozzi, Director of the Archaeological Mission in Cyrenaica of "G. D'Annunzio" University of Chieti, precious companion of travels and brainstorming, for proposing and entrusting to me the study of epigraphic material found anew in Cyrene. My immense thankfulness goes to Prof. Paola Lombardi for constantly supporting me with her illuminating suggestions and opinions. I would like to dedicate this chapter to the memory of James and Dorothy Thorn and to their passion for ancient Cyrene. The photographs of this chapter are part of the Chieti University Archive of the Archaeological Mission in Cyrenaica.

1 Sourvinou-Inwood 1996, 122–169.
2 Chamoux 1953, 287.

FIGURE 9.1 *Cyrene, view of the Necropolis.*

necropolis testifies both to centuries of Greco-Roman history and to the interaction of the city with other cultural identities (Fig. 9.1).

The rich epigraphic heritage coming from the funerary context of Cyrene consists most recognizably of stone inscriptions. Far less well-known are the texts that were created in more ephemeral media: painted inscriptions and those written in charcoal. Due to the perishability of the materials used (paint and charcoal), these represent a relatively exiguous group, but the surviving examples reveal a panorama that stretches beyond the typical funerary patterns, and provide a quality and quantity of information that is rarely available. Painted and charcoal inscriptions tend to distinguish themselves from other epigraphic evidence of the private sphere, with a less formal presentation and a wider range of possible functions. Through these epigraphic examples, it is possible to recognize various ways of commemoration, some of which might be unofficial and spontaneous and yet still work in association with the proper communicative and iconographic language.

In this chapter we will discuss the most peculiar part of the epigraphic heritage of the Cyrenaean area: the painted and charcoal inscriptions. First, we will reconsider the painted inscriptions that have been published individually in recent years, and then we will introduce and contextualize two recently discovered tombs that contain inscriptions written in charcoal. We will cover

a wide chronological span, from the earliest known examples belonging to the Hellenistic Period, through the Roman Empire, until Late Antiquity. This extended time span suggests that charcoal and painted inscriptions were alternative, valid modes of commemoration at any period. We will take under consideration examples coming from the necropolis of Cyrene but, concerning the painted inscriptions, we will also include in the discussion evidence from the greater region that shows affinities with the city in the use of painted images and words.[3] The final section of this chapter will evaluate the evidence, pointing out some distinctive characteristics belonging to both the epigraphic typologies considered, with the intent to shed some light on a panorama not yet well investigated.

While tracing these extraordinary discoveries from Cyrene and its territory,[4] we will notice that we are faced with handwriting and personal written expressions. In both painted and charcoal evidence, in fact, the *instrumentum scriptorium* does not oblige the writer's hand to trace engraving grooves but lets it glide on the surface. This gives the writing an impression of fluidity, lightness, and velocity, which makes it rather informal and suited to a private sphere, but also more liable to suffer damage. There may originally have been more examples and the small number of inscriptions we have is likely a result of the fragility of the medium. Nonetheless, the examples that do survive allow us the opportunity to conduct a palaeographical analysis of the inscriptions herein discussed, from which future comparisons and studies, especially of the new inscriptions written in charcoal, could possibly benefit.[5]

Painted Inscriptions

This section examines both painted inscriptions commemorating the deceased and inscriptions referring to images and scenes depicted on the internal walls of tombs. In the former case, we deal with simple inscriptions, attesting the name of the deceased or recommending him to the divine realm, and more

3 Evidence from the greater region is considered at the end of sections.
4 Beyond Cyrene, we find other examples of painted and charcoal funerary inscriptions in the Mediterranean area: cf., e.g., the hypogeal inscriptions of Naples: Miranda 1985, 298–299. In this chapter, the territory of Cyrene has been considered autonomously, in order to collect together the charcoal testimonies attested thus far and, whenever possible, to recognize the points of contact with painted inscriptions from the same area.
5 Whenever necessary, a palaeographic apparatus has been included. Otherwise, the palaeographic data are integrated in the text.

complex texts of commemoration, describing the circumstances of the death (Theuchrestos' Tomb; Christian Tombs; Dimitria's Tomb: see below). In the latter group, we find captions identifying the figures and quotations of literary works, "giving voice" to the depicted scene (Thanatos Tomb; Ludi Tomb; Veteran's Tomb; Tomb of Ulysses and the Sirens: see below). Moving thematically and chronologically, we will notice that the rural sites and the areas near the city share the same use of painting we find in the Cyrenaean necropolis.

Our analysis begins with inscriptions whose content involves the deceased. Their use, spreading from the city to the rural areas of Cyrene, covers an extremely large chronological range.

In Wadi el-Aish, in the southern cemetery of Cyrene, the earliest painted inscription known is the one commemorating Theuchrestos, son of Philothales, which was painted on the architrave of a stele in the shape of a *naiskos*: Θεύχρηστος Φιλοθάλους.[6] The stele is of white imported marble and skillfully tooled. The austere and formal letters of the inscription, which consists of only the name and patronymic, have been painted alternately in yellow and blue and, according to the editors, can be dated to the fourth century BCE.[7] They suggest the stele comes from a rich funerary monument and the name of the deceased probably refers to a Cyrenaean family or to a person of high social status.[8] The stele may have originally been located in a place protected against rain (maybe inside the sepulchre?), as traces of paint remain. In any event, it is interesting to note that this epigraphic form is first attested in a not so ancient phase of the history of the southern necropolis, where it is possible later to find other traces of painted and also charcoal inscriptions.

Moving forward throughout the centuries, the later epigraphic documents related to the deceased come from Christian environments. The inscription of Dimitria's Tomb[9] (N83),[10] dating the second half of the fourth century CE, comes from the northern cemetery and is quite unique in content and structure. As usual in the Cyrenaean necropolis, this tomb passed through several

6 Mohamed and Reynolds 1997, 36–38, n. I 9, fig. 2 = *SEG* 47, 2185.

7 The third century BCE is also suggested for dating this inscription, which, besides, may well have had a votive destination in Dobias Lalou's opinion: see *app. cr.* in *SEG* 47, 2185.

8 For example, a priest of Apollo was named Philotales in the fourth century BCE (*SEG* 9 11, line 6) and, among the contemporaneous occurrences of the name Theuchrestos, we can find Olympic victors (Paus 6.12.7) and also the father of Mnasarchos, one of the successful generals fighting the Makae and Nasamones (*SEG* 9, 77): Laronde 1987, 52–58.

9 Bacchielli and Reynolds and Rees 1992, with bibliography of the history of studies on the monument at pages 6 and 8, nos. 2, 3, 5, 6, 7; Bacchielli 1993, 98–102; Ward-Perkins and Goodchild 2003, 176, n. 10.

10 For the numbering of Cyrenaean tombs, Cassels (1955) has been followed.

phases of re-use spanning from the Hellenistic Age to the late Roman Era, incorporating renovations and adapting its architectonic structure to its possessors' needs. This funerary monument aroused the interest of modern travelers and, in the early nineteenth century, Pacho depicted an illustration of it.[11] Although it generated some confusion among later scholars,[12] Pacho's depiction gives the idea of the tomb's importance and originality. The exceptionality of this monument lies particularly in the decorative scheme, including a *paradeisos* put in an *arcosolium*, and in epigraphy, comprising both drawn and painted texts[13] merged in *CIG* 5149[14] and 9136. The inscriptions of Dimitria's Tomb have now received a definitive interpretation and publication by Joyce Reynolds and Bryn Rees.[15] There are two painted inscriptions (*CIG* 9136), one of which is reduced to a few meager traces, while the other is complete and describes the death of Dimitria and her son Theoboulos, due to an earthquake (probably that of 365 CE) in a rural site. The deceased were both buried by close relatives who entrusted to Christ their remembrance.

☧ Διμιτρία θυγάτηρ / Γαΐου τοῦ ὠνησαμένου / τὸ μνημῖο(ν) τοῦτο ἔνθαδε κῖτε / μετὰ τοῦ υἱοῦ αὐτῆς Θεω / δούλου οὗτοι ἐτελεύτησαν / ἐπὶ ἀγροῦ Μυροπωλᾶ σισμοῦ / γενομένου τέθικαν αὐτός / Κάλλιππος ὁ<υ> ἀνὴρ αὐτῆς κὲ / <κε> υἱὸς αὐτοῦ Γάϊος κὲ γαμ / βρεὸ[ς] αὐτοῦ Πολύβουλος / Κ(υρί)ε μνησθήτω τὸν ἐντὸ(ς) σπηλέ / ου τούτου *vacat*

Dimitria, daughter of Gaios who purchased this sepulchre, lies here with her son Theodoulos. They died in the area of Myropolas (?) during the earthquake. Kallippos himself, her husband, Gaios, her son, and her brother-in-law Polyboulos, laid them to rest. Lord, remember this grave.

Palaeographic apparatus. The *mise en page* is highly irregular with cursive writing sloping left, and with a strong contrast between wide and narrow

11 Pacho 1827, 207–9, 378–9, tab. LV.
12 The illustration (Pacho 1827, tab. LV) brings together elements of this tomb and tomb N241, the so-called Good Shepherd Tomb (Bacchielli 1990–1991).
13 Pacho 1827, 395, tab. LXIII–LXIV; Smith and Porcher 1864, 31, tab. 17.
14 For the confusion concerning the edition of these inscriptions in *CIG* and *SEG*, see Dobias Lalou in *BE* (1993) n. 700.
15 Bacchielli, Reynolds and Rees 1992, 16–22 = *SEG* 42, 1675. An exhaustive publication of the painted inscription was initially offered by Comparetti (1914), dating it to 394 CE. His study was cited in the *Dizionario di Archeologia Cristiana* (VII 1, cols. 643–4) and followed by Louis Robert (1978, 398). Later, Roques (1987, 322) proposed a new interpretation and dated the inscription to 365 CE.

FIGURE 9.2 *Dimitria's Tomb, inscription. Recently vandalized.*

letters.[16] The graphic chain appears fragmented and does not touch the base line, perhaps due to the uncomfortable position of the writer. The irregular layout, the distortion of some letters, and the downscaling of writing in the last lines reveal a certain fatigue. With a light distinction in the hatching of some letters, the most distinctive signs are the letter *delta* tied to left and similar to *alpha*, which occasionally has a transverse middle bar; *mu* with inner bar merging in a single curve; vertical of *rho* overflowing in the next line-spacing and little eyelet aloft; *tau* high shaped; *upsilon* in two bars, goblet shaped; *omega* with rounded branches (Fig. 9.2). The palaeographic data, according to the most recent estimates, confirm a fourth century CE dating.[17]

16 Bacchielli, Reynolds and Rees 1992, 19, fig. 14.
17 The documentary evidence of pre-Byzantine literary texts in semi-skilled hands is offered for comparison (see Roberts 1955, 24, n. 24a). Particularly, it is possible to find affinities, for the *alpha, delta, epsilon, mu,* also with Cavallo and Maehler 1987, 8–9, fig. 1a–b. Yet these testimonies are not completely suitable, since the inscriptions herein analyzed do not seem to belong to skilled or literary hands. For this reason, we prefer to refer here to the Cyrenaean epigraphic panorama and occasionally to the Alexandrian mummy-label evidence (see notes 43, 59, 74), which geographically are close examples of capable but likely not erudite writers. In this particular case of Dimitria's Tomb, the palaeographic affinities (which do not constitute watertight evidence by themselves), in addition to Christian data and mention of the earthquake, support its dating to the years following 365 CE.

Other painted inscriptions, more simple than the one from Dimitria's Tomb, come from Christian environments in rural areas of the Cyrenaean territory.[18] To the west of Cyrene, in the small settlement of Siret el Giambi, situated on the west bank of the Wadi Kuf, for example, a rock cut feature contains a tomb that accommodates painted texts on the walls.[19] Christian elements include monogram crosses and the formula Θ(εὸ)ς βοηθός, which are painted in large letters and very rich color. Letter forms include "C" for *sigma* and *beta* with triangular eyelet.

After this brief glance at the painted inscriptions commemorating the deceased, we will now describe the texts referring to images and scenes depicted on the internal walls of Cyrenaean tombs.

In the following two funerary monuments, the inscriptions function as captions that identify the figures. The "Tomb with Unfluted Doric Columns" is located in the most peripheral part of the southern necropolis, which has now been absorbed by the modern city of Shahat. This tomb is also called the Thanatos Tomb[20] because of the painted inscription placed beside a depiction of the angel of death, whose poorly visible and evanescent traces remain. Located to the right of the access door for the final loculus, the inscription identifies the figure: Θάνατος.[21] It is painted in black on what is left of a background of the white plaster that once covered the entire atrium of the tomb. The daemon's name is in the nominative and this suggests the inscription was a *paragramma*, or label, flanking the iconographic representation. According

18 In Gars Uertig, on the plastered walls of a rock cut cistern, Christian inscriptions (presumably of the Justinian Period), which may be associated with provision for water, have been painted. In this regard, the most recent edition states that these inscriptions are painted or incised, whereas in past editions it has always been said that they are painted: Mohamed and Reynolds 1996, 1325, 3a, b, tab. II; Fadel Ali and Reynolds 2000, 1494, n. 5; Ward-Perkins and Goodchild 2003, 401–402, n. 1, 2a–d, illus. 345 (with all previous bibliography on the inscriptions and site). In the Christian chapel (Room C) of Ras el Hilal, on the coast between Apollonia and Derna, fragments of text inscribed on wall-plaster have been found.

 Palaeographic apparatus: The features, observable from Harrison's drawings, highlight the writing of an experienced hand. This is evident from the hooked ended *chi*, from *delta*, executed in a single stroke, and from the lunate *sigma* with a final stalk. The middle bar of *alpha* is halved and the lunate *epsilon* has sometimes a disconnected middle bar; the *rho* and *beta* eyelets are triangular shaped; *omicron* is shrunk: Ward-Perkins and Goodchild 2003, 337, illus. 382.

19 Mohamed and Reynolds 2000, 1495, 8a; Ward-Perkins and Goodchild 2003, 411, illus. 361.
20 Bacchielli 1996; Gasperini 1998.
21 SEG 46, 2210 *app. cr.*

to the architectural and decorative elements, the tomb, as well as the inscription, should be dated to the late Hellenistic era.[22]

Palaeographic apparatus. The lettering of the inscription has a cursive shape. The right bar of the *alpha* is enhanced on top and the letter then curves downwards. The *theta* is elongated with a sloped middle bar. The *tau* has a curved horizontal bar and is tied to the *omicron* in a single stroke. The *sigma* is lunate.[23]

More painted inscriptions occur among the tombs of the necropolis of Cyrene. These inscriptions, enriching the tombs whose decoration consists of pictorial cycles, hold a prominent position.[24] In this group, the Veteran's Tomb[25] (N173) must be highlighted. As with most of the tombs of the Cyrenaean necropolis, this one passed through at least two phases of re-use,[26] spanning from the third century BCE into the Roman Age when, along with a rearrangement of the burial chamber, the addition of the painting cycle likely took place. One fortuitous discovery was that an inscribed stele,[27] found next to the tomb and dated by Joyce Reynolds to the second century CE, contained the name and identity of its owner, who probably corresponds to the individual responsible for the final decorative layout. He is Gaius Ammonis, a legionary who made his fortune serving as a soldier for thirty years away from his homeland. He invested heavily in his tomb, renovating and proportioning the existing space to suit his and his family's needs. If the pictorial decoration is related to him, this soldier tried to show his cultural level by setting up a series of paintings representing his personality and lifestyle, which were more disposed

22 Gasperini 1998, 277–278. Accordingly, the palaeographic data point towards a later period, as long as we recognize affinities with the writing of Tomb of Ulysses and the Sirens discussed below (*omicron* is linked to other letters and the rod of the letter *alpha* begins from the top). Nonetheless, palaeography is not a decisive clue by itself.

23 Bacchielli 1996, tab. 5a. The palaeography is recognizable in the photograph.

24 The tombs of the Cyrenaean area featuring pictorial cycles do not always include epigraphic enrichment. Renowned tombs such as the Altalena Tomb (Bacchielli 1975 and 1993, 78–81), or the Good Shepherd Tomb, N241 (Bacchielli 1990–1991 and 1993, 95–98), or even the Oedipus Tomb in Beit Ammer (Bacchielli 1997 and 1993, 104–107), do not feature any written evidence and, for this reason, are not included in this chapter. Nor are there traces of epigraphic material in the Carpet Style Tomb (Stucchi 1975, 533 fig. 562; Bacchielli 1997, 102–104, fig. 27: at n. 70 previous bibliography is given), in tomb S381A, in the Alexandrian Type Tomb (Stucchi 1975, 157–159; Bacchielli 1997, 107), or in the recently published S64 (Cherstich and Santucci 2010).

25 Bacchielli 1993, 85–86; Santucci 2010a; Santucci and Reynolds 2010b.

26 The phenomenon of re-use in later periods subsequent to construction occurs in a high number of tombs of the Cyrenaean necropolis. E.g.: Bacchielli, Reynolds and Rees 1992, 5.

27 *DAI* II 1, n. 123, fig. 78b (= *SEG* 9, 235).

FIGURE 9.3 *The Veteran's Tomb, Leda inscription top right.*

to quantity of imagery than to a coherent program. The *pinakes* are equipped with painted inscriptions (nowadays very fragmentary) acting as captions and defining the background of figurative representation.

On the left wall, first panel from the left, the didactic inscription identifying Ψυχή, drawn in red-brown color (as can be gathered from photographs), is divided into two syllables, one at either side of the female figure, who is portrayed between symbols of opulence and joviality. Then, in the following frame, the inscription Λήδα is located below the long swan's wings, the only element remaining of mythical representation (Fig. 9.3).

Other *pinakes* preserve traces of the inscriptions Γανυμήδης and Ἀκταίων, accompanying the corresponding figures (Fig. 9.4). These have been documented with line-drawings.[28] What clearly emerges here is the didactic functionality of the inscriptions featured within the panels of the Veteran's Tomb, for they complete the representation and support the identification of mythical scenes.[29]

28 Santucci 2010a, 354–357, fig. 1–4; Santucci 2010b, 285–292, figg. 14–15, 17–19. Also the captions [Μοῖρ]αι and Ἀδ[ωνις] (?) are recorded, even though they are not observable among the photographic apparatus.

29 In addition to the Veteran's Tomb, also the Oedipus Tomb and the Tomb of Ulysses and the Sirens (see below), preserve decorative cycles dedicated to mythical themes. The Oedipus Tomb (Bacchielli 1997) has a decorative cycle structured in paratactic panels that closely

FIGURE 9.4 *The Veteran's Tomb, inscriptions accompanying figures.*

Palaeographic apparatus: The few brief traces of writing detected do not constitute a complete prospectus of the writer's (= decorator's?) *modus operandi*. The left slope of the letter *lambda* in Λήδα and the soft and rounded hatching at the far end of bars give the impression of an informal and cursive layout of a hand accustomed to writing and experienced in hatching.[30]

In this collection of the painted inscriptions of the Cyrenaean territory we cannot neglect two tombs, respectively from the city and its hinterland, whose epigraphic material is connected to pictorial cycles, both as captions and as

recalls the decorative layout of the Veteran's Tomb but does not preserve any inscription, though.

30 On the contrary, it is interesting to highlight that the lettering of C. Ammonis' stele seems insecure, informal and tending to ties, as a non-professional letter-cutter incised it (Reynolds in Santucci 2010b, 292–293). Similar features, involving a sort of cursive lettering and hinting at inexperience, can be noted, e. g., in *SeCir* 46.

quotations of literary *pièces*, which the imagery references. The Ludi Tomb ("The Games Tomb") is in the northern necropolis and is so called because of the subject of the frescoes, which depict games and competitions.[31] Within this discussion, the tomb can be only partially described since the documentation is incomplete and the monument still awaits systematic publication. Execution of the inscriptions in this tomb is clearly attributable to multiple hands at different times. Some have been drawn with a stylus on the hardened plaster, while others have been traced on wet plaster with a paintbrush dipped in black. These inscriptions are arranged on every panel and are largely concentrated among the depiction of dramatic and musical ἀγῶνες (*CIG* 5149b[32]), where they fill the background.[33] The unique epigraphic traces reported so far are the etched ones on the hardened plaster and regard the *munus gladiatorum*,[34] whose inscriptions work as captions that identify the gladiators and their role, and the ἀγῶνες σκηνικοί.

Among these latter ones, the inscriptions of the comedy scene seem to be the quotation of a popular *pièce* of Menander and date toward the end of the second century CE.[35] We can recognize the hand of different writers on the panel of the musical and dramatic ἀγῶνες.[36] They have etched texts on the

31 Pacho's reproductions of this monument are valuable: Pacho 1827, 203–7, tabs. XLIX, L, LII, LIII. For a detailed history of the studies on this monument, see Bacchielli 2002, 285–289. Autopsy of the monument some years ago unfortunately revealed that it has suffered vandalism.

32 These have been transcribed by Pacho and included among his drawings of this burial. On this basis, they were published as *CIG* 5149, where further texts of heterogeneous provenance are also collected. This confusion is discussed in *SEG* 42, 1674 *app. cr. in fine*.

33 A similar method of insertion of the epigraphic text on the neutral background of a narrative frieze can be seen in the Christian themed panel of the Werscher Tomb's *exedra* in Kum el-Shoqafa: Venit 2002, 184–186, fig. 159.

34 The text [Ἐ]πίκτητος [ὁπλ]όμαχος (Bacchielli 2002, 297, fig. 17; *SEG* 52, 1845 with restoration) is clearly visible. The same hand seems to have traced also the inscription on the opposite side: [- - -]ΑΓΕΙ [- - -]ΡΑΧΟ[Σ].

35 Bacchielli 2002, 300, fig. 20, tab. IVa; *SEG* 52, 1845. Two inscriptions, atop the comedy scene, seem to be the work of two writers and contemporary to the fresco layer. One of them, which finds similar evidences in Menander dramaturgy, has been preliminarily reconstructed: ἀλλ'ἐψόφηκεν / ἡ θύρα· // ὁ πατήρ / προέρχεται / ὁ πατήρ // [κρούσ]ομαι αὐτός (Pacho 1827, tab. XLIX; according to Pacho, Bader 1971, 36, n. 2; Bacchielli 1993, 91–93, and Id. 2002, 300–305, with new reading and interpretation of the *mise en colonne* = *SEG* 52, 1845).

36 Bacchielli 2002, 300, fig. 20; 304, fig. 24; 306–307, figg. 25–26; tabs. IV–V. At least three writers can be identified. According to a preliminary analysis of the images, it is likely that one hand (Bacchielli 2002, 307, fig. 26; Pacho 1827, tab. L) wrote a curse, between the *syrinx*

FIGURE 9.5 *Ludi Tomb, inscriptions on the panel of musical and dramatic* ἀγῶνες.

hardened wall-plaster [37] and therefore incised them at a later time, compared to the ones on the wall decoration (Fig. 9.5). A palaeographic and epigraphic study of this monument would be invaluable not only to reconstruct the dating of the inscriptions and to analyze the different hands but also to establish suitable comparanda.

In the Tomb of Ulysses and the Sirens,[38] in a village called Asgafa El Abiar about forty kilometers south of Barke, inscriptions serve as both captions and quotations. These painted inscriptions allow for a more substantial discussion than those in the Ludi Tomb, because their publication is more complete. The Tomb of Ulysses and the Sirens captures our attention for its affinities with the Veteran's Tomb in the use of the pictorial apparatus. Here too we are faced with captions for figures and with a pictorial cycle, which actually encompasses a more homogeneous repository of decoration. Furthermore, the enrichment of a scene with

 and *aulos* players: καθ' ΙΑΜΑΛΛΑ κατά|ρατος Ἀ<ν>τωνῖνος (*CIG* 5149b follows the reading of Pacho: κα[θ]' ἀμ[ι]λλά[μ]ατα | [π]ρᾶτος Ἀ[ν]τωνῖνος). Whether this interpretation was valid, it would indicate that not all the inscriptions refer to the iconographic apparatus but that their content is heterogeneous.

37 Suitable comparisons to this typology of inscriptions can be recognized in the graffiti from the Wadi Bel Ghadir tombs (Paci 2003, 175–8) and from an οἶκος: *SeCir* 192.

38 Bacchielli 1993, 107–12; Bacchielli and Falivene 1995.

a literary citation, recalls the inscription associated with the comedy scene in the Ludi Tomb. Dating to the second half of the fourth century CE, this funerary monument of Asgafa El Abiar displays rich pictorial decoration applied to a plaster layer in fresco technique on its walls, on *arcosolia*, and on the vault of the burial chamber, including a painted inscription in the scene that represents Ulysses and the Sirens. Aside from the floral decoration and the banquet scene with the participation of the deceased, the representation is organized through scenes from the epic repertoire. Captions identify all figures depicted, including Achilles' two horses. The publication of the tomb includes illustration of one of these captions, that of Polyxena who is named in the nominative, whilst the captions for the other figures are discussed without photographic documentation.[39] The most interesting scene in epigraphic terms is the depiction of Ulysses and the Sirens. The three Sirens, winged and naked, are portrayed in standing position with female body and bird legs. The left one holds a *kithara* and the right one a *diaulos* in both hands. The central Siren displays a papyrus scroll on which a column of writing has been annotated, traced *a fresco* with the same color and paintbrush used for the scroll drawing.[40] The text is an evocation, without metrical structure, of the Sirens' Odyssean song, ideally accompanied by the sound of *diaulos* and *kithara* represented on either side of it.[41] In the Sirens' scroll we can read:

[Εἰσαφίκ]αν[ε]/ καὶ ἄκουσον/ Ὀδυσσε[ῦ] ὁ Σ[ει]/ρήνω[ν ὅδε]/ φ‹θ›όγγ[ος τῶν] ἀδιγ[άων]./ Τὶς ἀ[οιδῆς]/ ἀκού[σας παρ]/έπλευ[σε τὸν]/ λειμῶγ[α];[42]

Come and listen, Odysseus: this is the sound of the loud-voiced Sirens. Who, listening to the singing, sailed through the meadow?

Palaeographic apparatus: The informal majuscule writing contains cursive elements: the *delta* and *upsilon* are linked in a single stroke, the *theta* and *omega* have elongated pincers, the bards of the *lambdas* are considerably open, and the four-bar letter *mu* is tied to the *omicron* in the last line.[43] The square lettering, increases in size *ab initio* and the writing leans to the left.

39 For Polyxena, see Bacchielli and Falivene 1995, 107, tab. III 2.
40 Bacchielli and Falivene 1995, fig. 7.
41 Bacchielli and Falivene 1995, 100.
42 SEG 45, 2150; BE 109, 2 (1996), 88. The text is here registered with the restorations proposed by Falivene.
43 Similarities, in some letters and in the general impression of writing, are offered once again by the Egyptian panorama, particularly by a mummy-tablet preserved at the Allard

This inscription, together with Menander's citation in the Ludi Tomb and with the Pseudo-Epicharmean inscription of the Carboncini Tomb (which will be discussed shortly), confirms the affectation for literary citation in the funerary context of Cyrene. The use of these scenes and captions in Cyrenaean tombs may derive from anthologies and picture books of mythical and epic themes.[44] In those types of collections, the most representative images were likely equipped with brief comments and captions helping with identification of characters and scenes.[45] Altered representations and re-elaborated texts could depend on a large spectrum of visual and literary memories other than anthologies,[46] which the dialogue between customer and *pictor* likely sparked.

Charcoal Inscriptions

In the next section, the inscriptions written in charcoal that have been found in the necropolis of Cyrene will be considered. These have been discovered and documented during archaeological surveys in recent years and, up to now, they seem to represent the unique examples of charcoal inscriptions attested in the Cyrenaean necropolis. Two tombs in the southwestern part of the necropolis, The Garden Tomb and The Carboncini Tomb, have yielded these rare discoveries. The latter monument still awaits systematic publication. In this section, we offer an outline of the use of charcoal on the internal walls of these tombs, in order to shed light on a new aspect of funerary commemoration which can offer deeper insight for our understanding of Cyrenaean epigraphy.

The Garden Tomb[47]
The Garden Tomb, so called by J. C. Thorn[48] and the author of this chapter, does not feature in the Cassels 1955 list of tombs of the Cyrenaean necropolis since it is a recent discovery.

Pierson Museum of Amsterdam, dating between the second and the fourth centuries CE: Boswinkel and Sijpesteijn 1968, 54d.

44 Also for the scenes of the Oedipus Tomb at Beit Ammer, even lacking of epigraphic apparatus, has been hypothesized such an origin (Bacchielli 1997).
45 Weitzmann 1959, 84, 95–99; Bacchielli and Falivene 1995, 100.
46 Santucci 2010a, 360.
47 For detailed publication of this tomb, see Cinalli 2014 + Corrigendum 2015.
48 Thorn 2005, 361, fig. 238.

FIGURE 9.6A *Plan of the Garden Tomb. Position of inscriptions. (Drawing: A. Cinalli)*

The tomb had remained unknown because it was enclosed in a modern private garden.[49] The Garden Tomb is located to south-east of Cyrene, next to a side street that runs along Uadi-el-Aish, leading towards the hinterland. Here the tombs are not assembled in terraces, but extend over the plain, at the sides of an arterial road which has probably existed since ancient times.[50] This funerary monument consists of two burial spaces (Fig. 9.6A), a main chamber and a smaller chamber. Originally, the courtyard was at ground level, but the ground level is now considerably above it. A Doric frieze was located on the monumental façade, where probably a full-scale limestone statue of a funerary

49 The excavation was conducted in the Spring 2001 by the Department of Antiquities of Shahat in cooperation with the Universities of Chieti and Urbino. Finds included blocks from the Doric frieze, the slabs that closed the loculi, moulded blocks, the typical Cyrenaean half-figured statue of a funerary goddess, a full-sized statue with *himation* and papyrus scroll in hand, and a funerary portrait (now lost). None of these items were found *in situ*, perhaps due to collapse of the external façade, vandalism, looting and perhaps even flooding. The tomb was found in a poor state of preservation, as personally witnessed by the author and members of the Archaeological Mission of Chieti University in Cyrenaica in May and October 2002.
50 Chamoux 1953, 287.

divinity[51] was placed too.[52] The funerary room of the main burial space is arranged as a wide chamber with three funnel-shaped loculi on the side opposite the entrance. The typology of this first arrangement, following the architectural idea of funerary evolution conjectured by J. C. Thorn for the Cyrenaean necropolis, dates from the mid-fourth century BCE onwards.[53] The first structure of the Garden Tomb was progressively enriched with two more loculi and a *cubiculum* with *arcosolia*[54] on both short sides of the chamber. The various phases of enlargements and alterations of the structure of the monument testify to its re-use into the Imperial period. The walls of the main burial were covered with red and blue paint and a similar color scheme was also used to decorate the Red Tomb in the northern necropolis.[55] There are also traces of ocher, which may have been used to highlight the edges of the internal doors. On the south-eastern wall, between the last loculus and the *cubiculum*, next to traces of blue paint, an inscription was traced with a charcoal stylus (Inscription A):

ΤΙΜΗ
| ⊢Κ ⊢Κ |⊢Κ ⊢Κ

Below the inscription one can see traces of a poorly preserved drawing, also executed in charcoal. To the right of this, an additional, brief text is legible, consisting of either the letter *mu* with four bars or -νι. The interpretation of this inscription is uncertain and no comparanda are known thus far. The image drawn below the inscription seems to reproduce some sort of a plan of the burial, with rectangular shapes that could represent loculi or coffins arranged around a narrow corridor. The two shapes on the left seem to be highlighted. If the abbreviation is an indication of a number or rather of price, it should be considered to indicate "twenty drachmas"[56] repeated four times, divided into

51 For this sculpture typology, see Beschi 1972.
52 For more on the placement of funerary goddesses in Cyrenaean tombs, see Beschi 1972, 314–315; Collignon 1911, esp. 204–205.
53 Thorn 2005, 349–350.
54 For the study of this funerary typology: Cherstich 2008a, 135–138, and 2008, 84–87; Cinalli 2008.
55 Thorn 2007, 92.
56 The indication of price might follow the alphabetic numeral system, frequently attested in Cyrene: e.g. *SEG* 9: 39, 41, 73. See Oliverio's comment on the demiurges accounts: *DAI* I 2, 85–168.

two groups by the block signs (δραχμὰς κ', δραχμὰς κ'· δραχμὰς κ', δραχμὰς κ').[57] Accordingly, it could be interpreted as an announcement issued by the owners of the burial plot, indicating the value (τιμή) of depositions for purchase or usufruct. If we accept this theory, we can conceivably also calculate that the writer of the announcement was implicitly referring to an internal regulation on the re-use of burials, or to a Cyrenaean *ius sepulcri* allowing for the extension of the number of burials admitted in a tomb.[58] In this case, the image and the inscription may suggest four depositions distributed in two niches. However, this interpretation must remain hypothetical.

On the opposite wall there is a more extensive charcoal inscription, which is preserved on traces of vivid red paint (Inscription B, Fig. 9.6B):

ὑφ' ἡδονῆς ΔΕΠΑΝ [- - -]
[Λ?]φων ΗΝΩΣ *vel* [- - -] φωνὴν ὡς
Τιμα[- - -]

The palaeographic data of this text point towards the epigraphic trends of the second-third century CE[59] and show affinities with the Christian painted inscriptions seen in Ras el Hilal.[60]

The reconstruction of the text is challenging and any interpretation would perforce be hazardous. The parts of the missing text at the right and left edges

57 The damaged condition of the inscription allows two possible interpretations: the first, implying the transitive verb ἀποτίνω (= pay) + δραχμάς (cf. *SEG* 9, 4, ll. 42–43), or another that consists of a simple wish for price recording, implying the verb εἰμί + δραχμαί.

58 On the other hand, we have examples in Cyrene of inscriptions which forbid violating sepulchres and burying other people in a tomb: *SEG* 9, 248, Robinson 1913, n. 41 and 62, Mohamed and Reynolds 1997, 34–5 n. 4c (see also Robinson 1913, n. 42, alerting that the tomb is already full). Particularly interesting is *SEG* 9, 248, which clearly refers to a public regulation: Ὦ μὴ ἀνῆκεν, μή τι/[να βάλ]λιν· εἰ δὲ μή,/ χρησόμεθα/ κατὰ τὸν νόμον. We cannot be certain as to whether the above-mentioned testimonies from Cyrene concern the same νόμος, or a private regulation, or if they do not. The same uncertainty applies to the Garden Tomb, whose inscription, however, might indicate an extension of burials rather than a restriction. More evidence in the region of Cyrene for public regulation concerning the violation of sepulchres comes from Ptolemais: *IGR* 1027; *SEG* 33, 1468. Cf. also the epigraphic evidence from Asia Minor, variously attesting regulation on the admission of strangers, on purchase, and usufruct of tombs: Ritti 2004, 503–510.

59 For a funerary example, see Mohamed and Reynolds 1997, 43, n. 114, pl. VIIb. It is also possible to find these palaeographic features in some of the mummy-tickets stored in the Museum of Cairo and dated to the second/third century CE, e.g. *Milne, Cairo Mus.* 9346, 9383, 9398, 33008.

60 Especially for the *alpha* with the middle bar cusp shaped.

FIGURE 9.6B *Inscription B in The Garden Tomb.*

cannot be established with precision, even though it seems that there was no additional text above the first line. The third line is written in larger letters, as if the writer wanted to emphasize it; there may be various reasons for this. An invocation with the verb τιμάω comes to mind, based on the fact that the nouns ἡδονή and φωνή are often found together in Christian writings.[61] Another possibility for reconstructing the text would be to take the preposition ὑπό in the sentence as an agent or place complement and the possible verb that δ' ἐπαν[- - -] can indicate. The verbal form implied here could be ἐπανήχθης from ἐπανάγω which bears the meaning "lead back" or "bring back."[62] Supposing a burial subsequent to Ἡδονή's[63] generation, there could be a commemoration of Τιμα[- - -] who has been brought back to Ἡδονή and the ἀδελφοί. However, in this case, there would be a difficulty with the following letters ΗΝΩΣ.

Yet another option is to read ἐπανωρθώθης, from ἐπανορθόω,[64] which means "correct" or "set up", but which can also bear the meaning "teach," as in *IG* I³ 101, line 58. We cannot exclude the possibility that this inscription could also have a metric structure, bringing to the fore the comparison of death to a loss

61 E.g.: Basilius, *Enarratio In prophetam Isaiam*: 5.177, 13.277; Athanasius, *Doctrina ad Antiocum ducem* 2.21.
62 *LSJ* 1996, 607 s.v. ἐπανάγω.
63 This female anthroponym is not attested in Cyrenaica but is used elsewhere between the first and the second century CE, especially in Asia Minor.
64 *LSJ* 1996, 609 s.v. ἐπανορθόω.

of voice, an idea that we come across in some epigraphic texts.[65] The presence of φωνήν followed by ὡς recalls a comparison with an Attic epigram of the second/third century CE (*IG* II² 13134), where the voice of the dead is not audible as before: [ν]αὶ λίτομαι, γλυκερὴν ἀπὸ χείλεος ἔκβαλε φωνήν/ὡς πάρος. In this case, Τιμα[- - -] may have been raised by Ἡδονή (mother, nurse, guardian?) who does not hear his/her voice as before: just as an example, σὴν δὲ φωνὴν ὡς πάρος οὐκέτ' ἀκούει. This interpretation seems the most acceptable one, in so far as it allows us to connect the two lines justifying φωνήν in the accusative, as well as the following ὡς.

We have here two remarkable inscriptions belonging to two different moments in the life of the Garden Tomb. If we accept the interpretation proposed, the first text is thus far a unicum in the Cyrenaean epigraphic heritage and points to a pragmatic aspect within the funerary sphere: tomb selling. The other inscription on red paint is also fragmentary and various interpretations have been put forward for it. The most plausible one is that this inscription testifies to the use in Cyrene of the funerary theme that associates the concept of loss of voice to death.

The Carboncini Tomb

This large tomb was discovered in 2006 during surveys in the southern necropolis of the Archaeological Mission in Cyrenaica carried out by The University "G. D'Annunzio" of Chieti. Following completion of documentation, the tomb was reinterred and included in the Chieti University GIS. Even being registered in the Cassels' 1955 catalogue as Tomb S147, it remains unpublished and is currently under study.[66] Due to several elements of interest and innovation, the monument bears a relevant position in the panorama of Cyrenaean funerary architecture. The originality of this tomb lies in the complex and generous epigraphic apparatus, mainly written in charcoal, which bestowed on the monument the name of The Carboncini Tomb (The Charcoal Tomb). This is only the second time that a tomb with inscriptions written in charcoal has been found in Cyrene. Moreover, the richness of these inscriptions, in number, layout, and

65 E.g.: *IG* XII 5591; *CIG* 3765.
66 The author of this chapter, Drs. L. Cherstich, and D. Lagatta are arranging the study of the monument for publication. The tomb was presented in May 2013 at the XVIIIth International Congress of Classical Archaeology (AIAC) in Mérida. The forthcoming Proceedings will contain a preliminary description of the tomb from both archaeological and epigraphic points of view. In this chapter, an introduction of the epigraphic apparatus is provided.

FIGURE 9.7 *Plan of the Carboncini Tomb (Drawing: L. Cherstich).*

content, revealing a continual use of the tomb through different phases from Late Hellenism into the Roman Period, is unparalleled.

The external arrangement of the tomb consists of a large buried court with a false-façade on the western side, showing the entrance to the burial. The inner space of the Carboncini Tomb (Fig. 9.7) consists of a long sequence of burial rooms carved in the rock. The tomb was looted and, due to the silting up of the site with portions of the tomb remaining deeply underground, some loculi were not accessible to the research team. Despite these sub-optimal research conditions, it is evident that this is one of the most articulated among the tombs of the Cyrenaean necropolis. The structural complexity is the result of several transformations and enlargements testifying to a long continuity of use, from the Hellenistic period to the late Imperial age. So far, it has been possible to identify at least three phases for the Carboncini Tomb: 1) the late Hellenistic Gallery (AB), whose farthest loculi had been broken to enlarge the

burial space, and Room (C), with a barrel-vaulted soffit;[67] 2) the Alexandrian loculi Room (D); 3) a sequence of rectangular Rooms (E, F, G, H, L) to be classified between the second phase and later enlargements.

Numerous inscriptions crowd the internal walls of this tomb. They were gradually added to the walls, and in some cases they result in a palimpsest of texts. Texts consist of simple commemorations as well as more complex messages. These inscriptions seem sometimes to show genealogical connections among the deceased, some of whom can be identified as belonging to particular social groups. Different writers follow one another and testify to the prolonged use of the burial chambers. The most relevant inscriptions are herein presented, in order to offer an overview of the complexity and of the extraordinary richness of the epigraphic apparatus of this sepulcher.

The long and chaotic sequence of inscriptions in this tomb begins with the latter loculi in Gallery AB, from where the following rooms are revealed. The disposition of the inscriptions between the fourth and fifth loculus of Gallery A, framing the doors and creating an epigraphic frame divided in columns and lines, recalls a summary of burials introduced by εὐψύχι and ὑγίαινε. These formulas also occur elsewhere in Rooms C and E of the tomb, followed by names given in the vocative (Fig. 9.8). The sign -L (ἐτῶν/ἔτους) introduces numerical signs related to the age of the deceased. Particularly, among the inscriptions of Gallery A, we selected the following text:

Μεσορὴ ιγ ʹ ὑγίαινε Ἀναξάνδρε[68]

The main point of interest of this inscription consists of Μεσορή, month (July-August) of the Egyptian calendar well documented in Cyrene and Cyrenaica from the first century until the end of the third century CE. In the private sphere particularly, the month Μεσορή is frequently attested among the epigraphs

67 This feature often appears in Alexandria (Venit 2002, fig. 66–8). Within the tombs equipped with a decorative and epigraphic arrangement, The Carboncini Tomb is not unique in revealing remarkable contacts between Cyrenaean and Alexandrian architecture. See, e.g., the Dimitria Tomb (Bacchielli 1992, 10 and 12). These architectural observations will be discussed at greater length by Dr. L. Cherstich in future publication of the Carboncini Tomb. For preliminary observations about the cultural fusion, which for centuries connected Cyrene and Alexandria, see Cherstich 2008a, b.

68 The name Ἀνάξανδρος is often attested in Cyrene, from the third century BCE to the first CE: *SeCir*: 18. 6, 264; *SEG* 9, 51, line 3; *BMI* 1053 B, line 19.

FIGURE 9.8 *The Carboncini Tomb, Gallery A.*

of Teucheira, attributable to a Jewish group,[69] where a systematic use of the Egyptian months occurs.[70]

Remaining in the Gallery, beside the fifth loculus of corridor B, there is one of the most fascinating texts of this tomb commenting upon death and divine. The inscription is sketched lightly and there is a lacuna at the end. Nonetheless, it has been possible to reconstruct the text as follows:

> Νεκρὸς ἠμὶ κόπρος,
> κόπρος δ' ἔβη γῆ‹ν›·
> δ' ἐστὶ θεὸς ἤ τι
> θέον γῆ, κα[ὶ] θεὸς δ' ἐστὶ

69 According to Applebaum 1979, 130–144, this Jewish group moved from Egypt to Cyrenaica at the time of Ptolemeus Lagos. It is worthwhile adding that the Jewish movement can be traced within the greater territory but, up to this point, it has been poorly documented in Cyrene itself.

70 See Applebaum 1961; Lüderitz-Reynolds 1993.

νεκρός. [Χαῖρ]ε Φιλησὼ Ἰλ-
αρίωνος L z
[- - -]

Dead I am dirt, the dirt went in the soil. Earth is god or somewhat divine, then the dead is god. Farewell *Phileso* daughter of *Ilarion*, aged seven [- - -]

Although the end of the text is missing, we can infer that the syllogism has been dedicated to Phileso,[71] young Ilarion's daughter. The lines appear as a quotation of a well-known epigram shaped as a syllogism by Pseudo-Epicharmus (fr. 297 K.A.), attested by the Schol. (bT) Hom. x 414: εἰμὶ νεκρός·/ νεκρὸς δὲ κόπρος, γῆ δὴ κόπρος ἐστίν·/ εἰ δ' ἡ γῆ θεός ἐστ', οὐ νεκρός, ἀλλὰ θεός. This testimony from Cyrene can now be added to four other epigraphic examples of the Pseudo-Epicharmean syllogism. These funerary inscriptions—two in Greek from Eretria and Thespiae (*GVI* I 1126, 1941) and two in Latin from Rome (*CIL* VI.29609, 35887)[72]—span from the third century BCE to the third century CE. Among the replicas of the Pseudo-Epicharmus syllogism attested since, we can affirm that the Cyrenaean text is the closest one to the version transmitted in the literary sources. The inscription from Cyrene once more testifies to the huge revival, in geographical and chronological terms, of the Pseudo-Epicharmean sentence, which conceivably circulated as a maxim of popular wisdom suitable for funerary context.[73]

Several inscriptions crowd around the southern door of Room C and climb up to the barrel-vaulted soffit, where a hand with confident and fluid *ductus* uses contractions and words tied in nexus. It seems that the writer adopted a personal technique for circumscribing the epigraphic frame through the sign -F, which also occurs in Room D (Fig. 9.9). The inscription on the soffit informs us that we are in the tomb of Ἰσοκράτης ἀρχιερέος, indicating a family connected to the cult and the priesthood of Apollo.

Palaeographic apparatus: This writing has a highly irregular form, clearly due to the inconvenient position of the writer. This inscription finds affinities

71 The name Phileso is also attested in Alexandria on a funerary painted stele naming two Cyrenaean women: Phileso and Sparte (*SEG* 2, 855). The anthroponym Ilarion, with numerous testimonies throughout Greece, occurs in Egypt (Perdrizet and Lefebvre 1919, n. 637) but not in Cyrene.

72 Peek 1942.

73 A detailed study of this inscription is in preparation.

FIGURE 9.9 *The Carboncini Tomb. Room D, the barrel-vaulted soffit.*

with the writing of the Sirens' scroll (particularly for the letter *alpha*, whose middle bar is curved)[74] and with some graffiti in the Ludi Tomb.

From Room C it is possible to enter Room F (end of the first or second building phase) where we find three sarcophagi in imported Cycladic marble of a fourth century BCE typology.[75] They have clearly been disturbed from their original position (there are only two tops for three sarcophagi) and they likely come from an older tomb. Two sarcophagi are anepigraphic, whereas the third sarcophagus bears inscriptions. Among them, we read:

Ἰούλιος Κρίσπος Κ |
Γάϊος Ἰούλιος Κρίσπος

The deceased Ἰούλιος Κρίσπος, whose inscription appears on the long side of the sarcophagus (Fig. 9.10), bears a Latin *gentilicium* and *cognomen* and he is likely the twenty-year old son of Γάϊος Ἰούλιος Κρίσπος, whose *tria nomina*

[74] This shape of *alpha* is attested in Egyptian painted inscriptions of the second/third century CE: e.g. *Milne, Cairo Mus.*: 9355, 9357, 9371, 9372, 9380. Cf. the graffito of a Cyrenaean οἶκος: *SeCir* 192.

[75] For a general overview on Cyrenaean sarcophagi, see Lagatta 2005.

FIGURE 9.10 *The Carboncini Tomb. Room L, painted inscription of* Κρίσπος.

are inscribed on the short side of the same sarcophagus. The sign | is in fact attested in Cyrene for homonymy. The *cognomen* Κρίσπος is well documented in Cyrene, particularly in the second century CE, and is associated with individuals in the military. It should also be noted that this *cognomen* is documented among the Jewish community of Teucheira.[76]

In Room L, belonging to the latter phases of the tomb, we find two more inscriptions which deserve to be mentioned, although they are not written in charcoal but in red paint.[77] To be more precise, despite the predominance of charcoal inscriptions within the Carboncini Tomb, painted examples can be found also in Gallery B (fifth loculus' slab) beyond Room L. In Room L, we find the inscription of the little Εὐίππιον, Ἀναξέας' child, painted in red color with calligraphic letters which give the impression of aspiring to appear as a public

76 *SEG*: 9, 552 and 592, line 2; 13, 609h; 20, 742; Lüderitz and Reynolds 1993, n. 12.1.
77 Besides the texts in red paint, in the Cyrenaean area we also find red color used to overpaint cut inscriptions. Cf. for instance, six little altars (*arule*) from the *Via Sacra* of Cyrene (*SeCir* 156, 1–6) and the inscription in the Episkopos Theodothos Tomb at Sidi bu Breyek (Mohamed and Reynolds 2000, 1490, n. 2b; Ward-Perkins and Goodchild 2003, 345, n. 2).

FIGURE 9.11 *The Carboncini Tomb. Room L, painted inscription of little* Εὐίππιον.

document (Fig. 11).⁷⁸ In the same space, a stone stele is also preserved with a fragmentary red painted inscription: [. ?]ΠΑΠΩΙ Θεοδώρω. The name of the deceased⁷⁹ is in the dative case and seems to be followed by a patronymic in the Doric genitive.⁸⁰

78 It is the diminutive of the name Εὔιππος, widely attested in Cyrene, especially between the first century BCE and the first CE (*SEG* 9: 46, line 41; 133, line 7; 135, line 6; *SEG* 20, 735a II line 8). In general, the anthroponyms with the suffix –ιον are used for female diminutives (Chantraine 1933, 64; Masson 2000, 97), although some rare examples are attested also for males (Masson 2000, 64–6). Nevertheless there is no question that the deceased was young, as the size of the little niche below the inscription confirms.

79 The name is uncertain since the horizontal bar of *pi* seems to be extended and this could indicate other letters that preceded it (probably a rounded letter and an *epsilon*?). If, otherwise, we do not admit other letters preceding *pi*, the name Πάπος shows several occurrences from the second century BCE until the third CE across the Greek world but not in Cyrene. At any rate, a possible parallel could be the inscription acclaiming a priest of Apollo, Theodoros son of Eparos (?): ΕΠΑΡΩ Θεοδώρῳ: *SECir* 110.

80 The name Theodoros is relatively common in ancient Cyrene from the first century CE until Late Antiquity, in both pagan and Christian contexts. Among its forms, the Doric genitive is also attested: *SEG* 9, 284; 20, 742.

Conclusion

Among the hundreds of tombs from Cyrene and its territory, only a few preserve painted or charcoal inscriptions, making the monuments discussed above extraordinary as they guard a heritage that in other environments we no longer possess. Nevertheless, I hope it is by now clear that the evidence for painted and charcoal inscriptions treated in this chapter is only a limited fragment of a long tradition expressed across the centuries in the territory of Cyrene. The aim was to introduce to a wider audience one of the underrated aspects of Cyrenaean epigraphy, through the evidence at our disposal. Although the examples preserved do not allow us to establish detailed typologies, we can shed light on some aspects of society with which we would otherwise never be acquainted.

To review, then, we have seen that the painted inscriptions were used over many centuries, attested as early as the Hellenistic age and lasting into late antiquity. We can infer that their use was highly diversified, being suitable for didactic, instructive, and commemorative purposes. The heterogeneous heritage of painted inscriptions commemorating the deceased tells us that the technique of painting a text on a stone stele or in conjunction with a burial is employed as a replacement for stone engraving. We saw this in the Theuchrestos and in the Carboncini Tombs, on the stele for Theodoros' son and on the Euippion niche (Room L), respectively. Also in Christian inscriptions, painting provides an alternative to a chiseled inscription. This fact allows us to question whether there may have been financial constraints that led one to choose a painted over a carved inscription. These painted texts convey expressions of faith and a Christian message and are also a vehicle for precious information to us, as in the case of Dimitria's Tomb.

Additionally, the painted inscriptions referring to images or pictorial cycles allow us to extrapolate other clues. Since the Hellenistic Period, as the Thanatos Tomb shows, the painted inscriptions are applied to a didactic use, consisting of identifying figures or quoting notorious passages of narrative scenes. This very specific use of painted inscriptions continued for a long time and the written testimonies, together with pictorial decoration, demonstrate the inclination for ostentation in funerary spaces. The owner of a monument might aspire to show off his social status from both an economic (see the *ludi funerari* and the scene of a funerary banquet in Asgafa el Abiar[81]) and cultural point of view. They establish the capacity of representing myth and quoting significant

81 Bacchielli and Falivene 1995, fig. 3, tab. II.1.

passages of renowned works. Among the tombs discussed, captions for figures and the Sirens' scroll contribute to carrying out this function. Owners, as well as writers, may not necessarily have been erudite but did share a cultural heritage. Those creating these texts, possibly working alongside those decorating them, were conscious of current writing trends, reproducing and bringing them into the private sphere.

The funerary monuments with examples of charcoal inscriptions are fewer in number than tombs with painted inscriptions. This might depend on the fragility of the medium or even on the personal choices of a monument's owner or of a writer. Nevertheless, the charcoal inscriptions discovered in Cyrene over the past decade or so attest to an alternative way to leave written expression in funerary contexts. Compared to stone inscriptions, they testify to the use of the same language of abbreviation typical of Cyrene (see the Carboncini Tomb) but respond to different necessities that may have included a sense of urgency, limited resources, and pragmatism. The necessity of finishing in haste or with limited economic resources might have inspired the writer in Gallery A of the Carboncini Tomb to create on the wall a sort of *pinax* for the deceased or the Garden Tomb writer to draft the "pricing table." Pragmatism can have inspired the creative solution of defining the epigraphic frame and of adopting less common abbreviations in the Carboncini Tomb. Furthermore, the inscriptions of Gallery A of the Carboncini Tomb, as well as the Ludi Tomb, testify to the Cyrenaean tradition of re-use for inscriptions beyond the architectonic and decorative elements. As such, the inscriptions attest to the materiality of epigraphy—the addition and superimposition of personal and practical exigencies to the existing funerary tradition.

Furthermore, in charcoal occurrences, the typology of commemoration is expressed very differently from that of the painted inscriptions: the styles of public epigraphy and the parading of wealth are not models to reproduce and long for. Nonetheless, the charcoal writers are inspired by literacy and cultural heritage. This is the case of the syllogism inspired by Pseudo-Epicharmus in the Carboncini Tomb and, whether or not we accept the interpretation, also of The Garden Tomb's inscription, which reproduces the epigrammatic model of death as a loss of voice.

As for the palaeographic data, we have noted, for both charcoal and painted inscriptions, a double impulse of developing autonomous and personal paths and of reflecting epigraphic trends. We were also able to highlight points of contact between charcoal and painted examples and to point out similarities among writings of painted inscriptions from the third and the fourth centuries CE. While the examples we have do not permit speculation on graphic types, they do provide an entry-point for further study.

As occurs in other spheres as well, so too in funerary culture does the territory of Cyrene prove its uniqueness and originality, adopting and recombining trends and styles. This finds confirmation through the study of painted and charcoal inscriptions, which presents a rich new world, connected to various spheres, necessities, and inspirations. The corpus of painted inscriptions has allowed us to establish useful guidelines, whereas the testimonies written in charcoal have offered us new material for reflection and a starting point for research. It is hoped that further evidence and supplementary answers to the questions raised by these discoveries will help to establish new comparisons and enrich our vision.

Bibliography

Applebaum, Shimon. 1961. "The Jewish Community of the Hellenistic and Roman Teucheira." *Studies in History* 7: 27–52.

———. 1979. *Jews and Greeks of Ancient Cyrene*. Leiden: Brill.

Bacchielli, Lidiano. 1975. "Le pitture della 'Tomba dell'Altalena' di Cirene nel Museo del Louvre." *QuadArchLibia* 8: 355–83.

———. 1990–1991. "La Tomba cirenea del Buon Pastore." In *Rendiconti della Pont. Accad. Rom. d'Arch.* 23: 3–21.

———. 1993. "Pittura Funeraria Antica in Cirenaica." *LibSt* 24: 77–116.

———. 1996. "La Tomba di Thanatos nella Necropoli Sud di Cirene." *LibAnt* new series, II: 27–30, tab. III–V.

———. 1997. "La Tomba di Edipo a Beit Tamer." *ArchClass* XLIX: 1–13.

———. 2002. "La 'Tomba dei Ludi' a Cirene: dai viaggiatori dell'Ottocento alla riscoperta." *QuadArchLib Archeologia Cirenaica* XVI: 285–312.

Bacchielli, Lidiano, and Falivene, Maria R. 1995. "Il canto delle Sirene nella Tomba di Asgafa el Abiar." *QuadArchLib* XVII: 93–107.

Bacchielli, Lidiano, and Reynolds, Joyce, and Rees, Bryn. 1992. "La Tomba di Demetria a Cirene." *QuadArchLibia* 15: 5–22.

Bader, Bernd. 1971. "The Ψόφος of the House-door in Greek New Comedy." *Antichthon* V: 35–48.

Beschi, Luigi. 1972. "Divinità funerarie cirenaiche." *ASAA* XLVII–XLVIII: 133–341.

Boswinkel, Ernst, and Sijpesteijn, Pieter J. 1968. *Greek Papyri, Ostraka and Mummy Labels*. Amsterdam: Adolf M. Hakkert.

Cassels, John. 1955. "The Cemeteries of Cyrene." In *Papers of the British School in Rome* XXIII: 1–43.

Cavallo, Guglielmo, and Maehler, Herwig. 1987. *Greek Bookhands Of The Early Byzantine Period: AD 300–800*. Bulletin Supplement 47. London: University of London, Institute of Classical Studies.

Chamoux, François. 1953. *Cyrène sous la monarchie des Battiades.* Paris: de Boccard.

Chantraine, Pierre. 1933. *Formation des noms en grec ancien.* Paris: Klincksieck.

Cherstich, Luca. 2008a. "The role of Alexandria in Cyrenean cemeteries from 'Ptolemization' to Romanization," In *SOMA 2005: Proceedings of the IX Symposium on Mediterranean Archaeology, Chieti, Italy, 24–26 February 2005,* edited by Oliva Menozzi, Marialuigia Di Marzio and Domenico Fossataro, 129–42. Oxford: Archaeopress, British Archaeological Reports International Series 1739.

———. 2008b. "From looted tombs to ancient society: a survey of the Southern Necropolis of Cyrene." *LibSt* 39: 73–93.

Cherstich, Luca, and Santucci, Anna. 2010. "A new discovery at Cyrene: Tomb S 64 and its 'Pompeian second Style' wall paintings. Preliminary notes." *LibSt* 41: 33–45.

Cinalli, Angela. 2008. "La tipologia dell'arcosolium a Cirene: derivazioni, problemi, evidenze e confronti," In *SOMA 2005: Proceedings of the IX Symposium on Mediterranean Archaeology, Chieti, Italy, 24–26 February 2005,* edited by Oliva Menozzi, Marialuigia Di Marzio and Domenico Fossataro, 143–8. Oxford: Archaeopress, British Archaeological Reports International Series 1739.

Cinalli, Angela. 2014. "Documenting an unknown funerary complex at Cyrene: 'The Garden Tomb.' Architectural evolution and epigraphic issues". *LibSt* 45: 7–18 (see also Corrigendum, *LibSt* 46 forthcoming).

Collignon, Maxime. 1911. *Les statues funèraires dans l'art grec.* Paris: Ernest Leroux.

Comparetti, Domenico. 1914. "Iscrizione cristiana di Cirene." *Ann. Sc. Arch. Atene* 1: 161–7.

Gasperini, Lidio. 1998. "Novità epigrafiche dal settore meridionale della Necropoli di Cirene." In *La Cirenaica in età antica. Atti del convegno internazionale di studi* (Macerata, Italy, 18–20 May 1995), edited by Enzo Catani, Silvia M. Marengo, 273–9. Macerata: *Ichnia*, Collana del Dipartimento di Scienze Archeologiche e Storiche dell'Antichità, 1.

Jalabert, Louis, and Mouterde, René. 1926. "Inscriptions grecques chrétiennes." In *Dictionnaire d'Archéologie chrétienne et de la liturgie,* edited by Fernand Cabrol and Henry Leclercq, T. VII, cols. 623–94. Paris: Letouzey et Ané.

Lagatta, Debora. 2005. "Cyrenean Greek Sarcophagi," In *SOMA 2005: Proceedings of the IX Symposium on Mediterranean Archaeology, Chieti, Italy, 24–26 February 2005,* edited by Oliva Menozzi, Marialuigia Di Marzio and Domenico Fossataro, 155–60. Oxford: Archaeopress, British Archaeological Reports International Series 1739.

Laronde, André. 1987. *Cyrène et la Libye hellénistique. LIBYKAI HISTORIAI de l'époque républicaine au principat d'Auguste,* 385–387. Paris: Éditions du Centre National de la Recherche Scientifique.

Lüderitz, Gert, and Reynolds, Joyce. 1993. *Corpus jüdischer Zeugnisse aus der Cyrenaika.* Wiesbaden: L. Reichert.

Marengo, Silvia Maria. 1991. *Lessico delle iscrizioni greche della Cirenaica*. Istituto Italiano per la Storia Antica: Roma.

Masson, Olivier. 2000. *Onomastica Graeca Selecta*, III. Genève: Droz.

Miranda, Elena. 1985. *Napoli antica. Catalogo della Mostra (Napoli, Museo Archeologico Nazionale, 26 settembre 1985–15 aprile 1986)*. Napoli: Macchiaroli.

Mohamed, Fadel Ali and Reynolds, Joyce. 1996. "Inscriptions recently discovered in Cyrenaica," In *L'Africa Romana, Atti dell'XI convegno di studio* (Cartagine, 15–18 Dicembre 1994), edited by Mustapha Khanoussi, Paola Ruggeri and Cinzia Vismara, vol. 11.2, 1321–39. Ozieri: Il Torchietto.

———. 1997. "New funerary inscriptions from Cyrene." *LibAnt, new series* III: 31–46.

———. 2000. "Recently-discovered Christian inscriptions in Cyrenaica," In *L'Africa Romana, Atti dell'XIII convegno di studio* (Djerba, 10–13 dicembre 1998), edited by Mustapha Khanoussi, Paola Ruggeri and Cinzia Vismara, vol. 13.2, 1485–1503. Urbino: Carocci.

Pacho, M. J. R. 1827. *Voyage dans la Marmarique, la Cyrénaïque et les oasis d'Audjelah et de Maradèh accompagnée de cartes géographiques et topographiques et de planches présentant les monuments de ces contrées*. Éd. Didot: Paris (éd. numérique, adaptation Danielle Guiraudios. 2012. Éd. Harpocrate: Paris).

Paci, Gianfranco. 2003. "Le iscrizioni della Necropoli occidentale di Cirene." *QuadArchLib* XVIII: 173–82.

Peek, W. 1942. "Ge theos in griechischen und römischen Grabschriften," *Zeitschrift für Kirchengeschichte*, 27–32.

Perdrizet, P. and Lefebvre, G. 1919. *Les Graffites grecs du Memnonion d'Abydos*. Nancy, Paris, Strasbourg: Chez Berger-Levrault.

Ritti, Tullia. 2004. "Iura sepulcrorum a Hierapolis di Frigia. Nel quadro dell'epigrafia sepolcrale microasiatica iscrizioni edite e inedite," In *Libitina e dintorni. Actes de la XIe rencontre franco-italienne sur l'épigraphie*, edited by Silvio Panciera, 455–634. Rome: Quasar.

Robert, Louis. 1978. "Documents d'Asie Mineure." *BCEH* 102, 1: 395–593.

Robinson, David M. 1913. "Inscriptions from the Cyrenaica", *AJA* 17: 157–200.

Roques, Denis. 1987. *Synésios de Cyrène et la Cyrénaïque du Bas-Empire*. Paris: Éditions du CNRS.

Santucci, Anna. 2010a. "La 'pinacoteca' del veterano Ammonio e le pitture funerarie della Cirenaica tra inventio e tradizione," In *Atti del X Congresso internazionale dell'*AIPMA (Association Internationale pour La Peinture Murale Antique), (Naples, Italy, September 17–21, 2007), 353–64. Napoli: L'Università degli studi di Napoli, "L'Orientale."

———. 2010b. (with a note by Joyce Reynolds), "*Monumentum est quod memoriae servandae gratia existat* (Ulp., Ad Edict. 11, 7, 42): la tomba del Veterano Ammonio

nella necropoli nord di Cirene ed il suo ciclo pittorico." In *Cirene e la Cirenaica nell'antichità: Cirene «Atene d'Africa»* III, edited by Mario Luni. Roma: L'Erma di Bretschneider.

Smith, Robert M. & Edwin A. Porcher. 1864. *The history of the recent discoveries at Cyrene made during an expedition to the Cyrenaica in 1860–61 under the auspices of Her Majesty's Government*. London: Day & Son.

Sourvinou-Inwood, Christiane. 1996. *"Reading" Greek Death: To the end of Classical Period*. Oxford: Clarendon Press.

Stucchi, Sandro. 1975. *Architettura Cirenaica*. Rome: L'Erma di Bretschneider.

Thorn, Dorothy. 2007. "The 'Red Tomb' at Cyrene." *LibSt* 38: 87–92.

Thorn, James C. 2005. *The Necropolis of Cyrene: two hundred years of explorations*. Monografie di Archeologia Libica 26. Rome: L'Erma di Bretschneider.

Venit, Marjorie S. 2002. *Monumental Tombs of Ancient Alexandria: The Theater of the Dead*. Cambridge: Cambridge University Press.

Ward-Perkins, John B., and Goodchild, Richard G. 2003. *Christian monuments of Cyrenaica*, edited by J. Reynolds. London: Society for Libyan Studies.

Weitzmann, Kurt. 1959. *Ancient Book Illumination*. Cambridge, MA: Harvard University Press.

CHAPTER 10

Harnessing the Sacred: Hidden Writing and "Private" Spaces in Levantine Synagogues

Karen B. Stern

Lust and aggression remain inseparable in the world of Greco-Roman magic. Texts of ancient spells, which adjure gods, *daimones*, and angels to manipulate victims' sensory organs, reveal their writers' convictions that the mechanisms for achieving agents' erotic desires were necessarily violent. Despite the conventionality of such prayers in antiquity, certain examples remain particularly jarring to modern sensibilities—either due to the intensified savagery of their sentiments, or to the particularly strange locations of their deposit.

One such text, scratched in Aramaic onto ceramic then smashed into pieces, falls into the latter category (Figure 10.1). While the amulet exhibits multiple conventions of the literary genre by commanding angels to bend a victim's heart (and perhaps, mind and kidney) to succumb to an agent's amorous bidding,[1] the discovery context of the text appears rather unusual: it was found along the periphery of an ancient synagogue complex in Ḥorvat Rimmon,[2] a

* I gratefully acknowledge the assistance and generosity of Gideon Bohak, David Frankfurter, Marcy Brink-Danan and Molly Swetnam-Burland for their suggestions on earlier drafts of this chapter. Any and all errors, of course, are my own.

1 Drawing, transcription, and translation of this partially preserved text (Israel Department of Antiquities, No. 80.880) appears in Naveh and Shaked 1998, 84–90; Fig. 12: "You ho[ly... and mighty] angels [I adjure] you, just as [this sherd] [burns, so shall burn] the heart of R[... son/daughter of] [Mar]ian after me, I .. [and you should turn] [his/her heart and mi]nd and kidney, so [that he/she will do] my desire in this []...[*magic characters*]"; see also Bohak 2008, 156. The last three lines of the text are reconstructed based on close analogues in texts of the Cairo Geniza, the depository of sacred Jewish texts discovered in the Ben Ezra synagogue in Old Cairo, Egypt. Clay remains a conventional medium for spells of similar genre; known prescriptions for 'love' spells from later periods, specifically require the use of 'new sherd[s]' for such purposes; discussion in Naveh and Shaked 1998, 88; Bohak 2008, 157; also Gager 1992, no. 28. An overview of the historical significance of the Cairo Geniza, its discovery and its contents, considered in Reif 2000; treatment of Geniza traditions in Bohak 2009, 321–339. Please note that subsequent translations of Aramaic amulets from synagogues follow those of Naveh and Shaked 1998 and 1993, unless otherwise indicated.

2 The ceramic pieces that comprise this text were discovered scattered in the upper fill of the northeastern edge of the synagogue complex, which excavators date to the Byzantine period (fifth or sixth centuries CE); Kloner 1989, 46; 1981; 1980. Excavators have published little

FIGURE 10.1 *Ceramic sherds from Aramaic erotic amulet from the synagogue of Ḥorvat Rimmon (IAA No. 1980-880; Mariana Salzberger, Israel Antiquities Authority).*

additional information about the room in which the amulet was found, but other reported discoveries from the same stratum included jar fragments, oil-lamps, animal bones, iron nails and parts of a chancel screen (Kloner 1980, 1981). As Bohak notes, it remains impossible to determine, given the present state of the evidence, whether the placement of the sherds *necessarily* relates to the synagogue, or, rather, to a room immediately beside it (2008, 320). Correlation between the deposit of the potsherd and the use of the synagogue, however, remains likely on two counts. First, the deposit appears to be contemporaneous to multiple phases of the synagogue's use—even if the potsherds were placed just *outside* of the building, their extreme proximity to their structure suggests a strong spatial and chronological relationship. Second, discovery of several additional objects, buried nearby beneath the synagogue floor, also suggests a coincidental practice of making floor deposits that relates directly to the synagogue and associated activities. The latter deposits include two hoards of coins, found inside clay vessels and wrapped in cloth, which were hidden in antiquity beneath the paving stones of earlier and later phases of the synagogue; Kloner 1989, 46. Fragments of

ruined town roughly 13 km north of Beer-sheva in modern Israel (Fig. 10.2).[3] To a modern observer, the deposition of such an erotic spell around a presumably sacred building, in which Jews recited liturgies and biblical scripture, recounted stories of their collective history, and, ostensibly, communicated with their God, is surprising to say the least. Was the placement of this amulet around a synagogue accidental? An act of blasphemy? And why might an individual choose to use a revered communal space in this way?[4]

FIGURE 10.2 *Map of synagogues and locations mentioned in this chapter. Map Tiles © 2015 Ancient World Mapping Center.*

 the potsherd, as well as some of the coin deposits, are presently displayed in the Israel Museum, Jerusalem.
3 Kloner 1989, 46–47; its Aramaic text is followed by a line of *characterês*. The reconstructed ceramic piece is 9.5 cm high and 7 cm wide; the text is written in nine lines, its words are individually encircled, and one piece of the text (line 8) appears to be missing. The ceramic amulet was intentionally broken into five pieces in antiquity and visible signs of burning on the fragments suggest a correspondence between the physical treatment of the object and the contents of the text (line 4–5: "…just as [this sherd] [burns, so shall] burn the heart of…."); the shape of each fragment, moreover, aligns with deep incisions drawn onto the clay before firing; Naveh and Shaked suggest that "[i]n contrast to other potsherds, this is not an accidental fragment of a broken pot. It seems that the potter deliberately cut deep incisions on the surface of the jar before firing it, and that he broke the jar along the same incisions" (1998, 88); additional discussion of this point in Bohak 2008, 320, n. 62; 334.
4 It is important to note that the lacunae in the text need not justify assumptions about the genders of the agent and target of the spell. For greater elaboration of this and similar points, see Dickie 2000; also Patchouni 2013.

To scholars of magical praxis throughout the Greco-Roman world, acts of inscribing, destroying, and depositing erotic amulets in communal spaces remain unexceptional. But to scholars of Jewish history, the scattering of this type of amulet around a synagogue complex might seem more unusual, given the reputation of synagogues for activities considered esteemed and holy, including the storage and veneration of sacred texts, recitations of liturgies, and convocations in communal assemblies. But, while little discussed, depositions of inscribed objects are known in Jewish devotional contexts; several analogous spells were found deposited inside, around, and beneath other synagogues in neighboring regions of the Levant. Few have paid heed to these buried texts, perhaps because they seem tangential to the workings of the synagogues themselves.[5] By contrast, other types of preserved writings, including monumental votive and dedicatory inscriptions, once prominently displayed and found in the same buildings, draw greater attention: their texts appear to retain information more critical for reconstructing the communal functions of ancient synagogues as places of assembly, collective prayer, dedication, and cultural identity formation.

This volume's focus on writing in the private sphere, however, inspires renewed consideration of distinct genres of inscriptions also deposited inside Greco-Roman synagogues, including texts scratched on movable objects, such as ceramic sherds and *lamellae* (thin metal sheets). Consideration of the syntactical contents, media, and placements of these types of writing, I argue, collectively illuminates otherwise unrecognized and private activities concurrently conducted in and around their places of deposit. Inscribing spells and hiding them in synagogues, I suggest, constituted powerful acts: unbeknownst to most passersby, they singlehandedly and instantaneously transformed communal spaces into private ones for the purposes of their agents. As authors note throughout this volume, notions of privacy were arbitrary and mutable in the Greco-Roman world; as I suggest here, so too were notions of sanctity among contemporaneous Jewish and pagan populations.[6] Regarding hidden synagogue inscriptions from these perspectives nuances discussions of writing in the private sphere by offering new points of connection between the lives and practices of ancient Jews and other Mediterranean populations, so often treated as distinct by specialists in one culture or another.

5 General discussions of magic and amulets in the synagogue appear in Cohen 1989, 168; Naveh 1989; Fine 1997, 73–5, 145–46; Levine 2000, 274, 383–4, 428; Mock 2003. John Chrysostom famously pronounces that magicians frequently populated the synagogues of the Jews, but related discussions are obscure and embedded in his polemic (*Against the Jews* 8.5.6 and 8.8.7–9 (PG 48.935; PG 48.940–1); Bohak 2008, 320).

6 On this point also Bowes 2008.

Magical Writing and Jews in the Ancient Mediterranean

Multiple scholarly disciplines necessarily converge in this treatment of Jewish amulets and private space in the eastern Mediterranean. Those most relevant to this discussion consider Mediterranean magical traditions and Greek, Latin, and Semitic amulets of pagan, Jewish, and Christian association.[7] Reports from recent excavations conducted in modern Israel, moreover, continually inspire renewed studies of regional Jews and of the synagogues they designed and used in antiquity.[8] Distinct bodies of literature additionally evaluate the history of Levantine Jews, who dwelled along the political and cultural interstices of the Greco-Roman east and west and variously engaged in practices of ritual power.[9] The scope of the scholarship that collectively bears upon this evaluation is therefore immense and can only be briefly summarized here.[10] Furthermore, the nature of ancient 'magic' is sometimes counter-intuitive—meaning that we must initially investigate what may seem like natural assumptions about 'magical' materials and their architectural and social contexts.[11]

First, magical traditions require evaluation within their broader geographic and cultural scope.[12] 'Magic,' in this analysis, serves as a general term that classifies activities and materials associated with the ritual manipulation of power, regardless of their manifestations in Jewish, pagan, or Christian contexts.[13]

7 Relevant sources are too extensive to comprehensively summarize here, but some of the most important include: Betz 1986; Audollent 1904; Faraone and Obbink 1997; Faraone 1999; Jordan 1985; Gager 1992; Kotansky 1994; excellent treatment of the methodologies for the study of "magic" in Frankfurter 1994; Wilburn 2012, 1–53.

8 Recent discoveries of synagogues in the Levant, such as that in Huqoq, as well as farther south in the Mediterranean, such as Tunisia, offer new data for the discussions of the populations who used them. For a summary of new discoveries relating to synagogues and their broader historical impact, see Hachlili 2013; Magness et al. 2014; for broader summaries of the synagogue in antiquity, see Levine 2000, 1–5.

9 Historiography of Jews in the Levant remains surprisingly limited; see Schwartz 2001, 155–210; the seminal work of Avi-Yonah 1976; and portions of Sivan 2008.

10 Many, too, preserve Audollent's categorizations of magical texts according to genre, including binding (*defixiones*), juridical, and circus spells (1904).

11 Such perspectives permit the collapse of traditional binary distinctions between categories of 'religion,' and 'magic'; discussion of this point in Bohak 2008, 63–7; also Harari 2005.

12 For discussion of this and associated terminologies, which modify traditional categories of magic, see the work of Choat and Gardner 2013.

13 My use of the category of magic here demonstrates its mutability and its inextricability, in many cases, from other types of activities conducted in devotional contexts. This discussion draws from the summary in Frankfurter 1994, 212, n. 6; Wilburn 2012, 12–53. I intend to elide activities associated with 'magic' and those commonly classified as 'religious'—a term, which independently suffers from ambiguity and abuse. For the latter point, see

Other words conventionally associated with magical praxis, such as 'spells' (effective recipes or written records of rituals, rendered in symbols and texts), 'charms,' and 'amulets' (objects of power on which these records may appear), serve as hermeneutical tools, which label specific aspects of inscriptions and objects that concurrently exhibit multiple functions and traits.[14] As Andrew Wilburn notes, moreover, magical practices and objects were often conducted and used in public spaces, even if they concurrently reflect diverse personal or private behaviors or interests.[15]

Evaluations of the contents and placements of synagogue amulets and *defixiones* (binding spells) exemplify the complexity of magical traditions in antiquity: each inscribed object, deposited within or around a synagogue, adjures angels, the Jewish God, or other deities, to change people's dispositions and health by performing physical acts of transformation and healing. Associated writings, therefore, could equally be described as devotional, religious, social, political, psychological, or medicinal and thus demonstrate what countless scholars have cautioned repeatedly: that 'magic' and companion terminologies are not ancient and intrinsic, but serve as artificial labels for texts and activities, which overlap with other modern categories, such as religion, medicine, law, chemistry, physics, psychology, and the like.[16] Many of these texts thus could be classified in entirely different ways in other analytical contexts. Still, scholars' continued reliance on 'magic' and associated categories seems to reflect the ongoing utility of these terms and broader consistencies in modern assessments of associated materials and their uses.[17]

Ubiquity of written spells on amulets throughout the ancient world exemplifies the power associated with acts of writing and the objects on which letters and symbols appear.[18] While non-textual amulets proliferated throughout the Mediterranean, recurrences of so-called 'nonsense' writing on amulets and

Smith 1990. Bohak discusses the erroneous separation between categories of 'magic' and 'religion,' particularly in relation to ancient Jewish populations (2008, 63); also Harari 2005, 112–14.

14 I modify here Frankfurter's considerations of spells and amulets in Frankfurter 1994, 193, 195, 197. See also Häberl forthcoming. For discussion of ritual objects without writing, see Wilburn 2012, 28–32.

15 Wilburn advocates a lucid and tripartite definition for magic, which emphasizes the role of practice and action, and its intrinsic relationship to religious practices (2012, 15).

16 Faraone 2011, 135.

17 Wilburn 2012, 13–14, n.5 and Bohak 2008, 67.

18 Discussion of the relationship between writing and magic across Mediterranean cultures in Frankfurter 1994. Frankfurter 1995 also emphasizes the power of spoken as well as written utterances.

in mural graffiti demonstrate the relative prestige accorded to esoteric inscriptions, which could record rituals of speech and action in magical contexts.[19] Hired practitioners probably inscribed most amulets, but the agency associated with a recipe necessarily extended to individuals, who commissioned them; magical or otherwise, inscriptions constituted collaborative acts.[20] Unlike monumental inscriptions, however, the potency of magical formulae did not depend on the resilience of the objects they adorned; in magical contexts, acts of destruction or hiding could ultimately enhance, rather than diminish, the efficacy of an amulet and, by extension, the agency of its commissioner.[21]

Several important studies of ancient magic detail regional patterns in the composition and uses of individual recipes and the objects on which they appear (i.e. amulets or *lamellae*), ranging from diachronic Egyptian and Mesopotamian traditions to those, which proliferated in later antiquity throughout Greece, Rome, the Levant, Asia Minor, North Africa, and Britain.[22] Across the Mediterranean individuals commissioned amulets to resolve common problems; to call upon gods, demi-gods, or angels to punish thieves who stole personal property; to obtain power over insubordinate 'targets' (whether in love, in business, or politics); to induce healing in a disturbed body; or to advocate for particular combatants or 'teams' in athletic competitions.[23] Regardless of the variability in their ostensible functions, moreover, magical texts and their associated traditions were consistently inclusive, synthetic, and deeply crosscultural: diverse pagan, Jewish, and Christian audiences copied and modified

19 Frankfurter argues for the culturally relative status of writing and its variable "mnemonic-oral significance" in Frankfurter 1994, 199–205. For the discussion of apparent "nonsense" inscriptions, see discussions in Cox Miller 1986; Cox Miller also considers the continuities between writing and the oral sounds, which written vowels represent.

20 For this precise point, I thank Molly Swetnam-Burland. Note also the syntax of a graffito inscribed in a tomb in the Judean foothills in regions of modern Israel, which acclaims: "Remember the writer, the reader (and) me!" Kloner 1982, 99; the sentiment in this graffito emphasizes the collective benefit of the writing of the text to its writer, its reader, and *me*— perhaps referring to the commissioner of the inscription or to the dead inside the tomb.

21 The ephemeral qualities of many materials may explain their sporadic preservation throughout the Mediterranean. See discussion in Wilburn 2012, 20–21. On the other hand, the dissolution or description of inscriptions or materials in distinct contexts in the Ancient Near East could be tantamount to the destruction of its commissioner. Examples presented in the recent work of Levtow 2012a and 2012b.

22 Most recent treatment of the topic in Wilburn 2012; also see individual treatments in Gordon and Simón 2010; Adams 2006; Tomlin 2005. For discussion of earlier Levantine traditions, see Jeffers 1996.

23 On the limits of overlapping Jewish and Christian formulae, see discussion in Bohak 2008, 344. Also consider summary and discussion in Bländsdorf 2010, 147.

identical recipes for similar purposes from common sources.[24] Nonetheless, cultural, as well as, geographic factors informed magical materials and practice. As Gideon Bohak richly demonstrates, magic in Jewish contexts drew expansively, if selectively, from regional customs as well as from Egyptian, Greco-Roman, and Mesopotamian ones.[25] Mesopotamian magical traditions remained particularly influential among Jews in Egypt and the eastern Mediterranean; this pattern is documented in the later texts of the Cairo Geniza—one of the largest known caches of Jewish texts of ritual power, secreted, over centuries, inside a wall of the Ben Ezra synagogue in Old Cairo, Egypt.[26]

Many non-Jewish populations throughout the Mediterranean perpetuated the stereotype that Jews (just like Chaldeans or Egyptians) were a magical people.[27] Partly due to this belief magical materials throughout the Greco-Roman world frequently incorporated names similar to those from biblical ancestral genealogies, Hebrew-sounding words, vocabulary drawn from Jewish liturgies, biblical *historiolae*,[28] and biblical epithets for the Jewish God and angels.[29] These elements are so common in magical texts throughout the Mediterranean, in fact, that their presence need not predict Jewish authorship or commission of amulets, inscribed in multiple media (including clay, gemstones, and metal sheets), which included biblical and Hebrew-sounding names, quotations, and epithets, which were copied in abundance throughout the Mediterranean east and west.[30] Other texts, however, exhibit features indicative of particularly Jewish use, because Jews also generated comparable spells

24 On modifications of common formulae, see Wilburn 2012, 32; Gager 1992, 177; Bohak 2008, 287; also Bohak 2011. Review also discussions in Frankfurter, 1999a, 261.

25 Bohak 2008, 295, 350. On transmissions of spells in Mesopotamian contexts, see Shaked 2011. Also see Levene 1999; Harviainen 1995.

26 Studies of magic in the Geniza and Hechalot literature have burgeoned in the past decades. An important review of recent scholarship in Bohak 2009; additional bibliography in note 1 above.

27 Summary of sources for discussion in Bohak 2008, 295–96; discussion of Egyptians as "magical," in Frankfurter 1994.

28 Bohak defines a *historiola* as a "mythical event used as a magical precedent" (2008, 481).

29 Excellent examples of this, among many others, in *GMA*, nos. 14, 23, 32, 48, 52, 58, 64; discussion also in Frankfurter 2001.

30 Among many others, this pattern is exemplified by a Latin defixio from Britain in the fourth century CE: "Womb, I say to you, stay in your place, [which X] gave to you. I adjure you by Iaô and by Sabaô and by Adônai, so that you not hold onto the side, but stay in your place, and not hurt Cleuomedes, daughter of A[...]"; translation from Faraone 2011, 141. Comparable examples of Semitic names and terms in Greek magical traditions in Kotansky 1994.

for themselves. While factors that predict an amulet's direct association with Jews necessarily shift according to time and place, texts and objects that more clearly index Jewish authorship and use may adjure the Israelite god and angels and invoke biblical passages and epithets, but also include personal names of agents and victims often conferred by Jewish populations. Simultaneously, they might be inscribed in Jewish Aramaic and Hebrew scripts, in addition to Greek and Latin ones, and may be found in spatial contexts explicitly associated with Jews, such as synagogues.[31] The materials discussed in this paper concurrently demonstrate the latter combinations of traits that collectively suggest Jewish production, commission, and use in late antiquity.

Ancient Synagogues, between Public and Private?

In periods of earlier antiquity, the Greek term *synagōgē* was used more generally to describe an assembly or convocation; only in later periods did it apply more specifically to spaces where Jews convened. While the derivative term 'synagogue' is maintained in modernity, moreover, the modern institution offers an imprecise analogue for its ancient manifestations, which remain, in many ways, stubbornly elusive.[32] Documentary evidence attests to the existence of Jewish prayer houses (*proseuchai*) and synagogues in Hellenistic and Roman Egypt and Judaea, centuries before the Roman retaliations for the first Jewish revolt (66–71 CE) led to Vespasian's destruction of the central Jerusalem Temple.[33] The proliferation of synagogues in subsequent centuries, throughout the Levant, Europe, Asia Minor, Rome, and North Africa, probably owes as much to the absence of a central Temple, as to demographic and cultural shifts throughout the late Roman and Byzantine worlds and to the rise of competing Christian institutions.[34]

31 Bohak's nuanced argument, however, demonstrates that markers of potential "Jewishness" in a magical text necessarily change through time and place (2008, 295–6; also see 156–8, 291). On the use of names as a factor in determining the cultural provenance of commissioners of inscriptions, see discussions in Ilan 2002–2012.

32 While *proseuchai* and synagogues are certainly attested in Egypt and Roman Judea in the period preceding the Roman destruction of the second Jerusalem temple in 70 CE, little evidence attests to the flourishing of the institution before the fourth century CE. Seth Schwartz and others correlate the rise of the synagogue with the burgeoning of Church institutions in late antiquity; Schwartz 2001, 155–210. For discussions of *proseuchai* in earlier periods see seminal work of Hengel 1975; Rajak 2002; Honigman 1993.

33 Schwartz 2001, 216–241. These matters are also chronicled in Levine 2000, 7–8.

34 See also discussion in Schwartz 2001, 179–202; 289.

Activities associated with synagogues vary according to source, period, and region. Texts edited by rabbis in Roman Palestine and Babylonia, including the *Mishnah* (redacted interpretations of the five books of Moses, which independently constitute the written Torah), and the *Talmudim* (diverging Palestinian and Babylonian commentaries on the Mishnah), describe the synagogue as an architectural space, which served as a locus of assembly and prayer, where Jews recited, studied, and translated biblical scripture.[35] Archaeological and epigraphic vestiges of synagogues from late antiquity, which include decorative floor mosaics, architectural decoration, monumental inscriptions, and architectural features, additionally suggest the conduct of complementary activities inside their structures, including acts of dedication, implementations of institutional hierarchies (which famously included women), relationships between Jews and their neighbors, and, at times, institutionalized recollections of the memory of the destroyed Jerusalem temple.[36] While the majority of visitors to synagogues were probably Jews, furthermore, inscriptional and literary evidence from Syria, Asia Minor, and elsewhere, suggests that some Mediterranean synagogues were open to non-Jewish, as well as Jewish visitors and donors.[37]

One cannot accurately classify synagogues, writ large, as either 'public,' or 'private' spaces. While some synagogues, such as those found in Dura Europos and Ostia, were physically transformed from domestic buildings, others owed their constructions to the largesse of multiple donors from different families, who peppered decorated walls and floors with monumental inscriptions commemorating their altruism.[38] Individuals, moreover, visited synagogues for

35 Textual evidence available in Rabbinic texts, redacted in later antiquity in Roman Palestine and in Babylonia, describe variable activities conducted inside ancient synagogue buildings, which include prayer, recitations of liturgy and the translation of the Hebrew Bible into languages congregations might better understand (i.e. Hebrew into Aramaic and Greek); Levine 2000, 446–470; Fine 1997, 35–94.

36 Bibliography on the subject is extensive. For summaries of relevant scholarship see Levine 2000, 6–16; Fine 1996. On the subject of women and their roles in synagogues and synagogue hierarchies, see Levine 2000, 471–90; Ilan 1999, 242–243, n. 27; Rajak and Noy 1993, 87; seminal discussion of women in the synagogue in Brooten 1982.

37 While no synagogue has been discovered in Aphrodisias to this date, other epigraphic evidence suggests the involvement on non-Jewish populations in local Jewish institutions. Literature on the topic includes: Reynolds and Tannenbaum 1987; Rajak 1994; Chaniotis 2002. The cultural associations of Persian scribes, who visited the Dura Europos synagogue are considered in Fine 2010; Cohen 1987. Critiques of Christian presence in synagogues recur in the sermons of John Chrysostom (*Adv. Iud.* 11.3).

38 Specific connections between those who lived in the original house and those who populated the subsequent synagogue vary by case. For developments of synagogues and early churches from domestic spaces, see the seminal work of White 1990. It is worthwhile to note that even acts of private prayer were probably performed in spaces with spectators.

multiple reasons that equally synthesized individual and collective needs, including liturgy recitation, study, charity giving, commensality, and hosting of travelers.[39] Regardless of regional diversities in architecture, decoration, demography and precise use, therefore, synagogues were, above all, places for Jews (and occasionally, their neighbors) to interact and convene.[40] Ancient synagogues cannot be classified as public or private, but are best described as *communal* spaces.[41]

Greco-Roman temples and sanctuaries offer useful comparisons for discussions of sacred space in both the destroyed Jerusalem Temple and, subsequently, in smaller community synagogues.[42] In ancient Israel, Judah, and Persian and Roman Judaea (c. ninth century BCE to the second century CE), the central Jerusalem Temple was understood to be sacred (*qdš* in Hebrew), partly because those who worshipped there believed that God physically *dwelled* inside its precinct. This understanding is somewhat continuous with operative notions of sanctity in contemporaneous pagan temples and sanctuaries; their *leges sacrae* attest to this.[43] Synagogue buildings from later periods, by contrast, were not necessarily viewed as sacred in the same way: sacrifices did not take place in their spaces and scarce evidence suggests that Jews believed that their God physically dwelled inside synagogue structures. Still, literary texts, inscriptions, and iconography of floor mosaics overwhelmingly suggest that many Jews believed that synagogue buildings served as houses for sanctity—perhaps because of their encasement of sacred scrolls of the Torah, which recorded the names, words, and actions of God, or, perhaps, because they understood that some aspect of their holy God—the *šĕḥinâ*—remained imminent inside such spaces.[44] Alternatively, or in complement, the 'holiness' of synagogues may have related to notions that the Jewish communities that assembled within

39 For example, Cohen writes that "the cult of the synagogue consists of the public worship of God through prayer and study" in Cohen 1987, 160; see also Levine, 2000, 9–16; for discussions of attitudes toward eating practices associated with the rabbis, see Rosenblum 2010.

40 Cohen 1984; cf. *Midrash Tanḥuma Qedoshim* 10. Synagogues rarely appear to be associated with individual ownership or operation, for example, much like private chapels that began to proliferate in Christian contexts in late antiquity and the middle ages.

41 As Lee I. Levine writes in his introduction, "As a communal institution, the synagogue was fundamentally controlled and operated by the local community" (2000, 3).

42 See discussions in Cohen 1987, 160; and Cohen 1984, 152.

43 For Greek sacred laws, Sokolowski 1955; 1962; 1969; also Lambert 2000.

44 Branham 1995, 331; discussion of the sanctity of the biblical scrolls for Jews appears in Christian sources, such as Justin, *Dialogue with Trypho* 72.3. Some considered the shrine in which the scrolls were kept to be correspondingly holy; Fine 1997, 73. Consideration of the *šĕḥinâ* in the Babylonian Talmud: B. Ber. 6a–b; B. Megilla 29a; Leviticus Rabbah 11:7; Cohen 1987, 164.

them, and/or the activities they conducted inside of them (such as prayer or scriptural recitation) were collectively sacred.[45]

Despite ambiguities in the sources of or degrees of sanctity associated with synagogues in late antiquity, dedicatory inscriptions, floor mosaics and wall paintings consistently ascribe to synagogues holy qualities. Dedicatory texts from Gaza and Ashqelon in Byzantine Palaestina describe the surrounding synagogues as "[most] holy place[s]" ('αγιωτ[άτω] τόπω; ἅγιω τόπω), while an inscribed mosaic from ancient Naro in North Africa likewise proclaims its adornment of a *sancta sinagoga*.[46] The iconography of floor mosaics from Roman and Byzantine synagogues reinforces this sense: by illustrating cycles of the zodiac and the personified seasons, displaying scenes of divine intervention, and projecting images of the architecture, activities, and appurtenances of the destroyed and holy Jerusalem Temple, they entreated visitors to focus on the cosmic, the divine, and the sacred.[47] Subjects of the wall paintings from the synagogue of Dura Europos, which represent narrative biblical scenes, manifest these notions.[48]

Thus, while synagogues were not considered sacred in uniform ways, they variously encased or encompassed practical, inscriptional, decorative, architectural, movable, and demographic features, which attracted, represented, or possessed *degrees* of sanctity. Art historian Joan Branham has described the indirect association between sacredness and the synagogue as a type of 'vicarious' sacrality.[49] Ancient Jews might not have believed that their God inhabited a synagogue full time, but He (and his entourage of angels) might be more imminent in the synagogue than in other communal spaces, such as market-

45　Certain biblical texts describe the entire Israelite community as holy and late ancient Jews may have viewed themselves as heirs to such sanctity; Deut. 8:6; 14:2; 26.19; Ps. 114.1; Ezra 9:2; additional discussion of biblical texts in Knoll 1995. Notions of 'holiness' associated with an assembled community and their activities within Christian contexts discussed in Yasin 2009, 35; I thank David Frankfurter for this reference. Yasin also evaluates Origin's notion that God's intermediaries, such as angels, were more likely to be present in churches than in other types of spaces (2009, 35–6).

46　Inscriptions from Gaza are discussed in Ovadiah 1968, 124–7; 1981, 130; Lifshitz 1967, 58–9, no. 77; from Ashkelon, see Branham 1995, 333; Lifshitz 1967, 55, no. 70; on the "sancta sinagoga" inscription from Tunisia, Stern 2008, 193–253. A Greek inscription from the Stobi synagogue in Macedonia likewise refers to the meeting hall of a synagogue as the 'holy place' (τῷ ἁγίω τόπω); Levine 2000, 252–3.

47　Assessments of mosaic designs and their interpretation are found in Schwartz 2001, 252–57; also Magness 2003; discussions also in Fine 1996.

48　For a summary of this point, see Levine 2000, 235–239.

49　Branham 1995, 331. See also note 45 above.

places, also located nearby.[50] Interpretations of amulets from synagogues necessarily rely on these distinct notions of the complex uses of and variegated sanctity within synagogue spaces.[51]

Synagogues and Magical Tradition

Remains of more than 90 ancient synagogues have been identified in regions of modern Israel,[52] but only a small percentage of these have been excavated according to modern scientific standards. Of this subset, roughly twenty-six total objects, including lamellae and sherds, inscribed with words and images and collectively identified as magical materials, were found in controlled excavations of four regional synagogues (Fig. 10.2). These, in turn, represent a significant proportion of the total number of *published* amulets (roughly 40) from different spatial contexts, which were found throughout regions sequentially called Roman and Byzantine Palaestina and which date to the fifth through sixth centuries CE.[53] To this date and of that total number, sixteen amulets from the synagogue at Nirim still remain unrolled and unread. Several additional lamellae, more recently found in other synagogues, are known but unpublished.[54] Delays in site publication, looting, and lack of historical interest in smaller finds from synagogues, collectively curtail efforts to map regional distributions of these amulets with perfect degrees of accuracy.[55]

The precise language, syntax, and placement of known ritual materials vary, as do their specific find contexts in and around synagogue buildings. But while most inscribed amulets discovered throughout modern Israel, Lebanon and Syria are of unknown provenance, the consistent discoveries of inscribed magical materials, found within and around ancient synagogues in the eastern Mediterranean, offer rare opportunities to correlate their lexical contents, their secretion in and around synagogue spaces, and their use.

50 Of course, among pagan populations, places such as marketplaces were as 'religious' as they were commercial and included temples, shrines, and altars for the conduct of commercial oath taking and sacrifice. On this topic, see discussions of Stowers 2011, 35–56.
51 For discussion of this point, see Yasin 2009, 1–10.
52 Levine 2000, 161–231.
53 This total relies on the number of texts included in Naveh and Shaked 1998 and 1993, with the addition of three published amulets found in Bar'am, Nazareth, and Sepphoris (Naveh 2001, 179) and the total number of texts from Nirim, including those unpublished.
54 I thank Gideon Bohak for clarifying this point in conversation.
55 Discussion of the sparseness of evidence for Jewish magical practices in Bohak 2008, 136.

FIGURE 10.3
Bronze defixio *found under the eastern threshold of the synagogue in Meroth (IAA No. 1984-317; Clara Amit, Israel Antiquities Authority).*

Violent Spells

Some of the texts discovered on lamellae from ancient synagogues throughout modern Israel employ particularly violent and aggressive language. The erotic amulet found in Ḥorvat Rimmon Fig. 10.2), as well as one bronze *defixio*, discovered inside the synagogue of ancient Meroth in the Upper Galilee (Fig. 10.3), fall into this category.[56] While the Ḥorvat Rimmon amulet attests to an agent's fervent desire to control the body of one individual, the commissioner of the Meroth *defixio* seeks to forcefully control, or 'suppress,' an entire community.

Joseph Naveh and Shaul Shaked transcribe and translate the Hebrew and Aramaic text from Meroth, composed in 26 lines, as follows:

56 Bohak 2009, 318; Naveh and Shaked, Amulet No.16, Fig. 1; this amulet is presently on display in the Israel Museum.

'For your mercy and for your truth' (Ps. 115:1; 138:2)
In the name of YHWH we shall do and succeed.
Strong and mighty God! May your name be blessed
And may your kingdom be blessed. As you have suppressed
The sea by your horses and stamped the earth with your shoe, and as you suppress
Trees in winter days and the herb
Of the earth in summer days, so may [there be suppressed]
[…]
before Yose son of Zenobia. May
my word and my obedience be imposed on them. Just as
the sky is suppressed before God,
and the earth is suppressed before
people, and people are
suppressed before death
and death is suppressed before
God, so may the inhabitants
Of this town be suppressed
And broken and fallen
Before Yose son of Zenobia.
In the name of *ḥṭw"* the angel
Who was sent before Israel
I make a (magic) sign. Success,
Success, Amen
Amen, Selah
Hallelujah[57]

As Naveh and Shaked note in their edition of the text, the contents of this *defixio* follow an epistolary form, which begins by quoting biblical verses (line 1–2); acclaims the addressee (the Jewish God) as 'strong and mighty,' and follows with two invocation sequences, which draw upon biblical allusions (Ps. 138:2; 115:1; Habb. 3:15);[58] the latter formularies are closely mirrored in texts found in the Cairo Geniza, which date to later periods.[59] The *defixio* concludes with "greetings and blessings" (lines 23b–26).[60] Despite occasional breaks in the text, its strident objectives are lucid: the named agent, Yose son of Zenobia,

57 Naveh and Shaked 1993, Amulet No. 16, 45. The amulet measures in 4.8 × 13.8 cm.
58 Naveh and Shaked 1993, 46.
59 Additional discussion of the Geniza in note 1 above.
60 Naveh and Shaked 1993, 46; Naveh 1984, 367–382 [Hebrew].

FIGURE 10.4 *Aerial photograph of remains of the Meroth synagogue, facing E (Israel Exploration Society).*

adjures that his 'obedience be imposed' (line 11) on the 'inhabitants of this town' (lines 17–18), who should be 'broken and fallen' before him (line 19).

Excavators accidentally discovered this rolled lamella buried directly beneath the stone threshold of the eastern entrance to the synagogue when they dismantled its northern wall for the removal of a decorative mosaic (Fig. 10.4).[61] As Naveh and Shaked suggest, the *defixio* seems to have been deliberately hidden inside the threshold in order to be trod upon—perhaps as part of the associated ritual or by the victims it targeted (lines 5–6).[62] The precise placement of the text may thus relate, in multiple ways, to the physical mechanism of its activation and efficacy.[63]

Deposits of materials, such as this *defixio*, remain difficult to interpret in devotional contexts. After all, the prayer formulas of binding spells, such as this, may have mirrored, or mimicked, the conventional phrases and concluding

61 Ilan 1989, 29; Ilan 1995, 270.

62 Bohak 2008, 318–19; Ilan 1989, 29; Ilan 1995, 270; As Naveh and Shaked note (1993, 48), the verb (*rkʿ*) from lines 5–6 is unusual ("As you have suppressed the sea by your horses and stamped the earth with your shoe...") and may predict the trampling that would take place, above the amulet, whenever people entered and exited the synagogue through the threshold. See also the example of translation Frankfurter 1999b, no. 84, 177; which implies that the proper placement of that recipe should be under the threshold of a house (l. 5–6). I thank David Frankfurter for this reference.

63 Ilan 1989, 29. The *defixio* was not the only object found beneath the synagogue. Other types of objects were also hidden in the building during periods of its use, including 485 coins, 245 of which were gold (and the remainder bronze), hidden under a stone with a slot; *ibid.*, 29.

formulas of prayers recited in devotional contexts in the synagogue above.[64] So obviously related to the agency and desires of an individual, moreover, it is tempting to create narratives that 'explain away' the presence of aggressive texts in these contexts. Ilan and Damati, who excavated and published the site, for example, assume that the violence of the spell's language necessarily serves as revenge for injustices previously sustained by the agent (Yose, son of Zenobia) at the hands of his community, such as accusations of libel, public shaming, or other types of cruelty.[65] The burial of the text in a foundational feature of the synagogue, likewise, appears to beg additional explanation.[66] Excavators assume that the agent must have been one of the synagogue founders: this, they suggest, offers the only possible explanation for his unusual access to the foundations of the building while it was under construction, which, in turn, permitted his insertion of the binding spell.[67]

The syntax of the *defixio* remains relatively conventional for its genre; only its find context appears most troubling to excavators.[68] This discomfort, in turn, inspires their justifications, which often appear overstated, for the presence of a binding spell in the synagogue. No element of the text, for example, explicitly supports excavators' hypotheses about the community's preliminary insult to Yose; his quest to attain unbridled power over his neighbors might have been unprovoked.[69] And presumably, any person (whether Yose or a third party) could have inserted the lamella beneath the threshold of the

64 Compare the divine epithets repeated in an amulet from Nirim discussed below (Naveh and Shaked, Amulet No. 12, 17–19), which appeals to the "Holy, Holy, Ho[ly, Holy]... God of Vengeance (Ps. 94:1)... God of Israel (Gen. 33:20)"; these epithets, which derive from biblical scripture, recur in Jewish liturgies of earlier and later periods. See parallel discussion in Wilburn 2012, 17–18.

65 Ilan considers this to be "further proof of the tremendous significance of the local community. A power struggle such as the one implied in the amulet indicates a successful and prosperous community: internal struggles like this do not occupy this kind of attention when a poor community is struggling against an outside threat" (1989, 29); see also Ilan and Damati (1984) 257; general discussion of synagogue in the context of the town in Ilan and Damati (1987); see also Levine 2000, 428.

66 Ilan 1989, 29.

67 Ilan asserts that: "He had competition or because libel was spoken against him. He was probably involved in establishing the synagogue, which explains how he had the opportunity to hide the amulet in the wall while it was being constructed. Perhaps he intentionally put it under the threshold so that his request would rise to G-d through the bodies of those who entered the synagogue (1989, 29).

68 For discussions of the contents and conventional context of curse tablets, see summary in Gager 1992, 18.

69 Bohak, too, is skeptical of such explanations (2008, 156, n. 28).

synagogue during the building's construction—access to the space need not have required special status or permission. The specific act of burying a lamella in a synagogue, moreover, is explicitly commended in Jewish magical recipes, albeit from much later periods: a medieval collection of recipes, entitled the *Sword of Moses*, prescribes the burial of an inscribed lamella inside a synagogue, in order to generate fear among other people.[70]

Prophylactic and Healing Amulets

Review of another bronze lamella, found in the small synagogue at Barʿam in the Galilee, confirms the conventionality of the medium and placement of the example from Meroth. The Barʿam lamella also adjures angels, but, in this instance, marshals them to defend its agent against the evils committed by others and from the evil eye. Part of Naveh's literal reading and translation of its eighteen lines includes: "….on the heart of Gabriel.… by him [I]adjure/you Naḥamel, the angel, that you should guard/ the […]of Judan, son of Nonna and you should guard [him]/from the (evil) speech of the mouth and from [the] evil gaze.…"[71] According to Mordechai Aviam, who excavated the site, the lamella was found *in situ* in the western stylobate of the synagogue.[72] This object, like the previous one, was not deposited accidentally; it was deliberately hidden inside foundations of the synagogue building.[73]

Different recipes, which seek protection and resolutions for physical maladies of their agents, have also been discovered within other regional synagogues. The largest cache of such amulets derives from the synagogue uncovered in the western Negev in Ḥorvat Maʿon, near Kibbutz Nirim.[74] Nineteen inscribed amulets were discovered in the apse of the building,

70 Bohak translates this text to read: "And if you want your fear to be upon people, write on a lead lamella from X to Y and bury it in a synagogue in the western direction"; *Harba de-Moshe* (The Sword of Moses), no. 105 in Harari 1997, 44; Bohak 2008, 319; Gaster 1896, 86.

71 It continues: "[….] [open]/ (*broken/illegible*, lines 7–11) Ṣuriel. I have written you (the amulet?) […]/ in order that God shall be because of you(?)[….]/[…]from it until the time of […]/ that Judan son of Nonna […]/*magic words/magic characters/* Amen"; transcription and translation from Naveh 2001, 179–180; Aviam 2001, 169; n. 25; Bohak 2008, 319.

72 Aviam hypothesizes that in a later phase of the use of the synagogue, these walls were constructed to block a northern isle of the building, and a door was built on the northern stylobate to access a narrow room; Aviam 2001, 169; also Naveh 2001. Bohak classifies this spell as an aggressive one, because it is a text "intended to silence one's enemies" (2008, 156).

73 Aviam 2001, 169.

74 One partially preserved bronze lamella from Barʿam, found beneath the synagogue's western stylobate of the synagogue, may contain formulae that reflect conventions of healing texts.

FIGURE 10.5 *Bronze inscribed tablets discovered in the synagogue of Ma'on/Nirim (IAA No. 1987-748-750; Israel Antiquities Authority).*

although additional amulets were found nearby.[75] While only three texts have yet been unrolled, transcribed, and published, all 19 of them were found tightly rolled; one was folded (Fig. 10.5).[76]

The published amulets include requests to restore the health of their named agents. One partially preserved inscription invokes the "great name" of the Jewish God ("Holy, Holy, Holy, Holy, Holy … God of Israel,"[77] while others detail more carefully the ailments and proposed means of curing the sick. One amulet seeks to rid Natrun, the daughter of Sarah, of radiating headache (*"kephalargia"*): '… [that] goes into the bones (?) of the chest…'[78] Still another amulet reads: 'An amulet proper for Esther, daughter of *ṭ'ṭys*/to save her from/

75 Bohak 2008, 315; 152, Fig. 3.2249, 260, 315–17, 318, 319–20, 348, 372, 379; Naveh and Shaked 1998, Amulet No. 13.19–22, 90; (Fig. 3). Bohak notes that members of the modern kibbutz, which is located close to the site of the synagogue, keep some of these lamellae in their homes: none of these additional lamellae, however, have been counted or published (2008, 315).

76 Bohak 2008, 315; published amulets (numbered as Naveh and Shaked 1998, Amulet Nos. 11–13), correspond with Israel Department of Antiquities nos. 57.733, 57.739, 57.744.

77 Naveh and Shaked 1998, Amulet No. 12, 15–18.

78 Naveh and Shaked 1998, 91; Amulet No. 11.4–5, 10; Fig. 13.

her evil tormentors/from evil eye/from spirit, from demon/ from shadow-spirit, from/ [all] evil tormentors,/from evil eye . . .".[79] The closing formula of the latter text (lines 12–22), which quotes a biblical passage (Ex.15:26), reinforces its role as a mechanism of healing ("If you wilt diligently hearken to the voice of the Lord thy God, and wilt do that which is right in his sight, and wilt give ear to his commandments and keep all his statutes I will put none of these diseases upon thee, which I have brought upon the Egyptians. For I am the Lord that healeth thee").[80]

Remnants of fibers of fabric or thread were still visible on some of the excavated bronze lamellae from Nirim; a full string was still attached to one of these.[81] Presence of strings on the Nirim amulets has lead some to conjecture that they were originally worn around individuals' necks;[82] others differently conclude that the affixed strings physically suspended the rolled lamellae from a "wall behind an ark of the law"—the space inside the synagogue where Torah scrolls were stored and accessed.[83] Various and additional hypotheses have explained the clustering of these texts in this specific area. Their discovery close to a space designated for the storage of sacred texts, for example, has inspired some to argue that a collection of lamellae might have constituted a type of *Geniza*—literally a "storing"— a repository of old and esteemed holy texts, which mention the Divine name.[84] Alternatively, as Bohak also proposes, the cache might have incorporated amulets, which were deposited after the successful resolutions of their agents' maladies.[85] At minimum, the potentially public display of the rolled Nirim lamellae, as well as their relatively large number (reported to exceed significantly the published number of examples), suggests that the Jews in Nirim might have institutionalized, or at least sanctioned, the practice of collecting and, possibly, exhibiting prophylactic and healing lamellae inside their synagogue.[86]

79 Naveh and Shaked 1998, 99; Amulet No. 13.2–10.
80 Naveh and Shaked 1998, 99, Amulet No. 13.12–22.
81 Bohak 2008, 315.
82 As Bohak suggests, such amulets were often be worn around individuals' necks (2008, 150, 315).
83 Naveh and Shaked 1998, 91.
84 For related discussions see references above in note 1; see also Ahipaz 2013 and elsewhere in Guri-Rimon 2013.
85 Compare with *GMA* no. 44.
86 See also discussion in Naveh 1988, 42, n. 37, where he notes that one Geniza text recommends the burial of an amulet beneath an ark in a synagogue (ref. Geniza T-S K.1.162); Bohak 2008, 317. John Chrysostom also accuses Christians of using synagogues as places for healing (*Adv. Iud.* 1.6.2–3; 1.8.1).

Discoveries of other types of deposits of non-textual and numismatic materials, also in Levantine synagogues, help to contextualize the previous examples. Excavations of the Dura Europos synagogue, for instance, revealed a small collection of finger bones, buried within a sealed door socket of the main entrance to its assembly hall. Scholars speculate that these deposits served "amuletic" or "apotropaic" functions, but no supplementary information can singlehandedly explain their burial.[87] Comparable discoveries of coin hoards inside walls and beneath floors of multiple synagogues of Roman and Byzantine Palestine (including those in Ḥorvat Rimmon, Meroth, and Barʻam) and Asia Minor, also demonstrate impulses to hide or bury objects beneath and within synagogues.[88] Examples of the latter types of coin deposits also remain anonymous and, ultimately, inexplicable. Deposits of broken, hidden, and inscribed sherds and lamellae in the Ḥorvat Rimmon, Meroth, Baʻram, and Maʻon/Nirim synagogues thus differ dramatically from other genres of synagogue burials, because they are attributable and explicable; they record the names of agents, targets, and the precise reasons for agents' commissions of the amulets (their agents' purported desires).

Broader internal consistencies also emerge in the inscribed synagogue amulets, including the prestige associated with acts of textual inscription and the exclusive use of Semitic scripts for this purpose. While non-textual amulets are found inside and beneath buildings throughout the Mediterranean, each of the known synagogue amulets includes writing. Furthermore, Greek spells are ascribed to ancient Jewish populations throughout the Mediterranean and Greek monumental inscriptions were often displayed in Levantine synagogues, but these synagogue amulets consistently include Semitic languages and scripts. Lexical contents of most spells additionally and collectively reflect syntheses of Jewish and non-Jewish ritual formulations. While inscriptions of ritual power may quote and interpret biblical texts, explicitly adjure the Jewish God and/or angels, mimic Jewish liturgies, and/or suggest the conduct of rituals, echoed in later rabbinic stories and in recipes known from the Cairo Geniza, their syntactical contents and appearance resemble both Greco-Roman and Mesopotamian cognates.[89] Last, and perhaps most importantly, inscribed

87 For a discussion of these points, respectively, see Stern 2012, 189–191; Kraeling 1979, 18, fig. 5; 19, fig. 6. Excavators specifically connected the deposit of finger bones to Mesopotamian practices of "foundation deposits," while Jodi Magness has argued, more recently (2010), for different assessments of the practice. Also Fine 1997, 145.

88 Magness 2005; Ahipaz 2013, 65–68.

89 Amulets from Nirim reflect distinctly Mesopotamian, as well as Greek prophylactic and healing traditions. Discussion of this point in Bohak 2008, 318.

synagogue amulets were ultimately hidden from passersby, just like their non-literary counterparts; the final treatments of each text, which included acts of breaking, burial, rolling or folding, rendered its contents hidden from human eyes. Some Jewish traditions may explain these internal consistencies, but additional comparisons with *lamellae* and *defixiones* discovered elsewhere in the Greco-Roman world, promise to highlight other significant features of amulet inscriptions and depositions in Levantine Jewish devotional contexts.

Ritual Power and Sacred Space in the Mediterranean East and West

Synagogues, of course, were not the only ancient spaces associated with cultic and devotional activities, in which individuals secreted inscribed materials of ritual power. Archaeologists have uncovered written curses and amulets inside multiple pagan temples and sanctuaries throughout the Mediterranean east and west. While the following overview of magical materials from Greco-Roman sanctuaries is necessarily brief, it highlights important points of connection and comparison between Jewish and pagan practices, and in turn, illuminates internally consistent features of the synagogue amulets.[90]

Texts of ritual power were discovered inside buildings associated with cultic activities throughout the Mediterranean. Eighteen lamellae recently published by Ron Stroud, which invoke Kore and other deities, were found inside the sanctuary of Demeter and Kore in Acrocorinth,[91] while collections of comparable materials have been discovered in a Magna Mater temple in Mainz.[92] Other *defixiones* were deposited in sanctuaries in Sicily and of Dea Sulis Minerva in Bath; these texts specifically adjure and invoke the deities believed to reside in surrounding spaces.[93] Gods worshipped in temples are often identical to those adjured in the magical texts deposited inside and around them.[94]

Patterns in the contents, treatments, and modes of display of *defixiones*, moreover, have grounded distinct scholarly hypotheses about the uses of magical writing in Greco-Roman cultic spaces. Some of the *defixiones* found in

90 I use the term 'pagan' as shorthand, rather than as an evaluative term, for the practices and populations associated with polytheistic worship throughout the Mediterranean in periods that precede Christian political dominance in the fourth and fifth centuries CE.
91 Versnel 2010, 313.
92 Most of the *defixiones* discovered inside these sanctuaries, as predicted by their locations, are inscribed in Greek on lead.
93 Gager 1992, nos. 51; 94; Versnel 2010, 313–14; Tomlin 1992, 19; 1988.
94 Some curse tablets, found in temples to Isis, for example, conform to patterns of misalignment; see also Versnel 2010, 315.

sanctuaries, such as those from the Temple of Demeter and Kore in Acrocorinth, for example, were displayed unrolled in antiquity. In these cases, agents sought retribution or reconstitution for explicitly described injustices, such as petty theft. Christopher Faraone argues for causal relationships between the function of these texts and their modes of display: he suggests that juridical *defixiones* in Acrocorinth were deliberately left unrolled and displayed, because their agents *wanted* them to be seen by passersby. He explains that justice-seeking *defixiones* could be doubly effective if agents made their contents visible in sanctuaries:[95] on the one hand, their texts called upon powerful deities to right previous wrongs and to assure that justice was served; on the other hand, by remaining readable to literate passersby, their descriptions could publicly shame an offending party (who might then be more willing to restore the stolen goods).[96]

Other *defixiones* were publicly exhibited in temples in different ways including fixation to architectural or monumental features. Small holes in *lamellae* discovered in a precinct of Demeter in Cnidus in Asia Minor has lead some editors to hypothesize that the spells originally were affixed to the temple walls.[97] A silver lamella from ancient Thysdrus (modern El Djem, Tunisia), which records names of angels in Latin, was reportedly found in a prominent position of display—affixed to a stele dedicated to Saturn.[98]

Most binding spells and amulets, however, were not deposited publicly in temples, but in other strategic locations. Agents frequently hid erotic and violent binding spells, as well as other justice-seeking texts, inside tombs and cemeteries, where invoked deities were considered imminent.[99] An erotic *defixio* from Egypt, probably deposited in a cemetery, explicitly announces the expectation that resident deities and spirits of that 'place' (presumably, that cemetery) would assist his efforts to manipulate a victim ("I entrust this binding spell to you, gods of the underworld, Plutôn and *Korê, Persephonê, Erecshigal and Adônis.... I conjure all spirits in this place to stand as

95 Faraone, Garnand and Lopez-Ruiz 2005.
96 Faraone and Rilfe 2007, 155.
97 Gager 1992, no. 89.
98 The amulet from Thysdrus is recorded in *GMA* no. 64; of this example, Kotansky comments: "The magic names inscribed on the silver piece would have been invoked to protect the sanctuary to which the amulet was affixed, and/or the text was meant as a prayer directed to the god Saturn's attention" (*GMA*, 376). Remains of additional dedicatory stelai to Saturn were also discovered nearby.
99 One defixio, for example, was found in a pot with a figurine of a woman pierced with thirteen needles. Translation from Gager 1992, no. 28; image of figurine in fig. 13; see discussion in Wilburn 2012, 1–3.

assistants...").[100] Comparable binding recipes were secreted inside the possessions of intended victims, or were buried beneath private homes.[101] Those who wished to sway the results of circus or theater competitions dropped their *defixiones* into pits or wells close to locations of the contests, or nailed them to floors of racetracks.[102] Still others, who wished to curse businesses of fellow tradesmen, deposited amulets inside or beneath victim's houses and workshops.[103] Locations of *defixiones*, as much as their contents, impacted their potential efficacy.

Still other genres of inscribed objects, furthermore, were also deposited in particular places for specific reasons: many were positioned in Greco-Roman sanctuaries for purposes of healing or supplication. Individuals often placed surgical implements, anatomical votives and votive inscriptions inside healing sanctuaries before and after resolutions of their donors' health maladies.[104] Such votives were publicly displayed when dedicated to Aesklepios, or were prominently positioned in and around healing springs sacred to nymphs or particular local deities.[105] Their visibility inside these shrines attests to supplicants' expectations in, and gratitude for, the abilities of invoked deities to resolve their troubles. In other cultic contexts, inscribed *lamellae*, often composed of precious metals, were similarly placed amidst votives donated to relevant deities.[106]

Mediterranean analogues of diverse contexts and uses, then, offer useful comparisons for interpreting the placements of synagogue amulets in the Levant. The amulets and *defixio* from Ḥorvat Rimmon, Barʿam, and Meroth, respectively, follow deposit patterns common for aggressive recipes throughout the Mediterranean. Their formulas are violent and corresponding ritual treatments of the amulets (piercing, shattering, and burial) remain typical for such aggressive and binding spells. Unlike displayed justice-seeking amulets, such as those in Acrocorinth, moreover, whose agents' expectations for retribution were somewhat meritorious, agents and practitioners likely considered *defixiones* and cognate spells to be unsuitable for public viewing. Acts

100 Gager 1992, 99, no. 28.
101 Gager 1992, 94–100; Heintz 1998, 338–342.
102 Gager 1992, 19, fig. 4.
103 Gager 1992, no. 70; on such commercial and professional spells, see 151–174.
104 Discussion in Avalos 1995; see also Bolger 1992.
105 Cf. Pausanius 8.41.2–3.
106 One gold lamella was discovered in a votive cache of the cave-sanctuary of Mt. Ida (Gortyn) on Crete; discussion in *GMA* no. 44.

of burial kept agents' desires secret or private—hidden from human eyes and known only to the powers they adjured.[107]

Contents and placements of the remaining synagogue amulets, including those at Ma'on/Nirim, most closely resemble the votive deposits found in healing sanctuaries and springs in Palestine and elsewhere—[108] both with respect to their syntactical contents and to their (potentially) public display or deposit. These amulets sought remedies for agents, who suffered from medical problems, but their resolutions did not require harm to others. Perhaps, the public exposure of the deposit of healing amulets in the Ma'on/Nirim synagogue relates to the benign nature (and means) of their agents' requests. Still, unlike most of the votives from 'pagan' contexts, the Ma'on/Nirim texts ultimately remained inaccessible to all synagogue visitors, because of their additional rolling and folding.

Practical factors, then, might additionally predict the precise placement and treatment of synagogue amulets. As Bohak argues, agents probably deposited amulets in synagogues for logical and individuated reasons: the erotic amulet from Ḥorvat Rimmon might have been buried beneath a synagogue, because it was frequented by its intended target; likewise, the Meroth defixio, which targeted an entire community, was placed beneath a synagogue entrance, which was traversed by the targeted population.[109] These conclusions soundly explain deposits of violent spells and accord with known practices in Greco-Roman sanctuaries. Explanations for the Ma'on/Nirim cache necessarily remain more speculative, partly because our knowledge of the texts and their find contexts remains so incomplete.

Certain features of the synagogue amulets, however, are largely unprecedented in Greco-Roman contexts. Their media, languages, and cultural details, in particular, distinguish them from explicitly 'pagan' or Christian counterparts. First, most of the amulets from synagogues are inscribed in bronze; only the Ḥorvat Rimmon sherds are scratched into ceramic. As Gideon Bohak has noted, these materials are unconventional in comparable contexts elsewhere; ritual texts throughout the Mediterranean commonly appear on lead and, only more exceptionally, on silver and gold sheets.[110] The tendency to inscribe on bronze or ceramic may relate to the relative availability of raw materials, but a

107 Gager 1992.
108 Kessler 1999, 198.
109 Bohak 2008, 315–320.
110 Bohak notes that the use of lead is notably absent in identifiably Jewish magical contexts (2008, 319).

cultural preference for bronze and an absence of lead, most probably respond to undocumented internal traditions and aversions to particular media.[111]

Furthermore, the language choices in the synagogue spells may reflect practitioners' concerns about communicating with a distinct and specific divine audience.[112] Practitioners determined the languages of inscribed recipes, which did not necessarily correspond with the languages spoken by their agents. Unlike the monumental inscriptions also displayed in mosaic and stone in many regional synagogues, which sometimes included Greek, the synagogue amulets are inscribed exclusively in Semitic scripts (Jewish Aramaic, Hebrew). This linguistic consistency is suggestive of context-dependence: perhaps amulets deposited in synagogues were inscribed in Hebrew and Aramaic, because they were considered to be the most effective languages for communicating with the angels and divinities named in the inscriptions, who were specifically connected with the surrounding buildings and with associated liturgical and religious traditions.

Finally and for two interconnected reasons, synagogues might have offered rare and important places for Jews to deposit texts of ritual power in late antiquity: they were spaces associated with sanctity, in which divine powers (namely, the Jewish God and his angels) were considered most accessible (relatively speaking) *and* where intended victims and beneficiaries were physically most proximate.[113] Magical practitioners might have instructed agents to hide their aggressive spells around the homes of their victims, or somewhere inside marketplaces, where targeted individuals and communities also traversed and convened. Likewise, those who copied healing spells could have suggested any number of other places for their deposit. But just as in other regions of the Greco-Roman world, where agents deposited amulets in temples and cemeteries to manipulate their resident deities, so too might have Jews deposited their spells in synagogues—spaces associated, in diverse ways, with numinous presences. Foremost, placements of amulets inside synagogues, as Bohak has suggested, were expedient for practical reasons: they were secreted close to their target populations. By periods of late antiquity, Jews in the upper Galilee of Roman and Byzantine Palestine constituted a cultural minority in an increasingly hostile cultural environment; synagogues, perhaps, offered rare places to target Jewish communities exclusively.[114] Depositions of amulets inside

111 Bohak 2008, 319.
112 Stern 2012, 188–190.
113 Stern 2012.
114 Debates currently consider the variable ethnic composition of the Galilee region of Roman and Byzantine Palaestina. Edited works that address the topic include Jürgen K. Zangenberg, Harold W. Attridge and Dale B. Martin 2007; Meyers 1999; Lapin 1998.

Levantine synagogues thus were neither accidental, nor sacrilegious. Instead, they were efficient. For multiple reasons, their written recipes, just like other types of prayers or supplications, were considered to be most effective in these particular places.

Conclusion

Many have argued that writing served as a powerful tool inside ancient synagogues: the display of monumental inscriptions rewarded donors' beneficence with the perennial advertisement of their works.[115] Less discussed is the use of writing inside synagogues to commemorate personal or individuated acts of directed invocation, memorial, and prayer. As I have argued elsewhere, devotional graffiti, openly displayed inside some ancient synagogues, equally exhibited individuals' efforts to use writing to document personal prayers or acts of supplication.[116] Inscribed amulets, I suggest, take these features of writing (as communication, commemoration, documentation, and supplication) a step further: they draw attention to the names of their agents and detail their requests, but only for viewing by the divine and semi-divine audiences they adjure. Texts on movable objects, when buried, could offer a rare means of private communication with the divine being(s) considered to be most imminent inside ancient synagogues.

Unlike donor inscriptions, which publicly proclaimed the variegated good works of individuals for passersby, writing on amulets did not pretend to fulfill vows, contribute to the betterment of surrounding spaces and did not explicitly seek public acclaim for their agents.[117] Instead, the audience of an inscribed and hidden amulet was limited to the practitioner or scribe, the agent, and, presumably, to the supernatural forces she adjured. Unbeknownst to other visitors to ancient synagogues, then, deposits of inscribed amulets secretly, instantaneously, and physically 'privatized' the surrounding spaces for their agents, by harnessing all of their associated sacred and social powers for their individual ends. Secretions of inscribed amulets and *defixiones* inside Palestinian synagogues, in so doing, served powerful functions—they could, covertly, transform communal spaces into private ones. Architecture and social practice could bend to the will of an amulet's agent.

Despite a general paucity of evidence, repeated discoveries of synagogue amulets constitute a regionally significant pattern and suggest that Jews from

[115] As collected in Lifshitz 1967.
[116] Stern 2012.
[117] Phenomenon detailed in Satlow 2005.

the eastern Mediterranean may have conducted wider ranges of activities inside their synagogues than is conventionally thought. In addition to serving as sites of convocation and public or private prayer, synagogues also constituted powerful places for Jews to perform other types of acts—hiding and depositing written requests to their God and his angels, rendered more powerful by their etchings into clay or bronze. Evaluation of these amulets thus both expands our understandings of activities associated with ancient synagogues and draws attention to different ways that Jews and other Mediterranean populations could engage in common practices of inscribing and secreting movable objects in communal sacred spaces. The modern categories of religion, magic, and medicine collapse in the face of these examples.

Consideration of these materials, moreover, has implications for future research. To this date, no additional examples of inscribed magical amulets have been reported in other synagogues from the Mediterranean diaspora.[118] Perhaps enhanced awareness of the amulets from Levantine synagogues might encourage the reexamination of reports from excavations of diaspora synagogues, to determine whether such depositions were more widespread among Mediterranean Jewish populations than is presently known.[119] Moreover, abundant literary and archaeological evidence attests to Christians' engagement in practices of ritual power.[120] To this point, however, there are great difficulties correlating the placement of Christian amulets and their find contexts, as many of them were looted or sold on the art market long ago. Still, evaluation of Jewish amulets and synagogues might additionally encourage new and productive considerations of inscribed magical materials associated with the contemporaneous churches, shrines, and sacred spaces of early Christian populations.[121]

Jews who dwelled in different regions of the Mediterranean, in all cases, necessarily responded to the cultural, social, and religious practices of their neighbors. Likewise, centuries of Hellenistic, Roman, and Byzantine domination, distinctly shaped Levantine culture and the behaviors of Jews in its midst. Contextual review of Jewish spells in their broader geographic and cultural contexts thus contributes significantly, if unexpectedly, to our understandings of writing and the private sphere and illuminates unexpected points of cul-

[118] For discussion of the bones in the Dura synagogue, see Stern 2012, 189–191; on coins in synagogues from Asia Minor, see Magness 2005.

[119] I owe this suggestion to Gideon Bohak, in private conversation, August 2013.

[120] Chrysostom, *Against the Jews* 8.5.6 and 8.8.7–9 (PG 48.935; PG 48.940–1); see also note 5 above.

[121] This point also discussed in private correspondence with Gideon Bohak, October 2013.

tural contact and transformation among Jews and their Greco-Roman neighbors in the eastern Mediterranean.[122]

Bibliography

Adams, Geoff W. 2006. "The Social and cultural implications of curse tablets [*defixiones*] in Britain and on the Continent." *Studia Humaniora Tartuensia* 7.A.5: 1–15.

Ahipaz, Nili. 2013. "Floor Foundation Coin Deposits in Byzantine-Period Synagogues." In *Hoards and Genizot as Chapters in History*, edited by Ofra Guri-Rimon. Haifa: Hecht Museum, University of Haifa, 63–70.

Audollent, Auguste. 1904. "Defixionum tabellae quotquot innotuerunt." PhD diss., University of Paris.

Avalos, Hector. 1995. *Illness and Health Care in the Ancient Near East: The Role of the Temple in Greece, Mesopotamia, and Israel*. Atlanta: Scholars Press.

Avi-Yonah, Michael. 1976. *The Jews of Palestine: A Political History from the Bar Kochba War to the Arab Conquest*. New York: Schocken.

Aviam, Mordechai. 2001. "Ancient Synagogues at Barʻam." In *Judaism in Late Antiquity*, part 3, vol. 4, edited by Alan J. Avery-Peck and Jacob Neusner, 155–178. Leiden: E. J. Brill.

Betz, Hans Dieter, ed. 1986. *The Greek Magical Papyri in Translation, including the Demotic spells*, vol 1. Chicago and London: University of Chicago.

Blänsdorf, Jürgen. 2010. "The Defixiones from the Sanctuary of Isis." In *Magical Practice in the Latin West: Papers from the International Conference held at the University of Zaragoza 20 Sept–1 Oct 2005*, edited by Richard Lindsay Gordon and Francisco Marco Simon, 141–190. Leiden: Brill.

Bohak, Gideon. 2008. *Ancient Jewish Magic: A History*. Cambridge: Cambridge University Press.

———. 2009. "The Jewish Magical Tradition from Late Antique Palestine to the Cairo Geniza." In *From Hellenism to Islam: Cultural and Religious Change in the Roman Near East*, edited by Hannah Cotton, Robert Hoyland, Jonathan Price and David Wasserstein, 321–339. Cambridge: Cambridge University Press.

———. 2011. "The Magical Rotuli from the Cairo Geniza." In *Continuity and Innovation in the Magical Tradition*, edited by Gideon Bohak, Yuval Harari and Shaul Shaked, 321–340. Leiden: Brill.

Bolger, Diane. 1992. "The Archaeology of Fertility and Birth: A Ritual Deposit from Chalcolithic Cyprus." *Journal of Anthropological Research* 48.2: 145–164.

122 On the role of language choice, see *Schwartz* 1995; Lapin 1999, 258; Stern 2008, 187–92; see also discussions on language and magic in Bohak 2008, 254–6, 291–350.

Bowes, Kimberly. 2008. *Private Worship, Public Values and Religious Change in Late Antiquity*. Cambridge/New York: Cambridge University Press.

Branham, Joan. 1995. "Vicarious Sacrality: Temple Space in Ancient Synagogues." In *Ancient Synagogues: Historical Analysis and Archaeological Discovery*. Vol 2, edited by Dan Urman and Paul Flesher, 319–345. Leiden: Brill.

Brooten, Bernadette. 1982. *Women Leaders in the Ancient Synagogue: Inscriptional Evidence and Background Issues*. California: Scholars Press.

Chaniotis, Angelos. 2002. "The Jews of Aphrodisias: New Evidence and Old Problems." *Scripta Classica Israelica* 21: 209–242.

Choat, M. and I. Gardner. 2013. *Coptic Handbook of Ritual Power*. Belgium: Brepols.

Cohen, Shaye J. D. 1984. "The Temple and the Synagogue." In *The Temple in Antiquity*, edited by Truman G. Madsen. Provo UT: Brigham Young University Press, 151–174.

———. 1987. "Pagan and Christian Evidence in the Early Synagogue." In *The Synagogue in Late Antiquity*, edited by Lee I. Levine, 159–181. Philadelphia: ASOR.

———. 1989. "Pagan and Christian Evidence for the Synagogue." In *The Synagogue in Late Antiquity*, edited by Lee I. Levine, 159–81. Philadelphia: ASOR.

Cox Miller, Patricia. 1986. "In Praise of Nonsense." In *Classical Mediterranean Spirituality: Egyptian, Greek, Roman*, edited by A. Armstrong, 481–505. New York: Crossroad.

Dickie, Matthew W. 2000. "Who Practiced Love-Magic in Classical Antiquity and the Late Roman World?" *Classical Quarterly* 50: 563–583.

Faraone, Christopher. 1999. *Ancient Greek Love Magic*. Cambridge: Harvard Univesity Press.

———. 2011. "Magic and Medicine in the Imperial Period: Two Case Studies." In *Continuity and Change in the Magical Tradition*, edited by Gideon Bohak, Y. Harari, and Shaul Shaked, 135–157. Leiden: Brill.

Faraone, Christopher, Brien Garnand and Carolina Lopez-Ruiz. 2005. "Micah's Mother (Judges 17:1–4) and a Curse from Carthage (*KAI* 89): Evidence for the Semitic Origin of Greek and Latin Curses against Thieves?" *Journal of Near Eastern Studies* 64: 170–175.

Faraone, Christopher and Dirk Obbink, eds. 1997. *Magika Hiera: Ancient Greek Magic and Religion*. New York: Oxford University Press.

Faraone, Christopher and Joseph L. Rife. 2007. "A Greek Curse against a Thief from the Koutsongila Cemetery at Roman Kenchrai." *Zeitschrift für Papyrologie und Epigraphik* 160: 141–157.

Fine, Steven, ed. 1996. *Sacred Realm: The Emergence of the Synagogue in the Ancient World*. New York: Oxford University Press.

———. 1997. *This Holy Place: On the Sanctity of the Synagogue during the Greco-Roman Period*. Notre Dame: University of Notre Dame Press.

———. 2010. "Jewish Identity at the Limus: The Earliest Reception of the Dura Europos Synagogue Paintings." In *Cultural Identity in the Ancient Mediterranean. Issues & Debates*, edited by Erich Gruen, 303–320. Los Angeles: *Getty* Research Institute.

Frankfurter, David. 1994. "The Magic of Writing and the Writing of Magic: The Power of the Word in Egyptian and Greek Traditions." *Helios* 21: 189–221.

———. 1995. "Narrating Power: The Theory and Practice of the Magical *Historiola* in Ritual Spells." In *Ancient Magic and Ritual Power*, edited by Marvin Meyer and Paul Mirecki, 457–476. Leiden: Brill.

———. 1999a. *Religion in Roman Egypt: Assimilation and Resistance.* Princeton: Princeton University Press.

———. 1999b. "Spell for a Man to Obtain a Male Lover," *Ancient Christian Magic*, edited by Marvin Meyer and Richard Smith. Princeton: Princeton University Press, 177.

———. 2001. "Magical *Historiola* in Ritual Spells." In *Ancient Magic and Ritual Power*, edited by Marvin Meyer and Paul Mirecki, 457–76. Leiden: Brill.

Gager, John, ed. 1992. *Curse Tablets and Binding Spells from the Ancient World.* Oxford: Oxford University Press.

Gaster, Moses. 1896. *The Sword of Moses.* London, Nutt.

Gordon, Richard and Francisco Marco Simón, eds. 2010. *Magical Practice in the Latin West: Papers from the International Conference held at the University of Zaragoza 20 Sept–1 Oct 2005.* Leiden: Brill.

Guri-Rimon, Ofra, ed. 2013. *Hoards and Genizot as Chapters in History.* Catalogue no. 33. Haifa: Hecht Museum, University of Haifa.

Häberl, Charles G. Forthcoming. "Aramaic Incantation Texts between Orality and Textuality." In *Orality and Textuality in the Iranian World*, edited by J. Rubanovitch. Leiden: Brill.

Hachlili, Rachel. 2013. *Ancient Synagogues-Archaeology and Art: New Discoveries and Current Research.* Leiden: Brill.

Harari, Yuval. 1997. *Harba de-Moshe (The Sword of Moses): A New Edition and a Study.* Jerusalem: Academon.

———. 2005. "What is a Magical Text? Methodological Reflections Aimed at Redefining Jewish Magic." In *Officina Magica: Essays on the Practice of Magic in Antiquity*, edited by Shaul Shaked. Leiden: Brill, 91–124.

Harviainen, Tapani. "Pagan Incantations in Aramaic Magic Bowls." In *Studia Aramaica: New Sources and New Approaches: Papers delivered at the London conference of the Institute of Jewish Studies University College London 26th-28th June 1991*, edited by Markham J. Geller, Jonas C. Greenfield and Michael Weitzman, 53–60. Oxford: Oxford University Press.

Hayim, Lapin. 1999. "Palestinian Inscriptions and Jewish Ethnicity in Late Antiquity." In *Galilee through the Centuries: Confluence of Cultures*, edited by Eric Meyers, 242–3. Winona Lake: Eisenbrauns.

Heintz, Florent. 1998. "Circus Curses and their Archaeological Contexts" *JRA* 11: 338–42.

Hengel, Martin. 1975. "Proseuche und synagoge: Jüdische Gemeinde, Gotteshaus un Gottesdienst in der Diaspora und in Palästina." In *The Synagogue: Studies in Origins, Archaeology and Architecture*, edited by Joseph Gutmann, 27–54. New York: Ktav.

Honigman, Sylvie. 1993. "The Birth of a Diaspora: The Emergence of a Jewish Self-Definition in Ptolemaic Egypt in the Light of Onomastics." In *Diasporas in Antiquity*, edited by Shaye J. D. Cohen and Ernest S. Frerichs, 93–127. Atlanta: Scholars Press.

Ilan, Tal. 1993. "Meroth," *New Encyclopedia of Archaeological Excavations in the Holy Land, vol 3*, Ephraim Stern, ed. Jerusalem: Israel Exploration Society & Carta; Simon and Schuster, 1028–1031.

———. 1999. *Integrating Women into Second Temple History*. Tübingen: Mohr Siebeck.

———. 2002–2012. *Lexicon of Jewish Names in Late Antiquity. Vols. I–IV*. Tübingen: Mohr Siebeck.

Ilan, Zvi. 1989. "The Synagogue and Beth Midrash of Meroth." In *Ancient Synagogues in Israel: Third to Seventh Centuries CE. Proceedings of Symposium, University of Haifa, May 1987*, edited by Rachel Hachlili, 21–42. Oxford: BAR.

———. 1995. "The Synagogue and Study House at Meroth." In *Ancient Synagogues: Historical Analysis and Archaeological Discovery*, vol. 1 edited by Dan Urman and Paul Flesher, 256–288. Leiden: Brill.

Ilan, Zvi and Emanuel Damati. 1984. "Excavations: Kh. Marus, 1983 and 1984," *Israel Exploration Journal* 34: 256–258.

———, eds. 1987. *Meroth the Ancient Jewish Village*. Tel Aviv: Society for the Protection of Nature.

Jeffers, Ann. 1996. *Magic and Divination in Ancient Palestine and Syria*. Leiden: Brill.

Jordan, D. R. 1985. "A Survey of Greek Defixiones not included in the Special Corpora." *Greek, Roman, and Byzantine Studies* 26: 151–197.

Kessler, Christa Müller. 1999. "Interrelations between Mandaic Lead Rolls and Incantation Bowls." In *Mesopotamian Magic: Textual Historical and Interpretive Perspectives*, edited by Tzvi Abusch and Karel Van der Torn, 197–212. Groningen: Styx Publications.

Kloner, Amos. 1980. "Ḥurvat Rimmon, 1979," *Israel Exploration Journal* 30, 226–228.

———. 1981. "Ḥurvat Rimmon, 1980," *Israel Exploration Journal* 31, 242–242.

———. 1982. "New Judean/Jewish Inscriptions from the 'Darom.'" *Qadmoniyot* 71–72: 96–100.

———. 1989. "The Synagogues of Horvat Rimmon." In *Ancient Synagogues in Israel: Third to Seventh Centuries CE. Proceedings of Symposium, University of Haifa, May 1987*, edited by Rachel Hachlili, 43–54. Oxford: BAR.

Knoll, Israel. 1995. *The Sanctuary of Silence: The Priestly Torah and the Holiness School*, Jerusalem: Magnes Press.

Kotansky, Roy. 1994. *Greek Magical Amulets: The Inscribed Gold, Silver, Copper, and Bronze Lamellae. Part I: Published Texts of Known Provenance*. Opladen: Westdeutscher Verlag.

———. 1994. "Θωβαρραβαν= 'The Deposit Is Good.'" *The Harvard Theological Review* 87.3: 367–369.

Kraeling, Carl. 1979. *The Synagogue*. (*The Excavations at Dura Europos: Final Report 8/1.*) 2nd ed. New Haven: Yale University Press.

Lambert, Stephen. 2000. "Two notes on Attic *Leges Sacrae*." ZPE 130: 71–80.

Lapin, Hayim. 1999. "Palestinian Inscriptions and Jewish Ethnicity in Roman Palestine." In *Galilee through the Centuries: Confluence of Cultures*, edited by Eric M. Meyers, 239–268. Winona Lake: Eisenbrauns.

———, ed. 1998. *Religious and Ethnic Communities in Roman Palestine*. Bethesda: University of Maryland Press.

Levene, Dan. 1999. "'…And by the name of Jesus…' An Unpublished Magic Bowl in Jewish Aramaic." *Jewish Studies Quarterly* 6.4: 283–308.

Levine, Lee I. 2000. *The Ancient Synagogue: The First Thousand Years*. New Haven: Yale University Press.

Levtow, Nathaniel B. 2012a. "Text Destruction and Iconoclasm in the Hebrew Bible and the Ancient Near East." In *Iconoclasm and Text Destruction in the Ancient Near East and Beyond*, edited by Nathalie Naomi May, 311–362. Chicago: Oriental Institute of the University of Chicago.

———. 2012b. "Text Production and Destruction in Ancient Israel: Ritual and Political Dimensions." In *Social Theory and the Study of Ancient Israel: Essays in Retrospect and Prospect*, edited by Saul Olyan, 111–140. Atlanta: SBL.

Lifshitz, Baruch. 1967. *Donateurs et Fondateurs dans les Synagogues Juives: répertoire des dédicaces grecques relatives à la construction et à la réfection des synagogues*. Paris: J. Garabalda.

Magness, Jodi, Shua Kisilevitz, Karen Britt, Matthew Grey and Chad Spigel. 2014. "Huqoq (Lower Galilee) and its synagogue Mosaics: preliminary report on the excavations of 2011–2013," *JRA* 27: 327–355.

Magness, Jodi. 2003. "Helios and the Zodiac Cycle in Ancient Palestinian Synagogues." In *Symbiosis, Symbolism, and the Power of the Past: Canaan, Ancient Israel, and their Neighbors from the Late Bronze Age through Roman Palaestina*, edited by William Dever and Seymour Gitin, 363–392. Indiana: Eisenbrauns.

———. 2005. "The Date of the Sardis Synagogue according to the Numismatic Evidence." *AJA* 109: 443–475.

———. 2010. "Third Century Jews and Judaism in Beth Shearim and Dura Europus." In *Religious Diversity in Late Antiquity*, edited by David M. Gwynn and Susanne Bangert, 135–166. Leiden: Brill.

Meyers, Eric, ed. 1999. *Galilee through the Centuries: Confluence of Cultures*. Winona Lake: Eisenbrauns.

Mock, Leo. 2003. "The Synagogue as a Stage for Magic." *Zutot* 3: 3–14.

Naveh, Joseph. 1984. "A Good Conquest. One of a Kind. An Ancient Amulet from Galilee," *Tarbiz* 54: 367–382 [Hebrew].

———. 1988. "Lamp Inscriptions and Inverted Writing." *Israel Exploration Journal* 38: 36–43.

———. 1989. "The Aramaic and Hebrew Inscriptions from Ancient Synagogues." *Eretz-Yisrael* 20: 302–310.

———. 2001. "An Aramaic Amulet from Barʿam." In *Judaism in Late Antiquity pt 3, vol IV, Handbook of Oriental Studies I, 55*, edited by Alan J. Avery-Peck and Jacob Neusner, 179–85. Leiden: Brill.

Naveh, Joseph and Shaul Shaked. 1993. *Magical Spells and Formulae: Aramaic Incantations of Late Antiquity*. Jerusalem: Magnes Press.

———. 1998. *Amulets and Magic Bowls: Aramaic Incantations of Late Antiquity*. 3rd ed. Jerusalem: Magnes Press.

Ovadiah, Asher. 1968. "The Synagogue at Gaza," *Qadmoniot* I, 3: 124–127 [Hebrew].

———. 1981. "The Synagogue at Gaza." In *Ancient Synagogues Revealed*, edited by Lee I. Levine. Jerusalem: Israel Exploration Society.

Patchouni, Eleni. 2013. "The Erotic and Separation Spells of the Magical Papyri and Defixiones." *Greek, Roman, and Byzantine Studies* 53: 294–325.

Rajak, Tessa. 1994. "The Jewish Community and its Boundaries." In *The Jews among Pagans and Christians in the Roman Empire*, edited by Judith Lieu, John North, and Tessa Rajak, 9–29. New York: Routledge.

———. 2002. *The Jewish Dialogue with Greece and Rome: Studies in Cultural and Social Interaction*. Leiden: Brill.

Rajak, Tessa and David Noy. 1993. "*Archisynogogoi*: Office, Title and Social Status in the Greco-Jewish Synagogue." *Journal of Roman Studies* 83: 75–93.

Reif, Stefan. 2000. *A Jewish Archive from Old Cairo: The History of Cambridge University's Geniza Collection*. Richmond and Surrey: Curzon.

Reynolds, Joyce and Robert F. Tannenbaum. 1987. *Jews and Godfearers at Aphrodisias: Texts from the Excavations at Aphrodisias Conducted by Kenan T. Erim*. Cambridge: Cambridge Philological Society.

Rosenblum, Jordan. 2010. *Food and Identity in Early Rabbinic Judaism*. New York: Cambridge University Press.

Satlow, Michael. 2005. "Giving for a Return: Jewish Votive Offerings in Late Antiquity." In *Religion and the Self in Antiquity*, edited by David Brakke, Michael Satlow, and Steve Weitzman, 91–105. Bloomington: Indiana University Press.

Schwartz, Seth. 1995. "Language, Power and Identity in Ancient Palestine." *Past and Present* 148: 3–47.

———. 2001. *Imperialism in Jewish Society: 200 BC to 640 CE*. Princeton: Princeton University Press.
Shaked, Shaul. 2011. "Transmission and Transformation of Spells: The Case of the Jewish Babylonian Aramaic Bowls." In *Continuity and Innovation in the Magical Tradition*, edited by Gideon Bohak, Yuval Harari, and Shaul Shaked, 187–218. Leiden: Brill.
Sivan, Hagith. 2008. *Palestine in Late Antiquity*. Oxford: Oxford University Press.
Smith, Jonathan Z. 1990. *Drudgery Divine: On the Comparison of Early Christianities and the Religions of Late Antiquity*. Chicago: University of Chicago Press.
Sokolowski, Franciszek. 1955. *Lois Sacrées de l'Asie Mineure*. École française d'Athènes. Travaux et mémoires, fasc. 9. Paris: de Boccard.
———. 1962. *Lois Sacrées des cités grecques: supplément*. École française d'Athènes. Travaux et mémoires, fasc. 11. Paris: de Boccard.
———. 1969. *Lois Sacrées des cités grecques*. École française d'Athènes. Travaux et mémoires, fasc. 18. Paris: de Boccard.
Stern, Karen B. 2008. *Inscribing Devotion and Death: Archaeological Evidence for Jewish Populations in North Africa*. Leiden: Brill.
———. 2012. "Tagging Sacred Space in the Dura Synagogue." *JRA* 25 fasc. 1: 171–194.
Stowers, Stanley. 2011. "The Religion of Plant and Animal Offerings Versus the Religion of Meanings, Essences and Textual Mysteries." In *Ancient Mediterranean Sacrifice: Images, Acts, Meanings*, edited by Jennifer Knust and Zsuzsa Varhelyi, 35–56. New York: Oxford University Press.
Tomlin, Roger. 1988. "The Curse Tablets." In *The Temple of Sulis Minerva at Bath. Volume II: The Sacred Spring*, edited by B. Cunliffe. Monograph no. 16. Oxford: Oxford University Committee for Archaeology.
———. 1992. "Voices from the Sacred Spring," *Bath History Vol. IV*. Millstream.
———. 2005. *Curse Tablets of Roman Britain*. Oxford: Oxford University Press.
Versnel, Henk S. 2010. "Prayers for Justice, East and West: New finds and publications since 1990." In *Magical Practice in the Latin West: Papers from the International Conference held at the University of Zaragoza 20 Sept–1 Oct 2005*, edited by Richard Lindsay Gordon and Simon Francisco Marco, 275–354. Leiden: Brill.
White, Michael. 1990. *Building God's House in the Roman World: Architectural Adaptation among Pagans, Jews, and Christians*. Baltimore: Johns Hopkins University Press.
Wilburn, Andrew. 2012. *Materia Magica: The Archaeology of Magic in Roman Egypt, Cyprus, and Spain*. Ann Arbor: University of Michigan.
Yasin, Ann Marie. 2009. *Saints and Church Spaces in the Late Antique Mediterranean: Architecture, Cult and Community*. Cambridge: Cambridge University Press.
Zangenburg, Jürgen, Harold Attridge and Dale Martin, eds. 2007. *Religion, Ethnicity and Identity in Ancient Galilee*. Tübingen: Mohr Siebeck.

CHAPTER 11

Graffiti as *Monumenta* and *Verba*: Marking Territories, Creating Discourses in Roman Pompeii

Peter Keegan

Introduction

In relation to what has been said in this volume about graffiti in the Greco-Roman world of antiquity, it is fascinating to note the permeability of two conceptual threads: the territoriality of the inscribing population within contexts labelled as "private" spaces (howsoever we define the term); and the imperative to exchange the artifacts of socio-cultural discourse—ideas, attitudes, emotions—, whether graphically or as writing, in literal or symbolic form. No matter that the marker sought to memorialize both the act and the message, or to imprint one's identity as a member of a defined (and defining) community. Indeed, it would appear to make little difference whether the mark-makers of antiquity scratched their messages (figural and/or textual) inside domestic spaces or on surfaces in public areas or within a very specific urban environment. Regardless of the category of graffiti practice, the inscribing population expresses (explicitly or incidentally) notions of ownership or belonging—this is who I am, here is where I am entitled to (or, at the very least, wish to) make my mark. As importantly, those who participate in non-official inscribing practice—those who incise, paint, ink, or trace in chalk or charcoal words, drawings, numbers or symbols across the spectrum of durable surfaces encountered in the preceding chapters—do so with a range of purposes as varied as their technique: to preserve a trace of personal history or a record of individuality within a wider community of practice; to bear witness to or declare the authenticity of characteristics or traits that designate the inscriber as someone who is accepted (as a family member, a friend, a professional colleague, a constituent of a social or cultural collective); to communicate as fact or fabrication a concept or viewpoint or feeling to other consumers of inscribed meaning within spaces set aside deliberately or utilized regardless of permissions given or constrained for precisely this set of intentions.

As a starting point, consider two recent observations on the nature of cultural contextualization in Classical Greco-Roman studies. First, it is important to recognize the relationship between words and images in ancient urban,

suburban, and regional built environments.[1] Second, it is difficult—some would have it, impossible—to know how much men and women contributed to or took meaning from the epigraphic landscape.[2] Exploring such traditionally slippery quantities as "the artist" and "the audience" and "the viewer" usually entails falling into the trap of "inventing people's identities."[3] To address the epigraphic representation of Roman identity from a cultural perspective, this chapter explores a selection of non-official contexts within which men and women communicated in Roman Pompeii—primary sites offering practical engagement with the relationships of art and language, of the real and imagined.

> PYRRHVS CHIO CONLIIGAE SAL
> MOLESTE FERO QVOD AVDIVI
> TII MORTVOM ITAQ VAL

> *Pyrrhus Chio conl[e]gae sal(utem dat) | moleste fero quod audiui | tii mortuom (esse) itaq[ue] ual(e)*

> Pyrrhus gives greetings to Chius, his companion. I am desolate since I heard you were dead. And so, farewell. (CIL IV.1852)

Pyrrhus scratched this message on one of the plastered and painted brick walls inside the Basilica at Pompeii. The Basilica was an important public place of legal and commercial business in ancient times—a node or nexus of social condition, economic activity, political administration, and cultural exchange—and Pompeii was a large coastal town in the region of Campania in southern Italy—a multi-cultural, polytheist, demographically diverse harbour port under Roman rule since the 80s BC. Pyrrhus' emotional valediction to his partner or colleague (Ln. *conlega*) is one of almost 200 graffiti inscribed in the Basilica that survived the volcanic eruption which destroyed Roman Pompeii in AD 79.

It is eminently sensible to categorize this building as a public space, utilized, as implied above, by a broad demographic of resident, itinerant and transient

1 For a succinct presentation of these relations, see the introductory comments in Elsner 1996.
2 Literature addressing the problematic interactions of gender, orality, and literacy is particularly thin on the ground, at least from the standpoint of reconstructing participatory strategies. For efforts to engage with sexualized *facienda curare*, see (in alphabetical order only) Dewey 1995; Gilleland 1980; Harris 1989; Joshel 1992; Thomas 1989, 1992.
3 Kampen 1996.

FIGURE 11.1 Graffito *of Pyrrhus* (CIL IV.1852), *inscribed on a wall panel from the Basilica at Pompeii* (P. Keegan; Archaeological Museum of Naples, MAN 18.4684).

persons for any of a number of reasons. Notionally, however, it is equally plausible to conceive of certain spaces—located incontrovertibly within the boundaries of a highly frequented purpose-built context like the Basilica—as "private." While at first this posited duality of spatial dynamics might seem counter-intuitive (at best) or simply wrong-headed (in the worst interpretative light), defining space as "public" or "private" depends very much, as earlier discussants have noted,[4] on which definition is deployed in service of designating or otherwise "reading" a particular context within or outside the built environment. Here, how we apprehend and interpret the use of particular spaces will find a different intellectual purchase if we understand "private" to mean "belonging to or for the use of a particular person or group." As soon as we apply this sense to the word, it becomes apparent that the use of designated architectural elements of a public building (that is, features employed according to accepted custom)—in this instance, the undecorated panels of interior walls of the Pompeian Basilica—by a particular community of inscribers may conform to notions of "privacy" regardless of the "public" nature of the wider built environment.

4 See in particular the introductory remarks of Wallace-Hadrill, Baird, and Taylor (chapters 1, 2, and 3, this volume).

FIGURE 11.2 *Hiphop graffito. Melbourne, Australia (P. Keegan).*

A modern example of graffiti practice usefully illustrates the idea of 'private' epigraphic space within a 'public' context. Literacy and numeracy in 21st century first-world urban environments are widespread; broadly speaking, in relation to the acquisition and use of grammatical rules, syntactical principles, and visual recognition of symbols and patterns of meaning, the level of education in so-called developed countries that most people (children and adults) have achieved is beyond the purely technical. The manner in which most people gain their knowledge and understanding of text and image comprises, in the main, formal learning experiences. Of course, in common with social practice in antiquity, how we make sense of written and visual messages is also transmitted by way of informal schooling—decentralized networks in which skills, information and knowledge are shared outside institutional learning environments (e.g. the home, recreational contexts, cultural communities of interest and practice). In today's digital world, access to a superfluity of raw data and to the means by which information is communicated, created, disseminated, stored and managed affords most people the potential to consume a significant repertoire of meaning produced across a spectrum of media.

That said, for many (if not most) readers of this chapter, the graffiti text and art illustrated in Figure 11.2 would, I suspect, pose a considerable challenge with respect to decoding the intended meaning of the display. In relation to the notion of "privacy" within a demonstrably "public" urban environment, the point of this illustration is a simple one. Although readers of this volume will possess a level of educational attainment (including highly developed standards of literacy and visual recognition; in the broadest terms, a sophisticated aesthetic and intellectual sensibility), encountering the graffito above would represent for the majority a clear instance of the "private-public" dichotomy. Here, a non-official marking, painted on a durable surface within a

well-frequented ("public") urban context—a pedestrian walkway adjacent to open-access green space in the heart of the city of Melbourne—"speaks" to a very specific sub-culture—the community of men and women that extols a preference for hip-hop music, shared through related cultural activities and modes of expression. Simply put, while central to the perceptions of the tens of thousands of city-dwellers, office workers and tourists who pass through the urban environment in which the marking is displayed, this graffito "belongs to" or is "for the use of a particular group" and may quite reasonably be designated as a "private" inscription.

With this reformulation of spatial boundaries in mind, let us look more closely at the message cited above (*CIL* IV.1852). Pyrrhus is the Latinized version of the Greek name Purrov, which means "flame-coloured" or "red"; and Chius is the Latinized version of the Greek name Xiov, which is also the name of a Greek island. While it would be incorrect to assume from the text of this graffito that both men are of Greek heritage simply because their *cognomina* are Greek, the permeability of cultural affiliation common to what we understand as the Greco-Roman Mediterranean is certainly evident. Interestingly, the composer of the inscription displays a degree of education that supported not only writing in the Latin language but composing (or copying) his farewell in epistolographical form, a distinctive prosody type.[5] Here, we can also address the question of how to access and understand the emotions of a culture other than our own (both in geo-social space and historical time). Lexical equivalences, such as dictionaries provide, offer only the crudest aid: to know (say) that *moleste fero* can be glossed in English either as "I take it ill" (i.e. "it annoys me") or "I lament," depending on context, only highlights the disjunction between how modern English speakers divide up their emotional universe and how ancient Latin speakers did. In *this* context, it is fascinating to note that another Basilica graffito refers to Pyrrhus' deceased companion in decidedly different terms:

CHIE OPTO TIBI VT REFRICENT SE FICVS TVAE
VT PEIVS VSTVLENTVR QVAM
VSTVLATAE SVNT

Chie opto tibi ut refricent se ficus tuae | ut peius ustulentur quam | ustulatae sunt

5 Cf. Pliny, *Ep.* 3.21: *audio Valerium Martialem decessisse et moleste fero* ("I hear that Valerius Martial is dead, and I am much troubled at the news").

FIGURE 11.3 Graffito *to Chios* (CIL IV.1820), *inscribed on a wall panel from the Basilica at Pompeii* (P. Keegan; Archaeological Museum of Naples, MAN 5.4696).

Chios, I hope that your piles rub again so that they burn more than they burned (before). (CIL IV.1820)

The composer/inscriber of this excoriating indictment uses the Latin form of the name (Ln. Chius, Gk. Chios). The medical condition to which the graffito refers is recognizably a type of haemorrhoidal disease. Today, most varieties of this anorectal disorder will respond to conservative measures as long as the patient complies with the prescribed regimen. In the ancient world, however, it is more than likely that acute complications could well have resulted in management by cauterization, ligation, or surgical excision—or, if untreated, especially in the case of persons outside the elite social classes, death. Pyrrhus' plaintive leave-taking may well reflect the end-point of Chius' oesophageal discomfit.

Individually and/or as a paired cluster, we can focus on the dynamic processes each of these graffiti displays. Specifically, we can identify and decipher the 'script'—that is, a specific sequence of perception, evaluation, and response—through which the data of life are processed; or, in other words, a set of moves and motives that a person who expresses a fact, an idea, or a feeling enacts in inscribed form. The approach is cognitive rather than lexical, asking what each graffito *does*, and how it *works* socially and psychologically,

rather than simply asking what it *is* (a question that would tend to yield lexical equivalents). Thus, in the first message, we share one man's reaction to the death of another—limited, naturally, due to the nature of the medium; but an expression of grief that, while reflecting the manner in which lamentation was codified, lies outside the usual range of acceptable ancient genres and contexts within which such a feeling would be produced (literary texts, funerary inscriptions). So, too, the graffito indicates two fundamental facets of the Greco-Roman world: that persons of mixed origins live together in settlements on the Italian mainland—a fact which would have been an unremarkable fact of life in 1st century CE Italy (and especially in a long-settled town in Magna Grecia), yet still a fact which bears consideration in relation to the production and consumption of knowledge and understanding in ancient Greco-Roman communities; and, that persons of indeterminate but likely sub-elite social status could read and write at a level of education beyond the purely functional. Usefully, the second message confirms the cultural diversity and literacy of this particular urban community, albeit an undefined proportion of Pompeii at this point in our study. We can also begin to scratch the surface of the threats to physical well-being, if not mortality, faced by persons living at this time; not to mention the manner in which ordinary people, if pressed or predisposed, resort to insult—something we might expect of the graffitist in the modern world, but more often than not in the rhetorical arenas of public discourse in any age.[6] Moreover, in relation to the issue of reception, we should always ask ourselves to whom these messages were written and what we might learn about the process of consumption of meaning, and the nature of the consumers, in ancient contexts.

Finally, we should attend to the degree to which these inscriptions may be categorized as "public" or "private." That the two graffiti we have considered closely constitute a small percentile of a much larger corpus of non-official markings found in the Basilica (almost 200 inscriptions in total) alerts us to a continuity of informal inscribing practice within this multi-purpose built environment. Historically, it is easy enough to propose a period of such use beyond the traditionally narrow chronological range imposed on many incised or painted messages or images in Pompeii—governed in large part by the earthquake which rocked the colony in AD 62/63. Causing substantial damage to many sectors in the city, and necessitating significant renovation or recon-

[6] So, too, if we follow Milnor 2014, 167–8, it is possible to read *CIL* IV.1852 as a jest, addressing in traditional epistolographic consolation its "poignant" farewell to an already deceased recipient; thus expanding the utility of "reading" graffiti-texts to the sphere of popular culture (humour, word- and genre-play).

struction, this geological event marks, in many instances, a *terminus post quem* for the display of non-official markings on comparatively new architectural surfaces. Given the fortuitous but important survival of a graffito in the Basilica which includes a dating referent stretching back to the early years of the newly ratified *Colonia Cornelia Veneria Pompeianorum*,[7] the history of use as a context for non-official inscriptions is reasonably firmly attested. Of course, it may also be the case that only a certain proportion of the graffiti marked in the Basilica was preserved (deliberately or incidentally, as with many categories of evidence in antiquity). Importantly, however, this history of use pertains, as noted above, to a community of inscribers which recorded quotidian details of individual or colony life (politics, business, social relations, sporting activities, and so on) as matter-of-fact observations, or expressed thoughts and feelings in idiomatic or quasi-literary terms (personally composed or "cut-and-pasted" as quotations from recited or read texts). Within the conventional limits imposed on the extent to which men and women living in antiquity possessed differing types of literacy (ranging from the purely functional grasp of modes of communication necessary for fundamental social transactions to the sophistication of scribal or compositional language use), epigraphic evidence in the Basilica for clusters of graffiti reflecting a spectrum of linguistic usage-levels (in the main, pertaining to Latin and, far less so, Greek) may be taken as indicative of persons or groups in discourse with each other—and, in relation to the definition previously noted, could be said to have engaged in "private" discourse within the built environment of a significant public edifice in Roman Pompeii.

To contextualize this phenomenon in relation to ancient practices of meaning production and consumption, graffiti can be understood as an intrinsic element of the broader epigraphic environment in Roman times: what Greg Woolf regards as the notion of an "epigraphic culture," which "depends on taking both the monumental and the written aspects of inscriptions seriously"— namely, the *monumenta* and the *uerba* comprising the marked surfaces of Roman Pompeii.[8]

Graffiti—Social Media in the Greco-Roman World

The modern age views graffiti in a very particular way: as "writings or drawings scribbled, scratched, or sprayed illicitly on a wall or other surface in a

7 CIL IV.1842: *C(aius) Pumidius Dipilus heic fuit a(nte) d(iem) V nonas octobreis M(arco) Lepid(o) Q(uinto) Catul(o) co(nsulibus)* ("C. Pumidius Dipilus was here on the third of October 78 BC").
8 Woolf 1996, 24.

public place."⁹ This definition encompasses a broad range of texts—single letters, letter combinations, single words, phrases, sentences—and graphic representations—pictures, diagrams, and identifying artist(s) signatures. It also outlines the variety of stylistic choices available to the graffitist and on what the writing or drawing will be seen. What is interesting about this definition, and which marks our 21st century perspective on graffiti as different from pre-modern conceptions, is the fact that the act of writing or drawing comprising the production of graffiti is seen as illegal and confined to public spaces.

Evidence from the ancient world demonstrates that the legal status of graffiti depended, as it does today, on the permission of the owner of the property on which persons write or draw. According to recent legislation in countries which have enacted laws against graffiti,[10] it is an offence to mark property in such a way that it can be seen by the public unless the owner has given permission. What the surviving evidence tells us is that the degree to which permission to mark property was granted in the ancient world was clearly determined on a broader definition of consent. Graffiti in Pompeii can be found on every available public surface: not only the walls of civic buildings and associated infrastructure, but columns, doorposts, floors, lintels, and stepping stones. Moreover, writing and drawing are not confined to the substantial remains of the ancient urban fabric. Graffiti are marked on objects made from clay as well as metal, stone, and, if we are lucky enough to find it preserved, wood.

This plethora of extant evidence confirms the fact that writing and drawing graffiti in antiquity are widespread, commonplace, and highly visible acts. We know that property owners in the ancient world *did* express their desire to restrict or debar the marking of certain surfaces. There are a variety of inscribed messages on particular public or private buildings refusing consent to do so. For example, at Pompeii, in the years prior to the eruption of AD 79, we find the following prohibition: *si quis heic ulla scripserit tabescat neque nominetur* ("if someone writes something here, may he rot and his name be pronounced no more").[11] Similarly at Rome, on the cusp of the 2nd century AD, the refur-

9 *Oxford Dictionaries* (oxforddictionaries.com): s.v. graffiti (World English definition).
10 E.g. the Graffiti *Prevention Act 2007* (Victoria, Australia); anti-graffiti administrative and penal laws (Titles 10.117, New York City; Title 10.145, New York State); the *Criminal Damages Act 1971* (Section 5) and *Anti-Social Behaviour Act 2003* (Part 6) (United Kingdom); the *Criminal Code Act 1995* (France); the European Council's *Rules for Juvenile Offenders 2008* (Rule 45). For the purposes of such legislation, graffiti comprises defacing, writing, scratching or drawing on or property so that the marks can't be removed easily with a dry cloth, and includes stencil art and engraving.
11 *CIL* IV.7521.

bisher of a portico of a temple (located just outside the Porta Portuensis and dedicated to Sol) asks the general public to refrain from marking the sun-god's sacred building: *C(aius) Iulius Anicetus ex imperio Solis rogat ne quis velit parietes aut triclias inscribere aut scariphare* ("Gaius Iulius Anicetus, at the behest of Sol, requests that no one inscribe or scribble on the walls or *triclia* [covered, porticoed chamber]").[12] However, the fact that writing and drawing on a multitude of surfaces survived in so many contexts and in such numbers at Pompeii, in Roman Italy more widely, and across the ancient Mediterranean indicates strongly that these warnings did not constitute a widespread ban on graffiti. In terms of the exercise of legislative power at a local, regional or imperial level, the marking practices of graffitists would appear in large part exempt from proscription or penalty.

In the legal codes of modern nations, moreover, marking or defacing property with texts or images is a more serious offence if the graffiti are likely to offend a reasonable person. Political comments are an exception to this if they, too, are reasonable. It is clear that the criteria by which persons in antiquity took offence or judged political commentary as fair and sensible were at variance from today's conventions. A statistically significant proportion of ancient graffiti were marked on surfaces in contexts that would not, at least according to contemporary understanding, be regarded as public: namely, the interiors of structures on privately owned land or segregated work spaces.[13] Of the almost 11,000 graffiti surviving at Pompeii,[14] at least 50% were made on the exterior *and* interior surfaces of occupied or used areas like houses, shops, bakeries, brothels, fulleries, and gladiator quarters. In many instances, these graffiti were marked in full view of the persons who lived and worked in or visited these spaces. This tolerance for graffiti in domestic or occupational contexts is not confined to urban Pompeii.

In many countries today it is an offence to carry tools that could be used to mark graffiti in particular areas without a good reason, such as needing to carry these tools because of work.[15] This includes spray paint, gouging tools or

12 *CIL* VI.52. This admonitory inscription and a second dedicatory inscription (*CIL* VI.51, dating to 25 May, 102 CE) were discovered in the 19th century in the vigna Bonelli S. of the Porta Portese in Trastevere.

13 The compendium or digest of Roman law compiled by order of the emperor Justinian I in the 6th century CE (abbrev. *Dig.*) defines the term "public place" as applying to such localities, houses, fields, highways, and roads as belong to the community at large (*Dig.* 9.43.8.3).

14 This figure derives from a calculation of graffiti published in the volumes of *CIL* IV.

15 While it might at first sight seem absurd, it is nonetheless a fact that laws pertaining to the illegality of walking around with spray-cans and marker pens *do* exist. See, e.g., the Graffiti

even a marker pen. This legal prohibition did not apply in the ancient world, primarily since persons in antiquity produced and consumed meaning in very different ways to the means and methods of communicating ideas today.

Most interesting of all is the sharp divide between ancient and modern views on graffiti as representing anti-social behaviour (ASB). In legislative terms, anything which causes "harassment, alarm or distress to one or more persons not of the same household" may be considered as ASB.[16] By any measure, this is a vague definition that can include *any* unwanted activity.[17] Informed by notions of normative conduct and incivility, graffiti are understood as ASB in relation to the cumulative impact on individuals or groups of action viewed as annoying or offensive, especially if repeated and perceived as specifically targeted.[18] In sum, graffiti in modern communities are deemed to conform to the definition of ASB because of the environmental impact, the correspondence to minor criminal vandalism, and, in consequence, the effect on the quality of life of those who see the practice as ASB.

In contrast, graffiti in antiquity are the result of strictly *social* patterns of behaviour. Almost all ancient markings were originally located outside or within spaces used or viewed by people other than those responsible for setting them up. This means that the persons writing and drawing on fixed or portable surfaces in these locations intended that others would read messages set up as part of a broader social context. At the very least, they would have been aware of the likelihood of some kind of viewership for their texts or graphic images, and so composed (or, far less likely, commissioned) their markings accordingly. Aware of the contexts within which these graffiti were placed, modern historians of ancient society are well situated to interpret the cultural conventions *and* differences expressed through private epigraphic practices. The idea that the practice of marking graffiti on civic or private property constitutes ASB must be viewed as a distinctively modern perspective.

To deploy another contemporary example as a means of illustrating this aspect of Greco-Roman socio-cultural practice, we can cite the comparability of ancient graffiti and modern social media. In general, social media can be understood as the means by which people use digital technologies to create, share and exchange information and ideas. While the technology is vastly different, both forms of meaning production and consumption—graffiti and

Control Act 2008 (New South Wales, Australia), Section 5; the New York City Anti-Graffiti Statute, Section 10–117; and the California Penal Code, Section 594.1.

16 UK *Criminal Justice Act* 1998.
17 For discussion of the uncertainty over the precise meaning associated with ASB, see e.g. Whitehead *et al.* 2003; Harradine *et al.* 2004; Millie *et al.* 2005a; 2005b; Macdonald 2006.
18 Millie *et al.* 2005a.

social media—rely on the engagement of human communities or networks. Moreover, both provide the spaces within which individuals and groups participate, produce (rarely in isolation and often collaboratively), enter into dialogue and elaborate (by way of contemporaneous or asynchronous exchange) on what may be described (in digital parlance) as user-generated content. Whether the analogy encompasses blogs and micro-blogs (e.g. Twitter) or social networking sites (e.g. Facebook), the conceptual and structural relationships between Greco-Roman graffiti inscriptions and certain types of 21st century social media should be clear. As a means of representing aspects of self on a personal or communal level, as a channel for disclosure (anonymous or identified) of attitudes and beliefs, and as a measure of the presence and diversity of communities of interest, non-official markings in Pompeii perform similar functions to comparable forms of social media in the modern age.

In sum, as a form of written and/or graphic communication free (to a greater or lesser extent) of the usual social restraints limiting more polished artistic and literary works, the phenomenon of graffiti offers a striking opportunity to explore ancient culture through a pattern of human activity and the symbolic structures that gave that activity meaning. As a way of illustrating the manner in which I believe ephemeral inscriptions at Pompeii mark territories and create discourse, I offer for consideration the following graffiti: (a) inscribed in a variety of small, medium, and large social spaces across excavated Pompeii, (b) visible, legible, and memorable to a broad cross-section of the city's oral-literate social strata, and (c) conforming in content, form and location to the categories of *monumenta* and *uerba*. I begin with a selection of graffiti found in clusters numbering fifty or more, then move on to smaller groupings of less than fifty.

Graffiti Clusters I (50–100+)

1. On either side of the entrance, in the *uestibulum*, and on the S. wall of the peristyle in I.7.1, 20 is a cluster of graffiti, part of a larger corpus of eighty-five inscriptions, relating to Neronian Rome. These graffiti conform to the text-types of single name, salutation, dedication, and date statement. There are four single names, a name with an associated profession, and a name struck through. There are also two date statements, one incorporating a salutation. These graffiti refer to an *a rationibus* named Cucuta; to an emperor, the city of Rome, and nationhood (Neronis, Roma, Romanus); and possibly to Nero's quinquennial *munera* held at Naples (beginning on 30 March, AD 60). As a cluster, related by content and form, and by location (at or near the primary and secondary entrances to the house), these graffiti commit to individual and

collective memory representations of important personal experiences of civic identity, social status, and cultural affiliation.

2. A large number of graffiti has been recorded in House 1.10.4 (Casa di Menandro). Of these, I draw attention to three interesting clusters:

(a) At the entrance, and on three columns in the N. row of the peristyle, are graffiti relating to civic leadership and community recognition. There are three single names, two in one inscription. Other names are mentioned in two commemorative dedications and three congratulations (or possibly references to a divine abstraction) of the *feliciter* type. We are familiar with the names of Infantio, a *scriptor* frequently attested in Pompeian dipinti and graffiti, N. Popidius Rufus, member of Pompeii's *ordo decurionum*, M. Hirrius Fronto Neratius Pansa, consular legate of Cappadocia and Galatia in AD 78/79–79/80, not to mention extreme celebrities like Cleopatra, Tiberius Augustus and, implicitly, Nero. As Mouritsen (forthcoming) notes, these inscriptions are linked by contextual distribution to individuals waiting to enter and be received in the public spaces of the *domus*. As a cluster, they speak to experiences of *dignitas*, reciprocity of service, the importance of communal solidarity, mutual respect, and the chain of governance in Roman society.

(b) In the *uestibulum*, on a single column in the peristyle's N. row, and in one of the house's private spaces, we find graffiti relating to commercial interests. Five bill statements and an item of information address money matters on two levels: in the contractual language of the documents of Iucundus, the Sulpicii, and the *tabulae Herculanenses*; and the transactional terms of commonplace business dealings. Connected spatially (with the exception of the household notice 8357b) and substantively, these graffiti identify experiences of service and obligation within a mixed barter-market economy.

(c) At the entrance, in the *uestibulum*, around the peristyle, and in two private spaces are graffiti inscribed by persons displaying a level of scribal literacy. Allusions to epic and lyric poetry, fragments of epistolary writing and crafted conversational idiom, a ludic inscription of the "magic-square" type, and iteration of the name of the eponymous Greek comic whose seated image is painted nearby reflect the experience of degrees of literary culture possessed by a number of visitors to the *domus* and, likely in two cases, its resident servile population.

3. Similar pathways of memory and experience can be followed in the *atrium*, on four columns of the peristyle, and in the so-called *exedra* directly to the S. of the peristyle in V.2.i (Casa delle nozze d'argento), in the peristyle of V.5.3 (Casa dei Gladiatori) and along the exterior walls of IX.5.18–21.

Graffiti Clusters (10+)

This pattern of relationships between spatial distribution, territories of status, condition, and relationship, and categories of discourse, visible to the oral-literate pedestrian population of Pompeii, is also evident in smaller clusters of ephemeral inscriptions in the city.

1. In small interior rooms to the right of the entrance, and on the walls of a larger space NE of the *atrium* in I.6.4 (Casa del Larario di Achileo or Casa del Sacello Iliaco) are graffiti about aspects of *otium* and *negotium*, particularly the sources and costs of such social and economic capital. The smaller area to the SE registers two date statements, each including reference to either the cost or amount of consumable goods, possibly wheat and the refused from wine-pressing used as fertilizer. There would also seem to be a reference to Melicertes, the mythological son of Athamas and Ino who became the sea-god Palaemon, fleetingly alluded to in poetry of the early imperial period (Verg. *Georg.* 1.437; Ov. *Met.* 4.522; Pers. 5.103; Hyg. *Fab.* 1, 224.5). The larger room off the *atrium* provides four date statements, one indicating the date to be a personal reference to somebody's pecuniary expenditure or liability, another associated with the cost of some unidentified commodity. There is also a salutation and a single name ("VENVSTVS") inscribed in the form of a coastal trading vessel (a recognizable graffiti type in Pompeii and elsewhere), as well as a series of numerical marks, and another reference to Venustus, in this instance what appears to be a caption relating to a graphic representation of combat between a gladiator and a lion. Whether the exotic, or at least transmarine, origins of the *bestiarius* Venustus are commemorated in the inscription of the distinctive ship-name cannot be confirmed. What can be said is that the twelve surviving graffiti legibly trace memories keyed to details of popular social experience, as well as to matters of quotidian economic exchange.

2. On the exterior wall of I.10.3, E. of the entrance to the Casa di Menandro, is a vibrant, interdependent cluster of single names, congratulations, salutations, verses, and items of information. Particularly interesting is the context of this mixed dialogue. In proximity to the serving area of the nearby *caupona*, and close by two important Pompeian *domus* (1.10.3 and, across the thoroughfare to the N., I.6.15, the Casa dei Ceii), participants in the conversation on the wall's plastered surface, either at the beginning or end of the day's labour, or enjoying a break perhaps from other social transactions or obligations of dependence under cover from the midday heat, speak of and to each other about important civic, cultural, and personal experiences—(a) a certain Sabinus and Primigenia, connected in some way to illustrations depicting trade or entertainment in the arena; (b) the *textor* Successus, whose hopeless

love for a certain Iris, female slave of Cuponia, his rival Severus is diligent to clarify in painful detail; (c) possibly Successus in reply, indignant and aggressive, (d) answered in turn by Severus; (e) the unknown well-wisher, possibly a certain Modestus, offering congratulations to the city's imperial benefactors. Here the categories of *monumenta* and *uerba*—of space, text-type, and memory—intersect to provide a *tableau* of socio-cultural experiences shared in context by composers and viewers alike.

3. The ease by which a viewer, literate (and numerate) at either a functional or scribal level, could detect a related pattern of discourse among the accumulation of ephemeral inscriptions in any given spatial context, and thereby interpret naturally the record of particular markings, can be seen in the *CIL* IV transcription of graffiti inscribed on the exterior wall of a small house with stairway, VI.2.9–10. Here, it is important to reinforce, when considering the modern remainder of graffiti almost two thousand years old, how legible and memorable the original marks of letters, words, statements, and sketches inscribed, painted, inked, or outlined in charcoal would have been to a contemporary viewer. Following a pathway of related marked surfaces, therefore, would not have been nearly as difficult to an individual used to doing so, especially for a participant in the ongoing process of meaning production through ephemeral inscription. Importantly, the proximity of a *castellum aquae* and drinking fountain, directly opposite the entrance to VI.2.9–10, helps to explain the number and variety of graffiti on the exterior wall. It also provides a natural context for memorializing particular aspects of individual and shared social experience in a neighbourhood of the city used to regular, diverse pedestrian traffic along the Via Consulare through the Porta di Ercolano.

4. As in the sample of selected graffiti found in larger clusters, this phenomenon can be followed in other spaces in which smaller clusters were found: for instance, the peristyle of VI.14.43 (Casa degli Scienziati), the room with ramp forming the SE corner of the building of Eumachia, identified as a *cella ostiaria*, VII.9.67–68, and on the N. and S. walls of the long, narrow corridor running from the Via Stabia behind the Odeon or Covered Theatre to the E. entrance of the Large Theatre, VIII.7.20.

Conclusion

This paper has explored the creation of localized, elite and non-elite discourses within shared epigraphic spaces—specifically, the accretion of non-official graffiti within the urban fabric of ancient Pompeii between circa 120 BC and AD 79. The shift from an-epigraphic cultures to epigraphic cultures is not

simply a matter of commissioning the carving of an inscription or scratching graffiti: it also demonstrates new mentalities regarding the use of language, the relationship between local elites and the rest of the population and between local elites and the imperial power. The creation and replication of written spaces also marks a radical departure for some pre-Roman communities in the West and a new medium for the expression of local statuses and identities. As importantly, graffiti inscriptions record communications in informal contexts using vernacular media, offering the possibility of writing history about people living in the cities of these times which does not depend solely on the views of the cultural elites surviving in the European manuscript tradition and in formal epigraphic contexts. By the same token, examining the words and images inscribed on an ancient city's monumental fabric—its walls, doorposts, pillars, tombs, and so on—provides a means of assessing the manner by which and the degree to which ordinary men and women absorbed and exchanged culture and language through inscribed speech-acts under Roman rule. In consequence this paper tenders for further consideration the different trajectories of the creation and replication of discursive environments in a variety of locations within the urban fabric of Pompeii.

Bibliography

Dewey, Joanna, ed. 1995. *Semeia 65: Orality and Textuality in Early Christian Literature.* Atlanta, Georgia: Society of Biblical Literature, Scholars Press.
Elsner, Jas. 1996. "Inventing *Imperium*: Texts and the Propaganda of Monuments in Augustan Rome." In *Art and Text in Roman Culture*, edited by Jas Elsner, 32–53. Cambridge: Cambridge University Press.
Gilleland, Michael E. 1980. "Female Speech in Greek and Latin." *AJP* 101: 180–183.
Harradine, Sally, Jenny Kodz, Francesca Lemetti, and Bethan Jones. 2004. *Defining and measuring antisocial Behaviour.* Home Office Development and Practice Report 26, London: Home Office.
Harris, William Vernon. 1989. *Ancient Literacy.* Cambridge and London: Harvard University Press.
Joshel, Sandra Rae. 1992. *Work, Identity and Legal Status at Rome: A Study of the Occupational Inscriptions.* Norman and London: University of Oklahoma Press.
Kampen, Natalie B. 1996. "Gender Theory in Roman Art." In *I Claudia: Women in Ancient Rome*, edited by Diane E. E. Kleiner and Susan B. Matheson, 14–26. Yale University Art Gallery, New Haven: University of Texas Press.
Macdonald, Stuart. 2006. "A Suicidal Woman, Roaming Pigs and a Noisy Trampolinist: Refining the ASBO's Definition of 'Anti-Social Behaviour.'" *The Modern Law Review* 69(2): 183–213.

Millie, Andrew, Jessica Jacobson, Mike Hough, and Anna Paraskevopoulou, eds., 2005a. *Anti-social behaviour in London: Setting the context for the London Anti-Social Behaviour Strategy.* London: GLA.

Millie, Andrew, Jessica Jacobson, Eraina McDonald, and Mike Hough, eds., 2005b. *Anti-social behaviour strategies: Finding a balance.* Bristol: Policy Press.

Thomas, Rosalind. 1992. *Literacy and Orality in Ancient Greece.* Cambridge: Cambridge University Press.

———. 1989. *Oral Tradition and Written Record in Classical Athens.* Cambridge: Cambridge University Press.

Whitehead, Christine M. E., Jan E. Stockdale, and Giovanni Razzu, eds., 2003. *The Economic and Social Costs of Anti-Social Behaviour.* London: London School of Economics.

Woolf, Greg. 1996. "Monumental Writing and the Expansion of Roman Society in the Early Empire." *JRS* 86: 22–39.

CHAPTER 12

Writing in the Private Sphere: Epilogue

Mireille Corbier

Plurality of Spaces, Plurality of Texts

The contributions gathered together in this book highlight the fact that it is not a question of *a* private space but of *several* spaces. Even though in Latin there exists the opposition *publicus/privatus*, these dozen chapters point to a plurality of various spaces, including but not limited to domestic space. Under the definition of "privately-owned space," there also appeared stores, workshops, collegium headquarters, etc., but the notion of "private epigraphic space" has expanded to cover any "unofficial" writing present within a spectrum of discrete urban spaces—occupied, inhabited, utilized, or populated—and therefore, in that sense, "public" (Peter Keegan, Chapter 11). Also included in the "private sphere" are places whose access was limited to a small number of people, such as the interior of tombs only available for the family in Cyrene (Angela Cinalli, Chapter 9). The authors agree on the fact that the "domestic space" itself has nothing to do with "privacy," such as we understand it today, i.e., the family sphere, intimate, with a restricted access, even secretive. It is precisely under the category of the personal and of the secretive that various testimonies are shown, including magical writings discovered in the synagogues of the Levant, the synagogue itself not being considered as a private space but a communal space (Karen Stern, Chapter 10). Under the same heading "private," even "very private," belong messages, chiefly readable in the latrines but also elsewhere, related to what we regard as the most intimate bodily functions (Antonio Varone, Chapter 6). In sum, by playing on the polysemy of the word "private," the "private sphere" examined here has gone well beyond the notion, also extensible, of "private space."

In this plurality of spaces under consideration, we come across a plurality of texts which I will regroup—to simplify—under three main headings: the "inscriptions" designed as such and offered to the gaze; forms of individual, spontaneous writings, also visible; and personal writings made invisible, since

* The editors and the author would like to thank Ann Cremin for translating into English the French of the original chapter.

they were aimed at the powers in the great beyond. It is this last category that I address first.

The Jewish Magical Inscriptions

These scrolled strips insert the Jewish community in the West—for instance, in the Sulis Minerva spring in Bath, and in the sanctuaries of Magna Mater and Isis in Mainz—within a well-documented community of variegated practices, and have been much studied. Here, the phenomenon has as much to do with aggressive spells (*defixiones*), requests defined by H. S. Versnel as prayers for justice, or as prophylactic and healing amulets. The Jewish examples are different, owing to (1) the names of the persons invoked, the god of the Jews and his Angels, which are not intermingled as elsewhere with those of the devilish powers, and (2) the use of the Semitic language and writing that seemed to the writers the most appropriate to be heard by them: Aramaic and Hebrew. They are similar by their "invisibility," even if the reasons for the regrouping of certain protective amulets inside the synagogue in a not precisely identified place are not always clear to us, compared to the well-known usage in the West of carrying such inscribed tablets (including in fact supposedly magical Jewish references) wrapped up inside a case hung around the neck.[1]

The Inscriptions on Display

A first group of visible texts is the work of professionals. It was to this type of texts that the famous passage by Pliny the Elder referred (*NH* 34) about the *atrium* of the town houses of Italian notables which, thanks to the presence of statues, started to look like an authentic forum, as is mentioned by Francisco Beltrán Lloris (see below). Some texts were engraved on a statue's base. Many were associated with the owner's portrait.

For Delos, Ephesos and Pergamon, Mantha Zarmakoupi and Elisabeth Rathmayr (Chapters 4 and 8) provide examples of inscriptions which, under the portrait of the householder, give his name and provide a description of him, of his elevated social rank, and on occasion, of his capacity to receive his guests with all the pomp expected from one of his status as well as the culture that allows him to re-appropriate Homeric verses. To these testimonies of self-celebration written by the owners themselves, accompanying full scale statues,

[1] On this point, read Tomlin 2011.

busts or herms bearing self-portraits in bronze were added "professions of faith"—from Ephesus and Pergamon—expressed through the statuary and the text, wherein the master emphasized his religious preferences. A few centuries earlier, the wife of a Delian notable, originally from Athens, contented herself with recalling her husband's precious offerings to the main sanctuary in Delos to make clear his integration as a new arrival. The forms varied according to time and place.[2] In Delos, three freed slaves of the master of the household, authors of the bilingual dedication of his statue, conformed to Roman conventions of the times by paying homage to their patron. They manifested their Greek culture by employing the accusative instead of the dative, as would be expected in Latin for the identification of the honorand. And they artfully varied the order of their respective names in Greek and Latin (1, 2, 3 then 3, 2, 1), probably in order to erase the notion of hierarchy always present in a list.

Other texts were written elsewhere and brought into the home as homage and displayed to the house's visitors. Francisco Beltrán Lloris (Chapter 7) turns to the patronage tablets in bronze, duplicated so as to be exhibited twice, first in the *curia* of the issuing city (or of the issuing *collegium*) and then again in the semi-public spaces of private homes. He discusses the vitality of these practices continuing into fourth century Italy. When observed in association with other signs of the owner's high rank, such as honorific statue bases, the full meaning of these artefacts could be realized.

The patronage tablets in the West, the statues, the busts, the herms, like the signs of devotion in Pergamon, Ephesos, Delos, pose the problem of the hierarchy of the representational spaces where they were exhibited and of the eye they wish to attract. The potential viewer was placed at the heart of the scene: he saw the work of art or the bronze tablet even before he had experienced any impulse to approach and to read the corresponding text.

The funeral inscriptions painted or written in charcoal in Cyrene, examined by Angela Cinalli (Chapter 9), especially those that accompany a self-portrait of the deceased (the veteran) or that describe a mythological scene, are close *mutatis mutandis* to the texts linked to the numerous images in Pompeian paintings—except for the fact that they were only accessible to the visitors of the tomb and not to those of the house. Those that were written, sometimes clumsily, in charcoal are not graffiti—neither in the original meaning of scratches[3] on a hard surface nor in the current meaning of spontaneous

2 The home of a Roman senator in the third century is not comparable to that of a wealthy dignitary of Delos. It is also problematic to flatten chronologies in order to identify behaviors that seem recurrent among the members of the élite in the ancient Mediterranean world.

3 According to the word's etymology, the Italian verb *graffiare* = to scratch.

writings. Throughout the Mediterranean world and as far as Palmyra, paint and charcoal were writing materials suited to the hypogeum. Regarding the extreme variety of writing forms, two contributions by Paul-Albert Février, based on autopsy of sites in North Africa, provide worthwhile comparisons.[4]

Spontaneous Writing

The second group of texts refers, under the name of graffiti, to a practice of individual, spontaneous writing, which I called elsewhere "l'écriture en liberté"—a freedom that does not prevent it from following its own codes. These writings feature two points in common. First, the one who writes the text and the one who conceives of it is the same person. If he does not conceive of it *ex novo*, he decides on it by choosing in his memory a fragment of a literary text he had learned at school (or that he might have repeated as a writing exercise) or a proverb that he himself had heard or read, written on a wall by others. In the previous category belongs the first verse of the first book of Virgil's Aeneid *arma virumque cano Troiae qui primus ab oris* ("I sing of the weapons and of the hero who first fled the banks of Troy...") or the first verse of the second book *conticuere omnes intentique ora tenebant* ("All were silent, attentive, their eyes fixed on Aeneas..."). Among the second category are those widespread wishes destined for lovers (*quisquis amat valeat*: "he who loves, may he be well"), to which some people prefer the negative form (*quisquis non amat, non valeat*). Other formulas, having become proverbs, are especially well suited to the atmosphere of a tavern, e.g., *Venimus hic cupidi, multo magis ire cupimus* ("We were happy to come, we are even happier to leave").[5]

Secondly, this personal writing is carried out on walls. The primary function of this medium unlike the *tabulae ceratae* or the *volumina* in papyrus (or wooden tablets near Hadrian's Wall or ostraka in Egypt), was not to serve as a surface for writing. Walls were a place where writings were not necessarily expected. This kind of writing was a physical activity that presents simultaneously the intelligence, the wit, the sense of humor of an individual. Writing on a wall might also involve adapting one's posture (standing? lying down? crouching?) and required manual dexterity. Strong cultural and social differences (genuine or displayed) are obvious as regards the syntax, the style and the quality of the graphic expertise. They open up the way for endless questioning by a modern audience regarding the writers' identity—residents and/

4 Février 1987; Février 1994.
5 Seven examples in *CIL* IV, one in Narbonne.

or visitors, adults and/or children, those educated or not, men and/or women. For instance we may doubt that illustrious visitors, slaves or freed, in the emperor's service, whose name is accompanied by their function (*Cucuta ab rationibus Neronis Augusti*; *Apollinaris medicus Titi imp.*), were the authors of the graffiti that made them known. A witness probably wished to preserve the memory of their passage.

The writers who just wrote their names, like a signature, are almost exclusively masculine. Women are often present in graffiti because they are named, sometimes by their lovers—*Secundus Prim(a)e suae, Primigenius Successae*— or hailed, *Spe(n)dusa va(le)* (Benefiel, Chapter 5), or even mocked like Martha (Varone, Chapter 6). In this book there is no discussion of the room in Pompeii (belonging to the Casa dei Quattro Stili) where the greetings, *vale*, are addressed to five women (Quartilla, Nicopolis, Anthis, Cypare and Euplia) by writers who, judging from the height and the placement of the writings, might have been reclining on couches. These texts led to an attractive theory by Rebecca Benefiel suggesting that five women taking part in the same dinner party might have greeted one another.[6] It is possible, however, that those greetings might also recall the comments of the five guests addressing their lovers.

This type of spontaneous writing is sufficiently developed to establish *its own conventions*: privileged spaces, recurrent themes, formulas (such as the banal use of *hic* to indicate the writer's physical presence in this precise place).

I now return to the question of "places." "Writing summons writing," as I have often noted. It is the groupings of graffiti that our authors call "clusters." We find them in the houses of Pompeii as well as in certain public spaces. I have elsewhere analyzed the long texts, carefully inscribed one below another on a partition, close to the kitchen and to the *lararium*, of C. Iulius Polybius and C. Iulius Philippus' house in Pompeii (IX.13.1–3).[7] Here, Peter Keegan (Chapter 11) attempted to reconstitute the population expected to wait in certain rooms—a vestibule—or, on the contrary, allowed to move frequently in other places and to leave there groups of texts of a similar inspiration, coming from people sharing the same experience. The approach is original even if the extreme variety of themes broached by the associated graffiti makes it difficult.

But these "inscribed places" are not spread everywhere. The *writer* seems to respect an unwritten rule: one must not spoil the scenery. This is true of scenery both inside and outside, for instance, the professional *scriptores* of the electoral posters do not impinge upon shops' signs, nor on images of the shops' protective divinities. In fact it was the authors of the *dipinti*, i.e., those who

6 Benefiel 2011, 24–29.
7 Corbier 2011, 26, with a drawing p. 133.

painted the electoral posters or announcements of all sorts (games, sales, etc.), who seemed to be most feared by the owners of tombs, more than the authors of graffiti. In private houses, the authors of graffiti usually respected their forerunners' writings, by lining up their writing under previous inscriptions and sometimes by creating a second column of texts, unlike what can be observed elsewhere, e.g. on the wall of an Augustan building identified by Paavo Castren as a tavern, which is covered in a jumble of Latin and Greek words.[8]

Inside the houses, as soon as a very accurate listing of the placement of graffiti is carried out, as is done by Rebecca Benefiel (Chapter 5), one notices preferential choices: a concentration is to be found on the columns, on the pilasters, on the coated partitions without decoration, especially close to the lararium. The monochrome decoration, especially in light colours, lends itself to an easy reading—hoped for by the writers—of their name or of their message. The earlier group of texts that we identified in the domestic space, the statue bases and religious dedications, also seem to be respected by our graffiti authors, whereas, in the public space, statue bases are well known as being privileged supports for contestation.[9]

That writing is made *to be read*: the graffiti make up a kind of "communication in an informal context" (Keegan, Chapter 11). When it is encrypted, as is the case of the isopsephic riddles (which invite the reader to identify the name of the beloved woman—for it is often a woman's name—based on the numerical value of the Greek letters in the name), one example in Ephesus provides the answer to the riddle, but there are also some in Pompeii that allow the reader the pleasure of deciphering them. All these studies on graffiti insist on their presence in the houses' central spaces, the entrance halls, and the passageways, rather than in enclosed rooms, in Delos as in Pompeii. They were therefore written for a restricted potential audience, made up of residents and visitors. But, simultaneously, those handwritten texts, written in small characters, did not leap to the eye, even if inhabitants of the house were aware of their existence.

This writing is closely *linked to the oral*, the messages sometimes summoning by name, in the vocative, a person—man or woman. Thus can also be explained the abundance of the exclamations (*feliciter! salutem!*), greetings (*salve! vale!*) and wishes (*votum* to the Lares for the head of the household's *salus*). Their "performative" character is not in doubt. In a back room in Pompeii, the graffito *Lares propi*[*ti*]*os*, placed under the representation of

8 Corbier 2006, 74, fig. 39.
9 Cf. Zadorojnyi 2011.

an altar framed by serpents, recalls the psalmodies of the servant who carried around a patera for libations during the *cena Trimalchionis*, while two others placed statuettes of Lares on the table.[10] The same performative character has been observed regarding texts incised or painted on the partitions of various places of worship—whether it was the sanctuary of the source of the Clitumnus[11] or of sacred caves.[12] In a sacred place, the graffito *is* the religious dedication, even if it does not take the shape of a *votum* or the fulfilment of the wish. That is confirmed for us by the synagogue of Dura.

Writing was also *linked to scholarly apprenticeships*: to know how to write one's name; to know the order of the letters of the alphabet; to master the complex layout of the Roman figures; to express the date—the day of the month according to the three reference points provided by the Kalends, the Nones and the Ides, and the year by the eponymous consuls; to write the heading of a letter with the adequate formula of greeting; to memorize fragments of classical verses that one had to copy several times over on a writing tablet. Here again, one is totally free to summon the *performance*: the writer does not necessarily have as his only wish to prove his capacities to himself, he might be tempted to show off his know-how to inhabitants and familiars in the house. Are they children and adolescents? That is not in doubt for Peter Kruschwitz who attributes to these groups the paternity of the very large majority of graffiti, as he says is the case nowadays as well (this might be argued regarding the authors of tagged surfaces, who are often youths, doubtless, but definitely much older).[13]

Here, the distinction suggested by Dionysius of Halicarnassus of two phases in the accession to literacy[14]—"1) learn the letters, their form and their value in order to combine them into syllables then shape words, 2) write and read (syllable after syllable, and, at the start, slowly)"—seems pertinent to interpret the graffiti of the Roman period, some of which likely belong to the first phase of apprenticeship. Focusing for a moment on graffiti, whose

10 *CIL* IV.844; Petron. *Sat.* 60. Fauduet 2011, 118.
11 Those signs of popular devotion are mentioned with a certain condescension by Plin. *Ep.* 8.8.7.
12 Thus the *Cueva Negra* of Fortuna in Murcia (Gonzalez Blanco, Mayer Olivé, and Stylow 1987) or a cave in the Djebel Taya, in Numidia, to-day in Algeria, whose rock inscriptions, engraved at the entrance of the cave, provide the names of the municipal *magistri* of *Thibilis* who, once a year, in spring, came to bear witness of their civic community's worship of the god Bacax (*Inscriptions Latines d'Algérie*, 11, p. 407–421).
13 Kruschwitz 2010, 207–208.
14 Dionysius, *De compositione verborum* 25 *ad fin.*

study looms large in this book, we note that this form of writing is everywhere *present and preserved*. In Dura Europos as in Pompeii, the inhabitants appear disinclined to erase these markings. Unlike modern graffiti and most modern tags (some of which are conceived and carried out as authentic decorations, perhaps enlivening a wall's space, and, as such, are admired and photographed as such by passersby and tourists), ancient wall-inscriptions seem not to have been systematically regarded as an act of vandalism. As for ancient graffiti, we deliberately insist on the difference with the current tags; they are not necessarily anti-establishment, defamatory, or decorative—in fact they often appear alongside drawings and are sometimes narrowly linked to them. We mostly link them to places I call *places of masculine sociability* or to spaces where men are made to wait and, therefore, to *be bored*. Time is killed by writing. Boredom is mentioned by several authors; I recall on this matter the few hundred graffiti from the Severan period noted on the walls of the firemen's headquarters in the Trastevere.[15]

Among the numerous differences with current graffiti, recorded by Peter Keegan, I will point out a particularity that seems to me to not have been mentioned. Until recent times when trains, metros, buses, bridges, railroad walls started to be systematically "tagged" as an act of anti-advertising strategy, the spaces that attracted the most graffiti were certainly not private spaces but *enclosed public spaces*. The two extremes are public toilets, where one is enclosed for a few minutes, and the prisoner's cell, where one remains several months or several years. The walls of abandoned houses, without any resident owner, are also rich in graffiti: visitors took over the house for an instant. In the Roman world it did not seem necessary to hide to write upon a wall. In the case of long texts whose formulation is elaborate and the layout carefully thought out, one might even imagine an admiring "public" around the writer, such as in the house of C. Iulius Polybius. The time has passed when the excavators of Delos or of Dura Europos thought, precisely by analogy with the contemporary world, that the presence of graffiti corresponded to a state of shabbiness in the dwelling, even the abandonment of the living space, as is pointed out equally by Mantha Zarmakoupi (Chapter 4) and by Jennifer Baird (see below).

Antonio Varone (Chapter 6) reminds us that inscriptions in latrines also existed in Campania; however, in public latrines, one was not alone. The *iscrizioni privatissime* that he studies discuss particularly intimate subjects, which we would nowadays describe as scatological. They were appropriate to the place's function (a form of "Latin humor," apparently); they borrowed from the more common graffiti their conventions, especially in the practice of

15 Sablayrolles 1996, 372–380, 389.

dialogue; and they did not specialize in obscenities like ours in the same places. Indeed, obscenities were mostly found elsewhere, particularly in taverns. Still, Salutaris, an eminent personality in Ephesus and a contemporary of Trajan, was victim of an obscene graffito in Latin, in a house that might have been his own.[16]

The practice of individual writing was so prevalent that it had no limits. It might have had a functional character and, in that case, be totally private: thus, when someone used the wall of a room to make his own *accounts* or to settle accounts with a third party, as might be done today on the corner of a paper tablecloth. That type of text, frequent in the taverns, in Pompeii as in Narbonne, might also be encountered in the *tablinum*, the room that the master of the house reserved for *negotium*. In the case of strong concentrations of that type of graffito (like in Dura Europos), the link with the proximity of the shops is underscored by Jennifer Baird (Chapter 2).

I will insist on a point, to which Andrew Wallace-Hadrill and I had called attention during the panel at the Congress of Epigraphy in Berlin in August 2012. There is not much difference between the graffiti that flourish in public spaces and those found in private spaces, houses, boutiques, workshops, etc. Therefore the graffiti become a subject of study per se. The authors, more and more numerous, who study them rarely limit themselves to a type of space but are rather more interested in a type of text (poets' quotations, formulas now become proverbial, etc.) that is readable pretty well everywhere in Rome, in Campania, or elsewhere in the West. The same goes for this book where, not unreasonably, space is devoted to the basilica in Pompeii (Keegan, Chapter 11). Better still, the authors of graffiti sometimes imitated in the private spaces the *ordinatio* of the monumental public inscriptions. They were not satisfied with scribbling.

But the writer's intention is not always clear and, in any case, not always the same. All the authors here agree in acknowledging that a very large proportion of graffiti are proper names. Most of the time, the name is that of the writer—and we have already noted the domination of masculine names—who, in a few rare cases, chose the anagram of his name to engage in riddles with his reader. Often the writer wished to emphasize that he was actually present *hic*, here, in this place. Among the testimonies of that usage recently published we find the graffito of the wool artisan (*lanarius*) Eutychus in his workshop (*statio*) in Canossa.[17] These are inscriptions linked "to a day, to a moment, to an occasion,"

16 *AE* 2005, 1463 a–b.
17 Cf. Corbier 2011, 45, fig. 10.

to use the excellent expression of Marc Mayer.[18] One could nonetheless think, following Claire Taylor in discussing a house in Attica (Chapter 3), that the name engraved twice on the courtyard's pavement is that of the householder written by a resident or by a visitor rather than by the owner himself—and that, if the name remained in place, it was precisely because the owner found nothing to say about it. It might happen that a third party makes fun of two other persons: thus, the graffito in Pompeii that revealed the homosexual practices of Popilus and Renus.[19] But it might be worth considering whether a vulgar denunciation is not rather more a character of public spaces (basilicas, thermal baths, etc.) and the places of masculine gatherings (palestra, etc.) rather than the house's private sphere, even if a message of a sexual nature (*fellatio*) was addressed to Sabina in the Casa delle Nozze d'Argento and if Salutaris was mocked for his supposed penchant (*paedicare*) in Ephesos.

In comparison with publications forty years ago, which were then dominated by the rivalry of two approaches, that of the philologists and that of the palaeographers, there has not often been a question of *palaeography*, except for Angela Cinalli studying the funeral inscriptions, painted or drawn in charcoal from Cyrene, which cover a chronological span over several centuries.[20] However, the difficulty in reading is an important point, also underlined by Antonio Varone (Chapter 6), who corrected some readings of the corpus (*CIL* IV) for texts often deemed to be minor. They inform us as to trivial expressions in the spoken language that had few hopes of passing into Latin literature, even satirical writing. We note in passing that the letter E is usually rendered with a cursive character by two parallel strokes, which does not make of it a clumsiness. The philologist, who favoured a reading that made sense, and the palaeographer, who differently reconstituted the same word letter by letter, are playfully set back to back by Roger Hanoune.[21] Thus the letters which, in the years 1966–1967, Robert Marichal proposed reading as TELEG on the walls of the *Paedagogium* on the Palatine, and, conversely, Heikki Solin understood as the banal acclamation *felic(iter)*, might make sense today if they mentioned the *Telegenii*, so popular among the African amateurs of the games in the amphitheater, those promoters of spectacles having become a subject for study since then.

18 Mayer Olivé 2003.
19 *CIL* IV.8898 ; cf *AE* 1984.205 : *Popilus (ut) canis cunnu linge Reno*.
20 William West, who presented in the panel at the Epigraphy Congress in Berlin, had also analyzed the palaeography of Greek letters on archaic Aegean ceramics brought to light in Azoria, Crete.
21 Hanoune 2011, 280.

The ambiguity of the interpretation is, on the other hand, underlined by everyone. This is what explains the multiplicity of hypotheses. I recalled the one that attributed the greetings addressed to the five women as an exchange between those five women, who would therefore be the female writers. One might even go further. For instance, I ask myself if the two texts addressed in the basilica in Pompeii by Pyrrhus to Chius (Keegan, Chapter 11) should be taken at their face value. The Romans' humor is not always obvious to us.

I will happily insist on *the pleasure of writing* within a world where, unlike ours (I am here speaking of the West for, in very many poor countries, a ball point pen and a notebook are as joyfully greeted by children as sweets), writing material is rare and expensive. One could apply the French proverb "opportunity begets the thief" to all spontaneous graffiti (be they scratched or scribbled in charcoal or in chalk) provoked by the moment or the opportunity. Other graffiti texts, however, were carefully thought out and carried out with great care. There is therefore no simple unique definition of the graffito beyond the fact that the author and the writer are identical. I myself have also just devoted here too much space to graffiti, whereas the goal of the recent volume *L'écriture dans la maison romaine* was precisely to show the extreme variety of the writings that one comes across in the private sphere.

One of the lessons of this book is that one must begin by *contextualizing* the writing one is studying whatever its nature. Rebecca Benefiel, tempted to identify a notion of "graffiti habit" within the "epigraphic habit" characteristic of the Roman World, has made a speciality of that approach. The historian does not really run the risk of circular reasoning if he attempts to define the uses of a space by the messages inscribed there. The spaces of representation and of circulation were well identified in Pompeian houses as in the houses of Delos and Ephesos. But, for some places, which the archaeological context does not allow us to identify unambiguously like the taverns, the number and the nature of the graffiti can be sufficient to establish them.

Sometimes, on a broad scale, one can note *regional contrasts*. Thus, the patronage tablets, even if they have their origins in the Greek decrees of proxeny, seem specific to the West, whereas the Greek inscriptions inviting the reader[22] to remember (*mnesthe*) so-and-so, so numerous in Dura Europos—more generally in Syria and other Eastern provinces—do not have their equivalent in Latin but are found in Rome and Pozzuoli, where that type of Greek graffiti followed the migration of its Eastern writer.[23] As for the signs of devotion bearing their authors' name or of the one placed under the

22 In the third person singular of the aorist passive subjunctive.
23 Read Guarducci 1967–1978, 223–226.

divinity's protection that one finds in Ephesos and Pergamon, they do not seem to be as widespread in their written form in the Western households than in the Eastern ones. Thus, in Rome, in the second century, the *Papirii* dedicated in their *domus* two marble altars to *Hercules defensor* and *Silvanus custos* with a dual dedication in Latin on one side and in Greek on the other, and in the fourth century the *Aradii* offered a dedication to Mercury, *comes et custos* of their *Lares* and *Penates*.[24]

Inversely, bearing witness to the same popular culture or to a more or less erudite culture, spread throughout the Roman space by the migration of writers, graffiti bearing the same text are found in Pompeii and in Narbonne ("We were happy to come, we are even happier to leave"), in Pompeii and in Ephesos (the riddles based on the recognition of a Greek, feminine name, based on the letters' numerical value), in Dura Europos—and more generally in Syria—and in Rome or in Campania (the inscriptions blessing someone under the form of the wish *mnesthe*). Everywhere, in any case, the apparent loneliness of the graffiti's author aims to establish a sought-for complicity with his reader.

It is not surprising that one finds graffiti and, at the same time, elegant inscriptions engraved on the bases of statues in the wealthiest houses in Delos (Chapters 4 and 8). On the contrary. The same goes for the three large Pompeian households examined by Rebecca Benefiel (Chapter 5). They are houses that stand out thanks to three common features: the presence of a more or less numerous domestic staff, the occasional or regular welcoming of visitors, and a diversification of the inner spaces that allows for a relative hierarchal organization. The marked differences with our current practices—the praising and often the self-praising of the person of the master(s) of the house like the non-erasing of tiny graffiti spread here or there—also reflect the difference of activities, compared to ours, of which the house was the setting for the adults as well as for the children.

What seems important to me, to conclude, is to underline that two levels of culture, linked to two different uses of writing and of reading, managed to co-exist in the private sphere, to develop and interact in the Roman world—and more broadly Mediterranean world—over several centuries, as much with persons sharing the same standard of literacy, economic condition, and social rank as with those belonging to various social levels. It is that interaction that we must study for itself.

24 IGUR 171 and 195; AE 1987.102.

Bibliography

Benefiel, Rebecca. 2011. "Dialogues of Graffiti in the House of the Four Styles at Pompeii (Casa Dei Quattro Stili, 1.8.17,11)." In *Ancient Graffiti in Context*, edited by J. A. Baird and Claire Taylor, 20–48. New York: Routledge.

Blanco Gonzalez, Antonio, Marc Mayer Olivé, and Armin U. Stylow, eds. 1987. *La Cueva Negra de Fortuna (Murcia) y sus tituli picti: un santuario de época romana*. Murcia: Universidad de Murcia.

Corbier, Mireille. 2011. "Présentation. L'écrit dans l'espace domestique." In *L'écriture dans la maison romaine*, edited by Mireille Corbier and Jean-Pierre Guilhembet, 7–46. Paris: de Boccard.

———. 2006. *Donner à voir, donner à lire: mémoire et communication dans la Rome ancienne*. Paris: CNRS Editions.

Corbier, Mireille, and Jean-Pierre Guilhembet, eds. 2011. *L'écriture dans la maison romaine*. Paris: de Boccard.

Fauduet, Isabelle. 2011. "Écrits associés aux divinités dans la maison." In *L'écriture dans la maison romaine*, edited by Mireille Corbier and Jean-Pierre Guilhembet, 113–136. Paris: de Boccard.

Février, Paul-Albert. 1994. "La lettre et l'image." In *La mosaique Gréco-romaine IV: IVe Colloque international pour l'étude de la mosaïque antique, Trèves, 8–14 août*, edited by Jean-Pierre Darmon and Alain Rebourg, 383–401. Paris: Association internationale pour l'étude de la mosaïque antique.

———. 1987. "Paroles et silences (à propos de l'épigraphie africaine)." In *L'Africa romana: atti del IV Convegno di studio (Sassari, 12–14 décembre 1986)*, edited by Attilio Mastino, 157–192. Sassari: Dipartimento di Storia, Università degli Studi di Sassari.

Guarducci, Margherita. 1967–1978. *Epigrafia greca*. Rome: Istituto poligrafico dello Stato, Libreria dello Stato.

Hanoune, Roger. 2011. "Maisons d'Afrique, pavements de mosaïque et inscriptions." In *L'écriture dans la maison romaine*, edited by Mireille Corbier and Jean-Pierre Guilhembet, 279–290. Paris: de Boccard.

Kruschwitz, Peter. 2010. "Attitudes Towards Wall Inscriptions in the Roman Empire." ZPE 174: 207–218.

Mayer Olivé, Marc. 2003. "Usos epigráficos singulares: la epigrafía para una ocasión." In *Usi e abusi epigrafici. Atti del Colloquio Internazionale di Epigrafia Latina (Genova 20–22 settembre 2001)*, edited by Maria Gabriella Angeli Bertinelli and Angela Donati, 255–277. Rome: L'"Erma" di Bretschneider.

Sablayrolles, Robert. 1996. *Libertinus miles: Les cohortes de vigiles*. Rome: Ecole Française de Rome.

Tomlin, Roger. 2011. "Protective spells in Roman Britain." In *L'écriture dans la maison romaine*, edited by Mireille Corbier and Jean-Pierre Guilhembet, 137–144. Paris: de Boccard.

Zadorojnyi, Alexei. 2011. "Transcripts of Dissent? Political Graffiti and Elite Ideology Under the Principate." In *Ancient* Graffiti *in Context*, edited by Jennifer Baird and Claire Taylor, 110–133. New York: Routledge.

Index Locorum

AE
1894.108	136 n 20
1913.25	136 n 20
1913.40	134 n 13, 136 n 21
1937.119	135 n 19
1937.121	135 n 19
1950.4	136 n 22
1957.317	134 n 13
1962.288	135 n 17
1972.98	101 n 50
1984.205	274 n 19
1984.553	134 n 13
1987.102	276 n 24
2005.1463 a	273 n 16
2005.1463 b	273 n 16

Agora XIX
P9	40 n 22
P26	38 n 16

Baur and Rostovzeff 1929
no. R.5	17 n 11

Baur and Rostovzeff 1931
no. H.11	17 n 11
no. H.14	17 n 11

Baur, Rostovtzeff and Bellinger 1933
nos. 214–275	25 n 35
no. 217	25
no. 218	25
no. 227	25
no. 232	24 n 33
no. 235	24 n 33
no. 236	24 n 33
no. 237	24 n 33
no. 238	24 n 33
no. 239	24 n 33
no. 245	25 n 36
no. 392	24 n 33
pl. 23.2	27 n 46

Benefiel 2010
no. 29	104 n 58
no. 30	104 n 58
no. 33	104 n 58

CIG
3765	199 n 65
5149	185, 191 n 32
5149b	191, 192 n 36
9136	185

CIL
I^2.2504a–c, Add. p. 1017	114 n 2
I^2 2.2652	65 n 62
II.1343	134 n 13
II.2210	135 n 20
II^2/7.276	135 n 20
II.3695	134 n 13
III.1966	123 n 27
IV.51	257 n 12
IV.52	257 n 12
IV.659–660a	117 n 11
IV.844	271 n 10
IV.1820	252, 253 fig. 11.3
IV.1842	255 n 7
IV.1852	249, 250 fig. 11.1, 252–253, 254 n 6
IV.3782	122 n 24
IV.4159–4197	98 n 44
IV.4184–4187	105 n 59
IV.4586	122 n 24
IV.4621	117 n 11
IV.4957, Add. p. 705	128 n 37
IV.4966–4973, Add. p. 705	114 n 2
IV.5086	117 n 11
IV.5242	125 fig. 6.7
IV.5243	126 n 35
IV.5244	102 n 52, 126 n 36, 127 fig. 6.8
IV.5438	122 n 24
IV.6641	124 n 29
IV.6826	117 n 11
IV.7038	122 n 27, 123 fig. 6.6
IV.7196–7216	97 n 42
IV.7521	256 n 11
IV.7714	122 n 23, 122 n 26
IV.7715	122 n 23
IV.7716	122 n 24

IV.8065	103 n 55	VI.1691	138 n 30, 140 n 36
IV.8066	103 n 55	VI.1692	138 n 30, 140 n 38
IV.8067	100 n 46, 120 n 18	VI.1693	138 n 30, 140 fig. 7.5, 140 n 37
IV.8068	100 n 46, 120 n 18		
IV.8069–8082	100 n 46	VI.2357	124 n 28
IV. 8228	87 n 16	VI.3828	135 n 19
IV.8518–8814	82 n 5	VI.13740	123 n 27, 124 n 18
IV.8585	82 n 5	VI.29609	203
IV.8625 a	82 n 5	VI.29848b	123 n 27
IV.8625 b	82 n 5	VI.31659	136 n 22
IV.8625 c	82 n 5	VI.31692	136 n 22
IV.8625 d	82 n 5	VI.35887	203
IV.8898	274 n 19	VIII.68	134 n 13
IV.8899	124 n 28	VIII.2383	136 n 20
IV.9245–9279	82 n 5	VIII.2403	136 n 20
IV.9837	88 n 20	VIII.8837	135 n 20
IV.9867	120 n 19	VIII.10525	133 n 8, 133 n 9
IV. 9990–10027	87 n 16	IX.730	136 n 21
IV.10050	87 n 16	IX.2845	142 n 50
IV.10051	87 n 16	IX.2846	142 n 50
IV.10070	120 n 21, 121 fig. 6.4	X.864	166, 167, 171
IV.10082 a	103 n 56	X.901	96 n 38
IV.10082 b	103 n 56	X.902	96 n 38
IV.10229	102 n 53	X.2702	166, 167, 171–172
IV.10232 a	102 n 53	XI.2707	165 n 76
IV.10232 b	102 n 53	XIV.2924	135 n 16
IV.10233	102 n 53		
IV.10235	102 n 53	*CLE*	
IV.10240	102 n 53	15	126 n 36
IV.10246 a–k	102 n 53	838	124 n 28
IV.10580	117 n 10, 118	932	128 n 37
IV.10619	119 n 18	934	114 n 2
V.4919–4922	134 n 13	935	114 n 2
VI.1374	141 n 46	1934	122 n 27
VI.1454	136 n 22		
VI.1483	142 n 50	Frye et al. 1955 (Dura-Europos)	
VI.1492	136 n 23, 137 fig. 7.2	no. 16	18 n 19, 21 n 25
VI.1531	140 n 40	no. 17	21 n 26
VI.1684	133 n 8, 138 n 30, 138 n 32	no. 18	20
		no. 19	20
VI.1685	138 n 32, 138 n 30, 139 fig. 7.3	no. 20	20
		no. 21	20
VI.1686	138 n 32, 138 n 30, 139 fig. 7.4	no. 22	20
		no. 23	20
VI.1687	138 n 30, 138 n 32	no. 25	20
VI.1688	138 n 30, 138 n 32	no. 26	20
VI.1689	138 n 30, 138 n 32	no. 27	21 n 26
VI.1690	138 n 30, 140 n 35	no. 28	21 n 26

INDEX LOCORUM

Giordano and Casale 1991
 no. 124 87 n 16

GIV
 1.1126 203
 1.1941 203

GMA
 14 220 n 29
 23 220 n 29
 32 220 n 29
 44 232 n 85, 236 n 106
 48 220 n 29
 52 220 n 29
 58 220 n 29
 64 220 n 29, 235 n 98

Goldman 1999
 E.10 27 n 41
 F.5 27 n 47
 F.6 27 n 41
 G.21 27 n 47
 G.23 27 n 46

IAA
 1980.880 214 fig. 10.1
 1984.317 226 fig. 10.3
 1987.758–750 231 n 10.5

IAM
 2.488 135 n 18

ID
 1730 56
 1761 56
 1802 53, 56, 57, 57 n 30, 165 n 73
 1961 70
 1987 53, 54, 54 n 22, 55, 162 n 63, 166, 167, 170
 2325 164 n 71
 2328 53 n 15
 2329 53 n 15
 2378 53, 54 n 22, 58, 164 n 68, 166, 167, 171
 2379 167, 171

IEph
 502 150 n 8, 153 n 21
 502A 150 n 8, 153 n 21
 834 150 n 8, 153 n 22
 1099 150 n 8, 153 n 21
 1267 150 n 8, 166, 167, 168

IG
 II2 1314 199
 XII 5591 199 n 65
 XIV 11 68 n 66
 XIV 612 134 n 12
 XIV 952 134 n 12
 XIV 953 134 n 12

IGR
 1027 197 n 58

IGUR
 171 276 n 24
 195 276 n 24

ILCV
 1592 140 n 41

ILLRP
 1125 a–c 114 n 2

Israel Department of Antiquities
 57.733 231 n 76
 57.739 231 n 76
 57.744 231 n 76
 1980.880 213 n 1

HEp
 7, 1093 135 n 17

Langner 2001
 no. 21 92 n 30
 no. 22 92 n 30
 no. 76 61 n 55
 no. 95 68 n 66
 no. 117 92 n 30
 no. 125 92 n 30
 no. 215 88 n 19
 no. 246 88 n 20
 no. 250 88 n 19

no. 292	88 n 19
no. 385	88 n 19
no. 432	92 n 30
no. 433	92 n 30
no. 453	88 n 19
no. 501	88 n 19
no. 525	92 n 30
nos. 861–864	88 n 19, 92 n 29
no. 1145	71 n 80
no. 1408	61 n 54
nos. 1411–1413	61 n 53
no. 1837	92 n 30
no. 1875	62 n 58, 62 n 59
no. 1906	65 n 60
no. 1915	66 n 64
no. 1916	62 n 58, 62 n 59
no. 1941	62 n 58
no. 1978	62 n 58, 62 n 59
no. 1981	62 n 58, 62 n 59
no. 1984	66 n 64
no. 2035	62 n 58, 62 n 59
no. 2081	66 n 64
no. 2082	66 n 64
no. 2151	62 n 58, 62 n 59
no. 2152	62 n 58, 63 n 59
no. 2153	62 n 58, 62 n 59
no. 2154	62 n 58, 63 n 59
no. 2161	66 n 64
no. 2201	62 n 58, 63 n 59
no. 2207	68 n 66
no. 2209	61 n 52
no. 2316	88 n 19, 92 n 29
no. 2488	92 n 30
no. 2492	92 n 30
no. 2493	92 n 30
no. 2519	88 n 19, 92 n 29

MDAI(A) 29, 1904

no. 21	170
179–186	160 n 57, 170

MDAI(A) 32, 1907

no. 117	169
no. 118	169–170

Naveh and Shaked 1993

no. 12	229 n 64
no. 16	226 n 56, 227 n 57

Naveh and Shaked 1998

no. 11	231 n 76, 231 n 78
no. 12	231 n 76, 231 n 77
no. 13	231 n 75, 231 n 76, 232 n 79, 232 n 80

ÖJh 53 1981/1982

no. 140.1	166, 167, 168, 169

Rostovtzeff et al. 1952

40	27 n 42

Rostovtzeff, Brown, and Welles 1936

40–43	27 n 48
129–130, no. 868	17 n 14

SeCir

18	201 n 68
46	190 n 30
110	206 n 79
156	205 n 77
192	192 n 37, 204 n 74

SEG

2.855	203 n 71
3.672	68, 68 n 66
9.39	196 n 56
9.4	197 n 57
9.41	196 n 56
9.46	206 n 78
9.51	201 n 68
9.73	196 n 56
9.77	184 n 8
9.133	206 n 78
9.135	206 n 78
9.235	188 n 27
9.248	197 n 58
9.284	206 n 80
9.552	205 n 76
9.592	205 n 76
13.425	53 n 16
20.735a	206 n 79
20.742	206 n 80
26.53	43
26.137	43
28.208	43
31.149	43
32.233	38 n 16

32.812	53 n 20	48.166	36
33.147	34	50.187	34
33.1468	197 n 58	52.1845	191 n 34
35.885	53 n 19	54.387	38
40.262	43	54.712	53 n 15
40.263	43	55.84	43
42.1674	191 n 32	55.85	43
42.1675	185 n 15		
44.240	36	Solin 1975	
44.25	43	no. 36	104 n 58
45.2150	193 n 42	no. 37	104 n 58
46.2210	187 n 21	no. 40	104 n 58
47.2185	184 n 6		

Index Nominum

Achilles 193
Actaeon 189
Adonis 235
Adrastos of Myrrhinous 55, 171
Aemilius Lepidus, M. 131n2
Agathokles 53
Albucius Celsus, L. 96
Alkamenes 160, 170
Ammonis, Gaius 188
Ἀνάξανδρος 201
Ἀναξέας 205
Ancharia Luperca 165–166, 172
Ancharius Celer 172
Anthis 269
Ἀντιδίκε 43
Aphrodite 59, 70, 153–155, 164, 168, 171
Apollo 53–55, 58, 72, 162, 171, 184, 203, 206
Apollinaris 120, 269
Aradius Rufinus Optatus Elianus, Q. 138n28, 276
Aradius Rufinus Valerius Proculus, Q. 138–139, 276
Aradius Valerius Proculus, L. 138–140, 276
Artemis Soteira 53, 58–59, 164, 171
Asinius Gallus, C. 134n13
Asklepios 236
Athamas 261
Athenadorus (pirate) 51, 60
Atilius Vernus, M. 134n13
Aufidius, Cn., T. f. 134n12
Augustus 132, 134, 141, 167
Aurelios 17
Aurelius, Marcus 137n26
Avidius Quietus, T. 135n19, 136n22

Bacax 271
Barlaas 17
Bruttius Crispinus, L. 171–172
Byzantia 101

Caecilius Iucundus 6, 260
Caetennius Onesimus 171–172
Castricius, Maius 95–100, 104–106

Cestius 141
Chius 249, 252–253, 275
Cicero 133, 136n24
Cimber, slave of Nero 103
Claudius (emperor) 131
Claudius Attalos Paterklianos, C. 155–161, 167–170
Claudius Julianus, Appius 171–172
Cleopatra 260
Cornelius Balbus 132
Cornelius Rufus, C. 164–165, 171
Cucuta, slave of Nero 103, 120n18, 259, 269
Cuponia 262
Cybele 158n46
Cypare 269

Dea Sulis Minerva 234, 266
Demeter 234–235
Demetrios (Delos) 69
Demetrios, son of Diodotus (Syracuse) 134n12
Dimitria 184–187, 207
Dione 168
Dioskurides 53–55, 59, 72, 162–165, 168, 170–171
Dionysos 150–152, 154–155, 168
Domitian 2
Domitilla Lucilla 137n26
Domitius Ahenobarbus, L. 134n13

Ἐπάγαθος 70
Epicharinos 34
Erecshigal 235
Esther 231
Εὐίππιον 205, 207
Eumachia 262
Euplia 269
Εὐφρόσυνος 43
Euthydike 34–35, 39–45
Eutychus 273

Flavius Furius Aptus, C. 149–155, 167–169
Flavius Hyginius 135n20

INDEX NOMINUM

Flavius Lollianus Aristobulus, T. 149
Flavius Vedius Antoninus, T. 156n32
Fronto 5

Gabriel 230
Ganymede 189
Gellius, Aulus 3

Ἡλιοφῶν 65
Hercules *defensor* 276
Hermes 160
Hermes Propylaios 159, 170
Hermias 69
Hirrius Fronto, M. 260
Horace 128n38

Ilarion 203
Ino 261
Insteius, Q. 135
Iris 262
Isis 266
Iulius Anicetus, C. 257
Ἰούλιος Κρίσπος, Γάϊος 204
Iulius Philippus, C. 269
Iulius Polybius, C. 103, 114, 269
Iulius Secundus, Q. 135n20

Juvenal 132n5

Καικίλιος Ἐπάγαθος 70
Kallippos 185
Kephisios 36
Kleopatra (resident of Delos) 53–55, 59, 72, 162–165, 168, 170–171
Kore 234–235
Κρέων 43

Laberius Gallus 165–166, 171–172
Leda 189–190
Leo the Isaurian 51n8
Lesbianus 120–122
Licinius Crassus Frugi, M. 134n13
Licinius Silvanus Granianus, Q. 133
Lucretius Fronto, M. 4
Lucullus 51
Lucretius 101
Lysias (resident of Dura-Europos) 18–22, 42
Lysimachos 53n15

Magna Mater 234, 266
Makae 184n8
Marcellus Empiricus 120n18
Marius Balbus, Q. 134n13
Marius Pudens Cornelianus, C. 136n22
Martha 102, 127
Martial 2, 119, 126
Mater Deum Magna Idaea 157n44
Medusa 158n46
Melicertes 261
Menander 194
Mercury 276
Mithridates 51, 60
Mnasarchos 184n8
Modestus 262

Nasamones 184n8
Natrun, daughter of Sarah 231
Nebuchelus 22–23
Nero 103, 114, 120n18, 150n9, 259–260, 269
Nicopolis 269

Oedipus 188n24
Orthonobazua 22n30

Palaemon 261
Papirii 276
Paquius Proculus, P. 96–100, 103–106, 120
Paquius Scaeva, P. 142n50
Pergamios 160
Perikles, friend of C. Fl. Furius Aptus 153–155, 169
Phileso 203
Philokrates 36, 40–46
Philothales 184
Pliny the Elder 6, 131–132, 141, 266
Plutarch 136n22
Pluto 235
Polyboulos 185
Polyxena 193
Pompeius Amarantus, Sextus 8
Pomponius, C. 133
Pomponius Atticus, T. 136n24
Pomponius Bassus, T. 135n19, 136–137
Popidius Rufus, N. 260
Poppaea 104
Prima 269
Primigenia 261

Primigenius 269
Psyche 189
Ptolemeus Lagos 202
Pupius Rufus 89
Pyrrhus 249–250, 252–253, 275

Quartilla 269
Quintilii 137n26

Romula 104–105

Sabina 105, 274
Sabinus 261
Sagitta, slave of Nero 103
Salutaris 273, 274
Saturn 235
Sallius Pompeianus Sofronius, C. 135
Secundus 269
Seneca 119
Σερουίλιος Ἐπάγαθος 70
Severus 262
Silius Aviola, C. 134n13, 136
Silvanus *custos* 276
Sirens 184, 188, 192–193, 204, 208
Sittia 105
Sol 257
Sossius Hilarus, T. 171–172
Sparte 203n71
Spendusa 105, 269
Stertinius, Spurius 53, 58–59, 164, 168, 171
Successa 269
Successus 261–262
Sulpicii 260

Theoboulos 185
Theodoros 206–207

Theodoros of Myrrhinous 55, 171
Theuchrestos 184, 207
Tiberius Augustus 260
Tiburtinus 114
Timarchos of Athens, archon of Delos 54–55, 162, 171
Timarkos (resident of Dura-Europos) 17
Titus 120, 269
Trajan 136n23, 273
Triarius, legate of Lucullus 51, 60
Trimalchio 141
Tullius, Quintus, Q. f. 53, 56–57, 59, 70–72
Tullius Alexandros, Q. l. 56–57
Tullius Aristarchos, Q. l. 56–57
Tullius Heracleon, Q. l. 56–57

Ulysses 174, 188, 192–193

Valerius Maximus 138n28
Valerius Publicola Balbinus Maximus, L. 140
Valerius Severus 140
Venus 114, 255
Venustus 261
Vespasian 221
Vettii 89
Vibius Habitus, A. 134n13, 136
Vibius Postumus, C. 136n21
Virgil 261, 268
Vitruvius 4, 5, 142n51

Yose, son of Zenobia 227–229

Zeus 168
Ζωῖλος 43

Subject Index

abecedaria, see also alphabet 27
access 4, 14, 32–33, 41, 44–46, 58, 71, 113, 131–132, 142
Achilles 193
aedile 1–2, 96
Aemilius Lepidus, Marcus 131n2
Aesklepios 236
Alexandria 69, 201
alphabet 17, 27, 85n10, 106, 271
alytarch 150, 153
amphora 8–9, 83, 85–86
amulet (*lamella*) 213–220, 225–240, 266
anagram 117–118, 273
andron 34–35, 42
Anthologia Palatina 69
Aphrodisias 222
Aphrodite 153–155
Apollinaris 120, 269
apotropaic 117
Aramaic 21n25, 213–215, 221–222, 226, 238, 266
arcosolium 193, 196
Artemis Soteira 53, 58, 164, 171
Asia Minor 50, 198, 219, 221–222, 233, 235
association 52, 141, 152, 164–167, 172–173
ateleia 50
Athenadoros (pirate) 51, 60
Athens 34–37, 41, 44, 267
atrium 3, 5–6, 42, 97–98, 100, 103, 132, 136, 138, 141, 165–166, 260–261
Attica 32–49, 162, 274
audience 16, 33, 45, 113, 219, 222, 239, 258, 270
Augustus 132, 134, 141

Barʿam 225, 230, 233, 236
basilica 7, 82, 113
baths 96, 160
bench 3, 19–20, 22
bilingual inscriptions 56–57, 59, 65, 71–72, 165, 267, 276
bouleuterion 134–135
Britain 40n21, 219–220
brothel 7, 38, 83, 106, 257
built environment 45, 249–250, 254–255

cacatores 120–125
calendar 27, 201, 271
Campania 114, 249, 272–273, 276
Canossa 273
capital letters, see lettering
caption 190–192, 207
Capua 9
castellum aquae 262
cemetery 33, 131, 181, 184, 235, 238
charcoal ix, 122n24, 182–183, 194–208, 267–268, 274–275
Chreophylakeion 26
Christian context 184, 187, 197–198, 206–207, 217, 221, 224, 234, 237, 240
church 221–222
Cicero 133–134, 136
city council 2, 166
city-block, see *insula* 18, 81, 83, 85, 88–89, 93
Claudius 131n2
clients 3, 6, 106, 132, 141–142, 152, 155, 165–166
Clitumnus 271
clusters, graffiti 16–17, 20–22, 24, 45, 61, 63–65, 67, 71, 81, 98, 100, 105, 255, 261, 269
collegium 140, 165, 172, 265, 267
columns 7, 98–100, 138, 260, 270
commemoration 16, 42, 46, 33–34, 132, 182–183, 207
commerce 8–9, 22, 24, 59, 70–71, 114, 225, 260–261
communication 6, 25, 71, 81, 106, 113, 167, 182, 259, 263, 270
consul 135, 155, 157, 161, 167, 169
convivia 153, 167
Corinthian *oecus* 96
courtyard 14, 18–19, 21–22, 34–35, 40–42, 45–46, 58–59, 61–63, 66–67, 71–72, 195, 274
Crete 9, 236
cubiculum 92, 196
Cucuta 103, 259, 269
cultural identity 44, 72, 208, 216, 240, 248–249, 260, 269

curia 134–135, 267
curse tablet (*defixio*) 8, 33, 45, 142, 217–218, 226–229, 234–237, 239, 266
Cyrene 265, 267
 Christian tombs 184, 187, 207
 Carboncini Tomb 194, 199–208
 Dimitria's Tomb 184–187, 201, 207
 The Garden Tomb 194–199, 208
 The Ludi Tomb 191–194, 208
 Thanatos Tomb 184, 187, 207
 Theuchrestos' Tomb 184, 207
 Tomb of Ulysses and the Sirens 192–193
 Veteran's Tomb 188, 190, 192

daily life 13, 26–27, 83–84, 86, 119, 255, 261
Dea Sulis Minerva 234, 266
decoration 71, 100, 192, 222, 270
decurio 135–136, 260
defacement 13, 21–22, 27, 39, 43, 99, 258, 272
defecation 8, 113, 119–120, 122–123, 125, 128
defixio (curse tablet) 8, 33, 45, 142, 217–218, 226–229, 234–237, 239, 266
Delos 34, 42–43, 50–79, 146, 167–168, 272, 275–276
 Agora of the Italians 57
 "duty-free" status (*ateleia*) 50
 House ID 64, 71
 House IIA 71
 House III K 71
 House E 58
 House VI L 69
 House of Dionysos 61, 64, 67–68, 71
 House of Kleopatra and Dioskourides 53–54, 59, 72, 162–163, 165, 170
 House of the Lake 67, 71
 House of Quintus Tullius 53, 56, 59, 70–72
 House of Spurius Stertinius 59
 House of the Tritons 71
 Insula of the Jewelry (Ilot des Bijoux) 62–64, 67
 Insula of Tragic Actors 71
 River Meander 68
 Sanctuary of Aphrodite 59, 164, 171
 Sanctuary of Apollo 50, 53, 58–59, 72, 162
 Stadion District 53, 56, 60, 64, 67, 70–71
 Theater District 53–54, 61, 67, 69, 71
denarii 20

dialogue, graffiti with each other 17, 39, 41, 45, 62, 255, 259, 262
Dionysos 150–152, 154–155, 158, 168
Dionysius of Halicarnassus 271
dipinti (painted inscriptions) 81–83, 85, 183–194, 207, 260
distribution, graffiti 17, 19–21, 26, 81, 83–94, 98–100, 106, 261
divination 23
Domitian 2
drachmas 197
drawing, act of 15, 27, 45, 87–92, 98, 101–102, 256–258
duovir 96n38
Dura-Europos 13–31, 34, 37, 94, 222, 224, 233, 240, 272, 275
 House of the Archive 22
 House of Lysias 18–21, 42n29
 House of Nebuchelus 22–25
 Synagogue 27, 271
 Temple of Bel 27
"duty free" status, see *ateleia* 50

ergasterion 34–41
Egypt 70, 213, 219–220, 232–233
Egyptian calendar 201–202
Egyptian cult 70, 72
electoral posters (*programmata*) 3–4, 6, 81, 85–86, 88, 97, 270
emperor 51, 103, 114, 120, 150, 152, 168, 257, 259, 269
emperor cult 150
entrance 7, 19, 21, 38, 55, 59, 61, 65–67, 98, 100, 103, 120, 148, 155–165, 200, 228, 233, 237, 259–261, 270
Ephesos 146–155, 273, 275–276
 Curetes Street 147–148
 Terrace House 2 146–147, 168–169
epigraphic habit vii, 21, 80, 255, 275
epikleros 34, 41
epitaph 141–142
equites 134
Euphrates 14
Euthydike 34, 39, 45
exedra 61, 68, 102, 156–157, 260

façade 4, 81, 88, 93, 97, 195, 200
fascinum 122

SUBJECT INDEX

fauces 98
figural graffiti (drawings) 13, 15, 88, 90–92, 98, 256
 animals 15, 43, 61, 70–72, 92
 boats/ships 17, 22, 43, 60–66, 68, 70–72, 92, 120
 geometric designs 61, 71
 gladiators 27, 88n19, 261
 head in profile 43, 88, 92, 115–116
Flavius Furius Aptus, Gaius 149–155, 167–168
formula 17–18, 21–22, 113, 125, 187, 201, 219–220, 227–230, 236, 269
forum 3, 6–7, 131, 135
freedman 56–57, 59, 70, 132, 142, 165, 267
fresco 71, 96, 191, 193
Fronto 5
fullonica 89
funerary monument 82, 102, 132, 184–185, 187, 193, 208

Gades 133
Gaza 224
Gellius, Aulus 3
gender 104–105, 249, 269, 272, 275
gladiators 3, 27, 81, 88, 191, 257, 260
graffiti, poetry 52n12, 101, 114–115, 260–261
graffiti, size of 7, 16, 25, 40, 62–65, 71, 101–102, 105, 115
greetings 42, 104, 261, 269–270
gods 18, 215, 218–221, 223, 227, 229, 231–233, 236
guest 14, 19, 42, 67, 106, 119, 134–135, 155, 162
gymnasium 3, 170

Hadrian's Wall 268
handwriting 81, 101, 115, 119, 128, 183, 270
Hebrew 221–223, 226–227, 238, 266
hemorrhoids 253
Herculaneum 2, 6
 Casa della Gemma 119
 House v.30 117–118
Hercules 276
herm 157–158, 160–161, 164, 169, 171, 267
Hermes 160, 164, 170
high-traffic location 3, 17, 42, 86, 98
historiola 220

Homeric verses 158–159, 161, 266
Horace 128n38
horos inscription 34–36, 40–41, 46
horoscope 17, 27, 23–25
Ḥorvat Rimmon 213–214, 226, 233, 236–237
household 2, 14, 28, 33, 40–42, 46, 67, 71, 114, 119, 126, 222, 236, 267
 house owners 7, 21, 52–53, 72, 152, 155, 158–159, 161–166, 274
 see also clients, guests, visitors, and residents
household shrine 158
humor 119, 128, 268, 272, 275
Hymettos 43–45

identity, cultural 6, 53, 58, 216
inscriptions, types of
 boundary 34–36, 40
 bronze 1, 6, 131–142, 165–166, 171–173, 226, 230, 237–238
 dedicatory 17, 57, 71, 165, 216, 224, 271
 monumental 219, 222, 238–239
 votive 59, 236
insula (city-block) 18, 81, 83, 85, 88–89, 93
interior decoration 81, 95, 98, 101, 192
inventories 22, 25, 28
Isis 234, 266
isopsephic 270
Israel 213–241

Jews 53n15, 126n36, 202, 205, 213–241, 266
Judea/Palaestina 222–225, 233, 238–239
Juvenal 132n5

Kerameikos 37
kyrios 40

lararium 269–270
Lares 65, 276
latrine 7, 65, 102, 115–119, 122, 125, 127, 272
leges sacrae 223
legislation 1, 141, 256–257
lettering 6, 40, 184
 capital 101, 115, 122, 125, 193
 cursive 101, 121, 188, 193, 274
Levant 216–217, 219, 221, 233–234, 239–240
literacy 27, 44, 86, 104, 106, 121, 249, 251, 254–255, 271, 276

literary quotation 101–102, 106, 191, 194, 207, 255, 268, 273
Lucretius 101

Ma'on/Nirim 225, 229–233, 237
magic 26, 213, 216–220, 225, 230, 234, 237, 265–266
magistri 57
Magna Graecia 254
Magna Mater 234, 266
maritime traffic 51
Martha 102, 127, 269
Martial 2, 119, 126
memorialization 45
Menander 194
Mercury 276
Meroth 226, 228, 230, 233, 236–237
military 205
Mishnah 222
Mithridates 51, 60
mnesthe inscriptions 16–17, 26, 19–22, 80, 275
Mont Michel 43
mosaic decoration 97, 156, 222, 224, 228, 238
multicultural community 70
municipal charters 1
municipium 9, 131, 141
mythological scene 267

names 16, 20–21, 28, 35–36, 38, 40, 42–46, 69, 85n10, 105, 261, 269–270, 273, 275
Naples, Bay of 71
Narbonne 273, 276
necropolis 34, 132, 142, 181–188, 191, 194, 200
negotiator (merchant) 57, 59, 68, 72
neokoros 150, 153
Neoteric poetry 115
Nero 103, 114, 150n9, 259–260, 269
Nirim 225, 229–233, 237
North Africa 132–135, 138, 219, 221, 224, 235, 268
Numidia 135n20, 271n12

orality 219n19, 249n2, 259, 261, 270
Oscan 96
Ostia 69, 119, 222
ostraca 268

palaeography 185–187, 190, 193, 198, 203–204, 208, 274
palimpsest 101, 201
Palmyra 268
papyri 15–16, 24–25
parchment 15–16, 25
patron 6, 9, 56–57, 131–132, 134–135, 138, 165, 172
patronymic 184, 206
pedestal 96, 138, 140–141
performance 33, 16, 270–271
Pergamon 155–161, 169–170, 276
peristyle 7, 96, 98–99, 102, 105, 138, 156, 162, 260
Persius 125, 261
Petronius 124n28, 141, 271
phallus 43
Phileso 203
Philokrates 36, 40–43, 46
pinax 189, 208
Pliny the Elder 6, 131, 141, 266
Pliny the Younger 212n5
Plutarch 136n22
Pompeii 3, 6, 27, 34, 37, 40, 42, 69, 80–110, 120, 165, 171, 272, 276
 Amphitheater 82
 Basilica 7, 82, 113, 249–250, 252–255
 Brothel 7, 83
 Building of Eumachia 83
 Campus (*palaestra*) 82, 93
 Casa dei Ceii 88, 261
 Casa dei Gladiatori 260
 Casa dei Quattro Stili 65–66, 269
 Casa dei Vettii 89
 Casa degli Scienziati 262
 Casa del Bell'Impluvio 90
 Casa del Centenario 102, 125, 127
 Casa del Frutteto 87, 90
 Casa del Menandro 95, 260–261
 Casa del Moralista 122
 Casa del Principe di Napoli 92
 Casa del Sacello Iliaco 261
 Casa del Trittolemo 95
 Casa delle Nozze d'Argento 95–96, 98–99, 102, 105–106, 260
 Casa di Cerere 94
 Casa di Giulio Polibio 103, 114, 272
 Casa di Maius Castricius 95–96, 98–101, 104–106

SUBJECT INDEX

Casa di Paquius Proculus 95–99, 103, 105–106
City baths 83
Forum 82
Porta Nocera 102
Porta Stabiae 89
Porta Vesuvio 124
Small Theater 114
Theater Complex 83, 262
via dell'Abbondanza 84–86, 93, 96–97
vico di Mercurio 93
Poppaea 103, 114
portico 64
portrait 151, 158, 161, 165–167, 266–267
pottery 36–37, 215
Praeneste 135
priest/priesthood 56, 150–151, 158, 161, 167
privacy 8–9, 13, 16, 28, 32–34, 44, 46
property 2, 4–5, 8–9, 33–35, 40–41, 46, 85–87, 89, 93, 106, 219, 256, 258
proverb 268, 275
Pseudo-Epicharmus 203, 208
public space 1–3, 131, 134, 249
public/private dichotomy 1–5, 14, 32–33, 52, 81, 92, 105, 113, 128, 141, 221–223, 251, 265
Puteoli (Pozzuoli) 101, 275
proxenia decree 134–135, 275

reading 32–34, 39, 43, 45–46, 81, 86, 95, 104, 106, 219, 254, 268, 270–271, 276
reception room 58, 66, 96
religious character 17, 27, 114, 167, 271
resident 13, 40, 86, 103–104, 162, 249, 270, 274
road, see street
Rome 119, 134, 136, 164, 167, 273, 275–276
 House of Brothers Quintilii 137n26
 House of the Valerii (Celio) 136–141
 Palatine Hill 101
 Quirinal Hill 136
 Trastevere 272

sacred space 26, 125, 213–241
Salutaris 273–274
sanctuary 17, 21, 163, 168, 234, 236, 271
 of Aphrodite (Delos) 59, 164, 171
 of Apollo (Delos) 50, 53, 58–59, 72, 162

of Demeter and Kore (Acrocorinth) 234–235
 of Magna Mater 266
sarcophagus 204–205
Saturn 235
sculpture 146, 151–152, 156, 166
sculpture-text ensemble 146, 150, 153–155, 158–161, 163–164, 166
Semitic 17, 220, 233, 238, 266
senator 132, 134, 136, 138, 141–142
Seneca 119
shop 7, 22, 273
Sicily 134
signaculum 8
signature 22, 40, 103, 256, 269
Silvanus 276
slave 35, 56, 68, 70, 103, 114, 126, 260, 262
social status 21, 27, 35, 42, 46, 62, 72, 84, 86, 141, 155, 163, 167, 184, 207, 254, 260, 266, 276
Spain 132, 134–136
spoken language 117, 274
Spurius Stertinius 53, 58–59, 164, 168, 171
Stabiae 118
 Villa Arianna 115
 Villa San Marco 115–116
staircase 63–64, 66–67, 98, 100–101, 153, 156
statue 6, 53, 55, 58–59, 131–132, 135–136, 151, 153–154, 156, 162, 165, 195
statuette 53, 58–59, 152, 164, 171, 271
stele 184, 188, 206–207, 235
street 1–4, 14, 33–34, 86, 88, 93, 98, 102, 113
stylus 6–7, 115, 191, 196
symposium 42
synagogue 8, 21, 27, 53n15, 213–241, 265–266, 271
Syracuse 133
Syria 222, 225

taberna 3, 38, 84, 87, 89, 92–93, 101, 106, 270, 273, 275
tablets, bronze 5, 132, 134, 171, 231
tablets, wax 6, 86, 268
tablinum 165, 273
tabula ansata 26, 122n24
tabulae patronatus 5, 131–142, 165, 167, 267, 275
tabulae hospitales 131–142
Talmud 222–223

tavern, see *taberna*
Teucheira 202, 205
terracotta figurine 70
theater 236
thermopolium 94
Thorikos 34–35, 41–43, 46
Tiberius 260
Tiburtinus 114
Titus 120
tomb 8, 102, 131, 142, 181, 184–185, 189, 197, 219, 263, 265, 270
Trajan 136n23, 273
Triarius 51, 60
triclinium 127, 156, 158
Trimalchio 141

upper floor 2, 58–59, 62–64, 66–67, 71, 148, 156
urban landscape 106, 251, 262

Venus 114, 158
vestibulum (vestibule) 3, 14, 19, 58–59, 63–64, 67, 71–72, 98, 100, 103, 141, 152, 164, 260, 269
Vespasian 221
Virgil 261, 268

visibility 7, 26, 32, 40–41, 46, 59, 63–64, 72, 98–99, 102, 162, 165, 167, 266
visitor 5, 40, 42, 55, 58, 67, 71, 103, 105–106, 155, 165, 167, 222, 260, 272, 274, 276
visual strategies 52, 98, 105
Vitruvius 5, 142n51
Volsinii 165, 167, 171
votive relief/offering 53, 58–59, 162–163, 171, 216, 236–237

Wadi el-Aish (Cyrene) 184
Wadi Kuf (Cyrene) 187
wall-painting 15, 99–100, 224
wall-plaster 15–16, 18, 27, 37, 100–101, 187, 191–192
women 9, 103–106, 203, 222, 249, 255, 263, 269, 275
workshop 8, 34, 36, 41, 43, 84, 87, 89, 93, 106, 273
writing 5, 8, 16, 26, 32–34, 37, 39, 43–46, 81, 83, 86, 95, 98, 101–102, 104–106, 219, 240, 248, 254, 256–258, 271, 275–276

Xenophon 34

zodiac 224